© Lisa Lee

ABOUT THE AUTHOR

MICHAEL LARGO is an expert on the anomalous ways of American dying. He is the author of *The Portable Obituary* (a Bram Stoker Award Finalist), *Final Exits: The Illustrated Encyclopedia of How We Die* (winner of the Bram Stoker Award for Superior Achievement in Nonfiction), and three novels. He was the former editor of *New York Poetry* and the researcher/archivist for the film company Allied Artists. The son of an NYPD narcotics detective, Largo was the founding owner of New York City's landmark St. Marks Bar and Grill, where during the early 1980s he served an eclectic clientele, including Allen Ginsberg, Joni Mitchell, and Keith Richards, to name a few, allowing him to observe the "genius and heroin" phenomenon in its many variations.

For more information, please visit www.MichaelLargo.com.

GENIUS
AND
HEROIN

ALSO BY MICHAEL LARGO

Nonfiction

The Portable Obituary:
How the Famous, Rich, and Powerful Really Died

Final Exits:
The Illustrated Encyclopedia of How We Die

Fiction

Southern Comfort

Lies Within

Welcome to Miami

GENIUS
AND
HEROIN

The Illustrated Catalogue of Creativity, Obsession,
and Reckless Abandon Through the Ages

MICHAEL LARGO

HARPER

NEW YORK • LONDON • TORONTO • SYDNEY

HARPER

GENIUS AND HEROIN. Copyright © 2008 by Michael Largo. All rights reserved. Printed in the United States of America. No part of this book may be used or reproduced in any manner whatsoever without written permission except in the case of brief quotations embodied in critical articles and reviews. For information address HarperCollins Publishers, 10 East 53rd Street, New York, NY 10022.

HarperCollins books may be purchased for educational, business, or sales promotional use. For information please write: Special Markets Department, HarperCollins Publishers, 10 East 53rd Street, New York, NY 10022.

FIRST EDITION

Designed by Justin Dodd

Library of Congress Cataloging-in-Publication Data is available upon request.

ISBN 978-0-06-146641-0

08 09 10 11 12 OV/RRD 10 9 8 7 6 5 4 3 2 1

For Susy
Ces serments, ces parfums, ces baisers infinis

GENIUS
AND
HEROIN

INTRODUCTION

From the dawn of civilization there has always been a fine line between creativity and self-destruction. An inherent compulsiveness is often required in art to master a level of original thought and superlative skill. It requires everything, some believe, even one's own life. *Genius and Heroin* chronicles the lives of the famously talented in all fields, including writers, artists, musicians, actors, politicians, military leaders, sports figures, and even scientists, who entwined their genius with one of many paths toward self-ruin.

For many, their greatness and their pain are inseparable. The price for genius and the pursuit of creativity at all costs were steep, even if it resulted with a statue in the town square, a book on the bestseller list, or a picture hanging in a museum. Whether their downfalls were from opiates, pills, alcohol, absinthe, or the slow-motion suicide of obsession, *Genius and Heroin* examines how the notoriously creative lived and died. I was fascinated with the age-old question, did genius create their torment, or was it their anguish that created their genius? When Samuel Johnson observed, "A man of genius is seldom ruined but by himself," he had no idea of the variety of ways this could be achieved.

The means by which artists, writers, and other innovative minds liberated their creative powers, even when they knew it would cause their death, presents an interesting correlation to the type of work they created. The alcoholic produces work differently than the heroin addict, or the speed freak, or the artist plagued by an idea or obsession, although all are equally doomed. There is also a connection between the style of art produced and how they died. There's a distinction in putting a noose around the neck, a bullet in the brain, or one's head in a gas oven, as opposed to eating or drinking oneself to death or overdosing on drugs. Although the result is the same, we search for a reason to make sense of such endeavors. I've concluded that, of the five hundred artists examined in *Genius and Heroin*, for nearly 80 percent, alcohol and drug abuse were ultimately detrimental to their creative output, especially if they lived past the age of fifty, even if many of their best works were produced in the height of their addictions. For a few, less than 10 percent, their only remembered works of creativity were produced as a direct result of some form

of drug or alcohol use. For the remaining figures, it had neither benefit nor any other effect on their work—other than that it killed them. By examining some of the more lurid details, we can see a surprising link between creativity and self-destruction. It is also a culturally acceptable spectator sport to learn who's who in the creative arena and how they lost their battle to keep feeding their muse.

For the artists and ingenious personalities portrayed in this book, the passion to pursue a creative endeavor required their adaptation to a different set of rules. The basic instinct of self-preservation became secondary to the desire to produce original works. This seems an unexplained glitch but was nevertheless part of the human psyche from the earliest attempts at art.

What drives creativity at the cost of self is a question science has yet to answer. Today, it's vogue to view it as a mental illness. Just as bloodletting was once a cure prescribed to alleviate the excessive desires of "mad artists," today mental disorders are the assigned diagnoses to explain a creative anomaly. Vincent Van Gogh, for example, persisted at painting without accolades or financial gain for more than fifteen years, and for this unexplainable passion, no less than thirty different medical conditions have been named to account for his genius. Was it genius, or was some form of mental illness the reason Van Gogh could do nothing else but paint? Is it drugs, drink, and obsession that creative minds use to alleviate their condition, and are they the only means to allow genius to bloom unencumbered? Now, the genius of ruin is cut into jigsaw pieces and fit the portrait of the artist as a young bipolar. To disagree with the validity of this synopsis in this age of prescribable disorders would be like dropping a match at the foot of the stake at which one is to be burned, much as it was in an earlier age to question the science of bloodletting. Nevertheless, as psychologist Dr. Stephen Ilardi noted, "If throughout the course of human evolution people were as vulnerable to depressive illness as the twenty-first century Americans, we would have long since gone extinct as a species."

Of course, it would be unwise to discount scientific advancements made in understanding the brain, or refute a medical opinion of mental illness diagnosed for anyone. However, the artist as self-sacrifice to his art is a powerful magnet. To the immortal mindset and inherent invincibility of youth, the image of a ruined life as a price to create immortal work seems an easy enough ticket to purchase. For example, no matter what school of literature one admires, it seems striking that many of the great writers were entangled with some form of obsession and devastation. The fact that five of the seven American Nobel Laureates in Literature were alcoholic becomes hard to ignore for a young writer who sets out to create work equally memorable. Poets such as Keats, Byron, and Shelley made their young deaths part of the poignancy of the work, as it is for the twentieth century icons Plath, Woolf, Sexton, and Berryman. How would Sylvia Plath's line "The blood jet is poetry and there is no stopping it" read today if she hadn't committed suicide and were alive, seen endorsing a product, say, a medicine for diabetes—or depression? Ernest Hemingway, likewise, clung to alcohol as a once reliable formula to kick his muse into action, persisting to the bitter end. Of craft and how to find inspira-

tion, he talked of the "clean, well-lighted" place needed to keep away despair, though many chose the thin ledge, the dank basement, the rooftop in the rain, or under sweaty sheets instead of the sunny studio facing the sea as the place to produce their masterpieces. And even when they had the plush pad, they brought their obsessed self with them. It's only natural to search for reasons, medical or otherwise, to explain self-destruction and wonder: besides the art, what in life ultimately cast the creative person over the edge—was it a broken shoelace or an atom bomb? In *Genius and Heroin* we get to see the details behind their fall.

Many creative people throughout history explained the indefinable rationale behind inspiration not as a mental illness, rather as a muse or entity invading from some outside source, whether demon or angel. What is considered genius is a matter of perception. In Roman times, everyone was thought to have one. The etymology of *genius* traces it to a Latin word that explained how a person came to an original or innovative idea. It was used to describe how a person was possessed by a spirit, an intelligent and good one, emanating from patron gods, or ghosts of dead heroes or descendants. However, at a whim this genius could easily transform in to a *dæmon*, or malevolent spirit, and needed to be watched closely, such that sacrifices made to appease the genius within were always performed on one's birthday. The figures examined in *Genius and Heroin* didn't wait for once a year; they made some sacrificial offering every day.

We like to think our preoccupation with difficult art and difficult artists passé, but when the actress/model Anna Nicole Smith died, she was noted primarily for her obsession with making her obsessions public, and the details of her slide were everywhere. Her ruin was observed even by those who claimed to do it merely to disapprove of everyone else's infatuation. Today, the artist as a sacrificial lamb is not a career path on the list of guidance counselors. Likewise, in *Genius and Heroin* there is no gloating over the look of terror or despair at their downfall, but rather over how the eyes remain wide open behind a blindfold at the moment they face their own firing squad. There's no genuflection or chest-thumping mea culpas before the altar of artists. From my twenty-year stint at "field research," as it was for those in this book, I found it difficult to stop once started, and ultimately acquired an unsympathetic outlook toward any preconceived romanticism attached to dying and self-destruction. To create remains noble; to kill oneself while doing it—questionable, at best.

I also now understand why my father, a New York City undercover narcotics detective, thought my decision in college to switch from science to creative writing less than an epiphany. When I later resigned from teaching to open a rock 'n' roll bar at St. Mark's and First Avenue in the East Village during the early eighties (following the advice of Tom Wolfe to young writers: "You need to get out there and find experience"), I developed something short of a bright-eyed-bushy-tailed view of what it takes to create, especially to the extent that it relied on drugs and drinking. Although I do remember learning an important lesson on perception, taught by one customer, a sculptor who referred to himself as an unappreciated genius who happened to be working in a pizza place. He insisted that the generic or speed-rack vodka was equal in

taste to the imported top-shelf brands, even after I showed on the bottle's label that it came from New Russia, New York, instead of Moscow. With one arm around the local transvestite, he raised his glass, declaring, "I know my vodka, just as I know a beautiful woman when I see one," and then leaned over for a kiss. There used to be a saying that I can't legally assist in your suicide, but can buy another round of drinks. In the end, it was— "just one of those things"—a phrase we hear often and happens to be a fitting epithet for the artists, writers, and creative souls you'll find in *Genius and Heroin*.

ART ACORD

Genius is more often found in a cracked pot than in a whole one.
—E. B. White

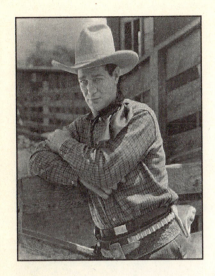

Artemus Acord was an authentic cowboy and rodeo champ when cast in Cecil B. DeMille's *Squaw Man*. Soon after, Acord shipped off to fight in World War I, where his real life rooting-tooting acts of bravery earned him medals. He returned to Hollywood and became one of the most popular actors in silent westerns, displaying a natural genius for capturing the bravado of the American cowboy era. He performed his own stunts, and reportedly could withstand any number of bottles crashed over his head without flinching. He didn't need to act too much for his barroom brawls, or for belting back a shot of rotgut, since he always insisted the colored water normally used to fill whiskey bottles contain the real thing. When his drinking became a burden he was canned, primarily because of an arrest for bootlegging. Acord went down to Mexico, in hope of finding a part in low-budget cowboy films, but he got quickly into trouble and more barroom fights, nearly being stabbed to death in one. In the end, Acord was employed as a miner below the border when he had the brilliant idea to stage his own kidnapping—he was certain the publicity would facilitate a triumphant return to the Silver Screen. When Acord brought the local police in on the scheme, he managed to get into more hot water by screwing around with one officer's wife. Eventually, Mexican authorities stated Acord died of suicide by ingesting cyanide, even if autopsy reports show the size of his enlarged liver may have caused his death (at age forty in 1931) from complications of chronic alcoholism. Others believe he was murdered by Mexican police. All but a few of Acord's more than one hundred films have been lost.

*Comedian **Hal Roach** was also cast in* The Squaw Man, *DeMille's first film. Hal stuck with iced tea in his whiskey bottles and lived to be one hundred.*

*Real-life cowboys are remembered for bellying up to the bar, but many legendary figures, including Wild Bill Hickock and **Kit Carson**, preferred opium dens over*

saloons. During the Civil War, morphine was frequently more plentiful to the troops than food rations, such that veterans on both sides, an estimated fifty thousand people, became opium addicts. In 1900 morphine addiction was considered such a serious social epidemic that a group called the Saint James Society offered free heroin in the mail to anyone wishing to kick morphine. By 1925 there were two hundred thousand heroin addicts in the U.S. Kit Carson died of a "ruptured artery in his throat," a typical complication caused by smoking opium.

JAMES AGEE

> *Genius is the father of a heavenly line; but the mortal mother, that is industry.*
> —THEODORE PARLER

When James Agee was six years old he learned that his father was never coming home: His dad died in a freak auto accident while returning from a visit with his dying grandfather. James and his sister were shipped off to separate boarding schools, James eventually landing in an all-boys conservatory in the Tennessee mountains run by monks. There, an astute priest recognized his creative side and fostered an education in literature that helped Agee get into New England's prestigious Exeter Academy and eventually Harvard. Agee started his literary career reporting for *Time* and *Fortune*, and then became a movie critic for *The Nation* and the *New York Times*. He published one book of poetry and a number of nonfiction flops, one of which was the now classic *Let Us Now Praise Famous Men*, a pictorial piece (photographed by Walker Evans) about Alabama sharecroppers that sold only six hundred copies before it was shredded because his opinions about social injustices were not yet accepted. Agee was active in politics that were left of center, which further stifled his reputation among a wider public. He worked in Hollywood for a while and is credited for the screenplays of *The African Queen* and *The Night of the Hunter*, even though by then his alcoholism was in full bloom. Eventually, Agee resented the demands made for cutting and rewriting and moved on. The sudden death of his father, and more so the apparent abandonment by his mother, caused a lifelong open wound, which Agee anesthetized with booze. His drinking, smoking, wandering, and womanizing brought on heart problems and divorces. The autobiographical novel that made him famous, *A Death in the Family*, was left unfinished when in 1955, at age forty-five, he suffered a massive coronary while riding in a New York City taxi. For once Agee seemed determined to clean up his act, and in fact was on the way to an appointment

with his heart doctor when he died. Agee's third wife and his children, one only a toddler, were rendered nearly destitute, but they were saved by an editor who reworked the novel for publication. The book received a Pulitzer Prize the following year.

Agee was once persistent in tracing the origin of his family name and found it to be a bastardization of a French phrase for "I don't know." Nevertheless, the result of his efforts in genealogy might have been the inspiration for his famous quote: "How far we all come away from ourselves . . . You can never go home again."

"THERE IS DEATH AND TAXIS, EVERYTHING ELSE IS JUST LIFE."

*According to the New York City Taxi and Limousine Commission, a typical Manhattan resident will take a hundred cab rides a year, and have only 0. 4 percent chance of dying in one over a ten-year period. Similar to Agee, rocker **Eddie Cochran** died in a cab—at age twenty-one in 1960. In his hit song "Nervous Breakdown," Cochran sang, "Hey, boy, you just gotta slow down/You can't keep a-traipsin' all over town." That's what he was doing in a cab to get to a gig in a hurry, when the driver lost control and smashed into a light post. The accident occurred near midnight, and the cab driver got six months in jail, even though he told authorities Cochran had instructed him to "step on it." **Margaret Mitchell**, author of* Gone with the Wind, *stopped for drinks at the Atlanta Women's Club before catching a movie one night in 1949. Although accompanied by her husband, Mitchell stepped first off the curb and into the street, when she was promptly struck down by a cab. No autopsy reports were made public to determine forty-two-year-old Mitchell's blood-alcohol level. However, the driver was said to be drunk and was sentenced to eighteen months in jail.*

HENRY ALEXANDER

The distance between insanity and genius is measured only by success.
—BRUCE FEIRSTEIN

No one knew why a photograph of the Hebrew Orphan Asylum was displayed so prominently in the studio of the promising painter Henry Alexander— and to this day it remains a mystery. Few took the time to know the young modernist artist after he arrived from San Francisco, determined to make a name for himself in New York City.

Other artists in his building went to lengths to avoid Alexander, since he quickly made a reputation begging for money that he never repaid. Whatever cash he got was spent on whiskey and painting supplies. He was definitely not an orphan, and according to a surviving sister, came from Californian pioneer stock and studied in Europe. Nevertheless, he was deemed noteworthy enough in the art scene to warrant an article about his death in the *New York Times*, published on May 16, 1894. The landlord of his artist studio had padlocked the door because he had paid only three months' rent in the prior year. Alexander pleaded with the landlord for access to retrieve one painting that he could sell for 150 dollars, and clear up his arrears. Apparently, Alexander did find a buyer, and instead, used the funds to go on a binge. Alexander checked into a decent hotel, and two days after, the night porter heard agonizing groans coming from his room. When hotel staff opened the door with a pass key, they found Alexander sprawled unconscious on the floor. An empty bottle of whiskey and a drained can of a metal polisher (ox-alic acid) were on the table. The *Times* concluded, "Lack of funds, it is thought, caused the artist to take his life." Before he died (at age thirty-four), Alexander's work was exhibited in a number of galleries, and seemed to offer promise of better things to come. He liked to paint the interiors of churches, and his most famous piece was prophetically titled "Lost Genius." The acid he ingested was sold as a product called Bar Keepers Friend, which was presumably used to pol-ish brass and not knock off patrons who didn't pay their tab. Records from the Hebrew Orphan Asylum, located on 137th Street and Amsterdam in New York Ciy, indicated that a thirty-five-dollar anonymous donation was made the day before Alexander died, though no child with his surname was registered.

LACK OF FUNDS

Alfred H. Maurer was the first American painter to be recognized in Paris for his Fauvist landscapes. He studied with Matisse, and seemed to have a bright future. When he went broke, he left France and retreated to his father's house in New York. What resentment

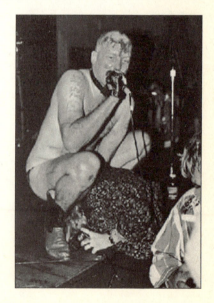

lurked behind his stifled genius remains un-known, though Maurer chose a telling place to hang himself. He was found dangling in the doorway to his father's bedroom in 1932.

GG ALLIN

> *I am convinced all of humanity is born with more gifts than we know. Most are born geniuses and just get de-geniused rapidly.*
> —BUCKMINSTER FULLER

Merle Allin Sr. named his son Jesus Christ after a visit from an angel. He got word that the newborn kid was

going to be a famous man. To get young Jesus (nicknamed GG), Allin's wife, and GG's older brother ready for this impending notoriety, the father raised them in a log cabin in the New Hampshire forest without electricity and running water. No one was allowed to utter a sound after dark. The experiment in quietude backfired when, by high school age, GG was stealing cars, breaking into houses, and doing an assortment of drugs. He showed up in women's clothing for his yearbook picture and began filling in as a drummer for rock and country groups. The first time he performed with his own band at the high school gym, he tore down all the homecoming decorations and generally went berserk on stage. The crowd applauded wildly, and from then on GG was hooked on becoming the most outrageous rock performer of all time. From the late seventies through the mid-eighties he was a regular front man for punk groups, but was only known in the hardcore scene. Then, heavily hooked on heroin, he took his supply to a cabin in New Hampshire and in the solitude wrote songs for his first solo album, *Eat My F**k*. Those in the know called it a masterpiece. He was known for his stage performances and for finding an expressive use of excrement, never failing to defecate or urinate at least one time before the show was over.

Allin took laxatives, drank heavily, and shot up to make sure he could crap on cue. To increase the audience's sensory experience, he rolled in his dung, injured himself, and taunted the most aggressive in the crowd, which many times nearly

Allin was the most spectacular degenerate in rock 'n' roll history.
—MySpace

GG Allin was a genius.
—scumgod13 (YouTube)

resulted in a riot. At this point in his career, because of the damage he did to sound equipment and other venue property, the plug was pulled often after only one or two songs. By the late eighties he was drawing crowds by promising to commit suicide on stage, philosophically believing you should go to heaven at your strongest. He also got arrested frequently for indecent exposure and assault and battery, and was once charged with rape and torture. Psychologists examined GG and deemed him "not psychotic," and of at least average intelligence, though with narcissistic and masochistic tendencies. His oddness, or perhaps his father's premonition, got him appearances and coverage on numerous talk shows, including *The Jerry Springer Show*, *The Jane Whitney Show*, *The*

My father thought I was the devil and blamed me for the way GG turned out. He was such an asshole. He did not even attend the funeral.
—Merle Allin, Jr.

Time don't let it slip away/Raise your drinking glass—Here's to yesterday.
—Aerosmith

Morton Downey Jr. Show and *Geraldo*. During his last performance in New York City, in 1993, they yanked the power after the second song. He trashed the club and left in a rage, walking the streets naked and covered in feces. When he went back to his friend Johnny Puke's flat, on Avenue B, Allin overdosed on heroin and died. He was thirty-six. Strung out groupies showed up, and not thinking

he was dead, only severely dosed, propped GG up for pictures. At his open-casket wake, he was dressed in a black leather jacket and a jock strap, with one hand holding the neck of a bottle of Jim Beam.

DIANE ARBUS

Those whom the gods love, die young.
—HERODOTUS

At forty-eight, in 1971, photographer Diane Arbus was done; sleeping pills and slit wrists made no return possible. Sister of U.S. poet laureate Howard Nemerov, Diane was raised in a world of high art and philanthropy in New York. She ultimately rebelled by pointing her lens in the opposite direction, bringing a black-and-white

starkness to decidedly less mainstream subjects: transvestites, dwarfs, giants, and ordinary citizens in odd poses. She had the gift of capturing her own surprise in a photo, and seemed to be asking with each image, how do you possibly handle this—"this" being life. Her subjects, from "A young man in curlers," to "A Jewish giant at home with his parents," resonated with a sense of silent tragedy, rather than celebration. She was always passionate, falling in love at fourteen to the man she married at eighteen. The young couple worked in fashion photography at first, but when they divorced, Diane made a career as a photojournalist. From Central Park to the Bowery she prowled the streets, hunting for a photo as much as for an answer. In the end those that deserved a click of the shutter reconfirmed her notion of isolation, even nihilism. Her genius lies in that she still upsets. Critics claim the rich girl whose family made their money in fur seemed fraudulent photographing retarded persons in full drool and at their worst. About the freaks she photographed, she said, "I still do adore some of them. I don't quite mean they're my best friends but they made me feel a mixture of shame and awe." It was rumored she photographed her own suicide, but the trustees of her estate, with lawyers as determined as any circus leg-breakers, insist that's a sideshow attraction no one will view.

A photograph is a secret about a secret. The more it tells you the less you know.
—DIANE ARBUS

SLITTING WRISTS IS NOT THE MOST EFFECTIVE FORM OF SUICIDE, WITH LESS THAN 2 PERCENT OF THOSE THAT ACTUALLY TRY, DYING EXCLUSIVELY FROM IT. AND EVEN IF THE PERSON IS SEEKING RELIEF FROM AN INTERNAL PAIN, IT'S A PAINFUL PROCEDURE.

FRENZY BEFORE DYING

Francesca Woodman's parents were artists, specializing in photography, painting, and ceramics. It seemed natural for Francesca to follow and she studied diligently in notable schools in the U.S. and abroad. A year after graduation, she came to New York City to "make a career of photography." She showed her portfolio to fashion magazines, but no offers for work came. Her black-and-white images captured young girls and herself, some nude, with blurred faces and melding into backdrops. It seemed she didn't know how to hold the camera steady or what the correct time was

for exposure, and her talent was dismissed. She considered her technique high art, though, among other issues, she had no patience to wait for it to catch on. She leapt from her loft window at age twenty-two, in 1981. Woodman left behind an amazing ten thousand negatives, each numbered, but not named. All but a hundred or so have been exhibited, collected in books, and since praised.

ANTONIN ARTAUD

Great spirits have always encountered violent opposition from mediocre minds.
—ALBERT EINSTEIN

In the age before children were prescribed drugs to stem disruptive behavior, Antonin Artaud, French playwright, actor, and artist was placed in sanatoriums for his odd quirks, separated from his family and home for periods lasting more than four years at a time. At eighteen, he was drafted into the army, but was dismissed for repeated sleepwalking episodes. Back in the sanatorium, doctors prescribed laudanum as a way to subdue his restless mind, but that subsequently kicked off his lifelong addiction to opiates of any stripe. He began to get notice as an actor and surrealist playwright, becoming a visionary in experimental theater, especially after the publication of his most famous book, *The Theater and Its Double.* The manifesto introduced his "Theater of Cruelty" concept, urging that drama should move from pure literary form to one encompassing all the senses. He believed if you faced your darkest criminal desires, a release from hypocrisy and knowledge of the true unconscious self would follow. The notion

was quite radical and was considered an insightful transition that found its influence in many forms of entertainment to follow: Rockers Jim Morrison and Patti Smith were Artaud fans, as well as many punk and heavy metal bands—Mötley Crüe paid tribute to Artaud with their classic 1985 album *Theatre of Pain*.

When not in insane asylums, Artaud lived as a transient, crashing out in one cheap hotel after another. He was preoccupied with holding on to sanity, perpetually feeling as if his mind was unraveling, which in reality it was, due primarily to the drugs and their various side effects. His fiend-like addiction was no secret from publishers, theater companies, and writers, who offered help when pos-

Patti Smith's aesthetic program is one that owes an incalculable debt to Antonin Artaud, who, in the words of Roger Shattuck, "concocted a magic amalgam of theatrical style, occult and esoteric knowledge . . . antiliterary pronouncements, drug cultism and revolutionary rhetoric without politics."

—JONATHAN COTT,
NEW YORK TIMES

sible. Author Anaïs Nin described his lips darkened from laudanum, a mouth she did not want to kiss: "To be kissed by Artaud was to be drawn toward death, toward insanity." When Artaud gave lectures he was often booed and laughed off stage, especially when he began to perform dramatic variations of his own death.

Artaud's passion to experience the depths of his psyche took a turn for the truly bizarre, especially after he experimented with peyote during a trip to Mexico. After a few violent outbursts during his lectures that followed, yelling that he was "obeying the orders of Jesus Christ," he was eventually transported in chains back to France. He was locked up in a ward for drug addicts in a miserably underfunded public asylum. He spent five years there while doctors tried to cure his delusions, including his preoccupation with witchcraft incantations, by administering repeated electroshock treatments. In the last year of his life he lived in a halfway house, and for the first time was financially secure due to an auction for all his manuscripts and drawings, many of which he composed while in lockdown. During this time he was praised for his genius, but by then he began to take opium again. In the final irony, he no longer had to struggle to get more drugs, and was given all the morphine he wanted: He had an incurable case of cancer of the rectum and was in dire pain. He died in 1948 at age fifty-two.

It is not opium which makes me work but its absence, and in order for me to feel its absence it must from time to time be present.

—ANTONIN ARTAUD

There is in every madman a misunderstood genius whose idea, shining in his head, frightened people, and for whom delirium was the only solution to the strangulation that life had prepared for him.

—ANTONIN ARTAUD

RE-CHARGED

Psychiatrist Gaston Ferdière had tried a new idea out on Artaud. He encouraged the long-since stagnant writer to express his emotions through art. Art therapy was a revolutionary concept, and it was during a period of Artaud's least frequent opium use that his more famous musings and artwork were created. In addition, under Ferdière's direction, Artaud was given fifty-one elec-

troshock treatments between June of 1943 and December of 1944. Ferdière's former patient Maurice Lemaitre wrote a book, Antonin Artaud Tortured by the Psychiatrists, *in which he called the doctor "one of the greatest criminals in the entire history of humanity." And Artaud said, "I myself spent nine years in an insane asylum and I never had the obsession of suicide, but I know that each conversation with a psychiatrist, every morning at the time of his visit, made me want to hang myself, realizing that I would not be able to cut his throat."*

Spalding Gray*, actor, screenwriter, and founder of an experimental theater group, said his art and worldview were greatly influenced by Artaud. Gray wrote one autobiography and numerous one-man shows, once acting on Broadway, and appearing in many films, including* The Killing Fields. *His monologues for experimental theater consisted of Gray sitting at a desk, bottled water at hand, and wearing eyeglasses to read his notes. Critics praised his exciting voice. He talked about his mother's suicide over and over, and some believed he was depressed. Good guess, since at sixty-two, in January of 2004, he went missing after making one last call to his wife from a pay phone in lower Manhattan. It was believed he jumped from the Staten Island Ferry, saddened after watching the movie* Big Fish. *For two months a hotline was manned around the clock, with supposed sightings of Spalding at diners in New Jersey, and once at Katz's Deli on Houston. All reports were misleading. When the body was discovered in the East River, it was identified by the black corduroy pants Spalding had on the day he disappeared.*

ISAAC BABEL

A man of genius has a right to any mode of expression.
—Ezra Pound

What is it that brings a writer to write when he knows his writing will get him killed? Isaac Babel, a Jewish-Soviet writer, came of age during tzarist Russia and survived a murderous program that took the life of this grandfather. His book of short stories, *Red Cavalry*, published in the 1920s, was praised for its stylistic genius, although his portrayal of Cossacks and their savage battle tactics was considered slander. At first he fought on the side of the Communists, believing the theory that everyone was equal a good thing, though as the Soviet government moved in the direction of totalitarianism he realized it was worse. Yet Babel continued to write stories he knew Stalin disapproved of, though he hoped to withdraw from the limelight by turning to pieces about Jewish personalities he remembered growing up. But the enemies he made with *Red Cavalry* never scratched his name from the list. When Stalin formed the Union of Soviet Writers to control what was acceptable as literature, Babel's name was mentioned. He was mockingly called a genius of the new literary form, and "a master at the genre of silence." He was then accused of the crime of "low productivity." It wasn't long before Stalin's secret police burst into his cottage, dragged him away, and seized all his papers. He was tortured and then shot in 1940 at age forty-five. Only sixty of his stories remain; the boxes of confiscated writings and manuscripts were never found. His last words to his wife before they carted him off: "They didn't let me finish."

No iron can pierce the heart with such force as a period put just at the right place.
—Isaac Babel

WHAT TO WRITE

Stalin wanted all writers, musicians, and artists to create works of realism, though what that actually meant was anyone's guess. The dictator's purges during Babel's time not only silenced the country's intelligentsia but anyone deemed unwilling to glorify Soviet achievements. The secret police (NKVD) tortured detainees until confessions for crimes, including "low

productivity," were admitted. Babel was only one of more than six hundred thousand exterminated for cultural offenses. Although records have been altered, Stalin is alleged to have

killed as many as 1.2 million of his countrymen, and once stated, "Death is the solution to all problems. No man—no problem."

HONORÉ DE BALZAC

Passion is a positive obsession. Obsession is a negative passion.
—PAUL CARVEL

Balzac would've been even more destitute if he were alive today, when a cup of coffee costs five bucks, than he was in his lifetime—since he was the first writer of note known to be addicted to caffeine. Balzac preferred to work at night and discovered if he chain-drank cup after cup of coffee—black, without cream or sugar—he remained happily bugged-eyed and awake. Although Balzac's caffeine buzz is one way to explain his hyperactivity and prolific output of more than a hundred novels, long before he became hooked, he was a kid that couldn't stay in his seat. While today he would've been surely double-dosed with any number of behavior-modifying drugs, Balzac, with his mother's money, tried and failed at a dozen different business ventures before deciding to do nothing else but write.

When the epiphany above came to Balzac, he raced through Paris to find his sister and declared, "I am about to become a genius." His idea to create a series of books portraying not only the nuisances of the aristocratic class but all levels of society was revolutionary for literature, and ultimately established Balzac as the founder of the modern novel. His carefully crafted descriptions of places and his diverse cast of characters met with success, and his work was serialized from the start. Finally good at something, he worked ceaselessly at this true calling, producing a collection of work he titled *La Comédie Humaine*. He normally woke at midnight, dressed in a monk's robe, and wrote fifteen hours straight, though when he was on a roll and plenty of hot coffee was on hand, he could write for forty-eight hours nonstop, with only catnaps for rest.

A grocer is attracted to his business by a magnetic force as great as the repulsion which renders it odious to artists.
—HONORÉ DE BALZAC

He moved throughout Paris frequently and stayed wherever he could find a room to work, as long as there was space for pen, paper, and a coffee pot. He was considered by some to be one notch above a drifter and part-time hermit. Balzac went back often to his mother's house, and created many of his characters in a small second-floor bedroom that today is a Balzac museum outside

of Paris. He wasn't totally reclusive and did some bingeing—though mostly on coffee—at cafés and salons, staying on good terms with many of the leading artists and writers. In fact, Victor Hugo was one of Balzac's pallbearers after the wired writer died (in 1850, at age fifty-one). His failing health, stomach cramps, and hallucinations were attributed to "brain congestion," though the excessive caffeine had caused an enlargement of his left heart ventricle, which seemed to be the thing that killed him. In the months before his death, his sight was nearly destroyed from long hours spent writing under candlelight, he had the complexion of wax, and he had a facial twitch like somebody on way too much speed.

> *An unfulfilled vocation drains the color from a man's entire existence.*
> —Honoré de Balzac

LATTÉ MADNESS

According to the Journal of the American Medical Association, a 1994 study found caffeine more addictive than alcohol. If a beetle nibbles on a coffee plant, its antennae stick straight up and then it keels over and dies, because the alkaloid compound that gives coffee drinks their stimulant properties is a natural pesticide. Balzac suffered from what medicine now calls caffeinism, *causing any number of physiological malfunctions. Mental health experts recognize four psychological disorders caused by caffeine, though writing one hundred novels, as Balzac did, is apparently only a side effect. The hallucinations Balzac experienced were surely from caffeine poisoning. If he were alive today, he'd bypass the liquid, crush caffeine tablets sold over the counter, and snort it for faster results.*

WORKING BY CANDLELIGHT

Artists inspired after dark had problems. **Francesco Borromini** *was a prominent architect and designed many of Rome's remarkable baroque buildings, including the famous church Sant' Ivo della Sapienza, noted for employing a unique hexagonal design. One night in 1667, he was still up working at three in the morning when his servant came from the next room and requested he blow out the candle, reminding Borromini of his doctor's orders for rest. Borromini woke three hours later, still inspired, and called for the servant to relight the lamps. When the servant refused, Borromini grabbed a ceremonial sword*

displayed in his bedroom, wedged it in the headboard, and flung himself onto the point. He lingered for twenty-four hours, presumably with plenty of candlelight, until he died. He was sixty-six.

JEAN-MICHEL BASQUIAT

I thought I was going to be a bum the rest of my life.
—JEAN-MICHEL BASQUIAT

Jean-Michel Basquiat started on the road to becoming an internationally known artist by spray-painting the sides of buildings in Manhattan in 1977, when he was seventeen years old. What made his drawings stand out from the standard graffiti were cryptic messages he included that left many curious as to their meaning. An article in the *Village Voice* ultimately revealed his identity. His talent was encouraged and before long, Basquiat was heralded as a leading painter of the neo-expressionist movement. Even though he rose from poverty to acquire accolades and wealth, Basquiat still preferred the old heroin haunts that he had frequented during his years as a street artist. He died in his loft studio in Soho, New York, from a speedball (mixing heroin and cocaine), at the age of twenty-seven, in 1988. In 2007, his wall-size piece of art "Profit I" sold for more than fourteen million dollars.

CHARLES BAUDELAIRE

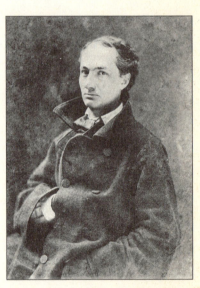

A genius is one who can do anything except make a living.
—JOEY LAUREN ADAMS

Charles Baudelaire's father died at age sixty-seven, when the would-be poet, art critic, and literary translator was six years old. An only child, Baudelaire was then left with his mother, Caroline Dufays, a poor orphan before her marriage and still only in her early thirties. A few years later, she became betrothed to Jacques Aupick, an army general and politician. At first young Baudelaire enjoyed the new status his mother's marriage afforded, but soon resented his dictatorial stepfather and pined for the loss of his mother's undivided attention. Aupick then shipped Baudelaire off to attend a boarding school in India. However, halfway en route, he jumped ship and returned to Paris. As luck, or maybe unluck, would have it, Baudelaire inherited a sum of money from his father's estate and quickly fashioned himself as an aristocratic man of letters, dressing in fine clothes, and becoming known as a big spender

at cafés and the City of Lights' finer brothels. It was there he acquired a taste for both exotic women and opium. Within two years he ran through nearly all of his money, and was only prevented from going completely broke when his stepfather obtained an order demanding whatever resources he had be put into a trust, placing Baudelaire for the rest of his life on a meager stipend. This was a major blow to Baudelaire's sense of grandiosity, and drove him from his refined haunts to Paris's Latin Quarter, then a less reputable section of town noted for its dilapidated flophouses and seedier brothels. There he met the Haitian actress and prostitute Jeanne Duval. She became his inspiration, "The Black Venus," his "mistress of mistresses," and his unattainable love for nearly the remainder of his life.

Early in his writing career, Baudelaire was singled out for the unique perspectives in his essays and criticisms of the Parisian art scene. He published an autobiography at age twenty-six and then focused on pro-

Bending over you, queen of adored ones
I thought I breathed the perfume of your
blood.
—CHARLES BAUDELAIRE

ducing translations, predominantly of the works of Edgar Allan Poe, who he felt was a kindred spirit. Craft-wise, Baudelaire worked slowly, primarily because of his opium addiction, and it wasn't until 1857, when he was in his mid-thirties, that he saw his first volume of poetry, *The Flowers of Evil*, in print. His themes of sex and death caused a moral outrage from the outset, setting off a tedious path of legal prosecution for publisher and writer, with both eventually being convicted of blasphemy, obscenity, and corrupting the morals of society. Although writers such as Flaubert praised his subject matter and noted, "It may be a perverted taste, but I love prostitution," Baudelaire was held up as a *poéte maudi*, a cursed poet without class. This ostracizing and persecution only made him fall deeper into addiction, and he surrendered hopelessly to the true mistress of his life—opium.

Baudelaire never married, and preferred to pay for sex, going back again and again to Duval. He usually asked Duval to do no more than the

An old and terrible friend, and, alas! like
them all, full of caresses and deceptions.
—CHARLES BAUDELAIRE

equivalent of a Victorian lap dance, wearing the cheap jewelry he provided her as gifts. Yet it was basically a one-sided love affair. Duval, herself an addict, couldn't care less, like any good hooker, obliging when Baudelaire had money, and infuriatingly aloof when he had none. Nevertheless, his fantasy image of her became the genesis for some of the best love poems. He imagined taking Duval back to Haiti, where he promised: "I'll love you to death."

IN THE BETTER BROTHELS A CLIENT WAS OFFERED A COCKTAIL THAT CONSISTED OF LAUDANUM, A TOUCH OF SAFFRON, CINNAMON, AND CLOVES, STIRRED INTO A PINT OF WINE. A GLASS COST TEN CENTS, AND TIME AND TIP FOR THE FEMALE COMPANION, A QUARTER. THE AVERAGE WAGE FOR A WORKING MAN WAS FIFTY CENTS A DAY.

As his notoriety grew, among writers, at least, so did Baudelaire's impotence, nagging abdominal pains, constipation, and general ill health. He blamed his depression and miserable life as a result of his unappreciated genius, and refused to view his sordid affairs as side effects of opium use. Even his crippling financial indebtedness, as he borrowed from whomever he could without intention to repay, was—and still is—another typical trait of anyone as wrapped up as he was in his addiction. Baudelaire found relief only when high, noting, "Common sense tells us that the things of the earth exist only a little, and that true reality is only in dreams." He was convinced that nothing ignited overlapping dream images better than opium.

Although it was once believed Baudelaire died of syphilis, many of his ailments were not entirely consistent with the end stage of that disease, and the decline of his health seemed more likely attributable to the decaying body of a junkie. As so many did when opium no longer worked, Baudelaire made a last-ditch attempt to get off the stuff and tried what is now called a "geographical cure" by fleeing Paris for Brussels. There he battered his already damaged liver by resorting to drink in vast quantities and soon suffered a stroke that resulted in hemiplegia, a condition where paralysis affects one half of the body. He was transported to a clinic in Paris. His condition worsened, his brain starved of oxygen, until suffering aphemia, a loss of the ability to produce and possibly comprehend language. He died in 1867 at age forty-seven, unable to speak, cradled by his mother, by whom he had always felt betrayed.

Opium magnifies that which is limitless,
Lengthens the unlimited,
Makes time deeper, hollows out volup-
* tuousness,*
And with dark, gloomy pleasures
Fills the soul beyond its capacity.
—CHARLES BAUDELAIRE

How little remains of the man I once was, save the memory of him! But remembering is only a new form of suffering.
—CHARLES BAUDELAIRE

BROTHELS AND OPIUM

In 1862 French painter Édouard Manet painted "Baudelaire's Mistress Reclining," at a point when the poet had finally ended relations with the prostitute. Five months after sitting for this bizarre and unflattering portrait, in which her right hand looks the size of

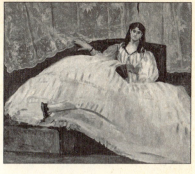

a lumberjack's, Jeanne Duval went blind and soon after died of syphilis, at age forty-two. During the 1800s, opium was believed to be an aphrodisiac, though in fact it stifled the libido—helping, possibly, only those afflicted with premature ejaculation. Brothels preferred to offer opium rather than alcohol because it lowered aggressive behavior and protected the women against the violent shenanigans of drunks. As one French madam pointed out, "The man who has the opium habit is not like another man; he does not care for women." It was good for prostitutes since the men paid for their company, but needed no more. Syphilis, or French pox, as it was called in Britain, was rampant in the mid-1800s and made taking opium safer than sex. Medical records from 1850 to 1855 show that 2,144 of 6,294 able seamen surveyed who admitted to sex in a brothel had contracted syphilis.

BRENDAN BEHAN

No animal ever invented anything as bad as drunkenness or so good as drink.
—G. K. CHESTERTON

Guinness, the Irish maker of the stout ale, tried to entice writer Brendan Behan to come up with a catchy slogan for their company by delivering a half-dozen kegs of their best brew to his home. After tapping the last barrel, he decided on what he believed its most important quality and offered what he thought a winner: "Guinness Makes You Drunk." They didn't use it, and instead got Christian writer Dorothy L. Sayers to pen the trademark, "Guinness Is Good For You." How good it was for Behan in the end was obvious. As Ireland's most popular playwright, Behan made no secret, nor could he, of his fondness for the frothy brew, describing himself as "a drinker with a writing problem." His persona as the jolly alcoholic, as he regularly showed up drunk on stage and on television, endeared him to the public. He started on a path not as jovial, as a member of the Irish Republican Army, and was sent to prison for four years, convicted for involvement in a plot to murder two police officers. Once out he left his previous employment working alongside his father as a house painter, and made his first earnings by writing pornography. His brilliant ad-libbing and lubricated wit earned him a spot giving readings on radio and writing newspaper articles on a variety of subjects. He noticed his talent slipping and decided to rise early and not drink until the pubs opened at noon. This modified regime

allowed him to write plays, focusing on his prison experiences, that became international hits. When he published an autobiographical novel, *Borstal Boy*, in 1958, he was considered a leading Irish writer of his generation, and dubbed by the *New York Times* as a "real writer." (The theater adaptation of *Borstal Boy* received the New York Drama Critics Circle Award for the best play of the 1969-1970 season.) At the height of his career, Behan was heralded as a genius for capturing the quintessence of old Gaelic's lyricism and spirit.

However, Behan's public deterioration became hard to watch, though he persisted at drinking, believing the public wanted to see his staggering and witty, drunken view of things. Much of the press he received at the end embarrassed his family and friends, though he lifted his mug and

Critics are like eunuchs in a harem. They're there every night, they see it done every night, they see how it should be done every night, but they can't do it themselves.

—BRENDAN BEHAN

exclaimed, with his still-genius ability for coining a line (which later became a maxim): "There's no bad publicity except an obituary." He got his at age forty-one in 1964, after suffering diabetic blackouts, renal and liver failure, and being locked down in a mental hospital in Dublin. Crowds lined the boulevards to watch his casket pass, dripping the first sip of their opened bottles into the street in his honor, recalling Behan's motto for the resigned alcoholic: "I only drink on two occasions—when I'm thirsty and when I'm not."

Stout was invented in the 1700s by first roasting malt and barley. It fell out of favor when "pale ale" became available. By the end of the 1800s, stout was used for medicinal purposes and was recommended for nursing mothers to fortify breast milk. In Ireland, a patient rolled back from surgery was given a bottle of stout.

JOHN BERRYMAN

The mark of genius is an incessant activity of mind. Genius is a spiritual greed.
—V. S. PRITCHETT

In 1972 at age fifty-seven John Berryman jumped from the Washington Avenue Bridge in Minneapolis. After endless years struggling with his craft, it had seemed all about to pay off. However, the road to that bridge included not only decades of persistence at his work, but a personal life entwined with relentless alcoholism, numerous scandalous affairs, and a four-pack-a-day cigarette habit. By any definition, he was a man obsessed in multiple arenas. In his final moments he sought to submerge himself in the baptismal, purifying current of the Mississippi River but missed, and landed on rocks, dying much slower.

For years, Berryman was considered a leading academic poet, writing proficient, though much of it stale, verse, and known as a stern instructor, chastising students for not following meters and other elements once considered essentials of the acceptable poem. When he shed these conventions, his poetry was heralded as innovative, and he was then considered the founder of the "Confessional School" of writers. He delved deep into personal hurts and unsolved haunts, particularly focusing on his remembrances at age eleven, when the supposed suicide of his father occurred: His father was found shot in front of an apartment owned by a man his mother married ten weeks later and who gave the poet the last name Berryman, changing it from his birth name of Smith.

The artist is extremely lucky who is presented with the worst possible ordeal which will not actually kill him. At that point, he's in business.
—JOHN BERRYMAN

As a youngster he learned that going into hysterics caught his mother's attention and continued to use this technique in adulthood. He was constantly breaking bones in his drunken sprees and sought refuge in many detox hospitals when things got too rough. Toward the end his public appearances and readings were often canceled due to his physical and mental deterioration. He felt trapped at teaching, and although the steady paycheck of academia had long treated him well, he felt he should be freer and survive financially on his poetry alone. It disturbed Berryman that a poet in America could expect to make less than a panhandler. It got to the point where he couldn't take care of the smallest of mundane tasks, and even required his wife to tie his shoes. He also made an about-face in philosophies, turning from a fanatical atheist to become a religious fanatic.

On a cold January day, with the prospect of yet another semester of teaching creative writing classes ahead, he was determined to end it. He wrote

Something has been said for sobriety, but very little.
—JOHN BERRYMAN

a note, "I'm a nuisance," and went out to jump. He came home, though, and finished one more poem, later found crumpled in the wastebasket. The next day, after downing a half bottle of whiskey, he went back to the bridge and climbed over a five-foot barricade. Students, arriving to get set up in dormitories, formed a crowd to watch Berryman from a nearby glass walkway. They didn't know it was the great poet, though he gave them a friendly wave before he leaned back and did a perfect reverse swan-dive. Police identified his broken body among the rocks more than a hundred feet below.

QUOTAS

Berryman's Washington Avenue Bridge ranks low on the score card for successful suicides, with only a dozen following his footsteps—though it's reportedly still haunted by the ghost of one, possibly Berryman's. The Golden Gate is number one for suicides, with more than twelve hundred when they stopped counting in 2005. (The tally only inspired people to be listed at a memorable number. When the one thousand mark approached in 1995 a radio DJ offered a case of Snapple to surviving family members of the one who hit the mark.) Seattle's Highway 99, Aurora Bridge, comes in second with more than 230. New York City, with the longest suspension bridge in the world, the Verrazano Bridge, does not attract as many as the Golden Gate, with an average of only four a year since 1981. In New York tall buildings are the preferred choice, with 81 percent leaping from their own residence. San Francisco, Seattle, and New York are among the cities with the highest average IQs and greatest concentration of artists.

AMBROSE BIERCE

Genius has no youth, but starts with the ripeness of age and old experience.
—MARK TWAIN

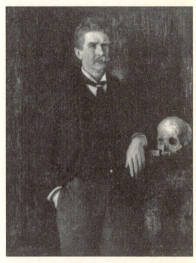

Ambrose Bierce was a battle-worn bar-brawler who made a name for himself as an outspoken critic, journalist, and writer of unsentimental prose. As a columnist, he often drew great praise or serious backlash for his opinions, and as it was for everything about Bierce, there was seldom middle ground or moderation. Neither his short stories nor his most popular work of the time, *The Devils Dictionary*, tiptoed around death, or recoiled from portraying grotesque ways of dying. In words or in person he'd attack anyone he perceived a fool. In his home life he seemed the same, dismissing his wife the moment he suspected her of writing letters to an admirer. For his children, two of the three seemed to inherit his spirit and preceded him in death, one son being shot to death in a barroom brawl and a daughter dying from complications of alcoholism. Bierce traveled widely and liked to disappear for stretches at a time, figuring it the best way to get the pulse of what was really happening, despite his constant bad health from numerous war wounds and debilitating asthma.

His last venture remains clouded in mystery, though it seems he was drawn to it by his lifelong obsession to see the blood and guts of war firsthand. At age seventy-two, in 1914, he went down to Mexico to write about Pancho Villa and the Mexican Revolution. Some say he was robbed by bandits, shot, and left for vulture fodder, since Bierce reportedly entered Mexico with a considerable roll of bills in his pocket. Others believe he was taken by Union soldiers back across the Rio Grande, carted off after he was found delirious and slipping into a coma, unrecognized as the famous American journalist, and shortly buried in an unmarked grave in Marfa, Texas. Bierce was an advocate of perpetrating a hoax, and those more in tune with his character believe he died much later than is supposed, though surely with a bottle in his hand and a young señorita on his lap. His famous story "An Occurrence at Owl Creek Bridge" is narrated by a man during the brief time from when the makeshift trap door on a gallows opens until he dies with a broken neck. Bierce was forever infatuated with wondering about what the moment of death would be like. Regardless of the means, there's no doubt he found it, even if the exact date remains unknown.

Good-bye—if you hear of my being stood up against a Mexican stone wall and shot to rags please know that I think that a pretty good way to depart this life. It beats old age, disease, or falling down the cellar stairs.
—AMBROSE BIERCE

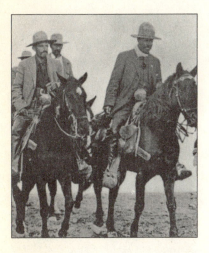

FINDING PANCHO
When Bierce headed to Mexico, Pancho Villa was still in favor, despite his reputation as a bandit and his being considered by many as a murderer. At the time, Pancho still captured the ideal of the quintessential revolutionary hero and had agreed to let Hollywood film him in action, in return for twenty-five thousand dollars and a share of the profits. The original film, The Life of General Villa, *though now lost, made him famous. Pancho was revolutionary in seeking all avenues for coverage. The typewriter had only been invented for ten years, though he realized the power of the press and was the first military general to allow journalists to travel wherever he went. He made sure the press corps was given the best food and plenty of tequila—and it's no wonder why Bierce intended to catch up with him. Pancho Villa's brilliant use of the media to boost his image and his cause, in the short term, didn't work for him: At age forty-five he was hunted by both the U.S. Cavlary and the prevailing Mexican government and finally assassinated in 1923, being caught off-guard sitting in a car. However, immortality did prevail and the likeness of the broom-handle-mustachioed folk legend is still painted on thousands of menus in Mexican restaurants around the world.*

To the P U B L I C K.
A large Committee having been selected by the several Musical Societies in Boston and its vicinity, beg leave to solicit the attention of the publick to the following

PROPOSALS
For Publishing a Volume of Original
AMERICAN MUSICK,
COMPOSED BY
WILLIAM BILLINGS, of Boston.

THE intended Publication will consist of a number of Anthems, Fuges, and Psalm Tunes, calculated for publick social Worship, or private Musical Societies. — A Dialogue between MASTER and SCHOLAR will preface the book, in which the Theory of Harmony, grounded on Question and Answer, is adapted to the most moderate capacity. — Also an elegant FRONTISPIECE, representing the ARETINIAN ARMS, engraved on Copperplate.

WILLIAM BILLINGS

Our current obsession with creativity is the result of our continued striving for immortality in an era when most people no longer believe in an after-life.
—ARIANNA STASSINOPOULOUS

Few have heard of William Billings today, but during the years preceding the American Revolution he was the country's most respected and popular musician, with many anxious for each new composition. Billings was close friends with such notables as Samuel Adams and Paul Revere, even if they called Billings "the gargoyle" to his face—among his deformities, Billings had a blind eye, one leg that was shorter than the other, and a shriveled arm. In fact, it enhanced his reputation as the premier psalm composer, conductor, and vocalist in a time when the appreciation of church music was a sign of cultural acumen. Billings's *New-England Psalm-Singer* was the first published book of American music. He also wrote a number of dance tunes, humorous songs, and parodies. His hymn "Chester" was the unofficial national anthem of the American Revolution. He also may be the first prominent figure to die from another American product—tobacco. By all accounts he was seriously addicted to snuff (finely powdered tobacco leaves), and was known to inhale handfuls from morning to night; he admitted he was unable to compose without it. Billings died in Boston in 1800 of esophageal cancer at age fifty-four.

SNUFF IT

Chewing tobacco and inhaling snuff causes some tainted saliva to drip down toward the stomach via the esophagus, often forming tumors in the submucosa and the muscular layer of this organ. Esophageal cancer is the seventh leading cause of cancer death worldwide, and accounts for about eleven thousand deaths per year in the U.S. Once a person is diagnosed with this cancer, he or she is often advised to make all necessary plans for departure because death is very likely.

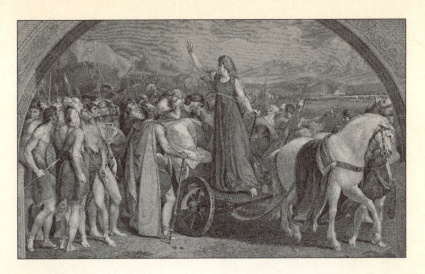

BOUDICCA

Revenge is an act of passion; vengeance of justice. Injuries are revenged; crimes are avenged.
—SAMUEL JOHNSON

Genius is awakened by many things. When it's for revenge, especially of a woman scorned, inventiveness knows no bounds. When the Romans first came ashore in Eastern Britain, they found local Celtic tribes and allowed the various leaders to keep their small kingdoms, as long as they acquiesced to Roman rule and paid the levied taxes on time. When Boudicca's husband, King Prasutagus of the Iceni tribe, died, the Romans refused to honor the Celtic custom of bequeathing wealth to wives and daughters; instead, they publicly humiliated Boudicca with a flogging and raped her daughters in the village square. Boudicca's obsession for revenge turned into a rebellion Rome had rarely seen, and through her persistence, she unified neighboring tribes to lead armies across the English landscape. In her short span of military brilliance, Boudicca burned London (Londinium) and other important Roman settlements, refusing to stop even though she had spilled the blood of eighty thousand, and had Roman Emperor Nero on the verge of recalling all troops from Britain. Fixed on revenge more than victory, in AD 62 she charged once again into battle and was killed by a pilum (a long Roman spear) at the age of thirty-seven. Afterward, Roman historians said she poisoned herself to avoid capture. Many believed her sudden transformation and knowledge about battle was a result of divine genius, and considered Boudicca, a once normal woman, a goddess.

CELTIC INSPIRATION

As early as the fourth century BC, word was out that the Celts were a people who overindulged in drink. Plato used them as an example of the dangers of excess, and both the Greeks and Romans considered them

inferior, because the Celts favored beer while their more enlightened societies preferred wine. When a Celt died, vessels of alcoholic beverages were always placed in the grave. One king was dug up and found to have nine gold-adorned drinking horns by his side, indicating not only his prestige, but evidently his priorities as well. Boudicca's genius and obsession was no doubt fueled by a potent drink made from fermented barley and honey. During Boudicca's slash and burn, she was careful not to torch the many wooden barrels of mead or the small breweries that were in every town. The day she was nailed and killed by the luckily tossed spear, she had just come off a three-day Druid feast. Those were classic beer-blasts where drinks flowed nonstop. Chunks of roasted wild boar were eaten from the tip of a knife, washed down with a helmet full of beer. In the end, it was a hangover that changed history.

LOUIS BRAILLE

My darkness has been filled with the light of intelligence, and behold, the outer day-lit world was stumbling and groping in social blindness.
—HELEN KELLER

Braille is a system that allows blind and visually impaired persons to read and write by passing their fingers over a code of variously arranged embossed dots signifying letters of the alphabet. The system was created through the dedicated fixation and genius of one man, Parisian Louis Braille, the son of a saddle maker. He was accidentally poked in the eye with a needle in his father's workshop when he was three. This led to the loss of sight in his other eye as well due to medical phenomena known as sympathetic ophthalmia. By age four, Louis was totally sightless. He was sent to a school where, as the blind and handicapped were treated then, he was fed stale bread, beaten, and locked up in closets for punishment. In addition, the blind were gathered for yearly festivals and made to wear dunce caps and paraded through the streets. In his teens, Braille luckily received a scholarship to a special school founded by Valentin Haüy, an advocate for the blind who had devised a system using dots on paper to signify letters, allowing students to read. In 1821, Braille, at age fifteen, used the sewing needles that made him blind to stitch a vastly improved system of letters that not only allowed students to read but to write as well. Braille eventually became a teacher obsessed with instructing blind children to read at the same school where he had learned. The actual school facility was run down, its air putrid and foul, and he knew staying there was killing him. Yet he persisted, though catching a fatal case of tuberculosis, dying in 1852 at the age of forty-three. He never lived to see his reading and writing system become the standard for sightless people worldwide.

PERFECT PITCH

In theory, when one sense is diminished another becomes more acute. Throughout history the blind have gravitated to music more than any other art. Some believe the sight-impaired have better hearing, even perfect pitch. In China, the Guilds of Blind Musicians and Fortune-Tellers dates to 200 BC, and throughout Europe many kings liked the novelty of blind musicians in their court. In America, blues music and gospel has dozens of notable sightless musicians. **Blind Blake**, *called "King of the Ragtime Guitar," was discovered playing on a street corner in Jacksonville, Florida. By the 1920s Paramount Records had signed him for a few recordings that sold well, but as success came he began to drink more heavily, and was killed by a streetcar at age forty in 1933.* **Blind Lemon Jefferson** *was blind from birth. Self-taught, he began playing and singing at parties, and was known for sitting on a crate and picking at the guitar strings for ten hours straight. Eventually, he was brought to Chicago and his recordings became top sellers responsible for taking unknown Paramount Records into the big league. Although Lemon was only paid a pittance, he did have enough money to hire a boy to guide him through the streets, and ultimately made a reputation for womanizing and drinking. Lemon died in 1929 at thirty-six years old. Some believe an old girlfriend poisoned his drink. Another news report claimed he became confused in a blizzard and froze to death.* **Blind Boy Fuller** *lost his sight in his mid-teens, diagnosed with "snow-blindness," though he once admitted that his girlfriend threw chemicals in his face. He taught himself to play by listening to Blind Blake records, at first making a living on street corners. A music scout for American Recording Company brought him to New York City, where he made more than 120 records. By age thirty-three, in 1941, he was dead from complications of alcoholism.* **Blind Willie McTell**'s *blues song "I Keep on Drinking," recorded in the late forties, fairly sums up this twelve-string guitar-picker's downfall. Willie suffered the same symptoms as Louis Braille, losing the sight in one eye, and then the other, and at a young age mastered Braille to read and write before his fingers found their genius making original music picking strings. He recorded more than a hundred titles before he died from the complications of alcoholism, diabetes, and ultimately a stroke*

at age fifty-eight in 1959, a poor man who believed obscurity was his destiny. Many rock singers, such as Kurt Cobain and Bob Dylan, have written songs and remixed numbers from McTell's repertoire in tribute.

More than half of all notable blind musicians had alcohol and addiction problems.

RICHARD BRAUTIGAN

Fame is a vapor, popularity an accident, and riches take wings. Only one thing endures and that is character.
—HORACE GREELEY

As a kid, Richard Brautigan watched his mother marry and divorce more than seven times. By high school he was writing novels and was considered "Most Likely to Become Odd," particularly after he was arrested for throwing a rock through a police station window. Instead of jail, they sent the teen to Oregon State Hospital, where he was treated with electroshock therapy. Brautigan eventually became a San Francisco fixture and was known to panhandle, offering chapbooks of his poetry in exchange for cash. A big break came in 1968, when an agent put his previously published small press novellas up for auction, catapulting this regionally admired writer into international fame. His slim book, *Trout Fishing in America*, was the passport every college student needed to be hip in the early seventies and went on to sell more than two million copies. Some critics thought Brautigan's work adolescent, and although refreshingly whimsical, lacking in any real depth. Lawrence Ferlinghetti, a stalwart of the Bay Area intellectuals, said Brautigan "was much more in tune with the trout in America than with people." Nevertheless, Brautigan made a ton of money and finally found the attention he had so long sought. In the end, his fame became his downfall, such that by the eighties he was dismissed as an aging hippie and had been for years in a sort of self-imposed exile, rarely giving interviews or readings. Once glowing accolades were replaced with an onslaught of negativity calling his new books, and style in general, passé, and he fell well below the radar. In 1984 at age forty-nine, with two failed marriages under his belt and a considerable alcohol problem, he went to his cabin in Bolinas, California. He was found four weeks later, badly decomposed with a gunshot wound to his head. A .44-caliber pistol and a half bottle of whiskey, alongside him in silent testimony, had been his last companions.

It's strange how the simple things in life go on while we become more difficult.
—RICHARD BRAUTIGAN

LARRY BROWN

Better beware of notions like genius and inspiration; they are a sort of magic wand and should be used sparingly by anybody who wants to see things clearly.
—JOSÉ ORTEGA Y GASSET

Inspiration takes its time to wiggle its way out of a cow pie, but manages to now and again despite the obstacles. Larry Brown was born in Oxford, Mississippi, and due to some unknown quirk in longitude and latitude, this sleepy Southern town has produced a number of notable writers, the most famous of which is William Faulkner. Larry, the son of an alcoholic World War II vet who managed to keep the family one lick above dire poverty, didn't start with literary aspirations. In fact, Larry failed high school English classes and soon dropped out of school altogether for a stint in the Marines. He returned to resume his place among the good-time-loving, hard-drinking echelon of the working poor, making ends meet at odd jobs, including pitching hay, cutting firewood, hauling two-by-fours, or poking at the cash register in a Jiffy store. He cruised the back roads in his pickup truck to fish, chain-smoke, drink beer, and fire up a bong whenever he got ahold of some weed. When he landed a steady job with the municipal fire department, he used the considerable downtime—and his insomnia—to read whatever he could find. He took one writing class, but taught himself the craft by two-finger-typing more than a hundred stories and half a dozen practice novels before his first fiction piece was published in a biker magazine, when he was thirty-one. When he started, the mantra in creative writing classes and the advice given to all wanting to know how to publish was of one consistent tune—write what you know. Larry took the advice to heart and persisted in creating a body of respected fiction, dubbed "Grit Lit," or "Rough South," which was praised as original and authentic. His characters were desperate drunks, whores, parolees, and just regular folk who by circumstance or choice met their own sad downfalls. People who knew Larry liked him, and when asked about his personal demons and the effect on his writing, he said, "I write by binges and I drink by binges. But it's not good to try to write and drink at the same time." *USA Today* reporter

Bob Minzesheimer was close at hand during an apparent binge and noted: "[Brown] went through a six-pack of beer, several small bottles of peppermint schnapps, and a few, post-dinner shots of whiskey. By midnight Brown was still going strong at the bar." When Brown died of what everyone was quick to note was a heart attack at the age of fifty-three in 2004, Larry's own path of self-destruction was left open to debate. More than six hundred people showed up for his funeral, and the title of his favorite country song was etched on his tombstone: "The Road Goes on Forever." It was from the Robert Earl Keen album *The Party Never Ends*.

> *I'm happy writing full-time and I've been making a living off it so far. I haven't had any complaints with it at all. I'm happy.*
> —LARRY BROWN

BEHIND GRIT LIT

For years, many believed certain genetics made some more disposed to alcoholism. American Indians have a 550 percent higher rate of alcohol-related deaths than nonnatives, though researchers find no difference in genetics. That Brown's father was an alcoholic made him statistically predisposed. Some scientists (probably nonalcoholic ones) think excessive drinking is a learned behavior. On the issue of longitude and latitude, a study conducted by the National Institute on Alcohol Abuse and Alcoholism found that even with lower rates of alcohol sales, certain regions had a higher incidence of alcohol-rating mortality: The Pacific Northwest, Pacific Southwest, Interior Southwest, New York City, and the South have the highest death rates. In the South, mortality from alcohol was noted as a greater problem among lower-income portions of society than in other regions, and its victims mirrored the personalities Brown wrote of. Regionally, among artists and non-artists, the Central Midwest had the lowest death rates.

LENNY BRUCE

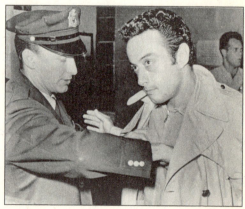

> *Nothing shows a man's character more than what he laughs at.*
> —GOETHE

At first a likeable kid, though a born liar, comedian Lenny Bruce, *né* Leonard Schneider, learned to be a chameleon at a young age. When he was eight years old his parents divorced, and although it was unusual for the time, he was sent to live with his father on Long Island, but was soon after shipped off to an assortment of relatives. His mother, once an aspiring dancer and comedienne, opened a dance studio and was too preoccupied teaching suburbanites the boogie woogie to give Lenny her attention, although she was later credited for encouraging her son to seek a career in showbiz.

Bruce, like many comedians, had an obsession with being accepted and gauged his self-worth by the amplitude of applause, no matter how he got it. After a stint in the Navy, from which he was discharged early for lying about homosexual urges, he started performing, doing impressions. When this gig brought only marginal returns he used his talent to impersonate a priest, stealing a robe and white collar, to solicit donations for a leper colony in Africa.

This stunt earned him nearly eight grand, two of which he sent to the real missionaries working with the ulcerated. Bruce persisted trying to entertain, doing impressions and half-borrowed jokes for the white patent-leather crowds of the Borscht Circuit,

> *I won't say ours was a tough school, but we had our own coroner. We used to write essays like: What I'm going to be if I grow up.*
> —LENNY BRUCE

the mostly Jewish resort hotels of the Catskill Mountains, and for retirees in Miami Beach. At age twenty-five, he met a voluptuous, red-haired stripper who went by the name of Honey Harlow. Although in her stilettos she stood a head taller than Bruce, he was in love and together they headed west to Hollywood, where they worked the brass pole joints and burlesque clubs. It was during this period Bruce started to pepper his often yawned-at monologues with curse words that got even this crowd, impatient for the women, to take notice and laugh. Today, it's hard to imagine how his use of "fuck" (one of the only words that can be used as a noun, verb, or even an adverb) could have gotten him arrested fourteen times for obscenity and ultimately made him villainous, then famous, and finally legendary. During one performance, Bruce was counted using more than a hundred obscene words.

Bruce knew from the first laugh that he was onto something and saw that if certain words were taboo, there were a dozen other taboos that could be dragged out into the open on stage for a laugh. Marriage, motherhood, religion, racism, the Pope, the President, and even Rin Tin Tin became comically fair game and were put into Bruce's stream-of-consciousness delivery. It soon took him from the seedy joints to established clubs, and even Carnegie Hall. When he was in his prime, Lenny Bruce's whirlwind monologues were brilliant. His ability to switch to

> *The only honest art form is laughter, comedy. You can't fake it . . . try to fake three laughs in an hour—ha ha ha ha ha— they'll take you away, man. You can't.*
> —LENNY BRUCE

different personalities and impressions, and the content of his insights, were fairly revolutionary for the time. However, it was the obsession to be liked and his thin skin, not to mention the heroin and cocaine habits he picked up years before working in the strip clubs, that pulled the plug on his show before he reached the top.

By 1961, soon after the Carnegie gig, Bruce became ill, the drugs and police trouble taking their toll. Recently released FBI files on "Lennie" Bruce reveal a man consumed by his own legal mishmash. He believed nothing less than that there was a well-orchestrated conspiracy by "the establishment" to destroy him, step by step. The FBI documents noted, with some sarcasm, that

the comedian celebrated his fortieth birthday by declaring himself a pauper, and that because of police harassment he could no longer get booked to do his act. Bruce told the FBI that his income went from $108,000 in 1961 to $10,983 by 1965. When he did perform, his monologue was all about his legal battles and filled the rooms with the humorless, bad aroma of a drowning man. His final performance was on June 25, 1966, at the Fillmore in San Francisco and was not remembered fondly by promoter Bill Graham, who later remarked that Bruce killed his own chance of a comeback as "whacked on amphetamines" as he was. Less than two months later, Bruce died, at age forty, of "morphine poisoning" and was found with his pants around his legs and a needle in his arm in the bathroom of his empty house. Authorities allowed access to photographers as the final "we gotcha" on Bruce's life, and humiliating pictures of his body circulated in the papers. In the end, the country's class clown was expelled by an overdose. *Playboy* published the best farewell: "One last four-letter word for Lenny: Dead. At forty. That's obscene."

ONE GOOD REASON

Dustin Hoffman, after playing Bruce for a film role, said: "I don't believe Lenny used drugs just to get wasted. Instead, I thought he used them to keep himself going for four days, since he was under enormous pressure from performing in clubs, writing new material, recording new record albums, and planning concerts." It's nothing new for an artist to believe that drugs are necessary to finish a project. In 1885, writer Robert Louis Stevenson showed his wife the first draft of The Strange Case of Dr. Jekyll and Mr. Hyde. *When she told him to burn it, Stevenson got a pile of cocaine and snorted the whole batch. Working nonstop for three days and nights, he wrote an entirely new version, making the book that remains a classic, though it was cocaine-fueled.*

SHOOTING UP

Intravenous drug use dates to the late 1850s when hypodermic needles were perfected by physicians Alexander Woods and Charles Pravaz, specifically for the administration of morphine. Addicts quickly learned that an injected dose required less of the drug for a faster effect. The downside was that sterilization wasn't considered and needle-sharing transmitted many diseases, such that many addicts' deaths were recorded as being caused by other illnesses. Richer addicts purchased hypodermic kits that were sold in ornate boxes with crushed velvet linings, with hypodermics made entirely of silver. The

basic glass syringe with a hollow-point needle remained standard fare until the 1960s, when disposable hypodermics became available. Needle-sharing persists, and 26 percent of all intravenous drug users are likely to borrow a needle at least once every six months. Of these, 95 percent eventually get HIV.

CHARLES BUKOWSKI

Some people never go crazy. What truly horrible lives they must live.
—CHARLES BUKOWSKI

With more than fifty books to his credit, Charles Bukowski has been praised as one of the most original and unapologetic of the inebriated poets and novelists of American literature—and dubbed by *Time* magazine as "the laureate of American lowlife." He worked for a number of years at odd jobs and in the U.S. Post Office, while writing nonstop for mostly underground magazines and maintaining a considerable drinking habit. Not until 1969, when he was forty-nine, did Bukowski turn to full-time writing, saying: "I have one of two choices—stay in the post office and go crazy, or stay out here and play at writer and starve. I have decided to starve." His unique take on life can be summed up with this insightful observation: "There was nothing really as glorious as a good beer shit—I mean after drinking twenty or twenty-five beers the night before. The odor of a beer shit like that spread all around and stayed for a good hour-and-a-half. It made you realize that you were really alive." He died from a blood disorder in 1994 at age seventy-three.

WILLIAM S. BURROUGHS

Junk is not like alcohol or weed, a means to increased enjoyment of life.
Junk is not a kick. It is a way of life.
—WILLIAM S. BURROUGHS

William S. Burroughs, known for the novel *Naked Lunch*, a book describing his heroin-addicted years, was noted by Norman Mailer as, "The only American novelist who may conceivably be possessed of genius." In his waning years, although Burroughs had given up dope, he remained a formidable though gaunt figure. He preferred to live in a quiet midwestern town rather than the racier streets of New York City that had once fueled his habit and his imagination. Burroughs died in 1997 at age eighty-three from a heart attack, believing that his early years using opiates when they were pure preserved him.

LORD BYRON

Conceit spoils the finest genius.
—LOUISA MAY ALCOTT

Born plain old George, the great Romantic poet inherited his title at the age of ten, eventually becoming George Gordon Noel Byron, the sixth Lord Baron Byron of Rochdale. Lord Byron came from a colorful cast of ancestors, and although he was born with a clubfoot, his anatomical short-

coming became his motivation of sorts, as he was obsessively determined to prove his superiority despite it, seeking out adventure and risk at every chance. By his early twenties he was publishing and became famous for satirizing a renowned critic who had the nerve to trash his first collection of poems, calling Byron "below stagnant water." Byron's *English Bards and Scotch Reviewers*, a satirical lyric counterattacking the literary establishment went through more than six editions and earned him a reputation as a writer to watch. Soon after, as was typical for young nobility at the time, Byron went abroad on a tour designed to expand his education of the world. From his early days at all-boy private schools Byron already preferred the company of the

According to his biographer, Thomas Moore, Lord Byron said, "I awoke one morning and found myself famous." He also felt curious about his status, remarking, "A celebrity is one who is known to many persons he is glad he doesn't know."

same sex more than girls. He had numerous homosexual affairs while in Italy and Greece, and bequeathed one local Greek boy a small fortune when he bid adieu. Byron changed the pronouns of nearly all his famous love poems from masculine to feminine before publication, attuned as he was to the sensibilities of the time. When he published *Childe Harold's Pilgrimage*, with its altered pronouns, upon his return, his genius was instantly recognized and *The* Lord Byron was heralded as a great poet.

Byron perfected the persona of the romantic adventurer attuned to nature and brimming with passion that society and culture were seeking. Without planning to do so, Byron became one of the founders of the Romantic Movement in literature, one that encouraged the sensory appreciation of the natural world and the potency of one's emotions and imagination.

He entered politics while in London, was noted for sticking up for the discriminated-against Catholic class, and had a number of affairs with notable women, though they quickly turned sour. When he did marry rumors of marital violence, incest, and sodomy began to circulate around the great manor where Byron lived. In 1816 he wisely left England, where such conduct, regardless of class and literary reputation, was not tolerated, at first traveling to Geneva, then Italy, and was never to return to his native land again. His mingling with other literary greats such as poet Percy Bysshe Shelley and his wife Mary, whom Byron inspired, during one rainy weekend after reading to them French fantasy tales, to write the novel *Frankenstein*, are legendary. However, Byron became bored easily and bristled at the hint of any domesticity, staying in one place, or having the same lover for too long.

In 1823, when he heard the Greeks were at war with the Turks, Byron sailed for the adventure. He used his own money to refit Greek battleships and took command of an army, despite the fact that he had absolutely no military training. Once again, to overcome any notion that his clubfoot would hinder his actions, he trained incessantly through cold February winds. Subsequently, Byron came down with

A mistress never is nor can be a friend. While you agree, you are lovers; and when it is over, anything but friends.
—LORD BYRON

pneumonia. After a number of bloodlettings, the acceptable medical cure at the time, he was further weakened and died in 1824 at age thirty-six, officially of fever. His near-completed work *Don Juan*, published posthumously, was considered the greatest English poem since Milton's *Paradise Lost*, and is still studied in universities. The persona he created in life became an icon, and all who aspired to imitate it were dubbed "Byronic heroes." The Greeks cut out Byron's heart and buried it in a tree, and shipped the rest of the body back to London.

> *Death, so called, is a thing which makes men weep,*
> *and yet a third of life is passed in sleep.*
> —LORD BYRON

APPLICATIONS ACCEPTED

To be a Byronic hero one must embody passion, hide dark secrets, display bravery for the underdog, and have a sufficient measure of arrogance, though, in the end, you must always act in a self-destructive manner and die in action.

INTO THE WILD

Davis Douglas was inspired by Byron and the Romantic poets' love of nature to study botany. Following their adventurous example, Douglas was not content to sit in a white lab coat yawning as he waited for seeds to grow in the laboratory. The year Byron died, Douglas decided to venture from Scotland to trek the relatively unexplored Pacific Northwest in search of unnamed plants. He particularly liked pine trees and the Douglas-fir remains a legacy to his insightful industry. During one outing, obsessed with looking up to name more tree species (as opposed to looking down as more conventional botanists to name weeds and flowers), Douglas stumbled into a pit. Shortly after, a longhorn bull fell into the same hole. Douglas, thirty-five, was gored to death before he could climb to safety. Some make sure their Douglas-fir Christmas trees always have at least one dangling horn ornament in memory of Douglas's passionate obsession.

MARIA CALLAS

I don't need the money, dear. I work for art.
—MARIA CALLAS

Famed soprano Maria Callas died at age fifty-five in 1977. She made the news when she transformed her rotund figure (she was once called "monstrously fat") into that of a svelte and sexy Diva at the height of her career, even if music critics marked her weight loss as the downturn of her vocal brilliance. She was more interested in having fun and dated powerful men. She became a favorite of tabloid gossip when, while still married, she was seen with Aristotle Onassis, and the tabloids reveled in her anguish when he chose Jacqueline Kennedy over her. Rumors circulated that Maria kept her weight off by ingesting tapeworm larva, but she insisted it was a sensible diet and said, "I have been trying to fulfill my life as a woman." In the end she lived isolated in Paris, unhappy in her quest for love, and acquired a taste for non-caloric Quaaludes, a sedative-like drug that gives a euphoric though rubbery-legged feeling. Officially, French officials deemed her death was due to "undisclosed causes," though they cited a heart attack when pressed by the media. Others claimed she was murdered for her sizeable estate. A note written by Callas was found near her body, though it raised only more questions about her final state of mind. She borrowed a line from the suicide scene in the opera *La Giocanda*: "In these proud moments."

JOHN CANDY

You can tell a lot about a fellow's character by his way of eating jellybeans.
—RONALD REAGAN

There's something about Canada, some say the air, water, or maybe it's the bird's-eye view of the United States, that produces an inordinate share of successful comics. However, for John Candy it was the food there, across the border, and ultimately everywhere, that was both his success and ruin. As soon as he died, at age forty-three, tabloid newspapers ran headlines indicating that Candy ate

himself to death, and offered to give details of his eating binges in full color, without mentioning his cigarette habit, workaholic ethics, and a genetic disposition to heart disease. The fact that he had ballooned to 375 pounds at the time of his death and was working twelve-hour days in stifling Mexican heat while shooting his last movie led to a massive heart attack: The autopsy found he had nearly complete clogging of the arteries. In reality, his true obsession was acting, either comic or dramatic, and like a writer who believed drinking would make his books better, Candy assumed his rotund size brought him roles. Given the public's expectations, it might've been true for Candy, since from the beginning he gave his best performances playing the obese, loveable loser with low self-esteem. On screen he made jokes about his weight, but when the cameras stopped Candy was self-conscious to the point of self-loathing. He attempted a few times to lose weight, but couldn't gamble that the next film that cast him as the big man would be the one that finally brought him to the level of stardom he sought. Ultimately, he never gave himself the chance to reinvent his image. Candy's career was mixed, with hits often punctuated by a string of flops that made downtime impossible, and despite his growing size, he worked nearly nonstop, leaving a cinematography record of more than thirty-four films in fifteen years. That he killed himself solely by eating is not entirely true; it was only the means to a greater obsession that ended his life early, in 1994.

> *I think I may have become an actor to hide from myself.*
> *You can escape into a character.*
> —JOHN CANDY

CREATIVE EATING

*Eating oneself to death is not an exclusively comedic act, and even took down a few of the ultra-serious. **Julien Offray** was a French philosopher and is credited with inventing cognitive science (defined as the "study of mental tasks and the processes that enable them to*

MISS HIBERNIA AT JOHN BULL'S FAMILY DINNER!!

be performed"). *He also wrote of the joys of materialism for materialism's sake, authoring the book* Man a Machine. *Presumably, he didn't intend the title of his book as a metaphor, since he frequently tested his body to the limits. As his last act, Offray conducted an experiment to prove the harmless effects of occasional gluttony. The philosopher was quite lean and always presented a carefree attitude, believing that life was meant for savoring one's favorite material pleasures as they arose. At a banquet given in his honor in 1751 he found the* pâte aux truffes *to be so delicious that he devoured tray after tray—until he collapsed to the floor. He died the next day after suffering a high fever and delirium at age forty-one.*

TRUMAN CAPOTE

It is strange that all great men should have some oddness, some little grain of folly mingled with whatever genius they possess.
—MOLIÈRE

Sharp as a two-pointed pencil, young Truman Capote taught himself to read and write before entering first grade. He claimed to have written his first novel by the age of nine, and practiced at writing as diligently as others learned a musical instrument. His earliest years were spent in rural Alabama, where he was best friends with Harper Lee (author of *To Kill a Mockingbird),* but was moved to New York City before his teen years. There, his remarried mother sent him to a military school for a while to toughen him up in the hope of making him more masculine. Truman, however, was the type that seemed to his mother genetically born gay, a fact she took so seriously that she aborted two following pregnancies, afraid of giving birth to another child with his personality. When Truman finished high school he was steadfastly determined to become a writer, and thought college only a waste of time. He got a job at the *New Yorker* cataloging cartoons, but soon made a name winning prizes and publishing short stories in other prestigious magazines. By the time he was twenty-four, his semi-autobiographical novel *Other Voices, Other Rooms* had made the *New York Times* bestseller list. As much as Capote was dedicated to perfecting his writing style, he equally obsessed with his image (in contrast to former childhood friend Harper Lee), and set out to create a public personality for himself from the start. His sexual preferences, at a time when being gay was not openly accepted, his small stature that reached an adult height of five feet four inches, and a unique, oddly inflected and high-pitched voice, would have seemed to most a detriment. Yet he capitalized on his strangeness, and considerable intellect, to make inroads and became, at least outwardly, accepted into the company of high society. Capote's publishing success grew astronomically after the publication of *Breakfast at Tiffany's*, followed by *In Cold Blood*, so that few could argue with his artistic genius. Noted critic John Hersey praised *In Cold Blood* as "a remarkable book," and writer Norman Mailer declared Capote

to be "the most perfect writer of my generation."

During the mid-sixties, he reached his heyday and considered himself the cat's meow of the jet set when his ultra-exclusive "Black and White Ball" became a coveted invitation. He succeeded in fulfilling his obsession to be counted among the elite, though he began to realize that he was never truly considered their equal, and perhaps no more than an amusement. The notion that he was the modern-day John Merrick, "The Elephant Man," an outsider allowed to mingle as a curiosity among the upper crust, took its toll. He drank more and more heavily and took drugs, entering numerous rehab programs while deciding to seek revenge.

Capote promised to write a book that would expose the secret foibles of the debutantes and dignitaries in his characteristic cuttingly crafted way. After many false promises and multiple delays in the delivery of his awaited tome, he became more and more ostracized, eventually withdrawing nearly entirely from the limelight. After a few drunken appearances on TV and more rehab, doctors determined that Capote's brain mass was shrinking. He could no longer write coherently. In 1980, at age fifty-nine, he died during a morning nap, officially, from liver disease complicated by "multiple drug intoxication." It seemed he had finally kicked his drinking habit, though barbiturates, Valium, antiseizure drugs, and painkillers were found in his blood.

> *No one will ever know what writing* In Cold Blood *took out of me. It scraped me right down to the marrow of my bones. It nearly killed me. I think, in a way, it did kill me.*
>
> —TRUMAN CAPOTE

> *Deborah Davis, in* Party of the Century, *wrote: "The Black and White Ball was a work of performance art. It was a work that was every bit as important to Truman Capote as everything that he wrote,"* although then young actress Candice Bergen, seen wearing a fluffy, long-eared mink bunny mask to the masquerade ball, called the whole deal "boring."

> *When God hands you a gift, he also hands you a whip; and the whip is intended for self-flagellation solely.*
> —TRUMAN CAPOTE

MAX CANTOR

Max Cantor was a Harvard-educated journalist who wrote in-depth articles about drug addiction for the *Village Voice*. While doing research about drugs and the addict population in the East Village, he too became hooked. He died from a hot shot in 1991, at age thirty-two.

LEWIS CARROLL

Charles Dodgson, the author behind the pen name Lewis Carroll and creator of *Alice's Adventures in Wonderland*, had a peculiar fascination with eleven-year-old girls. Today, just a hint of this might get the sirens and red lights of cop cars swarming, but back then it didn't seem to ruffle many feathers and Dodgson was allowed to keep his day job as an ordained minister and teacher. His hobby of photography

and his portfolio of young girls, many of them nude, were explained by Dodgson as a noble rather than erotic pastime. He was merely interested, he claimed, in capturing the "ultimate expression of innocence." Even though he asked the parents of an eleven-year-old girl for permission to marry when he was thirty-one (they declined), there is no evidence he acted out his desires. To his credit, Dodgson had a tremendous imagination and created original and memorable stories, featuring talking rabbits, grinning Cheshire cats, mad hatters, and a girl-heroine immersed in a world where everyone was crazy. The settings appealed to children, although they seemed to follow the landscape and logic of any good opium-induced dream. Dodgson was no stranger to opiates and laudanum, or to cannabis or hallucinogenic mushrooms.

The creative habit is like a drug. The particular obsession changes, but the excitement, the thrill of your creation lasts.
—HENRY MOORE

Records indicate Dodgson took laudanum to relieve migraines; some believe it was to ease his lifelong stammer. Dodgson was a gentleman of the haughtiest variety, and preferred not to mingle with the "commercial" classes. Sexually, he seemed to have relations with adult women, even though he wrote: "I am fond of children, except boys." What caused his original genius to dissipate, and left him, in the end, publishing books that were barely readable and reeked of confusion, has the many prevailing academic camps divided into diverging theories. Some say his unrequited pedophilia, drug addiction, or lead poisoning was the cause of his demise. Others insist his habits were merely misinterpreted by Victorian Era standards. His genius lies in that he created work so unique it still needs to be debated regarding the source of his inspiration. Nevertheless, he died in 1898 at age sixty-five, officially of influenza and bronchitis, and of course, he never married.

FEED YOUR HEAD

A revival of Carroll's popularity in the 1960s was due primarily to the suspicion of his insider knowledge of psychedelics, and was further established with the rock song, "White Rabbit." Grace Slick and the Jefferson Airplane's rock classic brings out the story's thinly-veiled drug references.

One day Alice came to a fork in the road and saw a Cheshire cat in a tree. Which road do I take? she asked. Where do you want to go? was his response. I don't know, Alice answered. Then, said the cat, it doesn't matter.
—LEWIS CARROLL

VICTORIAN RULES

Dodgson followed the protocol of the upper class and in his day no proper gentleman would be seen in a bar, buying liquor, or heaven forbid, have it smelled on his breath. Drinking was for the blue-collar chaps. An 1881 article in Catholic World *noted that a gentleman "procures his supply of morphia and has it in pocket ready for instantaneous use. It is odorless and colorless and occupies little space." For life's daily aches and pains it was considered an appropriate choice. However, when Dodgson fell seriously ill at the end of his life— seemingly the effect of a lifelong use of opiates— morphine was withheld. Devout Victorian Christians believed the drug prevented "the good death of fortitude in the face of suffering."*

JOHNNY CASH

Success is having to worry about every damn thing in the world, except money.
—JOHNNY CASH

"The Man in Black," Johnny Cash—by selling fifty million albums over a fifty-year career—became the most recognizable country singer in American music. He nearly died during his rise to stardom due to a serious addiction that lasted from 1958 to 1967, hooked as he was on amphetamines and alcohol. Although drug-free for some time, Cash later admitted he was addicted to painkillers, blaming it on an injury caused by his pet ostrich, which kicked him in the chest. Cash died in 2003 of respiratory failure due to diabetes, at age seventy-one.

NEAL CASSADY

If confusion is the first step to knowledge, I must be a genius.
—LARRY LEISSNER

Even though he never published a single book in his lifetime, this wiry, motor-mouthed hustler possessed a magnetic personality and became the electric spark that ignited an entire American literary movement. Raised by an alcoholic father in Denver's transient hotel district, young Neal Cassady learned

early to navigate fall-down drunks and hookers gathered in doorways. His education continued in reform schools, where he was sent for hot-wiring one too many cars. He met the founders of the Beat Generation, Allen Ginsberg and Jack Kerouac, while visiting a friend at Columbia University, and soon started a homosexual relationship with Ginsberg that lasted more than twenty years. Cassady's most renowned contribution to literature was his friendship with Kerouac, to whom he was bound by their common interest in sports, which began in earnest when together they headed across the country. They traveled vagabond-style, out to discover themselves, searching for "lost inheritance, for fathers, for family, for home, even for America." Cassady became the semifictional protagonist Dean Moriarty in the first well-received "stream of consciousness" novel, *On the Road*. Neal's letters to Jack, with his run-ons, his jumping from one thought to the next, and his way of interrupting life, inspired Kerouac to write as Neal spoke. His influence wasn't limited to Ginsberg and Kerouac; chronicles of his unique personality appeared in the writings of Tom Wolfe, Ken Kesey, Hunter S. Thompson, Charles Bukowski, and Robert Stone, and in the songs of Bob Dylan, to name a few.

GANSER SYNDROME

Some believed Cassady, rather than being creative, suffered from a type of Ganser syndrome. Also called "prison psychosis," the disorder describes a person who overstates his mood and feelings and mimics behavior observed in mental patients. It seemed the only explanation for Cassady's "letting go," known as he was for saying and acting out whatever he felt on the spur of the moment.

Cassady was well read, a fountain of information, citing observations and tidbits, everything from why the Chinese ate tadpoles as contraceptives, to how to change a spark plug. He never ceased to amaze his cronies or be the life of the party. Privately, Cassady was torn by Catholic guilt, often consumed with the notion that he was a sinner doomed to limbo. He ultimately thought his life was a waste.

He married often and had many children, and used whatever drug or drink was at hand. Cassady wasn't a traditional alcoholic or heroin addict, but rather a "garbage head," since he didn't care what type of drug he took, as long as it would have an effect. He took anything that silenced the "you're just a worthless piece of . . ." voice that plagued his brain. He wanted to be something, at first a football star, and then a writer, but saw himself as an ex-con and ultimately as the same book as his alkie father, only with a different cover.

> *Suffice to say I just eat every twelve hours, sleep every twenty hours, masturbate every eight hours, and otherwise just sit on the train and stare ahead without a thought.*
>
> —NEAL CASSADY

Toward the end, according to Carolyn Cassady, an ex-wife, Neal admitted that twenty years of fast living hadn't left much. Before he went on the last of his many spontaneous road trips to Mexico, he was physically worn out, his mind not as fluid as before. However, he pulled his nineteen-year-old son aside before his departure and gave him the only inheritance he had to offer, telling him simply, "Don't do what I have done."

> *I became the unnatural son of a few score of beaten men.*
>
> —NEAL CASSADY

In 1968, four days before his forty-third birthday, Cassady was seen attending a Mexican wedding reception where he got high on barbiturates and some champagne. When the lanterns went dim and the mariachi band packed up, he decided to walk, alone, fifteen miles back to the next town via a deserted railroad track. He wore only a T-shirt and jeans and wasn't prepared for the chill that descended on that starry night in March, coyotes howling in the distance. He laid down for a quick snooze, it's presumed, and died. The physician who performed the examination on his corpse cited the cause as "general congestion in all systems," and not as a result of living the experiences of ten lifetimes in the space of one.

THE ULTIMATE FAST LANE

*The title of foremost wild man of the Beats belonged to **Bill Cannastra**. Like Cassady, he was a non-artist who influenced a generation of writers and painters and set the bar for outrageous behavior, free sex and abandon, and drug use more than a decade before it became fashionable. The parties at his apartment on West 20th Street in Manhattan in the late 1940s became*

legendary. He was a graduate of Harvard Law School but to the law he preferred spectacle, drama, and nihilism to the extreme, holding free-for-alls where anything went, including orgies with both sexes. He is often credited with giving Jack Kerouac the idea of using a roll of uncut paper as the best means to transcribe in one sitting the breathless novel the young writer was talking about. Cannastra died when he stuck his head out of a moving subway near Astor

Place in New York City in the spring of 1950, at age twenty-one. He was drunk and high and thought it cool to wave goodbye to his friends. What they witnessed instead was his head rolling on the tracks as the train went on down the tunnel, his eyes wide open, staring into space with disbelief. Afterward, Cannastra's former lover Joan Haverty was so distraught over his death that she accepted a spur-of-the-moment proposal from Jack Kerouac and married him two weeks later.

CATULLUS

I was an altar boy, but then at the age of fourteen I discovered masturbation and all that went out the window.
—GUILLERMO DEL TORO

Gaius Valerius Catullus was a first-century Roman poet who died before he was thirty. He came from the upper class and hobnobbed with the elite. While still a teenager, he wrote a satirical poem about Julius Caesar when the future emperor was only a governor, and nearly got his head handed to him, but was spared by the intervention of Catullus's well-connected father. After that, he wisely favored the less risky love poem, and even more so when he became obsessed with a classy woman ten years older than he who thought Catullus unsuitable. The erotic poems he wrote were so explicit, even the Romans called them obscene. He never gained scholarly notoriety in his life though fellow poets in his time and afterward admired his craft and imitated his techniques. He was praised for his genius in injecting personality into poetry, and for his stylistic techniques that incorporated his unique personal voice. According to many scholars, Catullus held the most influence on Horace when he wrote his famous *Odes*. Many of the particulars of Catullus's life are unsubstantiated by second-hand accounts, though it seems his work had an underground popularity; and before the days of X-rated magazines, his more sexual poems found their way to become favored bathroom reading. The many ragged-edged copies unearthed by archaeologists suggest that his more explicit verse made a good aphrodisiac for masturbation. It's uncertain if Catullus ever married or even had a girlfriend, though his official cause of death at a young age in 54 BC was "exhaustion." Perhaps his obsessive preoccupation with a certain type of self-indulgence was greater than many historians wish to admit.

General appearance of the features through thanatos

The average appearance of the features

Appearance of the Ophthalmos converged through thanatos

PROS AND CONS
The Romans already had the word mastur-bor *in the language to describe Catullus, and its meaning survived changing lexicons until a seventeenth-century dictionary*

defined "mastuprate" as "dishonestly to touch one's privates." **John Cowper Powys**, *a novelist, and direct descendant of the great English poet John Donne, claimed openly that masturbation was his inspiration and obsession, since he loathed penetration, unless, of course, for an enema. It worked for him, and he died in his nineties in 1963 with perfect vision. The Kinsey Institute study on sexual behavior of fifty years ago claimed that 92 percent of the male population practiced the art, while only 62 percent of females engaged, with new researchers suggesting that for males it prevents prostate cancer. The modern dangers stem from addiction to Internet pornography, with more than 1.8 million people each hour of the day glued to the monitor watching porn, and doing what comes naturally, with no need to read between the lines of Catullus's poetry for erotica.*

ARTISTS IN PORN

Sex. In America an obsession. In other parts of the world a fact.
—MARLENE DIETRICH

Every forty minutes a brand-new porn video is released. In the nineties, porn stars dropped by the dozens from AIDS, a fact made public when Brooke Ashley tested HIV-positive after breaking the anal intercourse record, with fifty men. More safeguards have been established since. However, murder, suicide, and overdose permeate the doings of artists occupied expressing their talent in this medium. A few include: **Trinity Loren** *(thirty-three) and* **Linda Wong** *(thirty-six) died from overdoses, as did* **J. D. Ram** *(twenty-six) and* **Jill Munro** *(twenty-five) on heroin, soon after appearing in* Consenting Adults. **Lolo Ferrari** *billed as "the woman with the largest breasts in the world," at seventy-one inches via silicone, broke a Guinness World Records for another obsession, undergoing twenty-two breast-enhancement procedures. It was believed her death, at thirty-eight in 2000, was from a rupture, though according to her husband, Lolo picked out a white coffin and laid out a pink dress for her wake three days before he claimed she died of an overdose. When it was discovered that a nonlethal dose of medication was in Lolo's bloodstream, her husband said she instead died in her sleep, suffocating on her breasts. Lolo had planned an operation to reduce her stupendous size to an expression more manageable, such that suspicions of foul play surround her death.*

RAY CHARLES

I never wanted to be famous. I only wanted to be great.
—RAY CHARLES

The famous and (to many) great musician Ray Charles, despite being totally blind by seven, taught himself to play the piano. With both parents dead, he was left alone in his teens, but Charles was already good enough to make a living playing piano with any number of bands. Long before he had his hit "Georgia On My Mind" or was invited by President Jimmy Carter to the White

House, Charles survived a seventeen-year heroin addiction. He died of liver failure at age seventy-four in 2004.

PAUL CELAN

I marvel at the resilience of the Jewish people. Their best characteristic is their desire to remember. No other people has such an obsession with memory.
— Elie Wiesel

Paul Celan is considered one of the best of the post–World War II German poets, and gave a voice to a painful duality, including guilt and rage, that many surviving German Jews experienced. Although he believed the Nazis stole his heritage and diluted the German language with propaganda, he felt it was his calling to use words to revitalize the long-respected tradition of Deutsch literature. He coined new words and used archaic references that made accurate translation difficult. Even though Celan garnered the respect of his literary peers and won international awards, he was often criticized by the public, which was put off by his curt, enigmatic lyrics. After one reading, Celan said, "this cold city Paris—It's gone quiet around me." When the widow of German poet Yvan Goll accused Celan of plagiarizing much of her late husband's work, Celan cracked. He was incapable of handling another round of persecution, and in April 1970, at age forty-nine, he jumped into the Seine River. His body was found downstream three weeks later, caught up in the nets of a French fisherman.

The trauma of persecution was no figment of Celan's imagination, even if the accusation of plagiarism seemed hardly enough to make Celan call it quits. He witnessed the Nazis' murder on a mega scale, and himself

Only in one's mother tongue can one express one's own truth.
In a foreign language, the poet lies.
— Paul Celan

survived two years in a labor camp. In addition to Jews, Gypsies, Russians of Asiatic descent, Jehovah's Witnesses, male homosexuals, anyone with a disability, those previously convicted of a crime, as well as artists and writers not in line with regime ideas—more than eleven million were exterminated. Celan's mother was shot when unable to continue work at a labor camp, and his father perished of typhus in German custody. Other ghosts, which Celan tried to exorcise with poetry, led him to the river and an early death.

THOMAS CHATTERTON

For some, the blast of genius has a short lifespan. Once this period of hyperactive creativity begins, one's physical age becomes irrelevant and follows the

ticking of another clock, many times ending in its own implosion soon after it began. Thomas Chatterton exemplified this phenomenon like few others, and is now considered the first Romantic poet of the English language. His was a burst of ingenious brilliance during puberty when, at age twelve, he became obsessed with achieving literary greatness. He came from a poor family in the overcrowded town of Bristol, England. His widowed mother arranged to send Thomas to a private school but he was dismissed, considered an idiot and too scatter-brained to learn. At age eight he was

Youth is not a question of years: one is young or old from birth.
—NATALIE CLIFFORD BARNEY

sent to a charity school that was set up for the less bright to become business apprentices, being taught only the barest of remedial skills. Here he had his head shaved, was made to wear an ankle-length smock, and was treated invariably as no more than an indentured servant. However, when he went back home during holidays from school, his mother gave him the few pennies he needed to borrow books from the library to satisfy his unusual thirst for knowledge. Thomas's favorite place to study was a nearby graveyard, crotched behind lopsided tombstones etched with skeleton heads and angels. When he was twelve, Thomas found a stash of old, blank parchments sequestered in a forgotten trunk in his attic, which his deceased father had once removed from the family's parish church. Stealthily, he took these faded parchments to a lumber room and, with pieces of charcoal and lead powder, wrote original poems that looked authentically like the work of some ancient, medieval writer. He saw the marketing potential of this immediately, and guessed correctly that if he presented his poems as anything other than a "discovered" medieval classic, he would be patted on the head and dismissed as a lower-class urchin grasping beyond his capabilities. He showed one of his parchment poems to an official at the school and duped him immediately into believing it was indeed an ancient find. The favorable reaction was so great that Thomas went on to create an entire body of work by a made-up monk he called Sir Thomas Rowley.

Thomas's station in life at school, and later when at age fifteen he was apprenticed to a Bristol lawyer, irked him, forced as he was to sleep with the footboys, being spied upon to make sure he wasn't idling away a moment of time. Thomas was frequently insulted and belittled, and if

I must either live a Slave, a Servant; to have no Will of my own, no Sentiments of my own which I may freely declare as such; —or DIE—perplexing alternative.
—THOMAS CHATTERTON

he was caught writing a poem the head of the house ripped it up, kicked him in the ass, and sent him to scrub a bedpan. Meanwhile, in his secret life as Sir

Rowley he saw his poems put in print, published in respectable magazines, and purchased by a notable scholar who included his medieval pieces as examples of the work of a late honorable citizen of Bristol. When Thomas came forth and revealed he was the true author, he was scoffed at, believed incapable of creating such masterpieces, and ridiculed as a liar. Thomas grew morose, and devised a plan to be relieved of his apprenticeship obligation by saying that he intended to commit suicide in his master's house. He was promptly deposited to the curb, dismissed with not a cent to his name.

In April 1790, when Thomas was seventeen, his friends donated money for his transportation to London, where he quickly got hired as a freelancer for numerous magazines. For a time he subsisted on the paltry payments for his writings, though when summer approached, back when businesses in the big city traditionally closed down, work dried up, which suddenly left Thomas in dire financial straits. He continued to write cheerful letters to his mother, extolling his rapid rise in the ranks of writers, while in reality he was holed up in a rundown boarding room without a crumb to eat. It's reported that many tried to offer help, and that his landlady, named Mrs. Angel, brought him food, which he refused, insisting that he was fine and needed charity from no one. At the end of August, on one exceptionally hot evening, three months shy of his eighteenth birthday, Thomas Chatterton drank a cup of arsenic tea. He was found in his room the next morning amid a shredded heap of his torn-up manuscripts. His death was deemed a suicide due to reasons of insanity.

*Arsenic was discovered as a perfect poison in AD 700 by an Arab alchemist, and long had a reputation for causing certain death. In England, a pile of the poisonous white powder was spooned at every doorway to kill rats. It was mostly used for murder, and was rarely the choice for a creative suicide. Chatterton was the first of note, though **George Periolat**, a silent film star, also took his tea with it in 1940. Francesco I de' Medici and his wife, patrons of the arts, were fed it secretly, both dying in 1587. Impressionist painter Paul Cézanne fell ill from it, since it was used to make green paint greener, and Claude Monet went blind, smeared as he was in all the colors, many of which contained arsenic.*

Color is my day-long obsession, joy, and torment. To such an extent indeed that one day, finding myself at the deathbed of a woman who had been and still was very dear to me, I caught myself in the act of focusing on her temples and automatically analyzing the succession of appropriately graded colors which death was imposing on her motionless face.

—CLAUDE MONET

ANTON CHEKHOV

*I put all my genius into my life; I put only
my talent into my works.*
— OSCAR WILDE

Geniuses have been known to
work nonstop, experiencing a sense
of timelessness during especially
enlightened periods of inspiration.
But when that pace is extended and
becomes a norm, certain frenzied work habits are as deadly and as addictive
as drugs. Famed Russian author and playwright Anton Chekhov, in addition to
being a literary genius, would now be called a workaholic, which seems to be
the underlying cause of his early death. As a medical doctor, he traveled from
Siberia to Moscow tending to the poor and wealthy alike at a grueling pace,
filling every other spare moment he could find by writing. When he finally
stopped practicing medicine to do nothing else but write, Chekhov continued
at a demanding self-imposed work schedule, which led to repeated bouts of
exhaustion. When he coughed up his first glob of blood, at age thirty-seven,
knowing it was the onset of tuberculosis, the most elusive of Russian liter-
ary bachelors decided to get married. Previously, Chekhov preferred the more
time-effective romance found at brothels. However, the woman he married
had to agree not to consume too much of his writing time—she remained in
the city and he in the country. As Chekhov said, "Give me a wife who, like
the moon, won't appear in my sky every day." But in reality, medicine in his
early years took up most of his hours, more than any wife, though literature
remained his true mistress. His ability to convey social ills and empathy for
human plights through an ease of ordinary conversation-like dialogue was his
genius. The superb craft of his short stories is still admired by writers. Novel-
ist and short story writer Eudora Welty once said, "Reading Chekhov was just
like the angels singing to me." Vladimir Nabokov called Chekhov's story "Lady
with a Lapdog" "one of the greatest stories ever written." Chekhov produced
hundreds of short stories, novels, nonfiction books, and nine plays that are
still regularly performed around the world and remain his most popular legacy.
Chekhov finally slowed down only on his deathbed, at age forty-four in 1904.
The physician in attendance gave Chekhov a shot of camphor (a chemical used
in embalming) and handed him a glass of champagne until he closed his eyes
in peace. His body was then placed in a railroad car and kept fresh by being
placed on top of bushel baskets filled with fresh oysters packed in ice. Once
his body reached Moscow the loss of his brilliance was commemorated with a
lavish funeral.

*Doctors are just the same as lawyers; the only difference is that lawyers merely rob you,
whereas doctors rob you and kill you too.*
— ANTON CHEKHOV

DOCTOR-WRITERS

Oliver Wendell Holmes, Sir Arthur Conan Doyle of Sherlock Holmes fame, and poet William Carlos Williams were doctor-writers who apparently used their medical knowledge on themselves and lived long. François Rabelais, a French doctor, was called a Renaissance man back then because he also wrote humorous satires and used references to the more grotesque parts of human anatomy when poking fun at political figures or church customs. He also wrote novels that had party-loving heroes telling dirty jokes. When Rabelais died, in 1553 at age fifty-nine, neither career path

had paid off. Wishing to be remembered as a humanist, he penned the best will ever: "I have nothing, I owe a great deal, and the rest I leave to the poor." Years later, French writer Honoré de Balzac said Rabelais was "a sober man who drank nothing but water," despite the robust characters Rabelais created. When this doctor-writer got sick, he trusted none of the treatments he prescribed for others and instead drank gallons of water to flush out his system. His death seems more from what is now called "water intoxication," a condition that kills from drastic potassium and electrolyte imbalance.

WINSTON CHURCHILL

*Towering genius disdains a beaten path.
It seeks regions hitherto unexplored.*
—Abraham Lincoln

Sir Winston Churchill was the British prime minister during World War II, and was credited as the stalwart leader who prevented Nazi Germany's invasion of England. He also won a Nobel Prize in Literature, for his historical writing, in 1953. Churchill made no excuses for his love of drink, saying he acquired the habit out of necessity: "The water was not fit to drink. To make it palatable, we had to add whiskey. By diligent effort, I learned to like it." Showed reports on the ill effects of excessive drinking, he noted: "Statistics are like a drunk with a lamppost—used more for support than illumination." Despite his brilliance, Churchill never seemed to correlate his numerous strokes or what he called "his black dog of depression" to alcohol. A miracle of sheer perseverance, Churchill lived to the age of ninety, dying in 1965 from a blood clot.

MONTGOMERY CLIFT

*You may have genius. The contrary is,
of course, probable.*
—OLIVER WENDELL HOLMES

If ever there were need for a poster-
boy for persons born with a sensitive
soul, actor Montgomery Clift could
fit the bill. He was a twin, though
apparently even at birth was reluctant
to enter the world, arriving several
hours after his sister. His father was a
low-key investment banker while his
mother was reportedly the passive-
aggressive, domineering type that had Montgomery on stage by age thirteen
and cast in a Broadway play two years later. He was an extremely handsome
child, calm and, from the first, a natural, possessing the uncanny ability to
act before an audience as if none were there—performing, it seemed, only on
the private stage inside his head. By age twenty he was a theatrical sensation,
deluged with scripts, and was known to have numerous offstage affairs with
actresses and actors. Although he was open about his attraction to both sexes,
a fact eventually accepted by his parents and friends, publicists kept a tight
lid, knowing that in the 1940s, his bisexuality would've been the death knell
for his promising career. Within two years of going Hollywood, Clift became a
national heartthrob, the sensitive, disillusioned hero of postwar America, earn-
ing his first Academy Award nomination in 1948. Clift said he had no burning
passion to act and took his time picking and choosing from the many scripts
offered. Yet he made film after film, some say, as he believed his mother would
want him to do. Beginning with his performance in *From Here to Eternity*, which
many consider Clift's finest, he began to drink on movie sets. Regardless of the
accolades, Clift seemed resolved from then on to commit suicide the slow way,
and was seldom seen sober. Movie studios took out a life insurance policy on
him, the industry's own "death pool," of sorts. In 1956 they almost collected
when Clift drove drunk and crashed into a pole while costarring with Elizabeth
Taylor in *Raintree County*. His face was irreparably mangled and his once classic
good looks were instantly gone, the left side of his face paralyzed, his mouth
drooping and nose askew despite plastic surgery attempts. There were no more
close-ups. Clift persisted and rallied, trying to regain the good reviews he once
took for granted.

By 1962, while shooting his last
major film, *Freud*, Clift's reputation
took a permanent nose dive. He had
difficulties with director John Hus-
ton and couldn't remember his lines,
in addition to suffering from blurred

*Failure and its accompanying misery
is for the artist his most vital source of
creative energy.*
—MONTGOMERY CLIFT

vision. His soft-spoken personality had become belligerent and argumentative. When Clift's delays made the studio lose money they filed a lawsuit against him. Clift was unemployable and branded a troublemaker: He retreated from the public eye, becoming a virtual recluse in his New York City brownstone. Although he was reportedly rendered impotent by drug and alcohol abuse, technically no longer bisexual or otherwise, he was attended to by a faithful male companion. In 1966, at age forty-five, he was discovered dead, lying naked in his bed.

THE MISFITS

A man loses his sense of direction after four drinks; a woman loses hers after four kisses.

—H. L. Mencken

Marilyn Monroe *starred with Clift in* The Misfits, *a fitting title for both stars, and was considered for the role as the neurotic patient in* Freud, *although Monroe chose a film with a more prophetic title*, Something's Got to Give. *Like Clift, Monroe ended with a bitter view of Hollywood; for her, it was because she had been stereotyped as a "dumb blonde." Although both Monroe and Clift played lost souls in* The Misfits, *she had no time to deal with Monty's drug and alcohol problems, suffering her own nervous breakdown and being extremely stressed by the Nevada heat during production. Monroe likewise relied on alcohol and drugs, but added affairs with high-powered politicians to the mix. She was found dead under still mysterious circumstances, though her death (in 1962 at age thirty-six) was officially ruled an overdose. According to Joe DiMaggio, a former husband, Marilyn was planning on remarrying him when she died, and that her true fatal obsession was a search for love.*

ROBERT CLIVE

No man's genius, however shining, can raise him from obscurity, unless he has industry, opportunity, and also a patron to recommend him.

—Pliny the Younger

Though he became a military genius and for better or worse was instrumental in securing India for Britain, Robert Clive had a tough time in school. Master Robbie was not interested in the basics of reading and writing, though he had a knack for arithmetic, especially when it came to counting money. He bounced around from school to school, missing out on requirements to attend more pres-

tigious universities. Schoolmasters believed he had some sort of depressive illness, but that was the diagnosis back then for anyone who couldn't seem to follow the rules. He was what they called a hooligan, certain to find his way to a premature jig at the end of a noose. Robert started out by climbing up cathedrals and hiding behind gargoyles to scare old ladies, and he progressed to running a gang to extort money from shopkeepers. Although he came from royal stock, his family's estate was a poor one, so when Robert was eighteen, in 1744, his father believed the best way to get him out of town was to secure him a job with the East India Company as a bookkeeper aboard a ship bound for India. Then, India was a wild place, ruled by various warlords who made trade risky, with the French, Dutch, and Portuguese vying to get a piece of the pie. Clive had no military training, but when dangerous conflicts and skirmishes arose he was singled out for his crazy brand of bravery. Eventually, he was convinced to leave his civil service position with the trading company and join the British army.

THE DESTINY TEST

When Clive first landed in India, he was penniless and distraught. He secured a pistol, put the barrel to his head, closed his eyes, and pulled the trigger. When nothing happened he clicked the trigger a few more times, until he threw the gun down in disgust. He then said: "It appears I am destined for something—I will live." Clive's giant pet tortoise, Adwayita, which he was given as a gift while in India, fared better. The creature died in 2006 of a cracked shell at 250 years old.

Clive proved to be a natural leader and wasn't afraid to dupe warlords into signing treaties, to pit one against the other, or to use any tactic to ensure victory. In short, he applied the same extortion tactics he used on the shopkeepers back in London. In a battle for Bengal he routed fifty thousand of the enemy with only three thousand men, and said that he saw in a dream that he could win. He didn't tell anyone that his confidence lay in a deal he made with the defending force's field commanders, who assured Clive that many of the enemy would desert their ranks. His bold approach rattled opponents, and Clive was quick to levy crushing fines and force enemies to pay steep tributes. Through his shrewd negotiations and military genius, the whole of India became part of the British Empire. Prestige, wealth, and greater titles than his father ever had greeted him on his visits to London. When summoned to a hearing at Parliament that questioned the source of his wealth, Clive was insulted and replied: "By God! I stand astonished at my own moderation." Eventually, it seemed the visions or dreams he often used to justify tactics were discovered to come from a source other than a sticky night on a cot. While in India, Clive picked up a taste for opium, and it appears his addiction lasted many years. At age forty-nine, in 1774, Clive took one last hit

of opium and, for reasons no one knows, then stabbed himself in the neck with a pen knife. Suicide was a serious stigma and Clive was placed in an unmarked grave, which remains so to this day.

Before India was part of the British Empire, most opium came from Turkey, but Clive discovered that poppy plants grew in Calcutta, and although it had a slightly different taste, Indian opium was no less potent. It was readily available and was smoked by the native population in long pipes. It wasn't until 1832 before a doctor who traveled with Clive convinced the British government to allow Indian opium to be cultivated on a large scale. A New York Times *article from 1896 described an Indian government-sanctioned opium den: "Men and women lying on the floor like pigs in a sty. A young girl fans the fire, lights the opium pipe, and holds it to the mouth of the last comer till his head falls heavily on the body of the inert man or woman who happens to lie near him. In no groggery, in no lunatic or idiot asylum, will one see such utter, helpless depravity as appears in the countenances of those in the preliminary stages of opium drunkenness." Today, Punjab, a northern state in India, has the highest population of opium users in the world.*

KURT COBAIN

Since when was genius found respectable?
—Elizabeth Barrett Browning

Generation X-ers, those born in the 1960s and 1970s, have been said to lack the same over-the-top enthusiasm for social causes the preceding generation of boomers had. Instead, they were misunderstood and considered a disappointing group of potential slackers, seemingly cynical and apathetic toward everything. Before the Generation X crowd showed their true colors (such as virtually inventing the Internet and bringing the world into its current techno-savvy state), Kurt Cobain was one of the first to give a mainstream glimpse of what an X-er might look and act like. He defined an attitude of disenfranchisement while rising to the top of a musical movement termed Grunge, an offshoot of alternative rock. He appeared on stage in unkempt and multi-day

slept-in wardrobes, stoned, wasted, blond hair straggly, though he was handsome and sensitive with large, doleful eyes; he became the new and more authentic image of the stoned-out rocker Generation X's parents thought was all their own. Musically, Cobain combined heavy metal, punk rock, and a reinvention of classic rock riffs to create a new direction for popular music. His lyrics expressed the anger and dissatisfaction of being born into a time he and many in his age group found disconcerting—and he sold millions of records. He alternated from guitar-smashing, body-slamming rock to folk-like songs and personally hoped to move from the image of a Grunge rocker to a singer-songwriter, as he said, to become in old age like Johnny Cash.

From an early age Cobain displayed a rebellious streak that would make for a musical icon but one that would also lead to an unpleasant life. Cobain did not cope well with the divorce of his

I'm so happy because today I found my friends—they're in my head.
—KURT COBAIN

parents, in the early seventies when he was nine. Afterward, anger, disrespect for even the slightest smell of authority, and a distaste for adhering to any notion of conformity became trademarks of his personality. In his senior year, after he had been shuffled around from his parents' and relatives' homes, his mother threw him out of the house for good. He developed his grunge-style look the hard way, sleeping (he later claimed) under bridges or crashing out wherever he found a place to stay. He eventually gravitated to the Seattle music scene and formed the band *Nirvana*. The group's struggles were typical of many, but by 1991 Cobain's genius was noted and through luck, circumstance, and his dedication to something Cobain finally found he was good at and loved, *Nirvana* had a debut album distributed by a major label. It catapulted Cobain into stardom. He did not process success well, especially as he became enmeshed in the business side of the music industry that to him represented an antithesis to all the causes of individuality and rebellion he embraced. He felt uncomfortable when fans suddenly began to treat him, as he noted, "like some kind of god." He started as a teen taking drugs, marijuana mostly, though later said, "I did heroin to relieve the pain." Cobain believed he had an incurable stomach ailment, though it had no medical name.

His marriage to singer Courtney Love smacked of the same dysfunction, and though somewhat altered under the spotlight of rock's craziness, was unbearably familiar to his childhood experiences. He planned on seeking a divorce, quitting the music business, and getting clean. Instead, in 1994, fresh out of a rehab, the twenty-seven-year-old rocker was found in his Seattle home dead with a shotgun wound to his head—discovered by his young daughter, no less. The autopsy found 225 milligrams of heroin in his blood, three times the amount needed for a lethal overdose. The hardest-core junkie would be immediately incapacitated after shooting that much dope, unable to hold a gun or fire it, which leads some to believe his death, although listed as suicide, has more sinister overtones.

All drugs, after a few months, become as boring as breathing air.
—KURT COBAIN

WHEN IMITATION ISN'T FLATTERY

Cobain was beside himself when he learned that a woman was raped by a few idiots who admitted they did so while playing his song "Polly." He also tried to conceal his drug habits from the press when he heard that heroin use among his fan base had increased by 25 percent in a two-year period, and made attempts to explain that there was nothing glamorous about a heroin addiction. When he died, there were many distraught admirers, but the saddest was the suicide pact a fourteen- and fifteen-year-old made soon after: Both boys were found dead

in their suburban basement from self-inflicted shotgun wounds. A Middlesex County, New Jersey, prosecutor said, "There were signs the two were depressed and had sought help. But I guess it wasn't enough." Apparently, they couldn't be dissuaded from imitating Cobain's image and his comment made shortly before his own death: "Rather be dead than cool."

SAMUEL TAYLOR COLERIDGE

It is not enough to have a good mind; the main thing is to use it well.
—René Descartes

As a child, famed Romantic poet Samuel Taylor Coleridge was constantly belittled by his older brother Frank, to an extent that it now would be considered psychological abuse. Young Samuel sought refuge in a local library and there, it's said, he taught himself to read the classics by the age of six. When he was nine years old his father died. Soon after, his mother thought it better to send him away to London to one of the most notoriously strict boarding schools in all of England. After that, he attended Cambridge University for a few years but dropped out and joined the military, though within months knew he had made a mistake and managed to get discharged, citing insanity. However, he was hardly insane, and possibly possessed one of the more astute minds of the era, called by his contemporaries, such as William Wordsworth, a "giant among dwarfs." He had two fatal weaknesses, nevertheless: one was unrequited love, first his mother's, and then that of Sara Hutchinson; the other was opium. He first took the drug as a medicine in the form of laudanum to ease the pain of a toothache when he was twenty-three years old. During the early stages of its use he produced his best and most-remembered works, namely *Rime of The Ancient Mariner* and *Kubla Khan*, which he admitted

were the result of an opium dream. He never left the drug completely alone again, though tried to quit often, alternately completing many other works. Today, he might be considered a "functional addict," in that he continued to produce. Coleridge once mustered the discipline while high to put out more than twenty-five weekly issues of a newspaper, *The Friend*, from the end of 1809 through the spring of 1810. Although Coleridge is often praised for his output, in reality, the opium addiction ultimately shortened his attention span and eliminated the persistence he needed to fulfill the promise of his true genius. The ever-increasing quantities of laudanum he needed just to keep from falling immobile and ill changed him; this once formidable man of five feet ten inches, with broad shoulders, a shock of black hair, and strikingly large and piercing eyes, became a frail, bent-over skeleton of his former self. At the end, he consumed a quart a day of the drug that ultimately made him quarrelsome, isolated, and embittered. He prepared his own epitaph: "Beneath this sod a poet lies, [who] found death in life, may here find life in death." He died in 1834 at the age of sixty-one of fluid on the lungs and heart failure due to opium abuse.

CURE ALL

Laudanum was discovered by Swedish alchemist Philippus von Hohenheim in the 1500s. He combined various poisons to come up with an opium tincture he thought so wonderful he named the new drug "laudare," a Latin word for "praise." By Coleridge's time there were dozens of different brands of laudanum elixirs, good for any ailment from the common cold to heart disease, and as one advertisement boasted, to simply, "check excessive secretions, and to support the system." Charles Dickens took it after a difficult reading tour in America and started to write a novel under the influence, The Mystery of Edwin Drood, *but never finished. Mary Todd Lincoln took it to relieve migraines. On the night President Lincoln was assassinated, the President*

planned to cancel the evening at the Ford Theatre due to Mary's persistent headache. When at the last minute another bottle of laudanum was procured, she took a dose and felt well enough to attend. Without a bottle of laudanum in the mix, John Wilkes Booth's plan would have failed.

THE LAUDANUM LOOK

During the 1800s tuberculosis made many ill, and to ease its symptoms, laudanum was dispensed widely, to adults and children alike. There was a sort of "tuberculosis chic" that crept into the culture and many who were not ill tried to have the pale and emaciated look

that the truly dying acquired. Some women even took small doses of arsenic to get a gray-ashen pallor to their skin. People knew too much laudanum was bad, but still its rampant abuse cut across all classes. Many working women binged on a bottle of it at the end of a heavy work week as a sort of cheap vacation. The rich and well-to-do indulged as well. Many of the higher-class, refined ladies regularly stashed a small vial of it under their frills and petticoats. From the 1830s to 1900, the British imported twenty-two thousand tons of opium from Turkey and India every year.

HART CRANE

> *A weakness natural to superior and to little men, when they have committed a fault, is to wish to make it pass as a work of genius.*
> —FRANÇOIS DE CHATEAUBRIAND

Strange that his father was the man responsible for inventing the candy known as "Life Savers" when in the end not the fortune the family earned nor the accolades of his peers could save this American poet from himself. Hart Crane published only two volumes of poetry in his lifetime, and they had many critics divided, with some important literary experts calling him the American Keats, while others panned his work as too difficult and doomed to obscurity. Signs of his rebellious streak surfaced early, as he dropped

out of high school and headed to New York City as a teenager to seek adventure. Although he went back home and worked briefly writing ad copy for his father's candy company, he preferred to drink and get into barroom brawls, often spending nights in jail. He was also reckless in his pursuit of men for homosexual encounters, particularly ones without those sexual leanings, which led to a number of bad beatings. He wrote letters to his concerned mother, explaining he acted this way to find "true freedom"; she in turn sent more money when he went broke, which happened frequently.

When it came to his poetry, he felt it was his purpose in life to compose the greatest epic poem ever conceived. This calling was reinforced when he discovered what he called "the seventh heaven of consciousness" in, of all places, the dentist's chair. Under the influence of nitrous oxide, he believed he heard a voice that revealed to Crane his uniqueness among men, due to his higher level of consciousness, and that he was, quite literally, a genius. He then went on to work at one poem for six years, even going to Paris, where he was put up and encouraged to carouse even more by the notoriously decadent Harry Crosby of the Black Sun Press. Meanwhile, his life, in contrast to the obsessed dedication to his writings, was chaotic and as far from any lyrical iambic pentameter as one could imagine. He struggled with immobilizing bouts of depression, not helped by his voluminous alcohol intake, or his distracting, often infatuated involvement he had in any number of failed love affairs, predominantly with sailors.

When his epic poem *The Bridge* was published it gathered mostly bad and crushing reviews that led Crane to believe he was ultimately a failure. Although Crane has since been appreciated as a genius—as Harold Bloom noted, "Crane was a consecrated poet before he was an adolescent"—the nearly unanimous critical disapproval devastated the poet. Nevertheless, Crane was awarded a prestigious Guggenheim Fellowship and went to Mexico on their money with the intent to heal and write. But once there, he could not create. He tried to knock his homosexual desires out of himself by having his first heterosexual affair with the ex-wife of his close friend Malcolm Cowley. He also got word that his father died, and although counting on an inheritance, learned he was to get none. Crane panicked and gulped down a bottle of medicinal iodine, along with a fifth of Scotch (his favorite drink), but his new girlfriend found him unconscious and summoned help in time to pump his stomach. He considered himself beyond hopeless, since, even with a beautiful woman in love with and caring for him, he secretly had another homosexual affair. In the spring of 1932 at age thirty-two he boarded a streamliner, the S.S. *Orizaba*, heading back to New York. Within a few days he was beaten by a male sailor whom he'd offended by his sexual advances. Around noon the next day, he climbed the railing, and waved, saying, "Good-bye, everybody," before he leaped overboard. Life savers, the real ones, were tossed his way, but the poet vanished under the waves in the Gulf of Mexico, and his body was never retrieved. A marker near his father's grave reads "Harold Hart Crane—Lost at Sea," without mention whether that was the true path to the seventh heaven of consciousness.

> *The form of my poem [*The Bridge*] rises out of a past that so overwhelms the present with its worth and vision that I'm at a loss to explain my delusion that there exist any real links between that past and a future worthy of it.*
> —HART CRANE

> *The bottom of the sea is cruel.*
> —HART CRANE

Psychologist James W. Pennebaker counted the number of pronouns in the works of many published poets. He concluded: "Suicidal poets use a large number of I's and a low number of references to other people." Regardless of the pronouns, the suicide rates are much higher among poets than all other types of authors.

STEPHEN CRANE

The principal mark of genius is not perfection but originality, the opening of new frontiers.
—ARTHUR KOESTLER

Stephen Crane's most famous book, *The Red Badge of Courage*, remains required reading on many school lists, but most classroom discussions side-step the author's advocacy of prostitutes' rights, and that Crane even married the madam of a whorehouse to prove it.

He was born in Newark, New Jersey, in 1871, the last of fourteen kids, which if nothing else speaks of the amazing durability of his mother. Neverthe-less, it's no wonder both parents died while Stephen was young. At nineteen he journeyed across the bay to New York City to seek his fame as a writer. There he found a raw pulse of life in the Bowery, when that area was truly rough, a haunt for streetwalkers, winos, and gangs. He had already made a reputation as what some call a "man's man," and was noted as an excellent bare-handed catcher in baseball. Crane took up the gambling, drinking, and smoking habits of someone twice his age. His self-published first novel, *Maggie: A Girl of the Streets*, about a hooker, was called offensive by critics, and the book flopped. Crane persisted. He received international acclaim at age twenty-five when *The Red Badge of Courage* hit the stands and was reprinted fourteen times in one year. Praise was lavished on Crane, including a detailed review in the *New York Times* that said, "he is certainly a young man of remarkable promise." Crane wrote stories using detailed imagery, with a cinematic eye, long before movies were invented. Forever on the go, with one foot always out the door, he trav-eled widely, seeking authenticity by heading to trouble-spots to get a bird's-eye view. When returning from one venture his boat sank, though miraculously he survived nearly thirty hours at sea until he washed ashore at Jacksonville, Florida. It was there he met and married the madam of the brothel called Hotel de Dream. His marriage to her outraged everyone, and Crane and his new bride sought solace in England, apparently then more accepting of the avant-garde. From the beginning, Crane's writing habits were of one possessed, as if he were in a contest with himself to produce as much work as possible in the shortest amount of time. He was a notoriously poor speller and said he had

no time to learn, knowing, perhaps, that the sand in his hourglass was quickly being depleted. Sure enough, with fountain pen to paper to the end, he burned out at age twenty-eight, dying of what reports variously said was tuberculosis, malaria, and possibly a venereal disease, in 1900.

> *Every sin is the result of collaboration.*
> —STEPHEN CRANE

HARRY CROSBY

> *Mediocrity is self-inflicted. Genius is self-bestowed.*
> —WALTER RUSSELL

Harry Crosby was the often forgotten member of the famed literary "lost generation" that gathered in Paris at the beginning of the twentieth century, and mingled with luminaries such as Ernest Hemingway, F. Scott Fitzgerald, and Gertrude Stein. However, Crosby found a rather odd and fatal obsession to call his own. Born with the proverbial silver spoon in his mouth, Crosby, of the Boston Brahmin class, with family ties to megamogul J. Pierpont Morgan, was educated at elite schools and assured a prosperous career in banking. The strikingly handsome young American aristocrat had other ideas and volunteered to drive a Red Cross ambulance during World War I. The experience of war, particularly the red glow of bursting bombs that left what he called "charred skeletons," led him to believe that the power of the sun had to be worshiped and seized. His family knew something was amiss when he returned a war veteran who couldn't stay sober and preferred to paint his fingernails black. They sent him to Paris in the hope he'd grow out of this foolery. Instead, there he took to heart the poet Rimbaud's advice to find truth through the "disarrangement of the senses," and Oscar Wilde's admonishment to "succumb to every temptation." Crosby's Black Sun Press was extremely influential to literature, publishing the early works of future icons, including D. H. Lawrence, Hart Crane, and James Joyce, thus making Crosby a personality many struggling writers of his generation wanted to know. Crosby also used the press to publish his own books of poetry, but he left the details of running the press to his wife. Crosby preferred to spend his family's stipend on caviar, champagne, cocaine, opium, and pretty women, and preferred to lounge many a day away wearing silk pajamas. When he published his poetry collection, *Chariots of the Sun*, he celebrated by having a giant sun tattooed on his back.

He didn't keep his suicide-wish a secret and talked of little else but a glorious "sun-death," setting fire to "the powder-house of our souls," and going out with an explosive bang, instead of what friend and poet T. S. Eliot described as the more preferred whimper. At age thirty-one, Crosby and a lover were found in bed, both with bullet holes in their heads. Crosby's pistol had a sun etched into the handle. The bodies were fully clothed, except for Crosby's bare feet. On the soles he had tattooed a pagan sun that looked not at all fashionable next to the morgue's tag dangling from a string around his big toe.

> *I have invited our little seamstress to take her thread and needle and sew our two mouths together.*
> —HARRY CROSBY

TAT ARTISTS

*Although Crosby had a few tattoos, covering every inch of his body with them was not one of his obsessions. People inspired to use the body to display artworks and drawings flourished during his time, rivaling today's current trend in tattoo popularity. Decorating the skin with permanent pigments dates back to fourth century BC, and has more or less gone in and out of favor ever since. A few people cover their entire bodies until every inch of the "canvas" is used up. In the late 1800s **Alexandrinos Constentenus** ended up with 388 inter-connecting tattoos and became the first person to make a living displaying his passion: billed as Captain Constentenus, he made the equivalent of a thousand dollars a week in P. T. Barnum's sideshow. He had them on the eyelids, ears, the penis, and everywhere else, with dirty messages inked between his fingers. A known womanizer and heavy drinker, he got into trouble flirting with female clientele, exposing more than some wanted to see. His fate remains cloudy, though he supposedly went down to visit Greek family members he had in Tampa Bay and while diving for sponges was either eaten by sharks or drowned. Today, people with tattoos say it makes them feel sexier, although it depends on where it is and what it's about, since certain tattoos are used for gang identifications, and more than 80 percent of those convicted for murder have at least two.*

DOROTHY DANDRIDGE

I think it takes obsession, takes searching for the details for any artist to be good.
—BARBRA STREISAND

In 1954 Dorothy Dandridge was hailed by the *New York Time*s as the most "beautiful Negro singer since Lena Horne." In reality, the musical that made her famous, *Carmen Jones,* had dubbed over her voice with that of an opera singer. They did the same in her next musical, *Porgy and Bess.* She believed she had a good, soulful sound, though she admitted, "People just seem to like to look at me." She had been in Hollywood since she was four years old, cast in a number of movies, and had remained diligent with singing, acting, and dancing lessons, always determined to make a name for herself. She started to sing professionally on the club circuit and picked it up again after her movie career began to fizzle. However, her short-lived heyday was grand: She was the first black female to be nominated for the Best Actress Oscar, in 1955, and the first to have her face on the cover of *Life* magazine, in addition to selling out performances in the U.S. and abroad. However, during the production of *Carmen Jones* Dandridge began an affair with director Otto Preminger that eventually proved to stifle her career and set off a cascade of events that would be her downfall. Although Preminger was married and would not divorce, he still wanted to retain control over Dandridge. Ultimately, at Preminger's urging, Dorothy refused to take bigger film parts that would have established her film career. To make matters worse, Dorothy then married a restaurant owner who drained her accounts to keep his business afloat. By 1959 she was in debt, owing back taxes, had filed for bankruptcy, and moved into a small West Hollywood apartment, where she was alone. Still, she persisted and outwardly appeared determined to fulfill her obsession with stardom, though it was a deep hole to dig out of. In 1965, at age forty-two, she was found dead in her bathroom. At first, attempts were made by her manager and friends to say she died of an embolism caused by a broken ankle, since her foot was in a cast. However, months later, the coroner rectified the cause due to an over-dose of Torfanil, an antidepressant, mixed, as it had been, with ever-increasing amounts of alcohol. Shortly before Dorothy died, she gave a forty-four-word, hand-written will to her manager, telling him that he'd be the one likely to find her: "In case of death—whomever discovers it—don't remove anything I have on—scarf, gown, [word crossed out] or underwear. Cremate me right away. If I have anything, money, furniture give to my mother." Dorothy only had two dollars in her bank account.

NO FEMALE IMMUNITY

Unfortunately, mixing pills and drinking has been many female singers' final note. **Billie Holiday** *(forty-four), the soulful jazz singer, died handcuffed to a hospital bed from alcohol and heroin addictions in 1959.* **Dinah Washington** *(thirty-eight), called the Queen of the Blues, and Grammy winner for "What a Diff'rence a Day Makes," one day in 1969 fatally mixed diet pills, booze, and sleeping pills.* **Judy Garland,** *with dual careers of acting and singing, like Dorothy Dandridge, died of what many called an accidental overdose. By 1969, Garland (forty-seven) had fallen deep into the bottle and the day she died had taken ten Seconals, when the normal dose is one.* **Florence Ballard** *(thirty-two) of the Supremes succumbed to complications of alcoholism and drug abuse in 1976.* **Candy Givens** *(thirty-seven) of the rock band Zephyr was loaded on alcohol and Quaaludes when she blacked out in a hot tub and drowned in 1984.* **Dalida** *(fifty-four), a popular European singer with eighty-six million records sold, was noted for releasing the first seventies French disco single, "J'Attendrai," which was all the rage in clubs. She overdosed on barbiturates in 1986, leaving a note, "Life's too unbearable."* **Brenda Fassie** *(thirty-nine), dubbed "The Queen of African Pop," born in Cape Town, South Africa, died in 2004 of alcohol and cocaine, after more than thirty failed stints in rehab.*

DANTE

Pride, envy, avarice—these are the sparks that have set on fire the hearts of all men.
—DANTE ALIGHIERI

An obsession for pride is one way to make sense of Dante Alighieri's life and death. This fourteenth-century poet and author of one of the most famous works of Western literature, *The Divine Comedy,* had the attribute in epic proportions. *The Divine Comedy* is a long epic poem describing Dante's macabre journey through Hell and exploits in Purgatory and Paradise; similarly, Dante's own life had been something of an odyssey. Caught up in the time of warring factions throughout Italy, Dante took part in battles and subversive plots to keep his place of position in his home city of Florence. As he wrote: "The hottest places in Hell are reserved for those who, in time of great moral crisis, maintain their neutrality." Ultimately, he was on the losing end, exiled from the place that gave him identity, prestige, and money. At first, he would've been burned at the stake if he had returned to Florence, though later it became clear that he'd be pardoned if he paid a fine. His pride never allowed him to set foot in his native city again. Although he was married to another woman by arrangement, Dante loved one Beatrice Portinari, to whom

he never did more than say hello. Dante became obsessed with her and made Beatrice his passion, the perfect ideal of beauty and love for the rest of his life. When she died at the age of twenty-four, he was nearly the same age.

There was such a forceful certainty in all Dante wrote that for centuries no one has ever doubted his greatness. It was this gargantuan-size pride that allowed him to boldly call and write what he saw as truth, yet it was the same that left him exiled and wandering, eventually succumbing to fever, probably from malaria. He refused medical advice, believing he knew better, dying at age fifty-six in 1321.

> *Lying in a featherbed will bring you no fame, nor staying beneath the quilt, and he who uses up his life without achieving fame leaves no more vestige of himself on Earth than smoke in the air or foam upon the water.*
> —DANTE ALIGHIERI

LIBRARIAN WARNING

Al-Jahiz was a famous Arab writer and scholar in the eighth century. Despite humble origins, eking out an existence as a fish seller, he had a passion for knowledge, and eventually wrote encyclopedias on animals, social manners, stories, and history. Along the way he collected untold numbers of books and stocked an impressive private library. He died when a bookcase toppled over and crushed him.

> *The sin of pride may be a small or a great thing in someone's life, and hurt vanity a passing pinprick, or a self-destroying or ever murderous obsession.*
> —IRIS MURDOCH

SALVINO D'ARMATO

> *We know that the nature of genius is to provide idiots with ideas twenty years later.*
> —LOUIS ARAGON

Salvino D'Armato, a glass craftsman in Florence, Italy, worked diligently to make a living providing colored shards used in stained-glass windows for cathedrals. He often held up pieces to a candle to test for purity. One day he examined a sliver of rejected glass, while by chance gazing through it at the fine-print design-drawing from which he worked. To his surprise, he was able to read the detailed instructions much more clearly. D'Armato suffered, as many in those times did who worked in poorly lit workshops, from what is now called hyperopia, or farsightedness. That day he had a stroke of genius

and thought to choose similarly shaped convex glass scraps, and attach the pieces to a wad of beeswax that he stuck on the bridge of his nose. It looked ridiculous, but from then on D'Armato dedicated his life to perfecting what we now know as eyeglasses. At first he was thought an imbecile for purposely attempting to make what was considered inferior glass. When D'Armato began to fashion frames from the same lead that held stained-glass windows together, he was able to sell a few pairs. Before this, poor eyesight was treated with any number of lotions and concoctions that usually resulted in even worse sight. Lack of patent protection back then didn't help the inventor's fate, since by then there were a number of craftsmen inserting his glass into lightweight gold and silver frames that sold well. He died penniless at age forty-nine, in 1317, when, legend has it, he didn't read the sign that warned against drinking at a contaminated well and succumbed to typhoid. Evidently, people thought he had other weaknesses than his obsession for invention, for an epitaph was written at the time of his death that read: "Inventor of Spectacles—May God forgive him his sins."

*Sunglasses were invented by **Edwin H. Land** in 1929 when he devised a polarizing filter to cut glare. He is primarily known as the genius behind instant Polaroid photography. Land apparently had a desire to keep things shady since to this day his death in 1991 cites merely "undisclosed causes." In addition, his last wish instructed an assistant to shred all personal papers and notes.*

JOHN DAVIDSON

> *To desire immortality is to desire the eternal perpetuation of a great mistake.*
> —ARTHUR SCHOPENHAUER

Scottish poet and playwright John Davidson was noted for his keen and brilliant mind, and believed his entire life that people would eventually catch on

to his genius. In March of 1909, he wrapped up his finished manuscript, grabbed his hat and cheerfully told his wife he was going to the post office to send it off before dinner. He was never seen again, and nothing but a package of old newspapers arrived at the publisher's desk. Witnesses later said they saw Davidson stop in at the local bar for a shot of whiskey and a big cigar. He was last seen strolling down the road, puffing away contentedly on the stogie. His cheeriness was probably the first clue something was amiss, since the writer had grown perpetually bleak, depressed about his worsening financial situation. In addition, his recent philosophical views were being attacked after he had proclaimed that his life, and human existence in general, was one big joke with a bad punch line. He even complained about the duality of night and day, and that it was absurd for the days to separate in such a way, concluding that death was the only state that rectified life's endless series of inconsistencies. Smoking a cigar might've been another clue, since his health had been seriously declining due to bronchitis and asthma. Nevertheless, the supposed sightings of John Davidson became a hot topic in newspapers until his body was found washed up on shore nearly six months later. That last evening he had apparently walked beyond the town to the cliffs of Penzance and threw himself into the English Channel. Though the scandal helped his last manuscript (discovered among his belongings), his final dramatic act never launched his work to the immortal status he had hoped.

> *Physical activity can get you going when you are immobilized. Get action in your life, and don't just talk about it. Get into the arena!*
> —JOHN DAVIDSON

TESTING GENIUS

Although Davidson never took an IQ test he would've inevitably scored high; however, IQ scores and genius do not always mesh. The IQ test, first developed in the 1920s, was devised to measure the supposed mental age in ratio to chronological age, and to determine if children were mentally handicapped. A "normal" person will range between 85 and 110. It is estimated that only 1 percent of the more than six billion people on the planet have an IQ above 135, once considered the threshold for genius. **Marie Curie** *was considered a genius, and won two Nobel prizes. She was passionate and persistent in working with radioactive isotopes, and although she had an astounding grasp on the entire concept, fell short in the ability to stop touching the stuff once she had seen how radiation affected her own body. She died of blood disorders compounded by radiation poisoning in 1934.* **John Stuart Mill**, *deemed a genius, wrote on logic, economics, and theories of government, women's rights, and more. A forward thinker on liberty, he opposed the prohibition of alcohol and tobacco and died in 1873 of "lung congestion," from smoking. Nevertheless, as psychologist Abbie F. Salny noted: "Genius may be in the eye of the beholder. Furthermore, a true genius may not*

score particularly well on a standard group IQ test. And really, those who are what we may call a genius don't need a score to prove it."

MILES DAVIS

A legend is an old man with a cane known for what he used to do. I'm still doing it.
—MILES DAVIS

Miles Davis picked up a trumpet when he was thirteen, and within two years was considered a virtuoso. By the late 1940s, and lasting through the sixties, Davis was the most innovative musician on the jazz scene. Due primarily to a heroin addiction, and its aftermath, Davis's appearances were infrequent during the last twenty years of his life. He died at age sixty-five in 1991, after a long bout of pneumonia and a stroke.

HUMPHRY DAVY

One science only will one genius fit: So vast is art, so narrow human wit.
—ALEXANDER POPE

Humphry Davy was a leading scientist and well-respected chemist of the early 1800s. Posterity recalls his role in the discovery of seven elements, and he was also known for giving well-attended lectures at the Royal Society of London on the early theories of electricity. Davy came from humble origins; he was a wood carver's son who was apprenticed out to an apothecary's shop, where he became interested in chemistry, and eventually made a favorable reputation for himself by being the guinea pig for many experiments. He was particularly interested in gases. Davy partook in one study to determine which was the better stimulant, alcohol or nitrous oxide. At the time it was believed alcohol was a stimulant, though it's now known to be a depressant, while nitrous oxide was considered a trigger that allowed the user to experience an otherworldly and even spiritual clarity. He sat down in his lab and guzzled a large bottle of wine in seven minutes. He took notes as best he could as he lapsed into drunkenness. Then he inhaled five pints of nitrous oxide gas and promptly collapsed to the floor and remained in a blackout for two and a half hours. Still, in the name of science, he persisted in inhaling the gas in various quantities and eventually concluded that it was healthier than booze, since it didn't leave the user with a hangover. In the process, however, Davy sadly became addicted. The papers he wrote, stating that the gas "made him dance around the laboratory as a madman, and has kept my spirits in a glow ever since," set off a nitrous-mania among everyone

from gentlemen and ladies to the town bloke. Davy even reported that the gas promoted longevity, even more so than oxygen, and wrote that nitrous oxide must be the air that is in heaven. As time went on Davy changed his public stance and told colleagues he had weaned himself from the stuff, noting that its use had seriously curtailed his scientific productivity. However, he admitted that the sight of an inhalation bag, or even the sound of a person laughing, triggered an insatiable, lifelong craving for the drug. Many biographical records have tidily cleaned up his episodes of relapse, preferring to remember him as the president of the Royal Society and as the humanitarian inventor who developed the first miner's lamp, which Davy donated without seeking profit to help save lives. Yet his use of nitrous oxide and his penchant for inhaling all types of gases truncated and eventually extinguished the true potential of his genius. Before he died, at age fifty in 1829, he blamed his fatal illness on the "constant labour of experimenting, and the perpetual inhalation of the acid vapours of the laboratory."

Other famous proponents of the use of nitrous oxide include Thesaurus *author* **Peter Roget***; ***Robert Southey***, an English poet;* **Theodore Dreiser***, an American novelist;* **William James***, the philosopher;* **Winston Churchill***, the English prime minister; and* **The Joker** *in* Batman*, whose most potent weapon was engulfing his adversaries in a deadly cloud of nitrous.*

Drawing of ether chamber, with the bottom removed to shew the inhaler. The relstet of the same metal as the chamber, is soldered to the top, and reaches to one-sixteenth of an inch from the bottom.

The dotted lines indicate the position of the expiratory valve when turned aside for the admission of unexpected air.

THOMAS DE QUINCEY

Opium teaches only one thing, which is that aside from physical suffering, there is nothing real.
—ANDRE MALRAUX

Thomas De Quincey was kept home in his childhood, considered too sickly and frail by his widowed mother to go out, and he was made accustomed to solitude, the house always as quiet as an empty church. Thomas read ferociously, devouring books and learning languages at such a pace that by the age of fifteen he was ready for Oxford University. But his mother decided that would make him too "big headed" and arranged to have his Oxford scholarship begin when he completed three

years at a less prestigious grammar school. Restless, Thomas ran away after about a year and a half. He subsequently lived as a homeless teen, moving frequently, knowing his family was on the hunt for him, yet too fearful of his mother's wrath to return. When they finally reconciled, Thomas was sent to Oxford, but after five years and no degree, he dropped out. During his college days he secured meetings with his literary heroes, including Samuel Taylor Coleridge, through whom he was introduced to opium and laudanum. Thomas was a "super-senior" of sorts, hanging out at the campus, taking drugs, and hardly working until the age of thirty-one. After agreeing to marry a woman who bore a child (presumably his), his hyperactive creativity kicked into gear. He wrote as furiously as he read, publishing articles and translations at a rapid pace. One publisher noticed his apparent opium habit, and as a lark, suggested the spaced-out-looking writer do a piece on his opium experiences. De Quincey wrote a series of articles later collected into a book titled *Confessions of an English Opium-Eater*. The vivid descriptions of his bizarre opium dreams kicked off a dope fad, with all levels of society looking for a taste of the stuff. The book was a hit, and the biggest one he'd ever produce.

Whereas wine disorders the mental faculties, opium introduces amongst them the most exquisite order, legislation and harmony. Wine robs a man of self-possession; opium greatly invigorates it.
—THOMAS DE QUINCEY

De Quincey continued to churn out pieces on a variety of subjects, but his ever-growing habit took most of his income. Ten years to the day from the publication of *Opium-Eater*, De Quincey was sent to a debtor's prison. Once out, he tried to slow his laudanum consumption, but soon he was again taking it to excess, which regrettably led to convictions for bad debt twice the next year and three more times the following year. His family life was intolerable, compounded by the ramifications of his addiction; he had three sons die, and finally his worn-out wife passed away from grief. During this period of funer-

als, De Quincey received a double conviction for more debt, which forced him into hiding much in the way he had spent his teenage years. When he was finally dragged before the magistrate, all agreed De Quincey had inflicted a punishment upon himself harsher than any court could conceive. He retired to a small cottage that he filled with books from floor to ceiling and labored in pin-drop quietude to complete a treatise on economics and a follow-up to *Opium-Eater*, which he titled *Suspiria de Profundis*. In the last years of his life a few editors sought him out—the way a relic from the sixties might be resurrected today—and a collection of his work was published to critical acclaim. De Quincey never stopped taking opium and died an old junkie at age seventy-three, in 1858.

The genesis for *Confessions of an English Opium-Eater* was first published as an article in the *London Magazine* in 1821, authored by an anonymous "X.Y.Z." De Quincey had written it on the run, sick for many days from withdrawal symptoms—as he said, "ill from the effects of opium upon the liver"—though he persisted, writing it in coffee shops and taverns. A longer version was published as a book the following year and remained in print for the remainder of the century, influencing many writers and artists, and was supposedly a favorite of Edgar Allan Poe. The book was considered a medical treatise and was actually used as evidence in court cases to demonstrate certain effects of opium use.

> *Solitude, though it may be silent as light, is like light, the mightiest of agencies; for solitude is essential to man. All men come into this world alone and leave it alone.*
> —THOMAS DE QUINCEY

"DOPE!"

Will John Bull's "pipe dream" ever come true?

OPIUM WARS

When De Quincey published Opium-Eater, *the "English" part of his title was the novelty. The English government under its East India Trading Company had been growing tons of opium in India and trading it with the Chinese for tea and other commodities for nearly a century, helping more than a quarter of the Chinese population to become dope fiends. When the Chinese rulers tried to stem its use, banning its import, and dumping all seized supplies into the sea, British battleships appeared on the horizon. Resisting ports were devastated, and the superior British naval and land armies easily decimated the Chinese forces, who were using old-fashioned artillery and bamboo-lashed junks. The resulting peace treaty effectively allowed Britain to establish a preferential trade agreement with China and keep the opium flowing, although on a more hush-hush basis. In a sad irony, one of De Quincey's sons was drafted into this war and died in the battle to keep opium trade routes open.*

DEBT TO ART

*It was easy for poets and artists to get into debt, then and now, even without an addiction as money-consuming as De Quincey's. English painter and writer **Benjamin Haydon** was close friends with William Wordsworth and among the top artistic notables of his day, painting portraits of Wordsworth and of John Keats—surely not the best-paying customers. Hayden called for poetry and writing to have a socially redeeming value rather than merely romantic images of flowers and such. He did a number of stints in prison as a result of his violent temper, which usually flared up against those trying to collect a debt. In the end he thought to go Shakespearean, and left a suicide note that quoted King Lear: "Stretch me no longer in this rough world." The sixty-one-year-old disillusioned artist had had enough in 1846 and shot himself; when he didn't bleed to death quickly enough, he then slit his wrists.*

JAMES DEAN

The lucky person passes for a genius.
—EURIPIDES

The fast and furious always grab attention. James Dean's death at age twenty-four from a fatal crash while speeding in his Porsche remains the benchmark many thrillseekers still emulate. It's arguable that Dean would've attained less notoriety if he hadn't died young and been spared the fate of many actors with his talent who lived to be seen later in life filling a cube on *Hollywood Squares*. Elia Kazan, director of Dean's film *East of Eden*, had to virtually lock up the young actor in a trailer during production to keep him from carousing all night and speeding on a motorcycle through the desert. The Academy Award–winning director said Dean had limited acting abilities, but worked hard, even if he was "highly neurotic." Others disagreed, and saw him as possessing a natural genius for the craft. Dean came alive and was atypically animated when he talked about racing, and even participated in a number of professional racing events. Although his obsession for speed was the passion that would kill him, he looked forward to a successful acting career so he could buy more sports cars and motorcycles, and actually had "Dean's Dilemma" painted on the side of one motorcycle. "Racing is the only time I feel whole," Dean told a reporter for one of the many fan tabloids that relished the bad-boy eccentricities of this new sensation. James Dean's mother died when he was nine, and he felt forever abandoned by her, as well as betrayed by his father's decision to ship him back to the Indiana farmland

where Dean's mother was raised. He grew to be five-foot-seven, thin, with pale eyes and a small nose. At first he studied law at Santa Monica College but dropped out to pursue acting. Only *East of Eden* was released in his lifetime: *Rebel Without a Cause* and *Giant* premiered after his death, and he was nominated posthumously for Academy Awards for each. Dean died in 1955 from a head-on collision while driving in a Porsche 550 Spyder. A car speeding in the other direction crossed into Dean's lane. Believing the driver would see him and swerve, Dean did not brake—a final game of "chicken." According to psychologist Dr. Edward Diener, who conducted a study of what is called the "James Dean Effect," some people "prefer shorter happier lives to longer ones." It's unlikely Dean would've agreed, although his untimely death in a fiery car crash assured his place in cinema history.

> *Dream as if you'll live forever. Live as if you'll die today.*
> —JAMES DEAN

EMILY DICKINSON

> *I have three phobias which, could I mute them, would make my life as slick as a sonnet, but as dull as ditch water: I hate to go to bed, I hate to get up, and I hate to be alone.*
> —TALLULAH BANKHEAD

Emily Dickinson fascinates as much for her simple, pure, and thoroughly original American poetry as for her steadfast introversion and hermetic life. In her lifetime, she never published the more than seventeen hundred poems she hid under her bed, and she remains a beacon of hope for many an undiscovered poet who likewise wishes for posthumous notoriety. Emily was shy to the point of being agoraphobic. Although she did attend school away from home for a short time and went on a few other trips into neighboring Boston, she preferred the sanctuary of her parents' home. As many agoraphobics are, Emily was very sociable to those who visited, even if, according to some accounts, during her later years she only conversed from behind slightly opened doors. More important than her phobias was her compulsion to write, coupled with an equal fixation for anonymity. She reportedly made some half-hearted attempts to find a place in print, but backed off at the first hint of criticism or revision. Her obsession to keep her work private and unaltered remains unusual, and has baffled more than a handful of scholars trying to

make sense of her artistic anomaly. In the end, Emily never married, dying in 1886 at age fifty-five of a blood disorder, then cited as Bright's disease, which is usually related to malfunctioning kidneys. It was the diagnosis du jour, though Emily was first thought to have "Domestic Illness."

Emily had been treated with warm baths and given a tremendous amount of laxatives and diuretic tea concoctions, the standard treatment of the time, which surely did as much to kill her as the disease. She

In the 1800s, "Domestic Illness" seemed to be the politically correct way to describe some sort of mental deterioration, often attributed to old age, or some unknown mania. Clues from death certificates that contain phrases such as "bedridden" or "hasn't been out for years," point to the possibility that Domestic Illness was cited for deaths from depression, Alzheimer's, or Parkinson's before those diseases were identified, or for any stroke victim—or agoraphobic—who was subsequently required to stay at home.

ended her days in fits of uncontrollable vomiting and high fever—and until her last breath kept the secret of her writing. When she died, her family was surprised to find more than forty carefully hand-bound books of her work amid her things. If it was fear of going out that kept her tethered to her home and gardens, it was a greater dread of rejection that kept her from pursuing publication, though there's no doubt Emily dreamed in her private loneliness of a lasting notoriety and recognition of her work.

Because I could not stop for Death, He kindly stopped for me;
The carriage held but just ourselves and Immortality.
—Emily Dickinson

PHOBIA OF DYING

A number of famous figures had phobias that influenced their life and work, and for the following theirs were greater than thanatophobia, defined as the fear of death and dying. President Ronald Reagan had aerophobia. He feared airborne noxious substances and drafts from windows: This might have attributed to his persistence and support for the "Star Wars" defense program, which aimed to knock flying objects from the sky. Benjamin Franklin had the opposite, and never slept with the window closed. Franklin died after catching a cold while sleeping in a room with the window open during the winter of 1790. Natalie Wood was hydrophobic, with a fear of water. This fact makes her drowning death in 1981 suspicious to some, especially since it was claimed she left a yacht after getting drunk for a solo sail in a raft. Napoleon Bonaparte had fear of cats, or ailurophobia. When he died while confined to a prison, some said his death was due to stomach cancer, citing his drastic weight loss. But it was the herds of cats used to keep the prison rat population down that discombobulated him so much that he couldn't eat. Adolf Hitler was claustrophobic, making his retreat to a bunker when facing defeat a more difficult one. That

he took cyanide to commit suicide, and that he shot himself in the head rather than waiting for it to take effect, were motivated by his phobia.

DIOGENES

> *What I like to drink most is wine that belongs to others.*
> —DIOGENES

Diogenes of Sinope was a teenager when Socrates was charged and convicted of heresy, and had previously attended many of the great philosopher's lectures. Shortly after Socrates's demise, Diogenes sought another mentor, and though he failed, he did find a substitute of sorts: He became fascinated by watching dogs fornicate. He spent many hours on the street corners and back alleys observing their carefree behavior until he reached an epiphany, deciding that man's four-legged friends had the answers to a happy life. Dogs,

he observed, cared not where they slept or what they ate, and defecated whenever and wherever they wished. He began to act like a dog, crawling on all fours, living on the streets, and lifting his leg on any number of classical statues to relieve himself. Surprisingly, he wasn't banished for madness, for when they accosted him, citizens were stunned when this filthy, dirt-covered man-dog began to discourse in elegant speeches. Diogenes believed man's achievements were a sham and called all to follow his example, finding true freedom in a return to animality. He eventually gave up all possessions and lived in a broken barrel on the side of a temple. Diogenes's legend spread far and wide, especially after he began to walk each night through the city holding up a torch, peering into the darkness. Without fail, many gathered around to see what he was looking for, and when finally asked, he always answered with the zinger: "I'm looking for one honest man." Diogenes is credited with another original one liner. When Alexander the Great searched him out to hear his wisdom, he found Diogenes sitting on a hilltop, staring out into the horizon. Alexander reportedly offered to grant whatever Diogenes wished, and a large crowd waited in silence to hear his request. Finally, Diogenes looked up and said, "There is one thing you could do for me. You can step aside, you're blocking my view." In the end, some say Diogenes died holding his breath, believing he had grown too attached to air, while others insist he was bitten by a rabid dog. Nevertheless, his odd genius was honored with an apt monument—a pillar with a statue of a dog perched on top.

GENIUS DOGS

No one appreciates the very special genius of your conversation as the dog does.
— CHRISTOPHER MORLEY

Champion George *was a famous pug that had his likeness painted on numerous products and advertising campaigns—one of the first to cash in on Americans' love for dogs. George sat among his handlers and looked back and forth at conversations as if he understood what was said, and he is considered the inspiration for paintings that had dogs doing human things. George was noted for heading to the tavern, where he made a reputation for lapping up his daily mug of beer, and during one summer afternoon in 1892, died unexpectedly in Philadelphia of heat stroke at age twelve.* **Barry III**, *the St. Bernard that gave the breed the reputation for saving people in avalanches, always with a little keg of whiskey around his neck, did actually rescue untold lives in Switzerland's Alps. He died in one attempt, trying to bring back hikers lost in a storm, in 1910. The hikers made it to safety but Barry couldn't stop from seeking out others, and was buried alive. German Shepherds were used in World War I to help medical units. An American captain found a puppy of one of these dogs in a deserted German medic station. He brought it home and named it* **Rin Tin Tin**. *The dog was so smart it starred in twenty-six Warner Brothers movies, receiving more than ten thousand fan letters a week, and is credited with saving the studio from financial ruin. Treated like a diva, Rin Tin Tin dined on chef-prepared, bite-size-cut filet mignon while classical music was played to help him digest. The dog died in 1932 at age sixteen.*

MICHAEL DORRIS

What is life? It is the little shadow which runs across the grass and loses itself in the sunset.
— CROWFOOT,
A BLACKFOOT WARRIOR

Michael Dorris was focused on one small part of his lineage, the Native American blood in his veins, and used this passion to become a writer, spokesman and scholar for Native American causes. In the 1970s all things Native American were in popular demand, and Dorris took issues to heart by adopting a Native American boy suffering from Fetal Alcohol Syndrome (FAS). Dorris further made

news by becoming the first single male in America permitted to adopt a child of any origin. Dorris wrote a nonfiction account of his trials, *The Broken Cord*, that won the National Book Critics Circle Award, and brought much-needed attention to the dangers of drinking while pregnant and remains required reading. To further champion his cause, he adopted two more Native American children suffering from FAS. Dorris, if measured by his written words, was talented, and the public persona he so diligently crafted to publicize his books seemed, for decades, impeccable. However, his unraveling came fast and heatedly: His first adopted son died in a hit-and-run accident; his second adopted child brought him to court and sued for child abuse; his long-time wife filed for divorce, with her three daughters bringing sexual-molestation charges against him. He knew, as the onslaught began, that reputation more than talent would be behind the judgment cast on his legacy, and if anything, Dorris was obsessed with presenting a persona devoid of flaws. Facing divorce and accusations of child abuse are no small challenges for anyone, and it's no wonder he tried to commit suicide on Good Friday.

After his first suicide attempt, Dorris spent time in a mental hospital, but on his first furlough he drove immediately to a nearby motel, took over-the-counter sleeping pills, drank vodka, and tied a plastic bag over his head. It could be argued that his obsession to maintain, at great cost to those closest to him, the public identity he had constructed, actually killed him at age fifty-two when the fiction irreparably fell apart. In his suicide note he apologized to the motel maid he knew would find him.

Whether Dorris was guilty of these transgressions remains unanswered, since gag orders were promptly enforced after his death in 1997. The lawyer, Lisa Wayne, who prosecuted Dorris said, "I feel like this suicide is a confession. Michael Dorris is talking to us from his grave." Others said he was innocent.

THE NICHE WRITER

Many new writers sit on the sidelines scratching their heads, wondering what they need, in addition to talent, to break into print. Considering the fact that an estimated one million manuscripts are at any given time floating through the mail vying for the attention of a major publisher, it makes sense for the persistent writer to focus on a niche. Whether it is, as it was for Michael Dorris, about Native Americans, or stories about zombies, or adolescent girls coming of age, the prospective author has a better chance when directing the work to a somewhat definable audience. However,

once an author breaks into a niche, greater lengths are needed to stay there. One writer, **Eugene Izzi,** *had found his place writing bestselling detective thrillers, and prided himself on striving for authenticity. Izzi knew the discerning crime reader would easily detect an implausible murder scenario and quickly send the author's book to the bargain tables. Many believe his death, in 1996 at age thirty-three, was the result of overzealous research. The author was discovered hanging outside the fourteenth-floor window of the Chicago office building where he wrote. The rope wrapped around his neck was attached to the leg of his desk. After his corpse was reeled in, police discovered that Izzi was wearing a bullet-proof vest: a can of mace, brass knuckles, and a computer disk were also found in his pockets. The authorities ruled out homicide when they read an outline for the exact crime scene before them that Izzi had just written and saved on the floppy found on his person. Izzi was working out the details of how one could plausibly escape after an angry, militant militia stormed an office building. Apparently, his idea needed revision.*

ERNEST DOWSON

Whiskey and beer are for fools. Absinthe has the power of the magicians; it can wipe out or renew the past, and annul or foretell the future.
—ERNEST DOWSON

Ernest Dowson liked books, but not sitting in a classroom. He dropped out of Oxford in 1888 to work at his father's prosperous dry-dock business down at the wharfs, and enjoyed being close to the pubs, where a mug of beer was the breakfast special. His father gave his rascal of a son flexible hours, which Ernest devoted to writing and carousing. Dowson was in the right time and place to become part of what was considered the Decadent Movement, filling the gap between the old-fashioned Romantic school and modern writers. He joined literary clubs and became chummy with up-and-coming notables, including William Butler Yeats, and for a spell joined Oscar Wilde's flamboyant entourage. One slender book of verse was the only poetry he published in his lifetime, and it was recognized by his fellow writers for its genius. Leading English critic Arthur Symons praised Dowson's literary brilliance for bridging the transition from pastoral literature to modern lyrical sensibilities, in addition to heralding Dowson as second in line, only after Oscar Wilde, as the greatest literary decadent of all time. Dowson's poems not only urged the reader to find "madder music" and "stronger wine," but a few of his lines remain popular in today's lexicon, such as "days of wine and roses," and "gone with the wind," which Margaret Mitchell used for the title of her famous novel. Dowson's success lasted only a few years, and his creativity reached its zenith when, at age twenty-three, he fell in love with an eleven-year-old girl, writing

some of his best work to her. He tried to collaborate on novels or do translations to show that he could earn money from his writing, but found no commercial success. He traveled widely through Dublin, London, and Paris on his family's considerable money until his ever-supportive dad got sick from tuberculosis. The senior Dowson decided not to endure a lin-

They are not long, the weeping and the laughter,
Love and desire and hate:
I think they have no portion in us after
We pass the gate.
They are not long, the days of wine and roses;
Out of a misty dream
Our path emerges for a while, then closes
Within a dream.

—ERNEST DOWSON

gering death, and euthanized himself with an overdose of chloral hydrate. A month later, Dowson's mother hanged herself. When Ernest discovered that the young girl he still pursued had been married off by her father to a tailor with better earning potential than a poet, Dowson was heartbroken. These multiple tragedies put an understandable damper on his carefree ways. His social drinking habits quickly advanced to the point that he was seldom seen sober. He eventually swore off beer and wine and switched to absinthe. A fellow writer friend found a barely recognizable Dowson penniless and begging for a drink in a bar. He took Dowson back to his cottage for recuperation, but the decadent poet was too far gone and died from complications of alcoholism at age thirty-two in 1900.

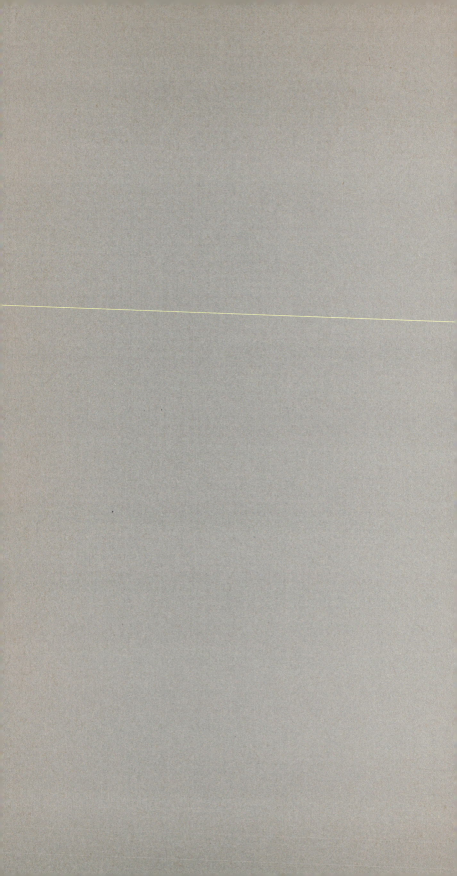

STUART ENGSTRAND

*A critic is someone who never actually
goes to the battle, yet who afterwards
comes out shooting the wounded.*
—TYNE DALY

Stuart Engstrand was raised in the
bucolic Midwest of which he retained
fond memories of swimming in creeks
and milking cows. That he drowned
himself in a lake in MacArthur Park
in Los Angeles at age fifty-one in 1955
to some seemed to mean he had come
full circle—though a wide loop it was.
From an early age, and surely by the
end of college, Engstrand was deter-
mined to be a writer. He turned down offers to teach, believing it would stifle
creativity and instead cut lawns and drove trucks. He even made a shack in the
woods, where he remained for three years, subsisting on wild nuts and money
he had squirreled away, seeking the undistracted time needed to feverishly
compose poems, stories, and long fictions. When none of this wilderness out-
put made it into print, he returned to civilization, attended writing workshops,
and married. As a writer, Engstrand considered himself a cultural observer, and
when he published his first novel, at age thirty-four, he was praised for his keen
eye for tensions underlying many societal relationships. The *New York Times*
praised Engstrand and wrote that the result of his work was "almost equal to,
if not identical, to brilliance." Today, interest has resurfaced in his 1947 novel
The Sling and the Arrow, which describes the deterioration of a marriage due
to the husband's latent homosexuality and his passion to dress in his wife's
clothes. Whether or not Engstrand was a practicing cross-dresser was a secret
he took with him to the lake. However, the day he chose to die is perhaps more
telling of his state of mind: He decided to drown himself on the very day his
last book, *More Deaths Than One*, hit the bookstores. Many believe writers are
ecstatic when the thing they labored on finally sees completion in the form of
a shiny new book. Yet a large number of authors experience a sort of literary
postpartum depression on publication date as they wait for the thumbs-up or
thumbs-down from the crowd in the stands. Engstrand didn't want to be the
bull's-eye for one more bad review.

*People who drink to drown their sorrow should be told
that sorrow knows how to swim.*
—ANN LANDERS

CRITICAL DROWNING

Francisco Rodrigues Lobo was a famed seventeenth-century Portuguese poet who wrote in Spanish, considered the language of culture. When he deviated from this practice and wrote in his native tongue, he met with harsh criticism. He soon drowned himself, in 1621 at age forty-one. **Johnny Burnette** *was a Top Ten regular during the fifties, winning praise for songwriting, and becoming known for singing "You're Sixteen." In 1964 his career was fading and he met with criticism when he tried to form his own music label.*

Traveling at night on a small craft at Lakeport, California, he drowned, at thirty, supposedly falling overboard after a collision with a motorboat. **Albert Ayler** *(thirty-three) was a jazz saxophonist, considered a leading exponent of free improvisation, who played with many greats, including Cecil Taylor. When Ayler turned from jazz and put out an album more in the hippie vein, critics called it his worst work yet. He smashed his sax over a TV set and boarded the ferry to the Statue of Liberty. He never made it to Lady Liberty; he was found drowned in the East River in 1970. When singer-songwriter* **Jeff Buckley** *released his second album, critics were not as kind as they were to his debut. In 1997, at age thirty, he was riding in a boat with some friends in Wolf River Harbor, in Tennessee, when he suddenly decided to go for an impromptu swim. According to the* New York Times, *"Mr. Buckley was wading and swimming when a speedboat passed by, creating wake. Although noted as an adequate swimmer, Buckley unexpectedly disappeared. A week later his body washed ashore downstream.*

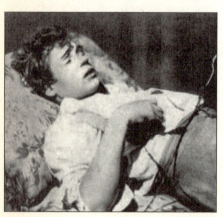

SERGEI ESENIN

In this life there's nothing new in dying And, in truth, to live is nothing new.
—Sergei Esenin

Sergei Esenin became a famous Russian poet when his verse sang the praises of the Bolsheviks during the Russian Revolution, and he himself emerged from the conflict as the supreme poet of the new order. Back then, people actually read poetry, and by the age of twenty-three, Esenin was published everywhere and was very popular, praised as the new Russian literary genius. However, Esenin had designs to become famous not only in Russia but throughout the world. When internationally renowned American dancer Isadora Duncan came to Moscow on tour, Esenin saw her as his passport to wider success. Esenin was twenty-seven, Duncan in her mid-forties, puffed up and podgy, and though neither spoke each other's language, they kicked off a public romance that was

noted for all-night drunken parties. After they married, Esenin accompanied Duncan to the United States, but wasn't welcomed as the international poet, as he had hoped. Instead, he was treated as the new boy-toy leashed and showed off by the dancer. A year later the marriage ended in divorce, with Esenin returning to Russia to find he was no longer favored by the ruling peasant class. In short, he was ostracized by the Communist government for his "unsophisticated and politically irrelevant verse." He had always been a hypochondriac of sorts, forever checking his pulse, sure he was on the verge of death. But he soon took on the appearance of one close to the crash-and-burn phase for real. In December of 1925, at age thirty, he checked into a hotel room and prepared to write his last poem. When the pencil broke, he used the jagged tip to slash his wrist and dipped the broken point into his own blood to finish the verse. The next morning he was found dangling from a pipe in the hotel bathroom, hanged by a belt he selected from the fancy American clothes that filled his steamer trunk. When they cut him down, photographers were allowed to pose him lying, mouth agape, on the bed.

Vladimir Mayakovsky, a Russian poet and Esenin's rival, won the title of poet laureate of the Revolution, and was endorsed by Stalin. Mayakovsky sold thousands of his poems to Lenin and to the Communist party to be used in posters and propaganda. At age thirty-six, in 1930, he shot himself in the heart with a pistol. He was given a state funeral, with more than a hundred fifty thousand people lining up to view his body.

CHRIS FARLEY

While many good comedic actors throw themselves headlong into their roles, Chris Farley did it literally. Farley specialized in physical slapstick, tossing his large frame about the stage, sweaty and red-faced. He used the effects of his high blood pressure

for a laugh and often looked about to die while performing his classic temper-tantrum routine. Farley's dad passed on the genetics of obesity, weighing six hundred pounds, making Chris Farley, in comparison to his father, the thin one. Majoring in theater in college, Farley was impatient for success and had the creative insight to use this franticness in his stage presence. Within a few years he was a regular on *Saturday Night Live*, though from the outset was made to attend rehab for drugs, drinking, sex, and food addictions. He prayed and went to Mass and more rehab, but in the end, every day was New Year's Eve for Chris Farley. He explained that his addiction was a way to dispel loneliness. At age thirty-three, in 1997, he hired an exotic dancer for company to snort heroin and cocaine and drink vodka. When he collapsed on the floor of an overdose, the dancer thought Chris was doing one of his comedy acts and took a picture of him dead before riding home in the limousine he provided.

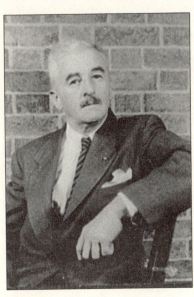

WILLIAM FAULKNER

A drunk man's words are a sober man's thoughts.
—STEVE FERGOSI

Nobel Prize winner William Faulkner chose the slow road toward self-annihilation as a periodic binge drinker, with many notorious benders lasting a month or more. When he drank he did so until he passed out. When he came to, he drank some more, until he conked out again. However, Faulkner stood out among the pack of writers who believed drinking helped the creative process, and admitted he couldn't write his laundry list when drunk, even though he wrote outlines on the walls of his house with a red grease pen when reportedly plastered. When a relative asked if he had been drunk when he conceived his work, he replied, "not always." When sobered up from a binge, he admitted to his ultra-patient wife, Estelle, that "he misbehaved," though said he felt better after each debauch. (She was not only patient with his drinking but with his numerous affairs with younger women.). The cycle of ruin and redemption,

regret and apology, became as routine as a dance step for their entire marriage, and was a predominant theme in his work.

I'm bad, I'm going to hell, and I don't care. I'd rather be in hell than anywhere where you are.
—WILLIAM FAULKNER

First noted as a careless mailman, with some recalling him as the Oxford, Mississippi, town drunk, Faulkner didn't earn literary recognition until he was in his early thirties. He spent years in Hollywood writing scripts, and during what many consider a decade of genius, through the 1930s, produced the bulk of his best-remembered novels. Faulkner became a public figure after winning the Nobel in 1949 and toured the world on behalf of American literature, though with numerous accounts of his periodic binges punctuating social protocol. Even at his acceptance speech for the award the crowd was shocked that his voice was garbled and he appeared wasted, unsteady at the podium. None knew what he had said until the next day, when the transcript was released; it's now considered by many to be one of the best Nobel acceptance speeches by any author.

I decline to accept the end of man I believe that man will not only endure, he will prevail.
—WILLIAM FAULKNER

Faulkner tried diligently to put to rest his personal love-hate affair with drink, even more so when he realized it was sapping his writing prowess. He even subjected himself to electroshock treatment in 1952 and supposedly gave the guy holding the electrified pokers a bear hug when it was over. Later in life, when he couldn't tame his alcoholism, he decided to try his hand at taming horses. He subsequently fell off many, receiving more and more bodily injuries each time. His last fall in 1962 precipitated his death, and he died shortly after of heart failure at age sixty-four, despite a forty-five-minute chest-pounding by the attending

physician. Alcoholism was not mentioned on his death certificate. Afterward, the *New York Times* ran an obituary the accuracy of which some might question: "Mr. Faulkner's writings showed an obsession with murder, rape, incest, suicide, greed and general depravity that did not exist anywhere but in the author's mind." Nevertheless, this five-foot-six high school dropout made an enduring mark on literature, bequeathing part of his Nobel Prize money to support the annual PEN/Faulkner Award given to new writers. Today, many wishing to get the blessing of Faulkner's ghost visit his gravesite to perform a traditional ritual in which a half-bottle of bourbon is poured on the ground, and the other half guzzled the way Faulkner perfected.

> *A writer is congenitally unable to tell the truth and that is why*
> *we call what he writes fiction.*
> —WILLIAM FAULKNER

F. SCOTT FITZGERALD

> *First you take a drink, then the drink*
> *takes a drink, then the drink takes you.*
> —F. SCOTT FITZGERALD

From an early age, Fitzgerald believed he was, in his words, "marked for glory." He tried to achieve this at first via football in Minnesota, then while attending Princeton. There he wrote humorous pieces for school publications, and earned a reputation as a ladies' man and a cut-up who drank until passing out. During a stint in the army he wrote about his Princeton days and reworked the manuscript numerous times until it was accepted for publication as the novel *This Side of Paradise*. He married Zelda Sayre, the daughter of a conservative Southern judge, likewise eccentric and bent on hell-raising. Together they made the headlines of gossip columns for their hotel room-wrecking antics and all-night parties. They proceeded to live lavishly but mostly on borrowed money for books Fitzgerald hadn't yet written. Almost from the beginning, the writer was perpetually digging out of debt.

In between hangovers, Fitzgerald barely managed to push out a hundred words a day, many for short stories, then a more lucrative product than novels. Although his third book, *The Great Gatsby*, which many consider his masterpiece, and some the greatest American novel, sold almost twenty-two thousand copies the first year of its release, by the late 1930s he made most of his income in Hollywood, writing script copy, having at that point been sober no more than a few days at a time since Princeton. He managed to stay dry for the last year or more of his

life, but it was too late to counter years of self-indulgence, as he succumbed to heart failure at age forty-four, in 1940. With many of his books out of print, he died believing he was a failed writer. Obituaries cited his botched chance at greatness, and his death was viewed by some as a fitting end for those who lived the excesses of the Jazz Age. By 1960, *The Great Gatsby* was selling fifty thousand copies a year, and is now required reading in nearly every high school in America. Generations are still captivated anew by Fitzgerald's masterpiece, drawn as the writer was to the green light beyond the green light Fitzgerald described at the end of the dock—the poignant symbol of optimism and the American Dream.

COST OF DRINK

During Prohibition, liquor consumption did decrease across the country, but mainly because the price of a drink was too high. A whiskey highball went from fifteen to seventy-five cents; at today's pricing, imagine if a bar drink sold at five dollars, then suddenly cost twenty-five. Speakeasies had to add to every drink the cost of protection money paid to both cops and gangsters to stay in business. All the action was at these joints, sending the Fitzgeralds further in debt.

In a real dark night of the soul, it is always three o'clock in the morning, day after day.
—F. Scott Fitzgerald

MOONSHINE MADNESS

Bootleg whiskey greatly increased incidence of dementia and caused four times as many deaths than during the decade preceding the Volstead Act that banned the sale of alcohol. Backwoods distillers in West Virginia and Kentucky were major suppliers for New York, where the Fitzgeralds partied. The mash was heated and treated

with carbide and sulfuric acid to speed fermentation. Today, those beverages, once sold as whiskey, would have a skull and crossbones on the label.

ZELDA

Zelda wanted to express her artistic side as much as her husband, and published a novel in 1932, but was accused by Scott of stealing his material; yet nearly all of his fictionalized

female characters had more than a touch of the real-life Zelda in them. Records indicate many things Zelda wrote in her journals were lifted verbatim into Scott's books. At their height of fame, Scott and Zelda sightings were as popular as if they were movie stars, and the pair was photographed hobnobbing with all the greats of the time. Hemingway in particular infuriated Zelda. She called him a phony and even accused him of being secretly gay, believing in fact that he was carrying on an affair with her husband. The quintessential flapper girl had her first nervous breakdown as soon as the Roaring Twenties were over and thereafter spent much of her time in and out of sanatoriums. She drank as Scott did for the decade preceding, and instead of being diagnosed as alcoholic with possible bipolar tendencies she was treated for the more serious disorder schizophrenia. Because of her fame, the leading doctors tried the newest techniques on her, including electroshock treatments administered in a variety of bizarre ways. She was even injected with various animal serums, including pure horse blood. As doctors tried more outlandish alternative treatments Zelda only got worse, though lucidly noted: "Why do we spend years using up our bodies to nurture our minds with experience, and find our minds turning then to our exhausted bodies for solace?" At age forty-seven, in 1948, she died in a fire at a mental hospital, along with eight other female patients. She was buried next to her husband; inscribed on the marble slab of their tomb is a line from The Great Gatsby: "So we beat on, boats against the current, borne back ceaselessly into the past." Millions play the video game The Legends of Zelda, though few know the game's creator Shigeru Miyamoto named it in her honor.

GUSTAVE FLAUBERT

*Genius does what it must,
and Talent does what it can.*
—OWEN MEREDITH

Gustave Flaubert was not born a genius. As a child, he was not singled out or noted for superior intelligence, and in fact struggled through most of school. However, from an early age he was determined to become a writer. He studied law as a matter of practicality. After a number of travels abroad Flaubert went back to his

home on the outskirts of Paris to reside with his mother and lived there for the remainder of his life. Flaubert labored at his writing, taking more than a week to finish a single page to his satisfaction, obsessed, as he became noted for, with perfection. Legend has it that he became bald because he constantly tugged on his hair as he sweated over finding the precise word he wanted. In his downtime, Flaubert found sex with prostitutes less time-consuming than marriage and became celebrated throughout Paris for his voracious sexual appetite. Subsequently, he acquired a venereal disease that in time compromised his health and mental lucidity. Flaubert took five years to chisel, word by word, the story of a doctor's wife, Emma Bovary, and her extramarital affairs. Once *Madame Bovary* was published, Flaubert was brought to trial for immorality, but the scandal only made the novel a bestseller and established his fame. His next book took seven years to write. It's no wonder that toward the end, especially after his mother died, Flaubert fell on difficult financial straits. He died in 1880 at age fifty-eight, officially of a stroke. Flaubert explored with such accuracy Madame Bovary's drug and sex addiction that it's certain he had insider knowledge, in addition to being accused of apparently being obsessed with fetishism, sadomasochism, and masturbation.

It's believed Flaubert returned to live with his mother after he suffered an epileptic attack in his twenties, and could never trust himself not to fall into another seizure in public. Epilepsy was the main reason he turned

I have nothing but immense, insatiable desires, frightful boredom and incessant yawns.

—GUSTAVE FLAUBERT

from a career in law, choosing the private, solitary life of writing instead. Flaubert became dependent on larger and larger quantities of bromine, believed in his day to be an effective anti-epileptic drug, in addition to remedies for syphilis. The bromine mixtures available at the time were corrosive to human tissue, especially blood vessels, and seem the medical reason why he died suddenly of a brain hemorrhage. Noted horror writer Guy de Maupassant was summoned and washed Flaubert's body, standing vigil over it for three days. (Some believe Maupassant might have been Flaubert's illegitimate son.) More than three hundred attended Flaubert's funeral, but the hole dug in the ground was not big enough to fit the coffin. A few literary heavyweights, such as Emile Zola, Edmond de Goncourt, and Alphonse Daudet were there, and many tried to cram the casket into its grave, but all finally left with Flaubert stuck in sideways and lopsided. It was said to be a good omen, surely meaning that even after death he would remain larger than life.

To be stupid, and selfish, and to have good health are the three requirements for happiness; though if stupidity is lacking, the others are useless.
—GUSTAVE FLAUBERT

EPILEPSY AND GENIUS

Epilepsy or "falling disease" was noted in medical records dating to the fifth century BC. Often stigmatized, epileptics were thought to be possessed by demons. Hippocrates discov-

ered its link to brain functions, and Aristotle even wrote a list of "great epileptics," which included Socrates. Nevertheless, for centuries epileptics treated their symptoms with various concoctions, though mostly with alcohol. When seizures became more frequent the sufferer was likely placed in an insane asylum. There are certainly mixed medical opinions about how the disease relates to genius, though some believe the abnormal brain activity an epileptic seizure produces in the temporal lobes can affect creativity and stimulate the desire to make art. Fyodor Dostoevsky reported seeing an aura of strange lights before an epileptic episode while writing Crime and Punishment. *Comedian* **Bud Abbott** *had epilepsy, and treated it mostly by drinking, dying of a stroke in 1974. Blues singer* **Jimmy Reed** *had seizures, though they were thought to be due to alcoholic delirium tremens, so Reed wasn't medicated, dying of a severe attack at fifty-one, in 1976.* **Margaux Hemingway**, *granddaughter of Ernest Hemingway, expressed her creativity through modeling and acting although she suffered from epilepsy. Her death in 1996 at forty-two was caused by an overdose of anticonvulsant medications.*

ERROL FLYNN

> *Neither a lofty degree of intelligence nor imagination nor both together go to the making of genius. Love, love, love, that is the soul of genius.*
> —WOLFGANG AMADEUS MOZART

Errol Flynn, the premier swashbuckling actor of the thirties and forties, had a reputation as a womanizer, and although he made sixty films was not once nominated for an award. His energy on camera made him a loveable hero to boys, and a sex symbol to women of all ages. Off screen, he was a likable guy no matter what he did, with the excitement of a twelve-year-old in a candy shop. His favorite treats were booze and women.

His father, a marine biologist, passed on the love of the sea and sailing. In fact, the younger Flynn was waxing his schooner when he was discovered by a director, and he was cast in his first film, without formal acting training, at age twenty-four. Flynn retreated often to his yacht and raised a flag with the initials FFF, meaning "Flynn's Flying F---ers." His Hollywood mansion was known for its erotic art, penis-shaped furniture, sex paraphernalia, and toys. The walls were decorated with murals of fish in Kama Sutra poses. As far as his addiction, alcohol seemed to be his choice, though he supposedly swabbed his member in cocaine to keep the colors at full mast longer.

When Flynn was indicted on charges of statutory rape of a minor, the young woman testified that Flynn "did it with his shoes on." The studio, ever

> *Women won't let me stay single and I won't let myself stay married.*
> —ERROL FLYNN

covering up his image, then cast Flynn in the movie *They Died with Their Boots On*. When Flynn died of a heart attack at age fifty in 1959, many believed he was on his yacht and succumbed during sex, when in fact he was on dry land with his trousers still zippered. Always in debt, Flynn had planned to go sailing on a real-life treasure hunt to earn money. On the way to the airport he complained of pains in his legs, and was taken to the apartment of a doctor friend, where an impromptu party broke out. Flynn excused himself for a short nap, promising to take the entire gang out to dinner, but he died shortly after on the floor in the doctor's bedroom. Flynn had planned on marrying a fifteen-year-old beauty and had just finished up a weeklong binge in prenuptial celebration. His death certificate cited liver degeneration and liver sclerosis as secondary causes. Nevertheless, Flynn's buddies put a half dozen whiskey bottles in his coffin just in case liquor stores were closed—wherever he ended up—on the other side.

> *I get the feeling that life is slipping by me—the time is passing and I am not living fully.*
> —ERROL FLYNN

SEX FACTS AND RUMORS
Extramarital sex is more dangerous for heart patients than encounters with their familiar partners. A study by the University Hospital of Johann Wolfgang Goethe that examined sex and longevity found

that more creative types died during or shortly after sex, and more than 50 percent did so while with a prostitute. Errol Flynn's hyperactivity placed him outside the norm, since the average age for this class of sexual fatality was 61.2. Creatively resilient politician **Nelson Rockefeller** tipped out at the other end of the scale, dying at seventy-one during intercourse with a twenty-six-year-old "aide." In 1899, French President **Félix Faure** (fifty-eight) died during oral sex with thirty-year-old mistress Meg Steinheil. (She was later arrested for killing her stepmother and husband, both found bound and gagged in her bedroom.) Under the "rumored" category, **President Franklin Roosevelt** died of a heart attack while having his portrait "painted" by a female, and **Catharine the Great** allegedly was crushed when a mechanical device that lifted a horse into position for intercourse collapsed, though in fact she died less adventurously, merely of a stroke while sitting on the toilet.

SIGMUND FREUD

When inspiration does not come to me, I go halfway to meet it.
—SIGMUND FREUD

The 1950s movie *Freud* portrayed Sigmund Freud, "The Father of Psychoanalysis," as a doctor obsessed with unraveling the unconscious workings of the human mind. The film didn't harp on Freud's other secret passion. Although the famous Austrian doctor is considered one of the most influential thinkers of the twentieth century, he also helped make cocaine a popular recreational drug. He experimented with pure extract and wrote papers praising it: "A few minutes after taking cocaine, one experiences a sudden exhilaration and a feeling of lightness, [providing] exhilaration and lasting euphoria." He prescribed it to his friend and fellow doctor **Ernest von Fleischl** as a safe substitute for morphine, to which Fleischl's was seriously addicted. Fleischl couldn't stop once he started and spent the equivalent of about ten grand on cocaine each month. Freud had second thoughts on its merit as a morphine replacement when he recorded Fleischl's cocaine psychosis and hallucinations that gave the sensation that "insects were crawling under the skin." Fleischl became the first person in history to die of a speedball, when he mixed heroin and cocaine, causing a heart attack at age forty-five, in 1891. Freud played with coke now and then, and seemed addicted during his cocaine phase, a three-year period from 1884 to 1887 when he published numerous papers on cocaine, though he stuck fervently to chain-smoking cigars. Even after part of his jaw was removed due to cancer, Freud continued to smoke. When he realized there

Ted Demme, director of the cocaine movie Blow, *died of a heart attack while shooting hoops at age thirty-eight in 2002. Cocaine was found in his blood during the autopsy.*

was no hope of beating his disease, he asked a doctor friend to give him high doses of morphine injections, and soon slipped into a fatal "sleep."

SPEEDBALL MADNESS

*The speedball seems a great idea for the addict, the reasoning being that a bit of heroin will suppress the anxiety caused by cocaine, while the excessive nodding heroin produces will get a kick and a pick-me-up with a touch of speed, just as Fleischl had hoped. However, it would require a pharmacological genius to get the mixture just right to avoid causing a heart attack. The CIA tried this combination of drugs to elicit confessions. In one arm they put an IV of amphetamines, and in the other an IV with barbiturates, and discovered varying shots of each got the uncooperative to blabber incoherently. A small sampling of famous speedballer deaths include: artist **Jean–Michel Basquiat** (twenty-seven), comedian **John Belushi** (thirty-three), comic **Mitchell Hedberg** (thirty-seven), and **Brent Mydland** (forty-four) of the Grateful Dead. According to the U.S. Office of National Drug Policy, creative use of these drugs accounts for fourteen out of eighteen heroin-related deaths.*

FEDERICO GARCÍA LORCA

So that he may drink
And in drinking, come to know himself
—FEDERICO GARCÍA LORCA

Born among rolling fields of asparagus and olive trees, Federico García Lorca did not do well in school, or on the farm, but he blossomed when his family moved to Granada, a small city in southern Spain. Its Moorish arches and domed rooftops cast odd and surreal shadows on its cobblestone streets and seemed to inspire his imagination. He published his first book of poetry when he was nineteen and was praised in the artistic circles of his town. He abandoned all else and became determined to create a lasting reputation in the arts. He attempted to gain a larger stage with the production of his play *The Butterfly's Evil Spell* at a prestigious theater in Madrid; however, his deeply felt portrayal of a cockroach in love with a butterfly was met with laughter and tomato-pelting, which forced the production to hurriedly close after only four performances. Aligning himself with the rising surrealist school and radical politics, Lorca persisted, writing several well-received books of poetry and a few more plays that fared better. Yet as his fame increased, so did depression and dark despondency. When his family heard of his rumored affairs with men, they took him for a yearlong vacation to New York City, hoping to "cure" him. There, Lorca was spotted drinking whiskey with poet Hart Crane and picking up sailors. Soon after, when civil war broke out in Spain, the fascist rebels Lorca opposed seized control his home city. Although he was momentarily out of harm's way in Madrid, with offers for safe haven waiting in France and even a ticket to travel to Mexico in his pocket, he hastily departed for Granada, saying he wished to attend his father's birthday party. His friends warned that traveling there was suicide. Lorca, who imagined himself a "gypsy poet," preferred to think it would be martyrdom. His friends proved correct, and Lorca was promptly arrested and killed by firing squad, at age thirty-eight in 1936. His body was dumped in a ditch and his work was banned. There have been many statues, paintings, books, and films made about his life, but despite extensive searches, his body has not been found.

I don't do drugs. I am drugs.
—SALVADOR DALÍ

JUDY GARLAND

To produce good [art] your intuition and your intellect
should be working together, making love.
—MADELEINE L'ENGLE

Judy Garland, famous for her song "Over the Rainbow," featured in the movie seen by more people than any other film ever made, *The Wizard of Oz*, remains a beloved icon to many. The appreciation of her brilliance was not marred by her public and painful downfall via pills and alcohol, mercifully ending in 1969 at age forty-seven. She was found dead in her bathroom from an overdose of barbiturates.

ROMAIN GARY

Ennui has made more gamblers than
avarice, more drunkards than thirst, and
perhaps as many suicides as despair.
—SIDDHARTHA GAUTAMA (THE
BUDDHA)

In 1980 at age sixty-six, Romain Gary, the one-time bestselling novelist and genuine World War II hero, shot himself in the head in his quiet Parisian apartment. He had been distraught over the recent death of his ex-wife, actress **Jean Seberg**, with whom he had a son and another child who had died soon after birth. Gary blamed Seberg's downfall on an FBI plot to defame her and discredit the actress because she had supported Black Panther militants and the Civil Rights movement in general. It was an effective name-smearing, and Gary's suspicions were revealed to be well-founded when a *New York Times* article, "FBI Admits Planting a Rumor to Discredit Jean Seberg," uncovered the details. Yet it caused Seberg's mental breakdown and death, at age forty-one, from an overdose of barbiturates and alcohol, even if questions about whether it was murder or suicide remain unanswered. Gary was extremely prolific, with more than thirty novels under his belt, and was the most popular French writer at the time. He had won prestigious awards both for books he wrote under his own name, as well as a pseudonym. Some suggest Gary killed himself due to ennui, and that the senseless death of Seberg made him weary of the ways of the world. He commented that a life dedicated to uplifting mankind through literature was, in the end, futile. On the other hand, it seems his obsession for writing had been completely quelled. He left no note, not a sentence, not a single word to explain.

*If Romain Gary's suicide was a sort of intellectual euthanasia, contemporary novelist and science writer **Arthur Koestler's** death by his own hand in 1983 was one that deliberately manifested his belief in a person's right to die. The seventy-seven-year-old writer, noted as one of the first to experiment with LSD, was sick from leukemia and Parkinson's disease, with scant hope of recovery. The troublesome part of his death scenario is that he allowed his wife, decades younger and not ill, to take the leap to the other side along with him: Her only disease, it seems, was a fatal case of codependency. In addition to authoring bestselling novels, Koestler wrote passionate essays espousing the benefits of euthanasia, arguing that pets when sick are put to sleep humanely, and even horses are shot in the head when they develop arthritis, yet humans must linger to the bitter end. He and his wife were found sitting dead in matching lounge chairs in their living room, OD'd on barbiturates. He did leave a note, instructing the poor maid he knew would find their corpses to call Scotland Yard.*

MARVIN GAYE

Genius starves while talent wears purple and fine linen.
—SOMERSET MAUGHAM

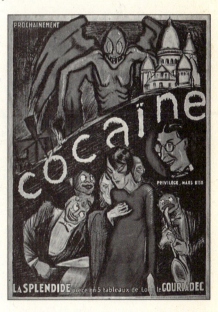

Marvin Gaye was one of those rare singer-songwriters who produced hits while reinventing his style, and selling more and more records while evolving musically. As an artist he was stubborn and butted heads frequently with producers, though in the end always got his way. His singles, with nearly twenty making the Top Ten, in addition to ten Top Ten albums, earned Gaye considerable money, though he would ultimately file for bankruptcy due to divorces, tax problems, and drug addiction. At one point, Gaye retreated to Hawaii and lived in a bread truck, but he rallied for a comeback and went on tour to promote his new album *Sexual Healing* with the huge title hit. Exhausted, Gaye sought reprieve from the public eye living at his parents' house. Gaye's cocaine addiction had set off the drug's typical paranoia, and one day he went after his father in a rage, accusing Marvin Gaye Sr. of misappropriating business accounts. In the ensuing argument, Gaye's father shot and killed the musician, one day before his forty-fifth birthday in 1984. The two had fought constantly their entire lives. Gaye criticized his father's lifestyle and accused him of hypocrisy—

the elder Gaye considered himself a preacher, lecturing on the evils of overindulgence; meanwhile, he drank heavily at home. Marvin Gaye Sr. got probation for the shooting when it was revealed he suffered from a brain tumor. He died in a nursing home at age eighty-four in 1998. When the musician of *What's Going On* fame was asked in an interview how much he spent on cocaine during his career he answered: "Enough to certify me as a fool. You'd have to call me a drug addict and a sex freak."

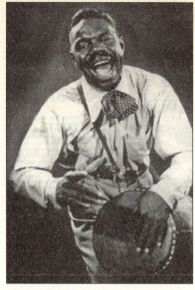

*An argument of another sort took the brilliant mambo percussionist **Chano Pozo**'s life. The thirty-three-year-old Cuban musician was buying pot while touring in New York City in 1948, and became very upset with the quality of the product. He slapped the drug dealer in the face for such an insult. The dealer promptly pulled out a gun and killed him.*

JOHN GILBERT

Effort only fully releases its reward after a person refuses to quit.
—Napoleon Hill

John Gilbert was one of the highest-paid romantic matinee idols of the silent film era, and had a genius for conveying, through exaggerated gestures and long, eye-fluttering glances, a strong and desirable masculine passion. Some things are better left unsaid, but when it came to this actor, it didn't matter the words; it was his voice that killed him. When audio was added to films, swooning girls sat on the edge of their seats to finally hear what the dashing and leading man of their dreams sounded like. A massive wave of audience-cringe and widespread reports of vomiting plagued theaters across the country when Gilbert appeared in the 1929 *Hollywood Revue*. For the first time, Gilbert was heard in a brief love scene, reciting lines to his lover swooning up on a balcony, though his high-pitched and nasal voice absolutely didn't match his image. Gilbert was, as far as audiences were concerned, finished as a leading man. Other Hollywood notables, such as Greta Garbo, remained loyal and insisted Gilbert be cast as her leading man. The studio gave him another shot, but by then Gilbert had

descended even deeper into drinking. He was dismissed by the studio from his last film, *The Captain Hates the Sea*, in which he played an alcoholic writer, for being too drunk on the set. Through his Hollywood years Gilbert attracted any number of women who might have saved him from himself. His last famous enabler was the married Marlene Dietrich, who secretly dated the rundown, once legendary film star with the hope of nursing him back to greatness. He was supposedly in bed with Dietrich when his years of drinking finally caused a fatal heart attack. He clutched his chest, gestured to speak, and died silently in 1936, at age forty-six.

ULYSSES GRANT

My failures have been errors in judgment,
not of intent.
—ULYSSES GRANT

In the 1850s, Ulysses Grant resigned from the army while serving in California, in part due to his reputation as a heavy drinker. He tried farming, but rising at dawn with tremendous hangovers was difficult. Then he tried selling ice, and finally worked as a clerk at his father's saddle shop in Illinois. His brothers and father considered him a weak-willed good-for-nothing, and Grant seemed destined to become the town drunk or to die as his grandfather did, ruined by booze. When the Civil War broke out Grant reenlisted, and before long, his bourbon-fueled bravery, God-given military genius, and a little luck helped him rack up a string of victories. Because of this reputation, he was eventually named commander of the Union Army, and ultimately defeated Robert E. Lee. He supposedly took a pledge of abstinence after being elected President, though he substituted drinking with a habit of chain-smoking cigars (and a few belts of Old Crow when no one was looking), leading to his death from throat cancer at sixty-three, in 1885.

ROBERT GREENE

Oft times many things fall out between the cup and the lip.
—ROBERT GREENE

Robert Greene, an English playwright, poet, and pamphleteer, was wildly popular at the end of the sixteenth century. Today, he is remembered for his superb ingenuity and wit, and is often held up as the ultimate party guy of the Elizabethan era. Greene not only wrote a string of popular plays and romances, but pamphlets on how *not* to be like him, which were bestsellers. What is known about his wild life is that once he graduated from Cambridge, he made the party rounds at the hipper castles throughout Spain and Italy, unlacing the

tightest of corsets and jimmying the locks of numerous chastity belts. When he returned to England short of cash, he quickly married a woman with a sizable dowry, ran through that, then left her and a child to fend for themselves. Afterward, he preferred to remain seldom sober though he managed a tremendous output of work, such that he was one of the first writers who actually made a living at it without a patron. He cultivated his bad-boy image just as furiously as he wrote and if alive today would be certain to have his picture with his flaming-red pointed goatee on the cover of any number of supermarket tabloids. Nevertheless, he paid his final tab at age thirty-four, dying from complications of alcoholism in 1592 after a "wassailing banquet of Rhenish wine and pickled herring." For some reason Greene rented a room from a shoemaker, where he could die in peace, and once he passed, the shoemaker's wife sewed a garland out of bay leaves and placed it on his head.

HERE WE COME A-WASSAILING

In Greene's time, to "wassail" was an old Anglo-Saxon word defined as "a drinking toast offered to good health." Men told their wives they were out wassailing and headed into the orchards to get wasted on hard cider, shaking the branches and encouraging the trees to bear more fruit. Instead of begging for a drink, if someone knocked on your door and sang a song, it became custom to give a drink for the effort. The practice developed into Christmas caroling and revelers were served a powerful punch consisting of sherry, wine, nutmeg, cloves, pepper, and sugar. There's no wonder Queen Elizabeth and all of England were concerned about trouble with Spain during the period, since their favorite sherry came from the Canary Islands.

D. W. GRIFFITH

I am careful in my selections, and, although I am apt to make a mistake now and again, as everyone is, I am seldom disappointed.
—D. W. GRIFFITH

Anyone who studies film will eventually watch a flickering rendition of D. W. Griffith's 1915 creation *The Birth of a Nation* and learn that it was this American director who first used the close-up, the wide pan shot, fading techniques, and other procedural staples of cinema. This former Kentucky grocery clerk became one of the most influential men in Hollywood during its formative years and was one of the three original founders of United Artists Studio. But when silent movies were replaced with talkies he quickly became yesterday's news. He tried to adapt, but was debt-ridden, nearly penniless, and alcoholic by 1935, when he received an Academy Award for distinguished and creative achievements. In his later years he was seen stumbling along the sidewalks of Hollywood with cane and old-fashioned bowler hat, pulling reluctant tourists aside to tell of his great achievements. To most, he appeared a delusional old coot and was given a wide berth. In 1948, his years of drinking caused a blood vessel to burst in his brain. He was living in a once grand Hollywood hotel, then in disrepair, with peeling paint and stained carpets. He managed to make it down to the lobby and rang the bell for service. He was met with a raised eyebrow and staggered away for his final death scene. There in the lobby he faded out into a fatal coma, sprawled below the grease-coated prisms of a grimy chandelier.

THE POWER OF FILM

D. W. Griffith was considered a genius for his experimentation with capturing spatial differential and cross-cutting techniques that were needed to add suspense in film, but his messages were often less than inspired. When modern viewers watch The Birth of a Nation's *portrayal of the Ku Klux Klan as heroes of the Civil War Reconstruction Period, and its degrading characterization of blacks, the images are much too painful to swallow. Nevertheless, the film was the biggest box office draw of the era, hailed as the greatest picture of all time. In reality, Griffith and his film probably did more to incite racism than any other cinematic work in history. When the NAACP boycotted the film, Griffith was stunned. He asserted that he wasn't a racist and had even hired a few black actors in the film, though most were white actors wearing blackface. Griffith believed until the day he died that he was a great humanitarian. While the film made millions, lynching across the country increased tenfold. Records indicate that for one hundred years starting in 1865 a minimum of 4,730 black people were executed by hanging, without trial, at the hands of a mob. In 1999, the Screen Directors' Guild whited out Griffith's name, removing it from its annual lifetime achievement award.*

JEAN HARLOW

When you lie down with dogs, you get up with fleas.
—JEAN HARLOW

Film legend Jean Harlow was known as "The Blonde Bombshell," and became an internationally renowned sex symbol for a generation. She rose from the ranks of movie extras on silent films to major star status when talkies arrived—all by the age of nineteen. Popular opinion cancelled the frequent negative reviews of Harlow's acting, and nearly every picture she appeared in raked in huge ticket sales. Her signature laugh as a way to turn

down flirtatious come-ons; it had men going crazy and women imitating Harlow's style, heralding an entire era of sexy, noirish dames (not to mention the thousands of women who went bald trying to dye their hair to match Harlow's platinum blonde). In her last years attempts were made to change the floozy image to one of more substance, though Harlow still preferred gaudy jewelry and see-through dinner dresses, flowing champagne, and any number of drugs. Her death, from kidney failure, in 1937 at age twenty-six, stemmed, say the guardians of her image, from a case of childhood scarlet fever, denying that Harlow's fatal renal poisoning was brought on by a batch of bad dope. As the oddest tribute of sorts, even after she was dead, Harlow remained one of the most popular pinup girls into the 1940s.

THOMAS HEGGEN

It just came to me all of a sudden. I was lying on my bunk this morning, thinking. And there wasn't a breath of air. And all of a sudden, a funny thing happened. A little breeze came up, and I took a big, deep breath, and I said to myself, Pulver, boy, there's women on that island!
—FROM *MISTER ROBERTS*

Thomas Heggen wrote the wildly popular post–World War II novel *Mister Roberts*. In the few short years after its 1946 publication nearly a million copies had been sold, and a play

based on the book, starring Henry Fonda, was a smash hit on Broadway, with movie rights already sold to Hollywood. Heggen had served five years in heavy combat, surviving battles in Iwo Jima, Guam, and Okinawa, to name a few, and like many war veterans, tried to make sense of the onslaught he survived by injecting a touch of light-hearted humor into his experiences. Heggen's Mister Roberts was the perfect hero for a healing nation, a likeable character who stuck up for sailors under the command of an overblown and petty captain. However, the book and the success it earned were sadly not sufficiently cathartic for the author. In 1949, at age thirty, Heggen took his own life.

Surviving friends struggled to understand what it was exactly that drove Heggen over the edge, and as it is with many suicides made excuses for his death. Heggen's writer friend Allan Campbell was sharing a room in Heggen's East Sixty-second Street apartment in Manhattan at the time of his death, and reasoned that the successful novelist must have taken a few extra sleeping pills and accidentally drowned in the bathtub. In fact, Heggen had gobbled down handful after handful of a powerful barbiturate, with only six of the fifty recently prescribed pills remaining in a vial on the vanity countertop. There was no explaining away a razor blade that was found in the bathwater under Heggen's body. Heggen had told friends that he was happily at work on another book, but it seemed he suffered from fatal writer's block. No other manuscript was ever found.

COMES IN PAIRS

When Henry Fonda, starring as Mister Roberts on Broadway, heard of the writer's death, he was deeply upset and wondered how the man who created his favorite lead role could come to such an end. As soon as the shock faded, Fonda had to deal with another suicide, this time of his wife. **Frances Seymour Fonda** *slit her throat with a razor. Both deaths occurred while he played Mister Roberts on stage, yet the actor never missed one of the 1,077 performances of the show. He told his then thirteen-year-old daughter Jane that a heart attack had killed her mother. She only learned of the truth from a movie tabloid.*

ERNEST HEMINGWAY

An intelligent man is sometimes forced to be drunk to spend time with fools.
—FROM *FOR WHOM THE BELL TOLLS*

Five of the seven American Nobel Laureates in literature were alcoholic, Ernest Hemingway—considered one of the most influential writers of the twentieth century—notably being among them. There are only a few writers who ascended from the pages of their books as Hemingway did to

become a legend for how he lived, replete with adventure, a cast of women, and an endless supply of bottles filled with the strongest stuff. He judged others as he judged himself, by a masculine code of self-reliance. From the days of his youth he tried to live up to his father's motto: "Be afraid of nothing." He frowned on whimperers and whiners and bullied them when he found them, in the bars, on the streets, on the battlefield, and he directed harsh criticisms at the work of fellow writers at every chance. He feared death, what he called the *Nada*, "the nothing," that awaited at the other side of life, yet time and again placed himself at the frontline of war, on deep sea excursions, or on expeditions through Africa.

Toward the end of his years alcohol had taken a tremendous toll and ultimately stole his greatest passion, his ability to write a clean, perfect sentence. Asked to write a dedication in a book to be given to President Kennedy, he took more than a week to compose only a few sentences. *Hemingway thought often of his father's suicide by gunshot, in 1928. According to one medical hypothesis, Hemingway and his family may have suffered from hemochromatosis, a pancreatic disorder that causes depression and leads to suicide.* When he saw his face on the cover of *Life* magazine, he turned away in disgust, and called his own image a "horrible face." Whiskey had stopped dispelling the secret self-loathing that had plagued Hemingway from his earliest days.

Hemingway's deterioration of mind and body was standard fare for chronic alcoholics at the end-stage of the disease, and his bouts of both paranoia and depression were actual side effects. Electroshock treatments were given months before his death in an unsuccessful attempt to reverse a lifelong history of self-medication with booze. Interestingly, he tried to kill himself a number of times before he succeeded, presumably in the only true fleeting moments of clarity he possessed. Twice guns had to be snatched from his hands, and once, while en route between hospitals, he tried to walk into the turning blades of an airplane propeller. In 1962, a few weeks shy of his sixty-second birthday, he found keys to a gun case in his home in Ketchum, Idaho, apparently hidden not all that well from a man with such a persistent suicide wish, and retrieved a double-barrel shotgun. He put the butt of the gun on the floor, leaned forward to rest his forehead against both barrels, and pulled the trigger. The family felt no autopsy was needed.

BROTHER AND SON
Leicester Hemingway, Ernest's younger brother by sixteen years, idealized his famous sibling, likewise writing six books and seeking adventure. Duke, as Ernest called Leicester, killed himself with a gunshot to the head at sixty-seven, in 1982. Ernest's son **Gregory**

Hemingway, a one-time medical doctor wrote a memoir about his father, calling him an "ailing alcoholic" and ridiculed The Old Man and the Sea *as "'sentimental slop." It's no wonder Hemingway portrayed Gregory in the posthumous novel* Islands in the Stream *as the "mean one." Gregory was likewise plagued with alcoholism, though also addicted to fetishistic transvestitism. He ultimately had breast implants and a sex change operation. When arrested for walking naked down the main street in Key Biscayne, Florida, in high heels with a hospital gown in hand, he was booked into the women's detention center. In his book,* Papa: A Personal Memoir, *he pondered:"What is it about a loving, dominating, basically well-intentioned father that makes you end up going nuts?" Gregory was found dead in his jail cell at age sixty-nine, in 2001.*

JIMI HENDRIX

> *Kings are not born: they are made by universal hallucination.*
> —GEORGE BERNARD SHAW

James Hendrix, legendary rock guitarist of "Foxy Lady" and "Purple Haze" fame, died choking on his own vomit after an accidental overdose of barbiturates at the age of twenty-seven, in 1970. Jimi's real drug of choice was LSD. Although he denied its use in the press to avoid prosecution, he snorted acid or took it in tablet form whenever he could. As a result, the psychedelic music he played seemed to come naturally, as did his ability to play the electric guitar behind his back, or with his teeth. He played one of the most politically understated, yet melancholic renditions of the "Star-Spangled Banner" ever heard, at the close of the 1969 Woodstock Festival, during an acid trip.

HENRY VIII

> *The greatest monarch on the proudest throne is obliged to sit upon his own arse.*
> —BENJAMIN FRANKLIN

Henry VIII, besides his other noble and notable doings, might hold reign as England's greatest alcoholic king. At eighteen, Henry was anything but the overweight, gluttonous monarch most recall and instead was exceptionally fit, standing more than six feet tall, athletic, and smart—fluent in Spanish, French, and Latin. When his older brother suddenly died, he found himself poised for power, even though he had to marry his dead brother's wife as part of the bargain. From the beginning, Henry was out to prove himself worthy of the job, but also from a young age was obsessive-compulsive, hooked on gambling, eating, fornicating, and drinking to excess. Being an alcoholic and an absolute monarch was a good combination for Henry: He always got what he wanted, when he wanted it,

no matter how whimsical his demands or passions. When the Pope refused to annul the marriage with his inherited bride, Henry's seemingly rash decision to break from the Catholic Church initiated the formation of a new church and the entire Protestant Reformation. In his tenure Henry racked up six wives; he beheaded two, one died, two he divorced, and only one survived. Before Henry VIII ended his reign, he almost literally rolled into court, with a round, fifty-four-inch belly, perched on two stick legs. Assembled courtesans cowered to see what each day's erratic mood would bring: If Henry laughed there was a pause to discern if it was mocking or sincere before those gathered either chuckled or frowned. Those invited to dinner with Henry sat in awe as the king spent three hours consuming sixteen courses (ten thousand to twenty thousand calories), from muttons, wines, breads, and puddings. His favorite food was said to be a turkey leg, and in between each greasy bite he was famous for telling a raunchy joke that made the ladies blush. As rotund as he was Henry still fancied himself an athlete. Once he had himself perched on a horse to partake in a little jousting when the bow-backed beast rolled over on him. A wound to his leg festered, and he officially died of carbuncles in 1547, at age fifty-five. Medical experts say his death was probably the result of complications of alcoholism and obesity, and it seems he suffered from both syphilis and diabetes as well. Type II diabetes would be the cause of death listed on his royal death certificate if he had died today. Erasmus, a Dutch philosopher and contemporary, called Henry VIII a "universal genius." During Henry VIII's reign, England prospered as never before and was well on its way to being a world superpower under his daughter, Queen Elizabeth I.

SELF-DESTRUCTING KINGS AND QUEENS

Official cause cited and year of death:

- William the Conqueror: "enormous fat, drink, and the violence of his passions" —1087
- Henry I: "surfeit" (Overindulgence of lampreys) —1135
- Henry IV: "fits of uneasiness" —1314
- Edward III: "dotage" (Excessive fondness)—1377
- Edward VI: "arsenic" (medicine for syphilis)—1553
- James I: "gout" (excessive eating and drinking) —1625
- George II: "excessive pushing" (while on toilet) —1760

O. HENRY

As a rule, adversity reveals genius and prosperity hides it.
—HORACE

A candy bar bearing the name Oh Henry!, a stogie-size chocolate bar filled with nuts, is an appropriate homage to writer William Sydney Porter, made famous using the pen name O. Henry. A sweet guy on the outside, Will (as he called himself) nevertheless had his share of mixed hardships and a few nuggets of mental quirks that led to his downfall just as his literary star had finally risen.

To help make a better life for his new bride and child, Porter took a position as a banker, though when the institution came under investigation for fraud, he was fingered as the fall guy. It looked like he might beat the rap, but Will foolishly bolted to Central America the day before the trial was to begin. After spending a year in Honduras trying to write (where he coined the phrase "Banana Republic" to describe the despotically racked, hastily formed government, not a clothing store), he sent for his wife to join him. When he discovered she was too sick from tuberculosis to travel, he returned to the states to be at her side, turning himself in to the police shortly after arrival. His wife died just as the trial began and he was grateful she wouldn't have to endure his being sentenced to five years in a federal prison. Porter had previously displayed a talent for writing, finding space in Texas newspapers for his humorous and satirical columns, but it was incarceration that made him turn exclusively to the short story format for which he is famous. With the intention of earning money to send to his child, he crafted inventive, twist-ending stories that were immediately popular. Will knew he had to conceal his

Novel Device for Stopping a Runaway Horse.
Designed by Ed. Richenbach, Orrville, Ohio.

PERPETUAL MOTION

O. Henry's father gave up on his obsession with creating a system to stop runaway horses when he took on a new obsession: inventing a perpetual motion machine. This device, once set in motion would never stop, generating its own energy. However, laws of physics deem it impossible. Leonardo da Vinci had made sketches for perpetual motion devices, as did hundreds of other thinkers from the Middle Ages on. Sadly, like many others throughout history who were captured by this improbable concept, the senior Porter abandoned the project. He turned into an alcoholic and left the education of his son to a doting aunt.

imprisonment from both publishers and the public, so devised a pen name using a numerical variation of his prisoner number, coming up with O. Henry. He mailed the stories off to a family relation who placed them in magazines. When paroled after three years, O. Henry went to New York City to be close to his publishers, and fell in with the bohemian crowd, becoming a regular at all the hipper taverns and pubs.

At one point Porter was churning out a story a week for the *New York World Sunday Magazine*, as well as for many national periodicals. He became a celebrity, with people waiting for his next original tale that not only captured the realism of ordinary life in America during the turn of the twentieth century, but often explored basic human instincts. Under the perpetual pressure of creating story after story, not trapped in a workshop like his father, but in a room at the Caledonia Hotel, he resorted to an ever-increasing intake of whiskey to lubricate his creativity. In the end, the writer who made a reputation of meeting every deadline fell behind, subsisting on advances from publishers for stories he was unable to finish. In 1910, at the height of his fame, he took a cab to Polyclinic Hospital, at 137th Street and Second Avenue in Manhattan, signed in not

Bohemia is nothing more than the little country in which you do not live. If you try to obtain citizenship in it, at once the court and retinue pack the royal archives and treasure and move away beyond the hills.
—O. Henry

as O. Henry but under his real name, and died the next day of an enlarged heart and cirrhosis of the liver, at age forty-seven. It was discovered he had less than a twenty-five cents to his name. A dozen empty bottles of gin were found under his hotel room bed. The box of loot some believed he had hid from his banking days was never found. Makers of the candy bar have since said their confection was not named after the writer, not wanting to be associated with O. Henry's sad alcoholic ending. Although father and son died the same fate, O. Henry did invent another form of perpetual motion device, since many of his memorable stories have never been out of print and are still admired today. The prestigious O. Henry Prize is awarded annually to writers of short stories.

Write what you like; there is no other rule.
—O. Henry

ROBERT E. HOWARD

*What is genius? It is the power to be a boy
again at will.*
—J. M. BARRIE

Robert E. Howard created Conan
the Barbarian, originally conceived
as Conan the Cimmerian, and was
among the most popular writers of
the sword and sorcery variety of fic-
tion. In addition, he is considered an
icon to admirers of horror, sci-fi, and
fantasy books and movies for his pio-
neering contributions to the genres. As
a sickly kid who was kept indoors, he
took up bodybuilding with a passion in
adolescence and grew to be a six-foot-tall, two-hundred-pound hulk. When his
mother became seriously ill, Howard remained obsessively loyal and stayed close
to home to care for her. The depth of his obsession was revealed when, in 1936,
his mother's illness confined her to the hospital. Naturally, he kept vigil at his
mother's side for days, until she was pronounced dead. However, a moment later
the thirty-year-old writer walked out to his car in the hospital's parking lot, took a
.38 revolver from his glove compartment, and shot himself in the head. Together
they were mourned at a joint funeral, their caskets side by side.

*Civilized men are more discourteous than savages because they know they can be impo-
lite without having their skulls split.*
—E. HOWARD HUNT

NO DAY JOB
*The world is indeed comic, but the joke is
on mankind.*
—H. P. LOVECRAFT

H. P. Lovecraft *is considered the father of
twentieth-century horror writing, specializ-
ing in alien entities invading human bodies,
science out of control, and truly bizarre
creatures and mythic gods effecting human-
ity's predetermined fate. Horror master
Stephen King had this praise: "H. P. Love-
craft has yet to be surpassed as the twentieth
century's greatest practitioner of the classic
horror tale," and the likeness of Lovecraft is*

on the statuette presented to recipients of the annual World Fantasy Award. Lovecraft had correspondence with Robert E. Howard (who, like Lovecraft, had work published by Weird Tales), and became depressed and affected by Howard's suicide, dying a year later. Lovecraft was a child prodigy and could recite poetry at two and write verse by six, though as a sickly boy, like Howard, he was kept at home by his overprotective mother, never receiving a formal high school diploma. He lived as a hermit with her in dire poverty, after a mismanaged inheritance drastically reduced their social standing. Lovecraft wrote academic poems until he found acceptance—and payment, although meager—with speculative short stories published in pulp magazines. After his mother died, he married briefly, but poverty and misfortune plagued him until he succumbed to the real body-invading entity of the twentieth century—cancer. As a writer, he was hardly known outside his small circle, and at times barely earned enough to buy food, though he retained the aura of the gentleman he believed himself to be. He had a library of fifteen hundred books, and often would purchase another volume to add to his collection before buying food. Only in his last years, when he was taken in by a pair of older aunts in Providence, Rhode Island, did Lovecraft feel he finally came home. His stomach cancer might have stemmed from his not eating, since his secondary cause of death, at forty-six in 1937, was listed as malnutrition, though lack of appetite is often a side effect of the disease. What caused it, none knew, but it churned in his insides and forced him to live hand to mouth—with such indignity—for all his writing years.

ALDOUS HUXLEY

The sway of alcohol over mankind is unquestionably due to its power to stimulate the mystical faculties in human nature.
—WILLIAM JAMES, quoted in Aldous Huxley's
"Drugs That Shape Men's Minds"

When Aldous Huxley's cancer became terminal at age sixty-nine in 1963 he was staying with friends, after his own home had burned in a mysterious fire. He communicated in a note for his wife to administer an injection containing a lethal dosage of LSD, which she did. A drug not known to ease one off into death, like morphine and other narcotics, and instead, for most, would make pain and anxiety more pronounced, Huxley, however, sought to use his own death as an opportunity for learning. Perhaps this makes his choice of LSD as his final bullet a fitting testament to his insatiably curious mind. Huxley, considered one of the most luminous writers and thinkers of the twentieth century, known for his enduring novel *The Brave New World*, was praised by the *New York Times* as a "brilliant prober into the human commonplace and the esoteric." His essay collection, *Doors of Perceptions*, which inspired Jim Morrison to name his band the Doors, and a book about a convent possession, *The Devils of Loudun*, especially display the wide range of Huxley's interests and his ability to offer an original point of view. Huxley came from a family of prestigious minds: His grandfather Thomas Henry Huxley was credited as popularizing theories of evolution, and his great uncle was famed poet Mathew Arnold. Since the early fifties Huxley pronounced LSD and many other drugs as a way to expand consciousness, and noted, "more people have died for their drink

and their dope than have died for their religion or their country." Huxley had a keen interest in seeking other levels of consciousness and used drugs regularly to get quick vignettes of what he called "another truth."

> *Who lives longer: the man who takes heroin for two years and dies, or the man who lives on roast beef, water, and potatoes till ninety-five? One passes his twenty-four months in eternity. All the years of the beef-eater are lived only in time.*
> —ALDOUS HUXLEY

WILLIAM INGE

*Death makes us all innocent and weaves all our
private hurts and griefs and wrongs into the fabric
of time, and makes them a part of eternity.*
—WILLIAM INGE

In 1973, sixty-year-old Pulitzer-winning play-
wright and Oscar-winning screenwriter Wil-
liam Inge chose to die in his Mercedes Benz. Raised in a small Midwest
town, Inge laid claim to the distant lineage of John Wilkes Booth, the actor
turned assassin infamous for killing Abraham Lincoln. Inge believed acting
was in his blood and he worked hard to learn about the theater. After years
of living "on peanut butter and jelly sandwiches," he gave up performing and
took a job as a theater critic for the *St. Louis Star-Times*, while secretly trying
to write his own plays. His first play was produced with the endorsement of
Tennessee Williams after Inge gave a thoughtful review of Williams's *The
Glass Menagerie*. When he was thirty-six, in 1950, Inge's second play, *Come
Back, Little Sheba*, made it to Broadway and became a smash hit, running for
more than 190 performances. Inge made hit after hit, becoming one of the
luminaries on the Great White Way. However, the favor of Broadway was
hard to retain. After he won the Pulitzer Prize for *Picnic*, in 1953, reviewers
savaged his next three productions; Inge was stung by the lack of applause
he had once taken for granted. By then his personal life was plagued by al-
coholism. He also felt a deep shame about his homosexuality. He decided to
head to Hollywood, where he wrote the screenplay for *Splendor in the Grass*,
which earned Inge an Academy Award. Afterward, he published three novels
and one last theatrical attempt (which made it only to Off-Off-Broadway);
all were panned and dismissed. Inge believed his talent as a writer was gone
forever, leading him to sit at the steering wheel of his brand new car one
early June morning, waiting until the idling engine inside his garage pro-
duced enough carbon monoxide to kill him.

THAT NEW CAR SMELL

*Americans have always loved their auto-
mobiles, which seemed a natural choice to
accompany self-destruction, for those so
inclined, from the start. From 1920 through
1977, more than 90 percent of all persons
who committed suicide in a car via carbon
monoxide poisoning did so in a model that
was less than two years old, and usually in*
an upscale brand, as Inge had chosen. Then, regardless of the make, auto exhaust contained
25 percent carbon monoxide, while since the early 1970s, when catalytic converters became
standard, 99 percent of the killer gas has been removed.

IVAN THE TERRIBLE

Madness is to think of too many things in succession too fast, or of one thing too exclusively.
—Voltaire

Rulers struggle with creative ways to appease populations and remain in power. Ivan IV, the first official tsar of Russia, tested out a few different methods until he hit on the style that established his well-earned moniker. Ivan inherited the throne at age three and was paraded around quite regally in public, though he was back-handed and beaten in private by his handlers. When he assumed the throne at age sixteen, Ivan called on the advice of a council to rule and established a new code of law throughout the land, dividing power among a system of nobles and giving much authority to the Orthodox Catholic Church. When it seemed his powerbase was in constant erosion after these so-called wise and benevolent acts, he put on the brakes and reversed course to become one of the cruelest monarchs in history. Around the same time, eyewitnesses said Ivan drank to "insensibility," and blacked out in mid-sentence, only to rouse demanding why his commands were not carried out. His inattentiveness to affairs found his country devastated by invading Poles, and famines caused thousands to perish of starvation on the streets of Moscow every day. As Ivan grew physically ill from drinking, and equally paranoid, he employed a notoriously brutal street gang to murder nobles he felt were in a plot against him. He then went from assassinating individuals to ordering entire cities destroyed because they were deemed poised to betray him. At the city of Novgorod, he sent an army to construct a barricade. Each day he had a thousand men, women, and children brought before him to be tortured and killed. He sat in a portable throne for the show while his vodka glass was continually refilled. He had not forgotten his devotion to the Church, however, and always said a small prayer before each execution. He seemed to find joy and a release for his creative energies in devising new methods to kill. A favorite was plopping a victim in ice-cold water, then boiling water, and back and forth until the skin came off "like an eel's" as he applauded. Other times he merely roasted victims, or sliced and diced them from the toes up, or once, when he was getting bored, he had eighty widows lashed together and drowned in the river, as Ivan noted, like one great ball of screaming yarn. Family life among the Ivans was no picnic either. Most of his seven wives died gruesomely, and again he took pride in never repeating himself: If one was dragged by galloping horse to the river and drowned, he murdered the entire family of the next before sending her off to a convent. When he beat his pregnant daughter-in-law for wearing two petticoats instead of three, his son, also named Ivan, confronted The Terrible. The old man, coming off a wine-bender, whacked the next heir on the head with his heavy staff, killing his son on the spot. When Ivan realized he had murdered not only the next ruler but also his drinking buddy and right-hand man in debauchery and blood, The Terrible's creative juices seemed to dry up. Ivan the Terrible died of mercury poisoning in 1584, at the age of fifty-three.

He had been taking the medication for syphilis, but was given an overdose by his personal aide after Ivan tried to rape the aide's sister. The writings Ivan left behind had future Russian historians calling the first tsar a "pamphleteer of genius," and suggest that the English word for terrible actually means "formidable" in Russian.

RAY MILLAND

JANE WYMAN

"THE LOST WEEKEND"

From the Novel by CHARLES JACKSON

... PHILLIP TERRY · HOWARD da SILVA · DORIS DOWLING · FRANK FAYLEN

Produced by CHARLES BRACKETT · Directed by BILLY WILDER · Screen Play by Charles Brackett and Billy Wilder · A PARAMOUNT PICTURE

CHARLES R. JACKSON

Constant effort and frequent mistakes are the stepping-stones of genius.
—ELBERT HUBBARD

Charles R. Jackson is known for the popular novel *The Lost Weekend*, which the *New York Times* heralded as "the most compelling gift to the literature of addiction," and its classic film adaptation. Though it's not found in the travel section of bookstores, it perhaps could be categorized as a travel book of another kind—a truly horrific and accurate view of the sordid world the alcoholic visits on a bender.

Jackson attended college briefly, dropping out to work in a bookstore. When he contracted tuberculosis, he sought a cure in the clean air of Switzerland, in addition to falling to the seduction of Europe's café life of overindulgence while abroad. He returned two years later to New York City, determined to be a writer. Though by the age of twenty-five, he was a confirmed alcoholic-addict. His

It shrinks my liver, doesn't it, Nat? It pickles my kidneys, yeah. But what it does to the mind? It tosses the sandbags overboard so the balloon can soar. Suddenly I'm above the ordinary. I'm competent. I'm walking a tightrope over Niagara Falls. I'm one of the great ones. I'm Michelangelo, molding the beard of Moses. I'm Van Gogh painting pure sunlight.
—FROM *THE LOST WEEKEND*

was not an easy indoctrination into his chosen field. He wrote three novels and submitted numerous stories, which all met with rejection before he found his lucky break with *The Lost Weekend* in 1944, when he was forty-two years old and married with kids. Based on his own bingeing habits, the book was the first mainstream novel to draw attention to the concept that many alcoholics were not merely weak and undisciplined, but displayed symptoms of a disease.

It appears Jackson was sober for a considerable time. In 1959, he gave a speech (now available on an audio file) at an Alcoholics Anonymous convention, telling his story of dual addiction to alcohol and drugs, namely paraldehyde and barbiturates. The advice his main character followed in *The Lost Weekend*, to get rid of the demons by writing them down, in the end, did not work for the author. Even though Jackson knew it was the first drink, or drug, and not the last that killed the alcoholic, an old fear surfaced once again. In 1968, at age sixty-five, he died of an overdose of barbiturates, discovering the devil he had tried to quell was only dormant. His publicists and literary agents refuted the New York City medical examiner's claim that the author committed suicide and believed the large quantity of drugs found in the writer's body was accidental.

STATISTICS ON ALCOHOLIC RECOVERY ARE NOT GOOD, WITH LESS THAN 9 PERCENT STAYING SOBER FOR MORE THAN FIVE YEARS. ACCORDING TO THE NATIONAL EPIDEMIOLOGIC SURVEY ON ALCOHOL AND RELATED CONDITIONS, SEVENTEEN MILLION AMERICANS ABUSE ALCOHOL, AND ALCOHOL IS A KEY FACTOR IN 68 PERCENT OF MANSLAUGHTERS. ALCOHOLISM IS A FACTOR IN 30 PERCENT OF ALL SUCCESSFUL SUICIDES.

RANDALL JARRELL

One of the most obvious facts about grownups to a child is that they have forgotten what it is like to be a child.
—RANDALL JARRELL

attentie... spelende kinderen

Former U.S. poet laureate Randall Jarrell's World War II experiences stamped his imagery and poetic phrasing with a recurring theme that most of man's suffering was self-created from stupidity. He referred to war, of course, but in 1965, at age fifty-one, Jarrell chose to leap into oncoming traffic as a way to kill himself. Only a few months before, Jarrell had tried to slit his wrists, and that only ended with a stint in a psychiatric ward and appointments with a physical therapist to return movement to his hands. He was diagnosed with manic depression. During his distinguished career, in addition to serving as poet laureate, Jarrell was a critic for *The Nation* and his collection *The Woman at the Washington Zoo* won the 1960 National Book Award.

ALFRED JARRY

Alfred Jarry was a legendary figure in the turn-of-the-century Paris art scene, credited as the pioneering genius behind the establishment of absurdist literature and abstract painting. At a young age he was singled out for his brilliance, although he made a more lasting impression as a witty and often cruel prankster during his school years. Once he arrived in Paris, Jarry's distorted charm, with its characteristic twist of the sinister, was seen as eccentric and liberating to many artists and writers. In 1896, when Jarry was twenty-three, he created a stir with the opening of his absurdist play *Ubu The King*, which nearly caused a riot in the theater. After that he was a star, with even Pablo Picasso praising him, sketching the writer's portrait, and buying many of his unpublished works. Famous painter Marcel Duchamp called Jarry "a great man." Jarry wrote three plays, four novels, and a collection of short stories that outraged traditional critics but were celebrated by the avant-garde. In addition, he was the most popular guy at any bar he walked into, applauded for his rashness, and noted, for example, for frequently waving a loaded pistol around when drunk. His shocking inspiration coincided with the growing seriousness of his absinthe addiction, which he affectionately called a "sacred herb," and his "green goddess." At thirty-four, in 1907, Jarry died from complications of alcoholism. In the end he apparently became more considerate of others, and goes down as making one of the least troublesome last requests before his death. When friends gathered and asked what he wished, Jarry seemed preoccupied. He said he simply wanted a toothpick.

JAMES JONES

To me death is not a fearful thing. It's living that's cursed.
—JAMES JONES

James Jones's most famous novel, *From Here to Eternity*, came from his firsthand experience when stationed in Hawaii as Pearl Harbor was attacked by Japanese war planes. Combat duty in World War II was both his inspiration and his undoing. His simple descriptions of ground rumblings, and an enemy plane flying so

He CAN'T forget Pearl Harbor—Can you?
BUY BONDS

low he saw the pilot's grin, added an authentic bite to his fiction. The book was published in 1951, won the National Book Award, and remains on the Modern Library list as one of the top books of the twentieth century. The movie adaptation broke Academy Award records, and the famous scene from the film, with Burt Lancaster rolling in the surf with his love, Deborah Kerr, has become an iconic image of romance. When Jones published his second novel, actually the first manuscript he wrote but couldn't get published prior to *Eternity*'s success, critics got out the knives and daggers, saying the book was filled with errors and grammatical snafus. Jones said he wanted it that way, to capture the essence of the character, though he came to be regarded by many as unschooled. A jury of serious literary types convicted him as crude and not all that gifted. The other camp, vastly larger, indifferent to stylistic techniques, praised Jones for what he was—a career soldier—and in the end, Jones produced the most accurate "fictional" account of World War II in American literature. Both in and out of uniform Jones liked to drink; he was a man's man who told war stories, alternately belligerent and sentimental, and was seldom photographed without a cigarette dangling out of his mouth. His unadorned portrayal of what it was truly like to be in battle was his raw genius. Jones once killed an enemy with his bare hands, and to do it, he wrote, one had to believe himself "already among the roll of the dead." He pounded out book after book, delving deep into old war wounds that seemed soothed only with the anesthesia of alcohol. When he learned he had heart disease, he cut back on the all-nighters and put a cork in the jug as best he could. While in the hospital, when he knew there were only a few days left, Jones began drinking again, wondering in perfect soldier logic if having given up the drink as the doctors suggested only killed him quicker. He died at age fifty-five in 1977.

JANIS JOPLIN

> *The nice thing about being a heroin addict is that you either have no problems or one big one.*
> —RICHARD SCHULDENFREI

On stage, Janis Joplin was a virtual human explosion. She sounded like she sacrificed part of her larynx with each bluesy rock number she belted out. She became the high priestess, "The Queen of Rock," inspiring a cult-like devotion. There's no doubt she put everything into her performances and was determined from the start to go out with both barrels blazing. Off stage, Joplin waited for the bad news, never believing she was good enough, and that the entire fame trip was all a mistake. In high school, Janice was a chunky, pimple-faced girl with greasy hair. She had a reputation as a troublemaker and as a foul-mouthed chick who only the most raucous kids thought was marginally cool. In college, her self-esteem took an even greater blow when she was voted

"The Ugliest Man on Campus." She had the luck of timing, though, breaking into music during the rise of the hippie era, a time that suited her style and talent, when her voice emerged as an antithesis to the crooner of the fifties. She started doing drugs as a teenager, and once she was a star, favored Southern Comfort and heroin in ever-increasing amounts. Joplin said she pursued addiction because her dreams were unfulfilled. Still, her star rose to the top of the rock scene. Jerry Garcia summed up Joplin by simply calling her a "skyrocket chick." Everybody watched her missile ascend and knew it'd burst into flames before making it back to the ground. Emotionally, she seemed to her closest friends like a fourteen-year-old girl going through puberty, stuck in the time when she first found comfort in dope.

She mainlined heroin and died of an overdose at age twenty-seven, in 1970. She didn't plan to, and like many junkies, believed she was being prudent by using only fresh needles and buying from a "trusted" dealer: The one she used claimed he had a chemist check the purity. Fans thought it was a CIA plot, but it was simply a bag of purer smack she shot up while staying in a room at a cheap motor lodge in Hollywood. The more philosophical say she died of an "overdose of Janis." Nevertheless, she had set aside a few grand to hold an all-nighter in the event of her death: Several hundred people showed up for the free whiskey.

AVERAGE AGE OF DEAD ROCKERS

The sixties had only a few pop and rock musicians dying of overdose, Frankie Lymon, and Brian Jones of the Rolling Stones, most notably. But by the seventies, starting with Joplin, the roll call began in earnest: Jim Morrison (twenty-seven), Jimi Hendrix (twenty-seven), Gram Parsons (twenty-seven), Billy Murcia of the New York Dolls (twenty-two), the Grateful Dead's Ron "Pigpen" McKernan (twenty-seven), Nick Drake (twenty-six), Average White Band's Robbie McIntosh (twenty-three), Vincent Taylor of Sha Na Na (fifty-one), Tim Buckley (twenty-eight), Tommy Bolin (twenty-five), Uriah Heep singer David Byron (twenty-seven) and bassist Gary Thain (twenty-seven), Paul Kossoff (twenty-five), The Who drummer Keith Moon (thirty-one), and Sex Pistol Sid Vicious (twenty-one)— making 27.9 the average age of an overdosed seventies rocker. In the eighties the average age for a dead rocker was 27.8. The nineties had the most overdosed rockers since rock began, with the average age of overdose at 34.8 years.

FRANZ KAFKA

The meaning of life is that it stops.
—FRANZ KAFKA

Famed poet W. H. Auden said Kafka was to the twentieth century what "Dante, Shakespeare and Goethe bore to their [age]," and respected literary critic Harold Bloom added: "In the age of great originals, Proust and Joyce foremost, Kafka is more original than the originals." Generally believed to be one of the greatest authors of modern world literature, with the coveted International Literary Franz Kafka Prize named in his honor, the author was nevertheless paralyzed by an obsession to remain anonymous and unnoticed, not only in his work but in all aspects of his life. Medical researchers and scholars are still in debate as to its cause. Kafka was a German-speaking Jew living in Prague in the early 1900s when he labored in secret to create an entirely unique fiction. His themes, particularly his portrayal of man's profound isolation, not only from other people but himself, and his spiritually malnourished environment, could be argued to have found their germination in his obsession. Kafka's most famous work, *The Metamorphosis*, tells the story of a traveling salesman who wakes up one day and slowly discovers that he had been transformed into a giant roach-like insect. At first the altered man's family hardly notices, and then grows repulsed, locking the bug in a room. Unable to feed himself with six useless arms, the creature dies from an infection he got from a rotten apple tossed at him months before. This, one of the few pieces of his writing published in his lifetime, and the few finished works he left behind, brought him notoriety years after his death, and they remain equally haunting and disturbing nearly a century later.

Fearing judgment to the extreme, Kafka stopped pursuing publication,

I need solitude for my writing; not like a hermit—that wouldn't be enough—but like a dead man.
—FRANZ KAFKA

and the thought of being judged even after death disturbed him deeply. This constant internalized obsession affected his health and by his late thirties he suffered from a number of ailments, including constipation and consumption (tuberculosis), that required increasing convalescence. He went on strange diets and eventually sought cures at sanatoriums. At the end he died the same way as his fictional bug, unable to eat because of a pain in his throat, and actually succumbed to starvation in 1924 at the age of forty. Even though most hospitals would have administered a force-feeding treatment, Kafka was coherent enough to dissuade his physician. Instead, he pleaded for an overdose of morphine. Kafka's last words: "Kill me, or else you are a murderer!"

A WORD OF HIS OWN

Kafka's style and themes were so imaginative that the word Kafkaesque has come to signify any menacingly bizarre, helplessly bureaucratic absurdity from which there appears no way out once it is set in motion. Kafka had asked his close friend, fellow writer Max Brod, to burn all his manuscripts when he died. Thankfully, Brod did not listen, and had Kafka not died as he did, there is a strong chance he would've been killed as his surviving sisters and his fiancée were, in the brutally efficient, some say, and beyond doubt Kafkaesque Nazi concentration camps.

ANDY KAUFMAN

The absurd is the essential concept and the first truth.
—ALBERT CAMUS

Andy Kaufman was not a comedian, or so he said, but an absurdist entertainer. Kaufman began performing at age seven and after formal dramatic training hit the stand-up circuit. His fame came when he perfected his "Foreign Man" persona, a character with a badly imitated accent, doing dumb stuff for the TV sitcom *Taxi*. From 1978 to 1983 he appeared in nearly all of the show's 114 episodes as non-English-speaking Latka, though he was allowed to show his range of talent only by playing this character as one suffering from a multiple personality disorder. Off screen, he performed as a wrestler, challenging women, primarily, until he went into the ring with Jerry "The King" Lawler, a 250-pound, six-foot muscleman noted for illegal tactics, including firebombs and brass knuckles. Once in the ring with The King, Kaufman quickly fell victim to a pile-driver move that apparently broke the comedian's neck. For months afterward, Kaufman never went out in public without a neck brace, though

it was revealed ten years later that it was a staged accident, and funny, he believed, because he could keep the gag up for so long.

In 1983, Kaufman began to cough and told his fans that he had a rare form of lung cancer. In his typical straight-face delivery he claimed that he would cure it by eating only fruits and nuts.

While all the other kids were out playing ball and stuff, I used to stay in my room and imagine that there was a camera in the wall. And I used to really believe that I was putting on a television show and that it was going out to somewhere in the world.

—ANDY KAUFMAN

Records also indicate he went to the Philippines to have mystics take a shot at curing his ailment via psychic healing. Those close to the performer confessed that Kaufman had talked regularly about faking his own death, and was at work on a screenplay about it. According to a very official-looking Los Angeles County death certificate, Andrew G. Kaufman died on May 16, 1984, of renal failure due to metabolic carcinoma at age thirty-five. However, announcements in *Variety*, advertising the availability of one Tony Clifton, one of Kaufman's stage personas, a syrupy lounge singer, persisted through the nineties. Kaufman always wanted to pull off the biggest bit in showbiz history and said that he'd have to keep the secret of his faked death at least twenty, maybe thirty years, before resurfacing. Some shrug off the controversy, while others ignore the death certificate altogether, saying Kaufman is undoubtedly still alive.

FAKING DEATH

*Rumors of death frequently attract attention, and artists have been accused of starting them to gain publicity. **Paul McCartney** was thought dead, and elaborate conspiracy theories were discussed by serious journalists on how it happened. Clues were deciphered from the then newly released album cover of* Abbey Road *to prove it, namely, that McCartney was out of step with the other Beatles band members. Some believe to this day the original McCartney was replaced by a double. **Ken Kesey**, the author of* One Flew Over the Cuckoo's Nest, *known for acid trips and all sorts of drug use, faked his own death to avoid arrest, and made it seem as if he committed suicide. It failed, and he served five months in jail for marijuana possession. When **Steve Burns** was suddenly replaced as the host of* Blues Clues, *many attributed his demise to a heroin overdose. He resurfaced in 2007 and was caught acting in a Shakespearean play, apparently sober. Though officially dead of "cardiac arrhythmia," **Elvis Presley** holds the record, with millions believing he faked his own death, primarily because his middle name, Aaron, was misspelled on Presley's tombstone. Even though Elvis would be in his mid-seventies, he's still seen everywhere. Some explain that Elvis was abducted by aliens, and is occasionally released, un-aged—an angle Kaufman would've been sorry he hadn't thought of first.*

JOHN KEATS

One has to pay dearly for immortality;
one has to die several times while
one is still alive.
—FRIEDRICH NIETZSCHE

John Keats's old man was a good-
natured, back-slapping bartender,
the innkeeper of a joint called the
Swan and Hoop that in those days
not only served up a drink to travel-
ers but tended to their horses while
they slept it off. Young John had a
happy childhood until age eight,
when his father was killed in what
could now be called a drunken driv-
ing accident: The elder Keats fell
from a horse during a bender and
cracked his skull. His mom, herself overly fond of the frothy, had a reputa-
tion for "entertaining" the guests when her husband wasn't looking. She
married a rich patron a few months later, though she left him soon after, and
in accordance with the laws of the time, forfeited ownership of the tavern
and custody of her children. This quirk of fate led to the formation of one
of the best poets in the English language, who might have otherwise been
known for wearing an apron and tapping a keg of ale. After these unfortu-
nate events, the destitute mother took John and his siblings to live at his
grandparents' overcrowded and drafty house. Within weeks of his mother's
death, six years later, Keats, then fifteen, was sent off to become a surgeon's
apprentice, though he was treated more like an indentured servant. He
found solace and comforted his sense of abandonment and loneliness by
reading classical literature after the long hours learning medical techniques
and apothecary. John inherited part of his father's temperament and was
noted as a brawler, with a good right jab and a swift left hook that left a
trail of bloody noses throughout London and its suburbs. When he had a
fistfight with his surgeon master, he was sent off to work at Guy's Hospital,
becoming licensed to practice medicine by the age of twenty-one. Keats
already had little interest in it and preferred to hang with the artist crowd.
Writers with connections helped Keats publish his first poetry, followed by
a book of verse that received terrible reviews. When John's brother died
of tuberculosis, as their mother had, Keats announced that he likewise
had no more than three years to live. With his knowledge of medicine, he
believed he had either acquired syphilis from the many hookers he vis-
ited, or that his cough was the deadly contagion he acquired while nursing
his dead brother. This self-diagnosis kicked off a singular year of creative

genius that has few equals in literature. Keats wrote a series of odes that has remained among the most widely admired and read poetry since. He became obsessed with trying to achieve a level of immortality that he knew only literature could bring. His health did deteriorate as he promised, and then he medicated himself with laudanum and mercury, a drug commonly prescribed for both respiratory congestion and syphilis. The opening lines of "Ode to a Nightingale"—"My heart aches and a drowsy numbness pains my sense as though of hemlock I had drunk, or emptied some dull opiate to the drains"—were more than a simile; they were an accurate description of the drug's effects. Despite the critics, many fellow poets recognized Keats's talent and tried to help. He traveled to Rome, believing a warmer climate would improve his condition.

Friends sequestered Keats in an apartment with a window facing the famed Spanish Steps. There, doctors put Keats on a starvation diet, and administered bloodletting to the point that he was severely emaciated. They also refused to allow him to write, as physicians believed patients with "consumption" should not become overly excited. Keats got hold of a triple dose of laudanum and attempted to kill himself, but he was too weak and was stopped in the act.

Although John Keats's name has never been added to the gravestone, his handlers decided that even after death they knew what was better for him and chiseled the longest footnote in tombstone literature:
This Grave contains all that was mortal, of a Young English Poet, who on his Death Bed, in the Bitterness of his heart, at the Malicious Power of his enemies, desired these words to be Engraven on his Tomb Stone.

At age twenty-four, in 1821, he died miserably, not only destroyed physically, but mentally tormented, certain that the brass ring of fame had eluded him. He requested that not even his name appear on his tombstone and demanded this line instead: "Here lies one whose name was writ in water."

SAM KINISON

There's no happy ending to cocaine. You either die, you go to jail, or else you run out.
—SAM KINISON

Sam Kinison was a heavyset, long haired stand-up comic who wore a trademark beret and screamed out his jokes to the audience in the late eighties. He found the sawed-off-shotgun-in-your-face approach the only way to rise above the multitude of comics clawing at the stage door. Nevertheless, he was an interesting man for his paradoxes, seemingly bent on self-destruction while simultaneously trying to find an inner peace and spiritual meaning. A onetime fire-and-brimstone-style Pentecostal preacher, Kinison knew the delivery tactics required to scare people into paying attention; however, once he gained comedic fame with his devil-may-care attitude, he plunged into cocaine and alcohol abuse with ferocious abandon. His celebrity was short-lived: In 1992, at age thirty-eight, Kinison was just six days married and trying to be clean and sober when his car was hit head-on by a teen driving drunk in a pickup truck on a highway near Fort Mohave, Arizona. After the crash, Kinison untangled himself from the wreckage and lay down on the side of the road. He believed the campaign to make people wear seat belts was part of the establishment's plot to curtail individual freedom. The impact of his chest hitting the steering wheel actually tore the aorta valve loose from his heart. Witnesses at the scene say Kinison screamed out, "Why me?" before passing away. Incidentally, the autopsy's toxicology report found small traces of cocaine in his bloodstream, a detail that got the inebriated teenager only a slap on the wrist. On Kinison's grave marker at Memorial Park Gardens in Tulsa, Oklahoma, visitors are left to ponder the inscription: "In another time and place he would have been called a prophet."

JERZY KOSINSKI

Genius that power which dazzles mortal eyes, is oft but perseverance in disguise.
—HENRY AUSTIN

The bestselling novel *The Painted Bird* portrayed Jerzy Kosinski's childhood attempts to flee the Nazis' hunt for Jews. The author claimed that when he was six years old his parents paid an exorbitant sum to a stranger to bring

the boy to safety; however, it was later revealed that Kosinski's parents had stayed with him the entire time. Nevertheless, if Kosinski witnessed only half of what the book's fictionalized child character encountered, including abuse, starvation, and torture, it's little wonder why the author struggled to keep his private demons in check. When the war was over, he was trapped under the watchful eye of the Soviet Bloc and managed to forge documents for passage to freedom, keeping a cyanide capsule at hand in the event he was discovered. He learned from his past that it was essential to hide feelings and to perfect disguises. At age twenty-four he made it to New York, with no more than a few dollars to his name. When he published *The Painted Bird* Kosinski was immediately heralded as a major literary figure, even as the book was banned in his native Poland for his slanderous portrayal of its people. He received death threats and even outwitted two thugs who managed to enter his apartment brandishing lead pipes: Kosinski pulled out a revolver that he had stashed behind a dictionary and forced the intruders to leave. He continued writing bestsellers and was a respected member of the cultural elite, yet the true Kosinski was seldom revealed, himself willfully embellishing autobiographical details. At age fifty-seven, in 1991, he attended a party and seemed to be in a good mood, mingling with the many dignitaries. Once home, he took a few sleeping pills, washed them down with a rum and coke, filled the bathtub with warm water, and then got in with a plastic bag tied over his head. His suicide by asphyxiation was explained with the note: "I'm going to put myself to sleep now for a bit longer than usual. Call the time Eternity." Friends recalling their last conversations with the author scratched their heads, each wondering which one of the many disguises Kosinski wore was the one they knew. Controversy stirred with claims that even his books were fake, written by ghost writers and riddled with plagiarism. Although Kosinski can be seen as a natural while acting in the movie *Reds*, the real Jerzy Kosinski, as he had hoped, remains ambiguous.

> *A novelist has a specific poetic license which also applies to his own life.*
> —JERZY KOSINSKI

JACK KEROUAC

> *My fault, my failure, is not in the passions I have, but in my lack of control of them.*
> —JACK KEROUAC

With the 1957 publication of the novel *On the Road*, Jack Kerouac was at once recognized as an exceptionally original American writer. The *New York Times* hailed him as the new voice of the generation, and he has since been regarded as a literary icon, representing the Beat movement. He binged on alcohol from his teenage years, and even more so following the success and attention given to him and his book. In 1969, at age forty-seven, he died of a stomach hemorrhage caused by chronic alcoholism.

When you lose your reason, you attain highest perfect knowing.
—JACK KEROUAC

BARBARA LA MARR

Beauty, more than bitterness, makes the heart break.
— SARA TEASDALE

Silent film star Barbara La Marr was called "The Most Beautiful Woman in the World." The title stemmed from her arrest in her teenage years for performing exotic dances in a Hollywood club: A judge lowered his glasses and looked down at her from the bench, admonishing her to go back home, saying that she was "too beautiful for her own good." From then on her anatomy made her famous, and she used every inch of it to pursue pleasure, through romance, just plain sex, and drugs. She was married twice before the age of twenty and some reports cite that just the thought of losing her caused her husbands to die. The first was a rancher who caught a fatal case of pneumonia after riding his horse out in the rain, overcome with sadness at the thought of La Marr leaving him, as she had threatened to do. The second husband married Barbara before divorcing his first wife and was promptly arrested for bigamy. Separated from Barbara he banged his head on the jail's bars and died of a brain aneurysm. Barbara said, "I cheat nature. I never sleep more than two hours a day. I have better things to do." She also admitted, "I take lovers like roses, by the dozen!" She was cast as what was then called the Vamp, which might now be loosely translated as "hot slut." On the other hand, taking into account that in La Marr's era some women still wore corsets and waited around pining for a man to make the first move, she might be considered a sexual revolutionary. She had a genius for tapping into male fantasies for her own advantage, and judging by her screenwriting talent and how she negotiated contracts, she was much more than a beauty, and in fact quite intelligent. In the end she was addicted to heroin and cocaine, and the official cause of her death, at age twenty-nine, in 1926, was tuberculosis. More than forty thousand people lined up, with riots reported caused by pushing and shoving, to get a view of what "The Most Beautiful Woman in the World" looked like dead.

VERONICA LAKE

Beauty is a form of genius—is higher, indeed, than genius, as it needs no explanation.
— OSCAR WILDE

Veronica Lake was a petite five-foot-two former beauty queen who wore her blonde hair combed always to cover her right eye. During World War II she became a pinup fantasy for GIs, while millions of American women back home likewise cut their vision in half, imitating her hairdo. Her small stature was perfect for her to be the leading lady for the then heartthrob Alan Ladd, who

at five feet four inches was tired of standing on boxes to look taller than most other starlets circulating the studios. The Ladd-Lake team busted box-office records. In her heyday, Lake was seen among the top echelon of the social elite, including billionaire Howard Hughes, and was photographed sunbathing on Aristotle Onassis's yachts. By the late forties she began to seem half-wasted and listless acting in yet another romantic scene, yet she was blindsided when the studio cut her loose. She found all doors in Hollywood suddenly slammed shut. A few years later she was living in a subsidized women's hotel in New York City when she was spotted by a paparazzo who photographed her looking bloated and puffy, working as a barmaid in a seedy tavern. She admitted she wasn't much of an actress, saying, "I wasn't a sex symbol. I was a sex zombie." She died from complications of alcoholism, namely acute hepatitis, in 1973, at age fifty-three.

Alan Ladd never seemed flustered by Veronica Lake, or any woman, and had the trademark emotionless stone-face in whatever role he played. Ladd, a big star throughout the forties and fifties, is most remembered for his classic cowboy movie Shane. *His small stature bothered Ladd, though, as did other things, including well-publicized alcoholism. When Ladd found he was no longer the main star and was instead cast in a supporting role, he decided not to wait for his last movie to be released. His 1963 attempt to shoot himself had been explained away as an accident, but at age fifty, in 1964, he died of an overdose.*

PIERRE LALLEMENT

> *Genius always finds itself*
> *a century too early.*
> —RALPH WALDO EMERSON

Historians are settling on the obscure Frenchman, Pierre Lallement, as the first to discover and patent the invention of the bicycle. At age nineteen he was a mechanic at a carriage-maker when he made a prototype of a two-wheeled contraption that propelled by the use of gears and pedals. A leading manufacturer saw the potential and used Lallement's ideas liberally, giving him payment in the form of employ-

ment at the contraption's factory. The bicycle, first called the velocipede, had a precarious larger front wheel, and though it was extremely difficult to ride, it kicked off a rage throughout Europe. Lallement never gave up on his obsession to create a better version of the bicycle, eventually going to America to seek backers. He shared his ideas with bicycle manufacturer Albert Pope, the country's first cycling advocate, who formed the League of American Wheelmen to petition cities to make bike lanes as early as 1900. Lallement doubted his genius and died penniless in Boston at age forty-seven, in 1891, where today a bicycle path is named in his honor. To the end he was fixated with perfecting a better bike, with some documents attributing his demise to a fatal hemorrhage, allegedly stemming from a collision with a horse and carriage.

> *Competition is a process or variety of habitual behavior that grows out of a habit of an obsessive mind.*
> —WILLARD BEECHER

A RACE FOR THE OBSESSIVE-COMPULSIVE

The largest bicycling event in the world is the Tour de France, a twenty-one-hundred-mile, twenty-day event viewed by ten million people. Since its inception in 1903, when only sixty riders competed, the race has had its share of winners who met bizarre fates, partly because the rigors of such an event often attracted the most obsessed, eccentric, and driven members of the sports world. One of the first winners, René Pottier, took the prize in 1906 and planned to race again, but was found dead, at age twenty-seven, days before the 1907 event, hung from the hook he used to store his bicycle. It was said he committed suicide after a woman broke his heart. In the early days, fans threw nails in the road, and allegations of poisoning by rival teams were widespread. In 1960, Fausto Coppi won top honors, but months later, while touring in French West Africa, he died of a mysterious disease, at age forty. Although his death certificate cites malaria, he was poisoned by an herbal concoction administered by the family of a cyclist who held a grudge, apparently for being driven off the road by Coppi during a previous race. A year later, Tour de France winner Hugo Koblet killed himself at age thirty-nine by driving his sports car at full speed into a tree on a highway near Zürich. Winner Luis Ocana shot himself in 1994, at age forty-nine, depressed about financial difficulties; another tour notable Thierry Claveyrolt did likewise in 1999 at age forty. Marco Pantani won the race in 1998, but at age thirty-four, he was found dead of a cocaine overdose in a hotel room with suicide notes strewn about.

MARIO LANZA

> *Opera is when a guy gets stabbed and instead of bleeding, he sings.*
> —ED GARDNER

BRAVURAS. *Rival Syrens, or John Bulls rehearsal of Capt. Macheath.*

Maria Cocozza saw something in her wayward son Freddie, and although he had no head for books and was expelled from school, he had a lovely voice. She enjoyed nothing more than to hear her boy sing along with opera great Enrico Caruso's recordings played on the neighbor's Victrola. She sweated on the double-shift as a seamstress to send Freddie to singing lessons and saved him from a life as a grocery clerk to become an opera great. By his mid-twenties, Freddie changed his name to honor his mother, calling himself Mario, and using her maiden name, Lanza, when he debuted at the Berkshire Music Festival in Tanglewood, Massachusetts, in 1942. His tenor range was incredible as well as his girth—already he weighed 250 pounds—though it didn't dissuade Hollywood moguls from signing him up for a movie contract. Lanza went on to make eight musicals for the silver screen, and sell more than fifty million records. From the beginning, champagne and tranquilizers, lavish meals and pursuit of gorgeous company, were often Lanza's off screen preoccupations. He loved the luxurious lifestyle, and didn't give a damn if he lived above his means. He did care about his weight, alternating binges with starvation diets, helped by amphetamines and diet pills to suppress his urges. The big man's heart began to strain, though he told critics, "I'm a movie star, and should live like one." While renting a regally outfitted villa in Rome, he became acquainted with mob kingpins. After he turned down a request by gangster Lucky Luciano to sing for free at an event in Naples, Lanza checked himself into a hospital. Lucky sent some muscle to make an offer Lanza couldn't refuse, but apparently did; Lanza died the next day of a heart attack at age thirty-eight, in 1959. Some reports claim Lanza was found in the hospital bed with an intravenous tube disconnected from the nutrient sack, pumping in air, and his face flattened, possibly from a pillow. Within a year, Mario's wife, Betty Lanza, followed, dead from gagging on her own vomit as a result of alcohol and drug overdose. His poor mother remained the steadfast work horse and was guardian of Mario's four orphaned children, dying in 1970, at age sixty-five, of a stroke.

MUSICAL SCALES

The more Lanza sang the more he wanted to eat. His creative pursuit might have contributed to his many self-destructive habits. Researchers found that opera singers train their lungs to expand and exert full capac-

ity differently than other types of vocalists. The large number of rotund opera singers might be explained by an excess of leptins, proteins used in the regulation of appetite, that are released by operatic endeavors, causing insatiable urges for more food and drink. According to The Journal of Voice, *the act of singing expands the rib cage, giving opera singers a barrel-like appearance.* But for Lanza it was Dom Pérignon and prosciutto, and unlucky contact with the wrong crowd, that did him in.

RING LARDNER

No one, ever, wrote anything as well even after one drink as he would have done without it.
— RING LARDNER

In some neighborhood taverns there's one guy who sits at the end of the bar staring into his drink. There are days when not a word comes from his lips, and he only taps a finger on the rim of a glass when he needs a refill. Despite himself, his opinions on things are often sought, since when he does have something to say it's usually a stinging one-liner, or a slightly cynical though humorous observation of the obvious. Ring Lardner, short for Ringgold Wilmer Lardner, made a literary career capturing the vernacular of one of these barroom-musing philosophers, since he was one himself, and a legendary drunk in his own time. He started out as a sportswriter when baseball was the true American passion, giving the players telling nicknames and revealing personality quirks that added a colorful mystique to the game. His fictional short stories about hard-drinking ball players and such put him on the national map in 1913, when the *Saturday Evening Post* ran his stories. Back then, this was equivalent to getting an endorsement spot on *Oprah*, and it yanked him from the rank of dime-a-dozen sports columnists to literary star. He thought himself just another hack, but when his collection of stories came out a few years later, Lard-

Ring Lardner was taller than most baseball writers, and towering above all in his genius for writing and expression. He won acclaim not only from the ordinary fan and reader but from the eggheads and top literati of the nation.
— FRED LIEB

ner was praised as a great American humorist, even given the nod of approval from such literary stalwarts as Virginia Woolf, and he took them at their word.

Lardner was paid well for all he wrote, though he continued to cover his beloved Chicago White Sox, until they, and the game in general, lost its innocent shine when the scandal of their throwing of the 1919 World Series hit the fan. He wrote little about baseball thereafter and took his wife and four sons to a mansion in Great Neck, New York, and later to East Hampton. He established

a friendship with F. Scott Fitzgerald, and although he was not the playboy type and was ten years older than Fitzgerald, the two became drinking buddies until the end. Ring helped Fitzgerald edit *The Great Gatsby*, and in turn Fitzgerald got him in with his publisher, serving to get a few more of Ring's books out under a respectable imprint. Lardner always wanted to write a novel, but could never put his hand over the glass long enough to finish one. In fact, he rarely had the discipline to make even carbon copies of his stories: He typed them out straight from his head and sent them off as they were. Nevertheless, despite Lardner's confirmed alcoholism, all four sons turned out to be good writers. Ring Lardner Jr. survived the longest and became more famous than his father, first for being one of the "Hollywood Ten" who refused to cooperate with investigations into "Un-American activities" in the film industry in the 1950s, and then for Academy Award–winning screenplays, namely for *Woman of the Year* and *M*A*S*H*. The children claimed to have good memories of their father, since he hid many of his heavier drinking binges, believing they would be unaffected if he returned home after any number of disheveling three-day runs only when he was certain the children had left for school. He tried to joke about his trips to hospitals with the classic wit for which he was celebrated: "In an ambulance they made you ride lying down, whereas you can take your choice in a taxi." But the reality of his overindulgence, and self-loathing, became more evident in his later work, with much of the lighter humor gone and a more cynical tone dominating. It's no surprise, since he was dying of end-stage chronic alcoholism, though officially succumbed to tuberculosis and died of a heart attack, at age forty-eight, in 1933.

ADULT CHILDREN OF ALCOHOLICS

Ring's oldest son **John Lardner** *likewise became a sportswriter, journalist, and World War II correspondent. He too got tuberculosis and died of a heart attack, in 1958 at age forty-six, leaving behind only seven chapters of his book in progress,* Drinking in America. *Second son* **James Lardner** *was a reporter covering everything from funerals to minor crimes before he joined Ernest Hemingway to cover the Spanish Civil War. On impulse, he enlisted in a rebel brigade as a fighter and was killed by machine gunfire and hand grenades at age twenty-four. Third of the clan,* **Ring Lardner Jr.** *died in 2000 at age eighty-five. Fourth son* **David Lardner** *became a sportswriter, movie critic, and columnist. He died as a war correspondent, blown up by a roadside mine in Germany in 1944, at age twenty-five. Incidentally, according to the National Association for Children of Alcoholics, kids reared by alcoholics typically become obsessed with seeking approval and recognition, and have a difficult time understanding what "normal" is. Impulsiveness, problems with following a project through, and loyalty to the undeserving are additional characteristics that can plague offspring of the alcoholic.*

D. H. LAWRENCE

Few people can see genius in someone who has offended them.
—ROBERTSON DAVIES

Inexhaustible is one way to describe David Herbert Lawrence's creative output, although he might have benefited from an occasional bout of writer's block, or at least a second glimpse at his work before he sent his voluminous writings off in the mail. In his forty-four years he created quite a stir with his ideas, namely his notions of sexuality and eroticism, leaving thirty-six books of short stories, nonfiction, travel books, poetry collections, and plays, thirteen novels, numerous reviews, essays, and thousands of collected letters, in addition to erotic oil paintings. He came from a mismatched pair of parents, his father a coal miner who barely knew how to sign his name, and his mother a school teacher with a love of the classics. Lawrence followed his mother's guidance and became a teacher, but after his first novel was published, in his mid-twenties, Lawrence decided to dedicate himself to nothing else. Although he seemed ambivalent about his sexuality, saying he had the only perfect love when he was sixteen with an old coal miner, he eloped with Frieda Weekley, a married woman with three children, and remained with her the rest of his life. He happened to write some of his best novels, *Sons and Lovers*, *The Rainbow*, and *Women in Love*, just before and during World War I, which limited the books' success. Once readers caught on to his radical ideas of sexuality, authorities cracked down, deeming his work obscene. His steadfast pacifism, in conjunction with his sexual views, sent him and Frieda fleeing England, off on a self-imposed exile and nomadic life he referred to as a "savage pilgrimage." Lawrence had an aversion to alcohol, hoping to distance himself from his father's habits, though he was no less plagued by compulsion: He traipsed the globe while writing at a feverish pace, to the neglect of his health. His only purpose in life was to create, and he managed to get pen to paper even if he was burning with fever and unable to stand unaided. When he died of tuberculosis, in 1930, physically spent, he was not popular, and most obituaries trashed him. It took some time to weed through the remains of his vast writings and bring attention to the masterpieces that floated to the top of his whirlwind productivity. In the early sixties, when his previously only privately published novel *Lady Chatterley's Lover* came out in England, there was a trial to ban the book because it contained explicit sex scenes and used previously prohibited four-letter words. This, of course, only led to a resurgence in interest in all of Lawrence's work and life, even if currently, certain feminist academics say Lawrence wasn't revolutionary enough.

> *If a woman hasn't got a tiny streak of harlot in her, she's a dry stick as a rule.*
> —D. H. LAWRENCE

T. E. LAWRENCE

> *Next to the writer of real estate advertisements, the autobiographer is the most suspect of prose artists.*
> —DONAL HENAHAN

T. E. Lawrence, an unassuming archaeologist specializing in medieval pottery, became famous as a warrior, better known as Lawrence of Arabia, when he encouraged Arab states to unify in defense against the invading Turks in the early years of the twentieth century. The British military enlisted Lawrence for counterintelligence and he soon went from shifter of sand to soldier riding on white horses (or sometimes camels) through the desert into battles. He also had a passion to write the most revealing autobiography ever and produced a half-million-word tome about his life. When he lost the first draft he supposedly sat down and reproduced the first thirty thousand words in one straight twenty-four-hour period. His obsession to reveal his "heart and soul" consumed him with rewriting, polishing, and making the book perfect, but the finished manuscript, *Seven Pillars of Wisdom*, was too big. He allowed a condensed version to be published, and it sold well, even if he felt the abbreviated edition was insufficient. He refused to take profits from his book and used his own money to produce his masterpiece in its entirety, knowing that accolades would follow just as the cheers from the crowds in the desert had once greeted him wherever he went. However, the book did not receive the literary kudos Lawrence had hoped, many saying his remembrances of his exploits were embellished. When his obsession to achieve immortality by writing the world's greatest autobiography seemed in question, and after a dismissal from the Royal Air Force, he retired to his country home in England. At age forty-six, in 1935, he got on his motorcycle, revving it to the highest speed possible, and aiming it full throttle at a tree. His suicide is contested by some who say he instead crashed with honor, trying to avoid boys he encountered in the road. Whatever the case, he did a somersault over the handlebars and died of internal trauma six days later.

DIPLOMACY FOR ART'S SAKE

*Before T. E. Lawrence, the title of original adventure-seeking artist belongs to **Robert Fagan**. Son of an Irish baker, he became a portrait painter for the rich, and is noted in art history for painting a then scandalous portrait of his lovely second wife with one nipple showing. He also made piles of money as an art smuggler, devising rooms with secret pas-*

sages and revolving doors to hide stolen classical works. Fagan became involved with military conflicts while in Italy, was employed as a spy, and was eventually named British Consulate of Sicily. When he seemed on top of the world, with a beautiful Roman wife and two young kids, he decided to jump from a window to kill himself. At age fifty-five in 1816, despite his industry, Fagan was secretly in financial ruin due to a nasty opium habit.

HEATH LEDGER

I only do this because I'm having fun. The day I stop having fun, I'll just walk away.
— HEATH LEDGER

By 2005, Australian actor Heath Ledger had been in nearly twenty films when he was Oscar nominated Best Actor for his brilliant portrayal of a conflicted homosexual cowboy in the Academy Award–winning *Brokeback Mountain*. He had a laid-back handsomeness, and there was a sensitivity in his stage presence that made him well-regarded and popular with fans. He was also a noted regular at after-parties and at celebrity watering-holes, known to frequently drink and drug. As his fame rose, so did familial problems, a penchant for stage fright, and insomnia, which he coped with by gathering numerous prescriptions for a wide range of medications. A week before his death in 2008 he suffered from an intensified insomnia that some believe led to his reportedly accidental overdose, on a combination of more than six drugs found in his blood. He died at age twenty-eight from the effects of "acute intoxication."

SINCLAIR LEWIS

The intermediate stage between socialism and capitalism is alcoholism.
— NORMAN BRENNER

Sinclair Lewis came from Midwestern stock that absolutely loathed drinking, gambling, fornication, and vice, and yet on the road to winning the Nobel Prize for Literature he adopted the most deadly of the habits on the list. His father was a doctor and rod-toting disciplinarian not as endeared to the sickly Sinclair as he was to his more athletic children. Sin-

clair's mother died when he was six, and in today's lingo he would be considered a geek extraordinaire, gangly and acne-ridden, infatuated with books, and an outsider at all school functions. He tried to run away during his teenage years to become a drummer in the Spanish American War, but was snatched back and eventually sent to college. His tendency to wax elegant and use obscurely antique big words made him odd man out there too, with Yale contemporaries remembering him as "the only man in New Haven who could fart out of his face." Nevertheless, he was determined to be a writer and eventually edited Yale's literary journal. After graduating he roamed from jobs to various locales, selling what writings he could to make ends meet. When he went out to join the Carmel Writer's Colony on the West Coast he dove in with the alcoholic crowd he found, and managed to make friends with Jack London. At five dollars a piece he sold story plots to the famed novelist of *Call of the Wild* when London began to suffer from one too many non-creative hangovers. Sinclair dabbled with different subjects, publishing with some success, but when he hit upon the subject of small-town life in the novel *Main Street*, it stunned the publishing world by selling more than two million copies in its first few years, quickly thrusting Lewis into international celebrity. The novel benefited from the notoriety of being banned first in Boston then throughout the U.S. because of its unpatriotic view of capitalism. Many internationals praised his courage, and it caught the eye of the Nobel literary committee, and received their nod for the award. As for his genius, it lay in his ability to capture the minutiae of personality and describe it as such that his characters became identifiable to many. As he grew older, Sinclair's temper grew shorter, and his wide circle of literary friends narrowed ever smaller to only a few. James Thurber, the cartoonist, and one of his last remaining friends, commented: "You couldn't always tell at seven in the morning whether he was having his first drink of the day or his last one of the night." Contemporary writer H. L. Mencken, accused Lewis of squandering his genius and of writing much of his later work in a "state of liquor." His wife pleaded for Sinclair to cease what she called his "pathological drinking," since his bouts had begun resulting in tremors, and frequently ended in the emergency room. He died from complications of alcoholism while in Rome in 1951, at the age of sixty-six.

> *Don't be a writer. Writing is an escape from something.*
> —SINCLAIR LEWIS

VACHEL LINDSEY

> *You can't crush ideas by suppressing them. You can only crush them by ignoring them.*
> —VACHEL LINDSEY

Disinfectants, Lysol in particular, factored significantly from the birth to the bizarre death of Vachel Lindsey, once a wildly popular American poet. Lindsey was born to an affluent Midwestern family, and his physician-father, who repeatedly lectured on germs and venereal diseases, expected Vachel to follow

Made only by Lysol, Inc., Sole Distributors, LEHN & FINK, INC., Bloomfield, N. J.
Canadian Offices : 9 Davies Avenue, Toronto

A Division of
LEHN & FINK PRODUCTS COMPANY

Lysol Disinfectant

Send for this
FREE *"Lysol" Health Library*

Mail today to: LEHN & FINK, INC., Sole Distributors, Dept. A 25, Bloomfield, N. J.

Name
Street
City State

him into medicine. In 1905, Lindsey got expelled from medical school and before long made his way to New York City, determined to become a famous American author. Cut off from family funds, he bartered a copy of his self-published, virtually stapled-together booklet of poems for food. His desire to become an appreciated man of letters, and regain respect, set him off on one of the craziest plans to gain notoriety in the history of letters. For more than six years, Lindsey walked from New York City to Ohio (450 miles), then from Jacksonville, Florida, to Kentucky (600 miles), and from Illinois to New Mexico (1,100 miles), reciting and trading his poems for subsistence. He billed himself as a reincarnated version of an old time troubadour, and his travels eventually made headlines as Lindsey became a sort of sideshow curiosity. This compulsive persistence culminated with his since most famous poem, "The Congo" (now criticized as racist), to be published in the respected literary journal *Poetry* in 1914. The poem was serialized in newspapers and magazines across the country, and made Lindsey a popular personality; Lindsey was invited to read "The Congo" at a private audience with President Woodrow Wilson and his cabinet. For the next twenty years Lindsey persisted at maintaining his respected position by becoming a dramatic performer of his work, noted for a great stage presence and a deep theatrical voice. Financially, he put on the illusion of doing well, packing in auditoriums that charged a nickel or a dime for a ticket to hear him, but in reality he often secretly worked at menial side-jobs to maintain a successful lifestyle.

His father's stern warnings about venereal diseases and germs seemed to always have a great effect on his personal life. Toward the end,

Then I saw the Congo, creeping through the black,
Cutting through the jungle with a golden track.
—FROM "THE CONGO"

he grew to dread live performances, reciting the same poems over and over, much the way a musician has to play a song that's twenty years old to keep the paying audience happy. He began to fear that he had lost his ability to write anything new and would be back to selling poems on the streets and walking great distances. He also became obsessed with the notion that his wife and father-in-law, in particular, were making plans to kill him before his fame waned, leaving the family name in disgrace. He accused his wife of cheating and willfully attempting to spread venereal diseases to him. He apparently became convinced that it was the very germs that his father once urged him to be wary of that were in some way causing his writer's block. One week in 1931, after he gave a performance to a packed auditorium in his hometown of Springfield, Illinois, he sent his wife to bed and then hurriedly rearranged the furniture in his living room. He sat inside a circle of old clippings and certificates of appreciations before he gulped a mugful of Lysol. This disinfectant

had become popular during the 1918 Spanish flu epidemic, marketed as a way to kill viruses.

Within minutes, his wife heard Lindsey barreling up the stairs and feared he was headed to the nursery to murder their children. As the poison burned a hole through his stomach he ran through the house with

Although the practice was not advised by the manufacturer, Lysol was also touted as a female douche, and became the most common folklore remedy for birth control from 1930 until the sixties.

arms above his head flailing the air, saying, "I got them before they got me. Let them try to explain this, if they can," before dying, at age fifty-two. His wife reported to the newspapers that he had passed of a heart attack, and kept up the façade, concealing his true cause of death for many years.

POPULAR POISONS

In the 1930s most all suicides and failed attempts thereof occurred during the evening, and rarely in the morning. Sunday and Monday were the days with the highest incidence. According to a 1933 suicide study published in the American Journal of Psychiatry, *suicide was most prevalent in females from age twenty to twenty-four, and from that group the recently divorced ranked higher. More than 50 percent of both male and female suicides were unemployed or had alcohol problems. Lindsey's death fell out of the norm in that men in the 1930s usually killed themselves by mechanical means. Women usually chose poisons: tincture of iodine was the most popular toxin, followed by Lysol, mercuric chloride (a syphilis medication), and phenol. Incidentally, phenol was a local antiseptic, sometimes prescribed to discourage female masturbation.*

ROSS LOCKRIDGE JR.

> *My significant other right now is myself, which is what happens when you suffer from multiple personality disorder and self-obsession.*
> —JOAQUIN PHOENIX

Many have dreams of one day chucking all demands to sit down and write the great American novel. Ross Lockridge Jr. decided to do exactly that, despite the demands of a wife and four kids. In 1938 he started work on a Civil War epic, *Raintree County*. Single-minded and passionate, he typed a maddening thirty or forty pages a day, though he crumpled most and tossed them into the waste basket. After seven years of this unin-

terrupted and frenzied labor, his fifteen-hundred-plus-page manuscript won a first novel contest from a major New York publisher and a separate contest for a movie deal from Metro-Goldwyn-Mayer. The hitch, however, that Lockridge didn't expect and which proved his undoing, stipulated that before either came to fruition, the author had to alter, cut, and bring down to a more manageable size this superb piece of writing. He went bonkers, sending an insulting letter to studio head Louis Mayer and bickered with his editor, asking if Tolstoy would've been asked to change *War and Peace*. The process of bowdlerization, and the slower-than-expected timetables of both Hollywood movies and New York publishing, sent the author into an emotional and physical tailspin. By the time the book hit the shelves in 1948, Lockridge had been treated with electroshock therapy. Although *Raintree County* came out against Norman Mailer's *The Naked and the Dead*, and Alfred Kinsey's *Sexual Behavior in the Human Male*, Lockridge's book was an instant bestseller, and received mostly rave reviews any writer would die for. Those close to the author hoped this success would alleviate his growing depression, but it grew only worse. When the movie-maker hesitated completing the film, once again asking Lockridge to make more changes, he went over the edge. Although Lockridge appeared eerily calm, smiling for a photo spread with his family to be published in *Life* magazine, the author was already shattered by the long years of struggle it took to bring the book to birth.

> *The world is still full of divinity and strangeness. . . . The scientist stops, where all men do, at the doors of birth and death.*
>
> —FROM *RAINTREE COUNTY*

Lockridge bought a brand-new car with the earnings from writing his great American novel. However, within months of the book's publication, he went into his garage, attached a vacuum cleaner hose to the tailpipe, and snaked it into the rear window. He turned on the ignition, got out of the driver's seat and moved to the back seat, waiting thirty minutes before he died of carbon monoxide poisoning. Lockridge's mother, a psychologist, used no clinical terms of manic depression or other mental disorders to explain her son's death, at age thirty-three. She simply reasoned: "He lived seven years with that story. It sapped his very heart's blood." The movie was made ten years later.

JACK LONDON

> *In a thousand generations to come men of themselves will not close saloons. As well expect the morphine victims to legislate the sale of morphine out of existence.*
>
> —FROM JACK LONDON'S
> *JOHN BARLEYCORN*

The title of Jack London's most famous novel, *Call of the Wild*, could be a part of an epitaph to sum up the life of this American writer: He answered the call of the wild and survived, but fell prey to the lone wolf of his own undoing. Though maybe not—there's no real inscription on his grave; just a huge mossy boulder sits atop an urn containing his ashes.

Jack London was born in a poorer section of San Francisco in 1876 to a frequently ill mother and a father who denied paternity. By the age of ten he put bread on the table by hawking newspapers, and then working in canneries, or poaching oyster traps in the Bay. He shipped out to sea on a merchant vessel bound for Japan, and headed to Klondike, Alaska, for the gold rush, all by the age of twenty-one. There were two sides to young Jack, the one that loved books and read everything he could find, and the one that gravitated equally to the company of robust men drinking and boasting in saloons. He felt comfortable around the burly crowd, grimy from a hard day's work. From the first, London liked what alcohol did for him, giving respite from the tedious backbreaking ventures of seafaring and prospecting. He later wrote of this phase of his drinking: "It was the way of men who lived the life. Did I wish to live the life; I must drink the way they did."

When he returned from Alaska with no more than five dollars' worth of gold dust to show for his efforts, he wrote stories about the adventures he experienced. In a time before TV or radio, a slew of cheap magazines offered the only readily available popular entertainment, and featured short stories and travel accounts accompanied by *You can't wait for inspiration. You have to go after it with a club.*

—JACK LONDON

colorful artwork and drawings. London dove into this enterprise with the same ethic he learned from line work in a factory, mending lanyards on a ship, or panning a stream for gold—you didn't quit until it was done. Subsequently, in the first year he wrote eighty-eight stories, and kept a journal that recorded 400 rejection slips with fifteen acceptances. One of the accepted stories about his Alaska adventures made it into the widely read *Atlantic Monthly* and soon caught the attention of a book publisher, which put out his first collection, *The Son of a Wolf*, in 1900.

Within a few years London was on retainer with a number of magazines to write more stories, earning today's equivalent of seventy-five thousand dollars annually. He married a respectable woman with the idea that she'd

ground him and save him from his binge drinking, which was slowly progressing to a daily habit. It didn't work, and after having two children, the couple divorced, partly due to her withholding sex upon his return from excursions, believing he had slept with prostitutes and fearing venereal diseases.

I write for no other purpose than to add to the beauty that now belongs to me. I write a book for no other reason than to add three or four hundred acres to my magnificent estate.

—JACK LONDON

Part of the effect of alcohol consumption is prodigality when it comes to money; this was true for London, who often spent more than he earned. In his later years, he said he only wrote to get funds to build a huge house, which he considered a tangible culmination of his life's work, dubbed "The Wolf House." For example, London demanded the house have an imported tile roof that cost more than he made from three years of non-stop writing even at the height of his career. Unfortunately, two weeks before the completion, the near-finished mansion burnt to ashes, every beam and timber charred and useless. He fled to Mexico and succumbed to a wild drinking spree that nearly killed him when he caught a bad case of dysentery. By then, he was in his late thirties, and the physical liabilities of a life of hard drinking had taken their toll. The sicker he became, the more he drank, adding a number of drugs, including morphine, to ease his pains. Where he started out drinking among the joviality of others, he now preferred to imbibe alone. His once magnetic and kind personality turned argumentative. It's never known which body organ will be designated to pay the tab for years of alcohol abuse, and in London's case it was the kidneys that began to fail, a condition that caused his hands to swell and joints to ache.

In the fall of 1916, at age forty, London was discovered comatose on the floor of a cottage on his land. Four doctors were summoned. Seeing a vial of morphine medication nearly empty, they administered an antidote, a heart stimulant, clutched him on the arms, and tried to get him to walk around. He didn't respond and died shortly after. His main physician called his death an outcome of kidney disease. "Uremia following renal colic," was given as the cause on his death certificate, and not suicide, as has long been part of the London myth. However, much of his writing flirted with that notion; he once wrote, "I would rather that my spark should burn out in a brilliant blaze than it should be stifled by dry-rot." Death by end-stage chronic alcoholism surely feels like dry rot and every alcoholic knows of this secret wish, the easing off the abyss when the very thing you counted on your whole life stops working. He had been finishing a novel, *How We Die*; that and another twenty years' worth of classics were never written.

HENRI DE TOULOUSE-LAUTREC

Of course one should not drink much, but often.
—HENRI DE TOULOUSE-LAUTREC

Henri de Toulouse-Lautrec came from a tightly knit aristocratic family—it was so tight, in fact, he was born with many congenital birth defects after generations of inbreeding. His body grew from the torso up, but he retained the legs of a child, in addition to possessing genital hypertrophy, commonly known as giant balls. Despite his physical challenges, he emerged as a notable artist and popular fixture in Parisian bohemian circles. His mother was an art dealer and helped promote and sell his prolific output of more than five thousand drawings and nearly eight hundred oils. Henri loved the good life in brothels, and earned a reputation there as well. For a number of years he actually resided in one whore house, living among the prostitutes who considered him such a dear. He was a good-natured drunk and painted his best work more than half-looped. The Moulin Rouge and other famous cabarets served a drink the painter invented called the Earthquake, a mixture of absinthe and cognac. He ended up in a sanatorium and died at thirty-six, in 1901, from complications of alcoholism and syphilis. In 2005, a Toulouse-Lautrec painting of a prostitute doing laundry, *La blanchisseuse*, sold for more than twenty-two million dollars.

REHABS OF YESTERYEAR

Sanatoriums were the polite word the rich used for psychiatric hospitals. They were shopped for by families with crazies in their midst, similar to the way nursing homes might be interviewed for the elderly today. In a good sanatorium the distressed were locked into rooms that attempted to disguise the severity of the situation. Chairs, beds,

even wash basins were bolted down, though there was an attempt to retain decorum with fancy fabrics covering bars and restraining devices made from soft, padded leather. Patients were subdued with ample amounts of morphine, giving the hallways a church-like quietude. Clients were allowed to relax outdoors in tranquil settings, although they were discreetly bound to chairs, with two burly attendants always close by in the event of unexpected agitation. The less well-to-do were placed in insane asylums, which had no need for the delicacy of calling them sanatoriums: Addicts, alcoholics, and mass-murderers were treated equal. In these places there was no money for morphine. An end-stage alcoholic would be chained to a post, or placed in a big version of a bird cage. Some of the cages were suspended to make room for more. The endless sounds of wails and madness made these first rehabs seem like torture chambers.

> *It is difficult to live without opium after having known it because it is difficult, after knowing opium, to take earth seriously. And unless one is a saint, it is difficult to live without taking earth seriously.*
>
> —JEAN COCTEAU

TIMOTHY LEARY

> *Rules and models destroy genius and art.*
>
> —WILLIAM HAZLITT

As an advocate of psychedelic drugs, such as LSD, psychologist and author Timothy Leary became a cultural icon in the 1960s with his pronouncement: "Turn on, tune in, drop out." LSD, Leary explained, was a drug that could lead to spiritual fulfillment, treat alcoholism, and rehabilitate criminals. His place in the spotlight and his use of drugs caused numerous run-ins with authorities, and ultimately led to his spending time in jail. He was addicted to heroin at one point and lectured widely on the need for space colonization as the only hope for humanity's salvation. To the end, he captured headlines, ultimately setting up a Web site for people to watch his death, noting, "The most important thing you do in your life is to die." He threw caution to the wind, also showing his evolution in drug preference, including his use of nitrous oxide, cigarettes, and crackers and cheese that he garnished with marijuana buds, morphine, and heroin. He died from prostate cancer in 1996 at age seventy-five.

PARANOIA AND LSD

*Writer **Harold L. Humes** was considered a genius, noted as co-founder of the* Paris Review *in the 1950s. His two novels brought gushing accolades, with the* New York Times *saying Humes was "alarmingly talented," and the* Daily Telegraph *of London praising his work as "truly monumental." Humes took considerable amounts of LSD and ended up as a fixture roaming the campuses of Harvard and Columbia. He became known as a harmless, wild-haired, bearded street person who gave brilliant though highly fragmented impromptu lectures, primarily on government conspiracy theories. Like Leary, he died of prostate cancer, in 1992 at age sixty-five.*

JOHN LENNON

> *People like me are aware of their so-called genius at ten, eight, nine. . . .*
> *I always wondered, Why has nobody discovered me?*
>
> —JOHN LENNON

The most iconic of the Beatles, John Lennon was not only praised for his musical talent but for his imaginative and free-spirited lifestyle. He drank and took drugs before joining the Beatles, and continued to do so at will during the band's early rise. In 1964 he began adding LSD; Lennon once said of those years, "I must have had a thousand trips." He also used heroin from around the time when he met Yoko Ono. As Lennon noted: "We took H because of what the Beatles and others were doing to us." With Lennon, no matter how famous he got, he managed to keep the attitude he had learned on the seedier streets of Liverpool, such that he felt comfortable enough to cop an occasional bag of heroin—alone and without bodyguards—in known drug areas of New York City. It's still unknown whether heroin was found in Lennon's blood stream when he was shot and killed by a deranged fan in 1980, at age forty, outside his New York apartment, since his autopsy report remains suppressed.

ROBERT LOWELL

The light at the end of the tunnel is just the light of an oncoming train.
—ROBERT LOWELL

If ever an American poet was born and bred to succeed in literary arts, it was Robert Lowell. His ancestors were writing even as they bobbed and swayed on the *Mayflower*, landing at Plymouth Rock with paper and quill in hand, going on to produce famous poets, philosophers, signers of the Declaration of Independence, governors, and a long list of other prestigious descendants. Of course, when his turn came, Robert was sent to the best Ivy League schools after he decided that he would become a poet. Soon after he graduated, World War II came around, but due to his religious beliefs and opposition to the notion of war, he refused the draft. Subsequently, despite having connections, he was sent to prison for a few months, a low-security facility that later housed Leona Helmsley, the hotel tycoon, and diet-guru-killing socialite Jean Harris. Although his genes, perhaps, helped Lowell to become regarded as one of the greatest American poets of the twentieth century, he was also plagued with severe mental disorders, which required his hospitalization nearly two dozen times for what psychiatrists variously deemed acute schizophrenia or manic depression. He was prescribed Thorazine, a drug that could make a zombie out of even the most vibrantly creative. Nevertheless, Lowell persisted between mood swings, writing poetry, seizing the Pulitzer Prize and numerous accolades. In his personal life he gobbled any number of powerful prescription drugs while drinking heavily and often to excess. Troubled marriages, extramarital affairs, and public outbursts and breakdowns only made him more

admired, though preferably observed at an arm's length. For those closest to him, Lowell was a seesaw where anything went: One day he could send a telegram to the Pope, or stand on his seat at an opera and start conducting with an imaginary baton; then he might break his wife's nose with a sucker punch, or lapse into an emotionally dark place if his toast wasn't buttered evenly. His work was always praised by academics, but once he ditched the old-fashioned style employing meter and strict form, delving into his unique structure, he secured a more lasting place in letters. On the day of his death, he got the notion to leave his third wife in London to return to his second wife in New York City. There's no record of how many mini-bottles of liquor he downed on the plane, but soon after he hailed a cab at JFK Airport, he clutched his chest and died in the back seat, at age sixty, in 1977. The cabbie, though he was more concerned with who was going to pay the fare, said Lowell was clutching a picture of the wife he had just left.

CONSCIENTIOUS OBJECTORS AND THE ARTS

Though less numerous than their European colleagues, notable American conscientious objectors include: boxer Muhammad Ali; writer Dave Barry; Bram Stoker Award winner Jack Cady; poet Carlos Cortez; poet Ezra Pound; actor Richard Dreyfuss; Beat poet William Everson; novelist J. F. Powers; poet Kenneth Rexroth; math genius William Sidis; novelist David Stacton; poet William Edgar Stafford; actor Fritz Weaver; and Beach Boy Carl Wilson.

MALCOLM LOWRY

> *Good God, if our civilization were to sober up for a couple of days it'd die of remorse on the third.*
> —MALCOLM LOWRY

Under the Volcano, which some rank among the top ten novels of the twentieth century, is the singular achievement of the thoroughly alcohol-soaked English writer Malcolm Lowry. He was born the last of four sons to a strict disciplinarian father, and he butted heads with his old man from the start, even if his father proved the most reliable financial support throughout the writer's life. Already a confirmed drinker by his late teens, Lowry signed on to work as a cabin boy for an ocean-going steamer. His first novel, about his experiences, published to no particular fanfare when he was twenty-four, had taken him six years to write. He came to New York for the love of a woman who had him committed to Bellevue Hospital for his drinking. Promising to quit, he was out after three weeks, and before long he headed to Hollywood to be a

screenwriter. Instead, Lowry ended up in Mexico, renting a house in Cuer-navaca, situated alongside an actual volcano, where he wrote the short story that would become the novel. He also began to drink even more furiously, acting not like a happy drunk but a raging madman, and was thrown in jail numerous times. Just before he was nearly lost to the Mexican penal system, his father sent lawyers to escort Lowry back to Los Angeles. Elder Lowry had his son deemed mentally incompetent and appointed a legal guardian. By the age of twenty-seven, Malcolm Lowry had narrowed down life's complexi-ties to two obsessions: drinking and writing. Amazingly, he found another woman to marry, and she tried to save him by moving them to a hand-built shack in the remotest part of British Columbia. He was an incessant reviser and wrote four different versions of *Under the Volcano* while there. When he finally finished it, the shack caught fire and the only thing he saved were the singed pages of his manuscript. It took seven years before the book was published; by then, Lowry had returned to Mexico, where he acquired the taste for mescal (stronger than tequila) and for the maguey worm found in the bottom of the bottle. He lived to read reviews calling his tale of his de-scent into hell a work of genius, although it was not a financial success. Back in England, where reviews were not as kind, he shortly found himself locked in a psychiatric ward and promptly strapped to the electroshock machine. At forty-seven years old, in 1957, after going on a particularly mean-spirited drunk, he chased his long-enduring wife from their small cottage in Sussex, England. When she returned the next morning, Lowry lay sprawled on the floor of their bedroom, a vial of sleeping pills empty, and, as legend has it, the worm from an empty bottle of mescal chewed in half. Instead of suicide, the autopsy listed "death by misadventure," as the cause—an understatement at its best.

LOWRY AND MELVILLE

Lowry understood if you want to sound like you know anything about American litera-ture you have to mention Moby-Dick, *by Herman Melville. The classic novel was not popular when first published, and Melville was considered a flop in his lifetime. He worked nearly twenty years as a seldom-sober customs inspector in New York City, few appreciating Melville's archetypal fable of obsession—the search for the great white whale. Lowry, in contention for the title as the greatest literary burn-out, was inspired not by Melville's persistence at writing despite the lack of applause, or the technical skills displayed in* Moby-Dick; *instead, Lowry's only, baffling comment on Melville was: "His failure absolutely fascinates me."*

LUCAN

*The gods conceal from men the happiness
of death, that they may endure life.*
—LUCAN

Marcus Annaeus Lucanus was born
in Spain to a mega-rich Roman fam-
ily. He was apparently so oratorically
gifted that people gathered around
his crib to hear him speak. One account of his life states that at only eight
months old he began to recite verse and was immediately taken to Rome for
further education. When Lucan was twenty-one he was off studying in Athens
when Roman emperor Nero got wind of his poetic genius and rhetorical skills.
At first, Nero merrily welcomed Lucan into his artistic circle and bestowed him
with a poetic award for his verse. He made Lucan the official Roman *quaestor*,
the "man who asks questions." However, it wasn't long before Nero became
jealous of the attention Lucan received. Since Nero considered himself the
greatest of all Roman artists he decided that he and Lucan should each recite
one of their poems at an informal competition to see whose was better. Though
familiar with Nero's deadly wrath, Lucan couldn't help himself, and, in what
some consider to be a reckless act and the ultimate cause of his early death, he
went off into an elegant poetic performance. There was no doubt that Lucan
received the more authentic applause, and the young poet quickly lost the
emperor's favor. A decree was soon issued banning Lucan's books from the em-
pire. Lucan wrote with an intensity in his imagery and a passion that made him
one of the more popular poets during his time and for centuries to come. He
was also extremely prolific, completing many poems, including *Bellum Civile*, a
seven-volume epic about Julius Caesar that influenced Shakespeare centuries
later. However, soon after Nero's ban, Lucan was implicated in a conspiracy
to overthrow him. Lucan applied his verbal skills to get himself out of trouble
and supposedly implicated his own rich mother in the plot to spare his life. But
Nero only thanked him for the information and for his obsessively uncontrol-
lable tongue. The young poet was condemned to commit suicide by slitting his
veins. Lucan was allowed to hold a banquet, after which the crowds waited to
watch the guest of honor carve open his wrists. As the blood drained and Lucan
died, at age twenty-six in 65 AD, he stayed true to form, reciting one of his po-
ems until the last drop of his life drained away. He left detailed instruction for
his wife on how to edit his works in progress, most intent that his voice keep
on going long after his lips finally stopped moving.

FITZ HUGH LUDLOW

*Marijuana is self-punishing. It makes you acutely sensitive, and in this world, what
worse punishment could there be.*
—P. J. O'ROURKE

Fitz Hugh Ludlow is regarded as a hero, or at least a pioneer, by the cannabis crowd, noted for a more than century-old bestseller, *The Hasheesh Eater*. Although considered a prodigy, Fitz Hugh seemed born with a desire to seek out intoxicants and started snorting cooking spices at the age of four. In college, he hung out at the local pharmacy and willingly volunteered to sample any trial concoction offered, though his life changed when a new drug, Tilden's Extract, became available. This first medicinal cannabis concoction was marketed as a cure-all, and as an alternative to opium. Fitz Hugh ingested the elixir,

each spoonful of which was equal in potency to approximately eight marijuana cigarettes, incessantly, to the point of hallucinating. His praise for the drug's ability to simulate "the stoppage of time" and to expand the mind "into great spaces surrounding me on every side" kicked off a cannabis craze throughout the U.S. Ludlow subsequently became a popular and eccentric figure in the New York City literary scene during the 1850s and 1860s. In the end, Ludlow started using stronger drugs, dying from complications of an opium addiction in 1870, one day after his thirty-fourth birthday.

*The gifted philosopher **Walter Benjamin**'s book* On Hashish *took a record seventy-five years to find a publisher. He hadn't smoked a puff until he was thirty-five, at that point being apparently no longer able to resist his favorite author, Baudelaire, who described cannabis this way: "Hashish always evokes magnificent constructions of light, glorious and splendid visions, cascades of liquid gold." In 1927 Benjamin began a memoir, initially titled* Main Features of My First Impression of Hashish. *He considered himself merely a philosophical observer of sorts, never buying his own stash of hash, or opium, and willingly taking whatever drugs that were offered. He persisted for seven years in getting high strictly for the purposes of writing his book. Although he was admired for his intelligence in other writings, drugs became his path to find man's true meaning, saying "in a state of intoxication—the new, the untouched." However, Benjamin was frustrated that the insights he had and wrote down in copious notes while using seemed worthless when he was sober. At age forty-eight, in 1940, while attempting to flee the Nazis, he took a fatal dose of morphine.*

BELA LUGOSI

Improvement makes straight roads; but the crooked roads without improvement are the roads of genius.
—WILLIAM BLAKE

Bela Lugosi *was* actually born in Transylvania, then a part of Hungary, to a well-off family, and it seemed the role of Count Dracula, for which he is famous, was always out there waiting for him. He left home at age twelve and worked in mines and factories before finding a way to attend theatrical school in Budapest. He rekindled his aura of the stilted aristocrat to become an applauded stage actor in Europe for nearly two decades. In the 1920s he eventually made his way to the U.S., primarily to escape the spread of communism in his native land, but his heavy accent and his penchant for striking a pose to display his regal profile limited the roles he was offered. Yet he soon appeared in Broadway plays cast as a werewolf and then, of course, as Dracula. While on tour in L.A. with the Dracula production, a few movie producers caught his performance. Lugosi's cultured vampire persona got him an audition for the 1930 film version when the originally slated star Lon Chaney died of a throat hemorrhage. Even if Lugosi signed on for a pittance compared to what Chaney was to be paid, the movie became a classic from the start, elevating the thick-accented Lugosi to the hot ticket in town. However, when offered the part of Frankenstein, Lugosi turned it down, saying that the heavy makeup would conceal his profile and that the few grunted lines were beneath his theatrical integrity. It was a big mistake and soon made Boris Karloff, the replacement, the reigning king of horror films. From then on Lugosi made mostly low-budgeted B-movies, cast as a mad scientist or deformed psycho-killer. By the late 1940s he had become a parody of himself and the studio thought it fun to cast him in his Count Dracula role for the comedy *Abbott and Costello Meet Frankenstein*. By the 1950s, his lifelong addiction to morphine, methadone, and pain-killers had thoroughly taken its toll. Broke, physically and financially, he took his Count Dracula act across the country, performing wherever he could, from county fairs, to school auditoriums. He got a gig in a Las Vegas nightclub, but could only last through four performances before

it was cancelled. He resigned to go into rehab and did so for ninety days, then announced to the entire world he was cured. While in treatment he received many fan letters wishing him well, but one from a younger woman, by the name of Hope, no less, caught his eye. Once he was discharged, they met, and Lugosi soon married this woman thirty years younger than him. However, the marriage was plagued with trouble, as Lugosi's previous marriages were, once Hope realized Lugosi was not the same romantic at home that he was in public. Despite having earned more than five hundred thousand dollars during his film years, Lugosi was desperate, with only two thousand dollars to his name, and took whatever roles offered. His years of addiction made it difficult for him to remember lines, and his choice of scripts was even worse than before. In 1956, his new wife found him dead of a heart attack, and a script for a film he planned to do by the name of *The Final Curtain* had to be wrenched from his death grip. Lugosi supposedly never expressed the wish to be buried in his Dracula costume, with full makeup, but his son and wife thought it only fitting. Few attended the service, but those who did reportedly were thoroughly spooked. Today, his genius portrayal of Count Dracula is held in esteem by many horror fans. Kids are now introduced to his rendition of Dracula—and their 1-2-3s —by the *Sesame Street* puppet inspired by his performance, Count Von Count.

Every actor is somewhat mad, or else he'd be a plumber or a bookkeeper or a salesman.
—BELA LUGOSI

The real Dracula was **Prince Vlad Tepes III Dracula**, or *Vlad the Impaler for short.* "Dracula" meant he belonged to the Order of the Dragon, a Catholic chivalric society supposedly started to do good deeds. After his father was tortured and murdered, young Vlad went on a rampage seeking revenge. He'd invite people from his revenge list to attend feasts, and as soon as all were seated, soldiers waiting beneath the floor impaled them with a sharp wooden spear. He hated homeless persons and beggars most of all, and likewise called them to a banquet, impaling them, too, before the first bite. Vlad also thought it clever to leave a jewel in the middle of the road. If anyone came by and put the gem in their pocket—impalement. He believed he was a social genius, instilling the virtues of hard work and honesty in his people. Vlad got a reputation for drinking the blood of his victims, but it was actually huge quantities of red wine that he drank, which helped him find the fortitude to personally skewer an estimated thirty thousand. In the end, Vlad proved mortal, dying in battle in 1476. The victorious Turkish sultan who defeated him put his head in a jar of honey and took it out occasionally to display, propped up on a stick like a gooey candied gourd. Upon his death, Christians hailed Vlad as a hero because he remained faithful to the Church, if not its ideals.

J. ANTHONY LUKAS

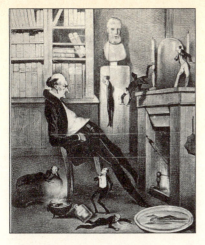

Genius means little more than the faculty of perceiving in an unhabitual way.
—WILLIAM JAMES

J. Anthony Lukas was a highly respected and brilliant journalist, admired for his painstakingly researched articles and books, and for winning two Pulitzer Prizes. He wrote a fourteen hundred-page book, *Common Ground*, about diverging families in Boston, winning the National Book Award in 1985. The memory of his mother's committing suicide by slashing her throat when Lukas was only eight years old remained an image he could not shake. "All writers are," he said, "to one extent or another, damaged people." He admitted that his obsession for research—the very quality that brought his fame—was a way of "filling holes" and a lifesaving distraction not to follow his mother's fate. However, in 1997 at age sixty-four, Lukas sadly hanged himself with the belt from his bathrobe.

DANGLING PARTICIPLES

Some creative artists and personalities who chose this route include: **Stuart Adamson** *(forty-three), of the bagpipe band the Skids;* **Lee Eun-ju** *(twenty-four), a Korean singer;* *actor* **Jonathan Brandis** *(twenty-seven), who starred in* The Neverending Story II; *Ray Combs (forty), host of* Family Feud; **Ian Curtis** *(twenty-three) singer with the band Joy Division;* **Pete Ham** *(twenty-seven) of Badfinger;* **Paul Hester** *(forty-six), drummer for Crowded House; Richard Manuel (forty-two), the Band keyboardist; David Munrow (thirty-three), musical historian;* **Phil Ochs** *(thirty-five), protest/folk singer;* **Marina Tsvetaeva** *(forty-eight), poet.*

NORMAN MAILER

Alimony is the curse of the writing class.
—Norman Mailer

Often overbearing and seemingly ever-sure of himself, Norman Mailer was the Mount Rushmore–size patriarch of American letters for the last half of the twentieth century. When Mailer died, writer Jimmy Breslin's phone rang off the hook with the curious calling to ask him, as Mailer's friend and the last of his curmudgeonly group, what it was actually like to belly up to the bar with the great literary icon during his alcohol-fueled heyday. Typical of many heavy drinkers, Mailer married often—six times, in fact. Not all of them ended amicably; he stabbed one wife with a penknife while he was under the influence, which understandably led to a divorce. People also asked Breslin about the details of Mailer's pot smoking and drinking habits during Mailer's bid for mayor of New York City in 1961, but Breslin simply said, "When you talk of Norman Mailer, right away I see Van Gogh's work boots. Norman was a working man." Another literary icon, Joan Didion, agreed: "Mailer [was] a great and obsessed stylist." Mailer was such an overshadowing presence to emerging writers that many sought to knock him from his perch, often through harsh reviews, which Mailer characteristically took as a compliment. The writer persisted despite what he referred to as his "pickled liver," forever at work on "the big one," hoping to write the great American novel. In 2007, at age eighty-four, Mailer died of renal failure.

KLAUS MANN

Talent is often inherited; genius, rarely or never.
—Samuel Taylor Coleridge

The famous German writer Thomas Mann thought his elder son, Klaus, a disappointment, even though he wrote brilliantly from an early age, and published a highly regarded novel, *Mephisto*. Regardless of accolades from others, it was impossible in Klaus's estimation to match his father's genius, subsequently leading to heroin addiction and what he called "the urge to die." After a few failed suicide attempts, he succeeded at age forty-three, in 1949, from an overdose. Thomas Mann didn't interrupt his lecture tour and missed his son's funeral.

MICKEY MANTLE

Baseball legend Mickey Mantle was considered a natural-born genius of the game. His personality on and off the field was magnetic; he was a true all-American hero who would go on to hit 536 home runs, and once whacked the ball so hard it sailed an incredible 461 feet. Even with that level of success, in the beginning of his career Mantle still rode the subway like a regular guy to play at Yankee Stadium. In later years, this loveable icon, because of old injuries and alcoholism, became cranky as he made the autograph circuit selling memorabilia. One fan, who was given the name Mickey Mantle Fortin in honor of the ballplayer, described the time he finally met his idol. The Hall of Famer, a few years into his drunk and belligerent retirement plan, looked up and tried to focus when Fortin explained, "I'm probably one of the first kids in the country named after you." Mickey: "You think I really give a shit, kid? You know how many kids in this country are named after me?" Mantle died of complications from alcoholism after a failed liver transplant in 1995. Regardless, Mickey Mantle, Number 7, remains a champion to many who are unable to forget the sweet sound of the ball when it met his powerful bat.

CHRISTOPHER MARLOWE

What feeds me destroys me.
—CHRISTOPHER MARLOWE

When a shoemaker learned that his wife had given birth to a son in Canterbury, England, in 1564, he was relieved that he'd have a dutiful apprentice as he grew older. He had no clue that the son he nicknamed "Kit" would instead become a literary meteorite and the most influential Elizabethan playwright next to Shakespeare. By school age, Christopher Marlowe showed enough wits to garner a scholarship to Cambridge, and is believed to have worked for England's

first master spy, Sir Francis Walsingham, supplying information on Queen Elizabeth's behalf, which to date remains sealed. Marlowe's first play was performed on the London stage when he was twenty-three. It met with great success and was heralded as the first to offer a more natural language, called blank verse. He also wrote certain parts in his subsequent plays for known actors that not only made them perform more authentically, but assured popular appeal. *The Tragical History of Doctor Faustus* had a record twenty-five stage pro-

ductions in three years. His genius in transforming the old folktale about a man who made a secret deal with the devil arose from a firsthand knowledge of such bargains—Marlowe was called upon by the spy network whenever they needed. However, as alliances changed during Elizabeth's reign, Marlowe became a liability. It was hard to tell where Marlowe stood in his plays, that is, whether he was Protestant, Catholic, or heretic. In addition, the theater scene had more than its share of underworld figures ready to make loans to starving actors who often spent all their money on loose women and flowing wine. Marlowe, a man of formidable stature who inherited the strong hands of a cobbler, had a reputation as a bar-brawler, because he had a short temper when drunk. A plan was hatched to bring Marlowe down; handbills considered libelous to the Crown were signed with Marlowe's name and posted around town. An order was put out for his arrest, but he happened to be staying with Thomas Walsingham, the old spymaster's nephew, who encouraged Marlowe to appear before the council and state his case of innocence. Marlowe did so, assuming that his service as a spy was still useful, and after a brief appearance at court, Marlowe was let go. Ten days later however, he was murdered, with a dagger stuck through his eye. His attacker was Ingram Frizer, a man with a rap sheet for loansharking and ties to the espionage circle. According to court documents, Frizer and two men employed by the Walsinghams met Marlowe in the house of a widow, Eleanor Bull, for dinner. Shortly after, a fight broke out, resulting in Marlowe's death. Frizer was found innocent, swearing under oath that Marlowe went into a drunken rage over the amount of money he owed and attacked him first. Pleading that he and the others acted in self-defense, Frizer received a formal pardon from the Queen. The loss of Marlowe's talent was recognized immediately and was mourned by artists. The performance of his work continued, though many directors added, deleted, and revised as they saw fit, making what Marlowe actually wrote a chore to decipher. One young actor-turned-writer by the name of Shakespeare liberally borrowed lines, themes,

and dramatic techniques Marlowe first devised. The deal Marlowe had made with his devilish muse was a bad one, as he died before but a small portion of his genius came to light and was buried in an unmarked grave, at age twenty-nine, in 1593.

GUY DE MAUPASSANT

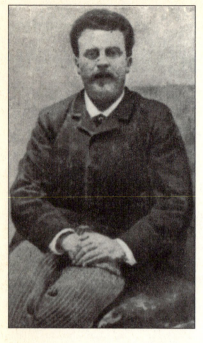

The essence of life is the smile of round female bottoms, under the shadow of cosmic boredom.
—GUY DE MAUPASSANT

French writer Guy de Maupassant had an obsession with getting laid. He grew up in an idyllic and scenic countryside, raised only by his mother after his father left the marriage for a younger woman. His mother tutored young Guy in the classics, and in turn he was overly devoted and close to her. She happened to be a child-hood friend of famous writer Gustave Flaubert, who eventually mentored Guy and got him in with publishers. When Guy finished college, the Franco-Prussian War had suffused the country with a patriotic spirit and he enlisted, with no incidents on his records except for bravery. He stayed with the military, working as a clerk and then in the Ministry of Public Instruction in Paris for the next ten years, and there not only practiced writing in earnest, but drank heavily and chased women, more often than not at brothels. Consequently, he had acquired syphilis by his early twenties. At age thirty his first important short story was published, to critical acclaim. For the next decade he wrote prolifically, earning enough to do nothing but write, producing six novels, three travel books, and three hundred short stories, many heralded as masterpieces in his own time. Today, he is remembered mainly for his thirty or so horror stories that predominantly preoccupied his thoughts as his brain was deteriorating from the effects of syphilis. He went into hiding, imagining that there were numerous plots afoot to kill him, and began to devise bizarre rituals to ensure self-preservation. By the age of forty he was pronounced legally insane and tried to kill himself by slitting his throat. Shortly after this failed attempt his elderly mother tried to care for her beloved son but had no choice but to place Guy in an insane asylum. In 1893, at age forty-two, the master of the short story died from exhaustion and syphilis, chained and strapped, gnawing at his own ankles to escape, reportedly howling with laughter, as hideously as any character in his stories.

MAUPASSANT'S HEADACHE CURE

"The dreadful pain racks in a way no torture could equal, shatters the head, drives one crazy, bewilders the ideas, and scatters the memory like dust before the wind. A sick headache had laid hold of me, and I was perforce obliged to lie down in my bunk with a bag of ether under my nostrils."

JOSEPH McCARTHY

Every man who observes vigilantly and resolves steadfastly, grows unconsciously into genius.
—EDWARD BULWER-LYTTON

Although former senator Joseph McCarthy's genius status is currently listed under "dubious," at one time he was considered as much. He started out doing honest work on a farm, then went to law school, became a judge, and then a Marine in World War II. He returned home determined to become a politician and used the patriotic appeal of his war record (and his opponent's lack of one) to get elected senator at age thirty-eight. Near the end of his undistinguished first term he suddenly showed himself to be a master politician. Virtually overnight he seized nearly every headline in the U.S. by announcing that he had a secret list of Communist sympathizers and spies working in the State Department. At a speech he waved a piece of paper that he claimed held 207 names, though if it was his grocery list instead that he unfurled, it was never known. In 1950 McCarthy was appointed head of a committee established to conduct "a full and complete study and investigation as to whether persons who are disloyal to the United States" were working in the government. The committee, run by a man well noted for traveling with a full flask in his briefcase, started the greatest witch hunt in American history. Thousands lost careers, and their families were made destitute by mere accusations. No spies were unearthed during the four years of McCarthy's free rein, until he was formally censured by the Senate in 1954. Afterward, disgraced and humiliated, he made numerous attempts at detoxification, but failed to stop drinking. Finally, he was taken to the famous Tower 16 at the Bethesda Naval Hospital, the private floor where prominent leaders went to secretly dry out. The attendants always had trouble with McCarthy, but his last visit there was the worst. He smashed a chair over an attendant's head and had to be wrestled into a padded cell, dying there at age forty-eight, in 1957, officially of cirrhosis.

This is the most unheard of thing I've ever heard of.
—JOSEPH MCCARTHY

Unlike McCarthy, J. Edgar Hoover, FBI director, was the man with the real list. In the 1950s he was at work on compiling a "Security Index" that had the names of twelve thousand U.S. citizens considered radicals and who "might be dangerous." He wanted to arrest and indefinitely detain this lot and try them, if at all, by one judge and two citizens that were not "bound by the rules of evidence." Hoover's obsession *for secrecy backfired when, after his death, a journalist once jailed by Hoover effectively spread the rumor that the director engaged in cross-dressing, and that many of his bright ideas were born while he was reflecting on the bottom of a highball glass. Hoover's personal papers on this issue were shredded.*

CARSON McCULLERS

Passion holds up the bottom of the universe and genius paints up its roof.
—CHAO CHANG

With five novels, two plays, and a few dozen other writings, Carson McCullers left an enduring mark on the cultural landscape. She specialized in describing the struggles and impossibilities sometimes inherent in trying to find love. Her childhood was unremarkable: She was the daughter of a jewelry store owner in a small southern town, where she preferred practicing the piano to playing in the schoolyard. A serious childhood illness, later believed to be a misdiagnosed case of rheumatic fever, curtailed her dreams of becoming a professional pianist, rendering her perpetually "sickly" for most of her life. Her time recuperating in bed was spent reading; she eventually found writing as a way to hit the melancholy notes she seemed born to play. At twenty years old, wrapped in fever-soaked sheets, she began her first novel, *The Heart Is A Lonely Hunter.* When the book was published, McCullers became an instant literary sensation, appearing on the New York literary scene dressed in pants, and with a pageboy haircut—the perfect embodiment of the adolescent angst the novel explored. Her personal life revolved around a troubled marriage which was further tested when both she and her husband Reeves McCullers had bisexual affairs. She married, divorced, and married him again, until at

last he tried to convince her to enter into a suicide pact. He eventually did kill himself with alcohol and barbiturates, which she chronicled in her play *The Square Root of Wonderful*.

Plagued by constant sicknesses—including numerous strokes, blurred vision, and the loss of movement on the left side of her body by age thirty-one— she also smoked cigarette after cigarette and drank to excess. Her alcoholism perpetuated and aggravated her condition, though she refused to believe that even slight moderation could improve her psychical rehabilitation. She relied on drinking to momentarily ease the pain, both physically and mentally. Despite the physical handicaps and constant hangovers, she wrote. McCullers believed if drinking herself to an even earlier grave allowed her to create another story, then it was worth it. She was argumentative and downright belligerent toward anyone who told her otherwise. In 1967 she had another stroke, which caused a fatal brain hemorrhage. Charles Bukowski, who could spot a fellow drunk, wrote a eulogy, saying that McCullers "died of alcoholism wrapped in a blanket on a deck chair on an ocean liner." She actually died in a hospital in Nyack, New York, after forty-seven days in a coma, at age fifty.

The writer by nature of his profession is a dreamer and a conscious dreamer. He must imagine, and imagination takes humility, love and great courage. How can you create a character without living and the struggle that goes with love?
—CARSON MCCULLERS

MICHELANGELO

When Michelangelo Buonarroti left home as a young man his father sat him down and gave a piece of advice he never forgot. Water, his father warned, and bathing in particular, was bad for the health. More than all else, Michelangelo took this counsel to heart and it became a monomania that affected his life and art. It's plausible that without this monomania, the logistics of creating his masterpiece, the painting of scenes from *Genesis* on the ceiling of the Sistine Chapel, would've been even more difficult to execute. He labored on a scaffold, standing straight, or kneeling, with his head perpetually tilted back and gazing up, for nearly four years to get each portion of the masterpiece perfect. (It's hard to imagine the neck and shoulder cramps he suffered each day.) In addition to being artistically a perfectionist, Michelangelo insisted on remaining at his post, wearing and sleeping in the same clothes for months at a time. Because the Sistine Chapel scaffold was sixty-nine feet off the ground, he relieved himself in buckets, and had what little food he ate passed up to him. Everyone recognized his genius, but undoubtedly had to stand downwind when Michelangelo came back to Earth. The artist has been called everything from "The Divine One," to "Inventor of Obscenities," since he had a knack for painting accurate male genitals

in much of his work. It's no surprise he never married. Though he believed he was strictly adhering to his own notion of a safer practice of hygiene, the Sistine ceiling, more than any other project, ruined his eyesight and his health. He seemed to become more depressed, or melancholic, as they called it, than before. But thanks to his father's odd advice, he survived, living a lonely life to the age of eighty-nine—which a scrub brush and a bath might have changed.

EDNA ST. VINCENT MILLAY

Come and see my shining palace built upon the sand!
—EDNA ST. VINCENT MILLAY

Edna St. Vincent Millay's middle name is taken from a hospital, St. Vincent's in New York City, where a relation had been spared from death only hours before Edna's birth. The father who thought up this bizarre token was later divorced by Edna's mother when he failed, she believed, to provide adequately for her and their three daughters. Edna and her family were allowed to stay in a small cottage on the grounds of a rich aunt's estate deep in the heart of Maine, and it was there she learned to write poems that would make her a literary celebrity for much of the middle part of the twentieth century. Independent and often belligerent toward authority from the start, Edna preferred to be called Vincent as early as her high school years, where her verse was deemed of such quality she was awarded a scholarship to Vassar College solely on the merits of one poem.

The soul can split the sky in two,
And let the face of God shine through.
—EDNA ST. VINCENT MILLAY

Upon graduation she migrated to New York City, settling in Greenwich Village, and before long became the epicenter of the bohemian community. Her fame was cemented in 1923 when she became the first woman to win the Pulitzer Prize for poetry. She was hailed as the epitome of the free-thinking female, even if many of her poems had to do with a traditional subject, love. Stylistically, she was criticized for not embracing many of the newer developments in the craft, preferring the older forms of lyrical writing. Nevertheless, her poems remain some of the most widely reprinted of any from the twentieth century.

In her personal life she had a voracious appetite for pleasure, racking up a long list of affairs with famous figures of both sexes. During her teaching career she thought nothing of having relations with female students. She married an older, wealthier man, Eugene Boissevain, who seemed unperturbed by her frequent dalliances, and kept her financially secure for as long as he lived.

Edna never gave him the boot as her mother had done to her father, and always returned to their 650-acre upstate New York country farm, dubbed Steepletop, when she had grown tired of whatever new infatuation had drawn her away. In fact, Boissevain left his career and dedicated his life to managing Edna's literary affairs. Even though Edna considered herself a feminist, she capitalized on the fragile girl-child image, and never failed to use her physical beauty to her advantage. It's no surprise that her quest for pleasure, since she was unwilling to resist any new experience that came her way, led to a serious addiction to drugs and alcohol. One entry in her journal shows that before lunch she had had a shot of morphine, three gins, and a half a pack of smokes. Her faithful husband took her numerous times to rehab, though he apparently also allowed her to return to her old ways once she was home, and he reportedly even tried some of her drugs himself to better understand her suffering. Eventually he had to entertain the numerous guests who wanted to be in the company of the great poet while she stayed in her room, often sobbing over the loss of her ability to create. Her addictions progressed to the point where Edna woke to an alarm

on the hour so as not to miss a morphine injection, in addition to ingesting Nembutal, Benzedrine, Demerol, Seconal, luminal sodium, phenobarbitol, codeine, insulin, and Nervosine. When Boissevain died of lung cancer, which was possibly caused by second-hand smoke, Edna descended rapidly. In 1950, at age fifty-eight, she was alone in Steepletop, reading and writing notes in the eerily dim solitude when she took her customary bottle of wine up to bed, though that evening apparently she left the bottle on the top step. She believed everything she had written was worthless and once commented about her whirlwind life: "I have been ecstatic; but I have not been happy." She looked in the mirror and saw a turgid, sodden hag and suddenly understood why young men and women no longer fell in love with her, or why the thunderous applause of her public reading, radio, and lecture days was gone, leaving only unbearable echoes. Officially, Edna's death was deemed an accident, but the exact cause of the accident remains a question mark: The night she died, she apparently searched for the wine in her bedroom when she remembered where she had left it. The wine bottle remained on the top step as Edna tumbled head over heels down the steep staircase. She was found dead with a broken neck at the bottom. Saint Vincent, Edna's (middle) namesake, is honored as the patron saint of wine producers; he was tortured and killed, also at the age of fifty-eight, in AD 304.

My candle burns at both ends,
It will not last the night;
But ah, my foes, and oh, my friends,
It gives a lovely light!
—EDNA ST. VINCENT MILLAY

FAMILY TREE

That cottage in Camden, Maine, where Edna spent her childhood must have had the blessings of the muse. Her sisters, Kathleen and Norma, both became poets and writers. Kathleen had the same driving ambition as Edna, publishing five novels and as many books of poems, though she never had the iconic reputation her older sister had. She badgered Edna for money and made negative comments about her in the press, eventually ending up working in a factory during World War II. Kathleen died at age forty-six in St. Vincent's Hospital in 1943. Youngest sister Norma moved into Steepletop as soon as Edna died and took over caring for Edna's papers, living the longest, to age ninety-two, dying in 1986 in the same house, though in a bed, not on the staircase. The mother of the muse-blessed daughters, Cora Millay, wrote a book of poems herself once the kids were off and running, but died of a cerebral hemorrhage while feverishly at work on another, at age sixty-eight, and was buried on the grounds of Steepletop.

JOHN MINTON

When World War II broke out, painter and noted theatrical set designer John Minton knew the draft would bring more than the dangers of warfare. Although a conscientious objector, Minton joined the British Pioneer Corps, and was responsible for logistics such as catering and laundry duties. Outwardly, Minton was spritely and charismatic, producing numerous drawings, and his work was exhibited in London and New York. His triumph lasted only a few years; by 1950 his style went out of vogue. He tried to adapt, but turned to heavy drinking, stung by criticism, considering himself a failed painter. He appeared his ever-energetic self until he came to a complete halt, to the surprise of many, with a death by overdose of Turinal in 1957, at age thirty-nine. His self-portrait, bequeathed to the Royal Academy, portrayed the unhappiness he saw in himself, and hid from all.

YUKIO MISHIMA

If we value so highly the dignity of life, how can we not also value the dignity of death? No death may be called futile.
—Yukio Mishima

Japanese writer Yukio Mishima (pen name for Kimitake Hirakoa) was famous for various obsessions, and although they changed, his final infatuation resulted in ritualized disembowelment and beheading with a samurai sword. As soon as he was born, his grandmother took charge of his rearing, reasoning that Yukio's parents lived in a second-floor apartment and that the fragile boy might fall from the window. It was not until he was twelve that he lived full-time with his doting mother and his father, who was determined to knock the apparently effeminate streak out of his son with heavy-handed discipline. Yukio's father once pretended he was going to throw him in front of a speeding train, hoping such tactics would shock some manliness in the boy. He worried that Yukio wrote poetry and was regularly beaten at school for his affiliation with the literary club. Since his father habitually ransacked his room to search for writing, he chose the pen name Yukio Mishima (meaning "man who chronicles reason"), to hide his identity. By his mid-teens, Yukio was already publishing stories in respected publications. When he was drafted into World War II, a few months before Japan surrendered, he manufactured a cough so he would flunk the medical exam—an act of cowardliness, as he later called it, that haunted him for the rest of his life. By age twenty-four he published an autobiographical novel, *Confessions of the Mask*, about homosexual yearnings and his fascination with masochism and death that was heralded as a work of genius, catapulting him into notoriety.

Although a frequent carouser at gay bars, he married and had two children. He also became obsessed with sculpting his frail and scrawny body into a work of art, practicing bodybuilding and becoming a master at kendo and karate, with the notion that he could cheat aging and death. Paradoxically, while he worked strenuously to get fit, he was equally fascinated with violent deaths, once posing semi-nude, showing off his six-pack, impaled with arrows, in imitation of St. Sebastian. Nevertheless, his literary output was nonstop; he produced forty novels, eighteen plays, twenty books of short stories, and as many books of essays before his death, mostly to rave reviews internationally.

In the last years of his life, his fame in Japan had waned, due partially to overexposure, but mostly because of his radical ranting. He became an advocate of returning the rapidly Westernized Japan back to its traditional self, complete with emperor-worship. While on one hand he called for the return of samurai ethics, on the other he lived in a western-style house and wore the latest in western fashions. He formed his own army, called the Shield Society, and enlisted one hundred young boys and men who were as dedicated as he

was to form a new warrior class. He provided military uniforms, the kind he never wore in World War II, and held rallies vowing to protect the emperor, who, at the time, didn't particularly need protecting. In reality, he was using this movement as a way to plan his own spectacular ending. Not only did he need to prove his prowess as a man, he wanted to be remembered for eternity not only as a writer, but as a warrior and martyr. In 1970 he arranged a meeting with the head general of Japan's army, and instead of sitting down for a talk, Mishima, and a handful of his closest cadets, took the general hostage. Then Mishima went out on the balcony in front of the assembled regular army troops

and encouraged them to stage a coup d'etat, in the hope of bringing samurai values once and forever back to Japan. The soldiers laughed and booed him into retreat. Once back in the general's office he ceremoniously knelt on the floor and then stuck a dagger into his gut. A moment later, a cadet, twenty-five-year-old Masakatsu Morita, whipped out a saber and with three fierce blows tried unsuccessfully to lop off Mishima's head. It got messy, until another cadet took a swing and succeeded. Morita then kneeled, and he too had his head severed. Mishima, the "man who chronicles reason," was forty-five.

Hara-kiri, also called seppuku, was a samurai tradition that required warriors to commit suicide if it seemed they were to fall into enemy hands, or to rectify shame. The ritual required a knife to be plunged into the abdomen, making a left to right incision, followed by decapitation. According to the purist, the head was supposed to be left attached to the body by a small thread of flesh, and not bounce away as Mishima's did. The man who did the job on Mishima and Morita was an expert swordsman and law student named Hiroyasu Koga. He served four years in jail for the incident and is currently a monk in a Shinto monastery.

AMEDEO MODIGLIANI

> *The artist's task is to become a successful eccentric, a strange but wise duck able to venture out of solitary confinement and mingle among society.*
> —ERIC MAISEL

Amedeo Modigliani was born to a prominent Italian-Jewish family, though by the time he arrived they were in dire financial straits. Nevertheless, his mother passed on an aristocratic air. She also passed along a genetic lineage riddled with madness that equally served and destroyed her avant-garde son. When Amedeo was a teenager his mother allowed him, her favorite and youngest child, to drop

out of all studies other than art lessons. Whenever he came down with any normal childhood illness his mother wept that poor Amedeo was singled out for an early grave. He came to believe her, and set out to live fully, ferociously pursuing pleasure—and his art. By age eighteen he had haunted all the museums of Naples, Rome, and Florence, and attended the Institute of Fine Arts in Venice. There Modigliani found an abundance of models in the canal city's brothels, and also acquired a passion for hashish and other drugs.

In 1906, at age twenty-one, he announced to his mother that life must be sacrificed for art and soon after migrated to Paris. In his head he heard drum rolls and trumpets heralding his triumphant arrival in the art world, which his mother had made possible with a small stash of money she had squirreled away.

It is our duty never to be consumed by the sacrificial fire. Your real duty is to save your dream. Beauty too has some painful duties: these produce, however, the noblest achievements of the soul.

—**Amedeo Modigliani**

At first, the legendarily handsome Modigliani did make a spectacle of himself, being seen about town wearing a black suit with starched white shirts and a flowing black cape, and renting a lavishly decked out apartment in an affluent part of Paris. However, within a year, his allotment of funds had been depleted and he was forced to move into a wooden shack in an artist shantytown. The aristocratic wardrobe was replaced by tattered work clothes that he nevertheless adorned with either a bright red sash which he wore for a belt or as a scarf around his neck. It wasn't long before Modigliani acquired a reputation, not only for his art, but for being forever high on hash, alcohol, ether, or all three. Despite his living conditions, an endless parade of models came happily to his hovel to be painted nude and to sleep with this eccentric artist, especially after his work was accepted for exhibition in notable galleries. For the next eight years his paintings and sculptures were exhibited and critically praised, yet no financial rewards materialized. He begged for marble and bartered for paints. By the time he was twenty-nine, his lifestyle and his frustration at his lack of success drove him to a mental breakdown. He returned home to Italy, unrecognizable to friends—his head was shaved, his clothes were in tatters, and he was apparently addicted to absinthe. His acquaintances put him up in a broom closet and supplied him with stones taken from the street to sculpt. When he again left Italy for Paris, he offered

his work to his friends, but instead they threw what today would be worth millions in a ditch. Once back in Paris he finally found a new dealer interested in his work. The dealer put Modigliani in a spare bedroom with a bottle and locked him in there until he had finished producing at least three drawings. By then Modigliani had developed an artistic philosophy that dictated he must complete a painting in its entirety at one sitting and never alter it again— perhaps he was aware that he was running out of time. At age thirty-five, in 1920, he began spitting up blood and soon died of a kidney ailment, or as some reports cite, tubercular meningitis. Modigliani once said, "Alcohol is evil . . . the Devil's beckon. But for us artists it is necessary."

The woman whom he married during his waning years, a nineteen-year-old art student named Jeanne Hébuterne, was nine months pregnant with Modigliani's child when he died. Hours after the artist expired she leapt to her death from an apartment window, killing herself and the unborn child. The man who died destitute, trading paintings for meals, has since had a dozen books and three feature films made about his life. One of Modigliani's portraits of Jeanne sold at auction in 2006 for more than thirty-two million dollars.

Life is a gift: from the few to the many: from those who know and who have to those who do not know and who do not have.
—AMEDEO MODIGLIANI

SETH MORGAN

I always was a rebel . . . but on the other hand, I wanted to be loved and accepted . . . and not just be a loudmouth, lunatic, poet, musician. But I cannot be what I am not.
—JOHN LENNON

If nine DUI arrests are not an omen of how death will come, scant else will qualify. Seth Morgan managed to write one novel, *Homeboy*, in 1990, which was praised for capturing the insider's view of the drug world's underbelly, and which the *New York Times* called a "savagely comic and often brilliant" book. Seth had the luxury to explore his bad-boy persona in both his written work and in life, funded as he was by a lucrative trust fund built on a family fortune made from household soap. By 1970 Seth had picked up a costly heroin addiction that soon exhausted even his trust fund. To feed his habit he took a number of odd jobs, including barker for a strip club, and then as a pimp—even making his wife work as a prostitute. Before long he was convicted for armed robbery and sent to prison for more than two years. Once out of jail he promised "to drink myself to death," but instead, during what he described as a six-

month period of sobriety, Morgan wrote *Homeboy*, for which he earned nearly a half million dollars. However, within weeks of its publication, Morgan was involved in a hit-and-run accident and had another DUI arrest, having blown most of the cash he had earned on drugs and on a spending spree for new cars and motorcycles—all of which he totaled. With his last funds, in 1990, he purchased a new Harley then soon crashed that as well. He didn't walk away from this accident as he had from numerous others; instead, Morgan, age forty-one, died from trauma—namely, a forty-foot flight that ended with his smashing into a concrete piling—precisely because of the cocaine, Percodan, and three times the legal limit of alcohol that were found in Morgan's blood.

JAMES MURRAY

Glory is fleeting, but obscurity is forever.
—NAPOLEON BONAPARTE

Some have a genius for timing, perhaps destined in some way to cross paths with others who might help achieve their goals. For actor James Murray it happened twice, though in the end it couldn't spare him from ruin. Born in the Bronx, James loved to spend time in movie theaters more than anything, and even got a job as an usher. When he finally decided to head to Hollywood in 1925 to be in movies, he seemed relegated to being a mere extra, playing no other part for more than three years. Then one day, King Vidor, an acclaimed film director, was pacing outside the MGM lot in deep thought when he suddenly realized that what he needed for his new film, which was eventually to become the Academy Award–nominated *The Crowd*, was a new face. As he looked up, he spotted James Murray walking by and knew instantly that James had the Everyman look he needed for his story, which centered on a lackluster office clerk who suffers trials and hardships amid the impersonal crowds of New York City. King ran after Murray and gave him his card, instructing Murray to show up for an audition. Murray thought he was the butt of a joke of some sort, or that the famous director must've mistaken him for someone else, and he decided to miss the appointment entirely. King went to great lengths to find Murray and subsequently cast him as the lead, despite the actor's protests that he didn't think he was good enough to play the part. When the film was released in 1928 Murray was proven wrong. The critics loved him, even if the film's dark realism and lack of a happy ending caused less laudable box-office returns. Murray was cast beside Joan Crawford for another film soon after, though fewer and fewer offerings followed, because of his excessive drinking. Murray returned to New York City, eventually becoming homeless, living as a panhandler and a street wino. However, a second stroke of serendipity struck: One day, Murray shuffled up to a passerby to beg for spare change.

Out of an anonymous crowd of millions, the man happened to be none other than his former mentor, King Vidor. The director was moved by the chance meeting and offered Murray a role in his upcoming film. Murray wanted to be left alone with his bottle, and refused, believing the offer was made as only an act of pity. In 1936, at age thirty-five, Murray fell through the slats of a dilapidated pier where bums often went to get a reprieve from the crowds. He drowned in the Hudson River. Police were unable to determine if the transient's death was accidental or self-inflicted. Nevertheless, once the John Doe corpse in the morgue was identified as the former star, the coroner believed suicide the only logical explanation—what else could explain the death of a man who squandered a double-dose of luck?

PAST LIVES

*In the 1940s **Bobby Driscoll** was a talented and very cooperative childhood star. He was the first human Disney put under contract, for* Song of the South. *In 1949 the twelve-year-old won a special juvenile Oscar for his performance in* The Window. *The kid had talent, but soon discovered that his boyish look was what mattered. As soon as the clock struck puberty, Bobby was out of work. By sixteen he was smoking pot, and by nineteen was arrested for heroin. His comeback attempts were stymied by the needle tracks on his arms. Asked why he continued to use drugs after attempts at rehab, he reasoned: "I was carried on a satin cushion and then dropped into a garbage can." In 1968, soon after his thirty-first birthday, his corpse was discovered in a trash-strewn, boarded-up building in Greenwich Village, lying beside two empty beer bottles and a hypodermic as the sad and final statuettes for his achievements.*

ALFRED DE MUSSET

> *How glorious it is—and also how painful—to be an exception.*
> —ALFRED DE MUSSET

The young Parisian named Alfred de Musset was spotted as a prodigy and won a prestigious contest for an essay that he wrote in Latin at the age of nine. He thought he wanted to be a doctor and was sent to medical school while still in his teens. However, he soon was repelled by dissecting dead bodies and quit, turning to literary endeavors. By the age of twenty he was the sensation of the cultured crowd and secured a cushy job as librarian of the Ministry of the Interior, even though he had an equally notorious reputation as a rowdy bad boy. He then made more heads turn when he had a celebrated affair with novelist and feminist George Sand, who was one of the first women to wear men's clothes in public and smoke a pipe. He called his love "the most womanly woman." It lasted two years, until they traveled together to Venice and both became ill, and Sand fell for the physician who nursed her back to health. Contemporaries

such as Charles Baudelaire didn't hesitate to attack: "The fact that there are men who could become enamored of this slut is indeed a proof of the abasement of the men of this generation." Musset was assuredly of his generation and became heralded as one of the leading French Romantic poets of his time. After he returned alone to Paris his shattered ego found shelter in brothels and weekend-long adventures at the inhalation end of an opium pipe. He was engaged once, but never married. Musset managed to keep up a balancing act of literary flashes of genius and an opium habit

for nearly ten years, though it had begun to considerably slow down his prolific output by his mid-thirties. The few plays he wrote afterward met with some success as he displayed a more introspective and sullen view on the psychology of love. As his health failed, high-level connections allowed him access to the best doctors. The leading medical minds determined the writer had an unusual heart problem termed in medical annals thereafter as the Musset symptom. They attributed Musset's jerking head spasms and the shaking of his whole body in synchronicity to his heartbeats as a "severe aortic insufficiency," and announced their discovery with great fanfare. However, no one ever told Musset to stop drinking incessantly or to quit smoking dope. He died at the age of forty-six in 1857.

GÉRARD de NERVAL

A person needs a little madness, or else
they never dare cut the rope and be free.
—NIKOS KAZANTZAKIS

The French Romantic poet and essayist known by the pen name of Gérard de Nerval was heralded as a major influence on the emerging Symbolist movement in the arts. He was a firm believer that marijuana and opium are necessary to free the spirit-muse within. He was the founder of the exclusive Club des Hashischins, where members such as Charles Baudelaire and Alexandre Dumas (author of *The Count of Monte Cristo*) gathered to smoke hash, drink laudanum, and conduct séances. He also turned into a tourist attraction of sorts, known for far-fetched eccentricities such as keeping a large red lobster as a pet, which he walked down the street attached to a blue ribbon. In the end, his destitution from the effects of his addictions became severe. One day he tried to pawn a leather strap he claimed was an antique, once owned by a famous actress dead two hundred years, but found no buyers. He went back to his flat, torched up a bowl of hash, and then tied the strap around his neck. He was found hanged from the window grate of his elderly aunt's apartment at age forty-six in 1855. His suicide note: "Do not wait up for me this evening, for the night will be black and white."

FRIEDRICH NIETZSCHE

A man who possesses genius is insufferable
unless he also possesses at least two other
things: gratitude and cleanliness.
—FRIEDRICH NIETZSCHE

Friedrich Nietzsche remains widely known as an influential philosopher and psychologist whose massive writings during the late 1800s were considered controversial, never more than when he wrote: "God is Dead." Although he labored in near obscurity during his life, many of his concepts proved brilliant and enduring. Nietzsche's contemporary, novelist Fyodor Dostoevsky said: "[Nietzsche] is

the only psychologist from whom I have anything to learn." Nietzsche began to show signs of mental illness in his later years and required hospitalization. Some believed his mental state was caused by his obsession for philosophical thought, while others believed it to be a side effect of syphilis. After more than a decade in and out of insane asylums, and what he described as excruciating pain "two hundred days a year," he died of a stroke, in 1900, at sixty-three.

ROGER NIMIER

There are no speed limits on the road to excellence.
—David W. Johnson

The handsome French novelist Roger Nimier cut an elegant figure and presented a newer, more carefree model of the spirited artist, rebelling against the preceding generation of writers. He formed a movement that distanced itself from the darker themes of fellow Frenchman Albert Camus and his talk of nothingness, and equally dismissed Jean Paul Sartre's persistent concern with politics. Instead, Nimier liked fast cars and wrote of young beautiful heroes seeking adventurous lives. At twenty-three he became a literary sensation with his first novel, *The Swords*, published in 1948. He was thrust into celebrity, representing a generation of youths who did not die in the war and who struggled with their personal and national humiliation of occupation and defeat. Nimier followed his debut with six more books in five years. Then he announced he had abandoned the novel, subsequently becoming a respected cultural critic. One theme persistent in Nimier's books was an infatuation with car crashes. In 1962 he was last seen driving his Aston Martin at a blurring 150 miles per hour. This was not such an oddity for this speed-demon writer; what was unusual was that, according to eyewitnesses, Nimier hit the brakes suddenly and aimed the car, still going a considerable speed, in a beeline toward a triangle of concrete pillars, dying at age thirty-six. The next year a literary award, the Nimier Prize, was established for young French writers who embody his industry, though hopefully not his driving record.

There are many roads to a calm life.
—Roger Nimier

The famous existential writer and philosopher **Albert Camus'** *wife, Simone Hié, was a drug addict from the age of fourteen. For two years he tried to cure her morphine addiction, but the marriage ended when Simone bartered sex for drugs with her physician. Camus noted of his difficult love: "It's a pity fairy tales cannot consist solely of beginnings." Ultimately, the experience amplified his obsession with loneliness and fear of death, and arguably furthered his absurdist point of view on existence, leading him to conclude that "life is pointless." Camus worked at a vineyard before he turned to writing and stuck more fervidly to the grape as his creative lubricant. After becoming the youngest writer to ever win a Nobel Prize in literature, Camus died in a car crash at age forty-seven in 1957.*

MABEL NORMAND

Say anything you like, but don't say that I "like" to work. Just say I like to pinch babies and twist their legs. And get drunk.
—MABEL NORMAND

Rising from poverty, Mabel Normand became the leading comedienne appearing in popular *Keystone Comedies* and in more than fifty flicks during the early 1900s. She was also one of the first female directors in Hollywood. Praised for her natural and gifted comedic timing, off screen she had a touch of the gangster in her. She also developed an addiction to heroin and alcohol during her heyday and was tied to a number of scandals, including the murder of director William Desmond Taylor, who was shot and killed only minutes after she left his house—and the crime not yet solved. By 1927 she was being sent to sanatoriums for tuberculosis and complications from dual addictions, dying in 1930 at age thirty-four. Newspapers compared Mabel to a "meteor which burns itself out by the very speed which gives it light." On her deathbed, Mabel was asked to reveal the true circumstance surrounding the Desmond murder, but refused and died without divulging clues or fingering anyone.

JOHN O'HARA

We are so vain that we even care for the opinion of those we don't care for.
—Marie Von Ebner-Eschenbach

At first John O'Hara didn't understand his father's last words, "Poor John," but soon learned that the prosperous doctor made no arrangements for his family and had left less than a thousand dollars in cash. John was set to go to Yale and join the upper stratum of the elite, but was unable to attend because of his sudden slide into the lower class. Subsequently, he became obsessed with proving his worth, while toting a heavy chip on his shoulder for the remainder of his life. When he left his hometown of Pottsville, Pennsylvania, to become a writer in New York he met setbacks, being fired for drinking and non-performance from all the majors—a remarkable list that includes *The Herald Tribune, Time* magazine, *New York Daily Mirror, The Morning Telegraph*, as well as the publicity department of Warner Brothers. Things changed in 1934 when he published a novel, *Appointment in Samarra*, which was praised for its insightful ear for dialect, and he went on to write numerous bestsellers throughout his career. Writer John Updike compared O'Hara to Chekhov, and Fran Liebowitz said, "O'Hara was a far superior writer to F. Scott Fitzgerald." During this run, O'Hara's drinking continued at full throttle. Notorious for his three-day benders, he was even more vicious and obnoxious when drunk and was known for chasing anything in a skirt. Once, when two women rebuked his advances in a bar, he started a fight, supposedly punching both women in the face and picking another fight with a dwarf. On the literary end, he remained admirably prolific and became one of the wealthiest writers of his time, living the life of a country squire, complete with a bevy of scurrying servants and a Rolls-Royce. However, as *New York Times* critic Charles McGrath noted: "O'Hara was without a doubt his own worst enemy, with a genius for burning his bridges behind him." When O'Hara suggested Yale should wise up and give him an honorary degree, they refused—especially because he asked. Eventually, his reputation was ruined by his insecure self-promotion. He was sure he would be the next American after Hemingway to win the Nobel Prize for literature, but was ignored year after year, furthering his bitterness. Editors, acquaintances, and nearly everyone else dreaded his wrath. In the end he helped to destroy what he sought most—a majority of the literary establishment came to consider his life's work to be second- or third-rate at best. But he shrugged it off, knowing that the good opinion of his genius would resurge. Just in case the unappreciative needed a reminder, when he died, in 1970 at age sixty-five, he left an epitaph he wrote to be etched for all eternity on his tombstone: "Better than anyone else, he told the truth about his time, the first half of the twentieth century. He was a professional. He wrote honestly and well."

So who's perfect? Washington had false teeth. Franklin was nearsighted. Mussolini had syphilis. Unpleasant things have been said about Walt Whitman and Oscar Wilde. Tchaikovsky had his problems, too. And Lincoln was constipated.
—JOHN O'HARA

EUGENE O'NEILL

Life is a solitary cell whose walls are mirrors.
—EUGENE O'NEILL

Playwright Eugene O'Neill is considered one of the most esteemed writers of the twentieth century, known for his plays that are still produced regularly, including *Desire Under the Elms, Long Day's Journey into Night,* and *The Iceman Cometh.* He won the Nobel Prize for Literature in 1936. In his personal life he struggled with alcoholism, unable to shake the specter of his youth, reared as he was by a morphine-addicted mother. In the last ten years of his life his physical deterioration had prevented him from writing. Although it seemed he died of alcoholism, O'Neill had stopped drinking at the time, dying of other neurodegenerative diseases, in 1953, at the age of sixty-five.

I really love fog. It hides you from the world and the world from you.
—EUGENE O'NEILL

DOROTHY PARKER

If A equals success, then the formula is A equals X plus Y and Z, with X being work, Y play, and Z keeping your mouth shut.
—ALBERT EINSTEIN

When at age seven she got a new step-mother, young Dorothy Parker displayed her caustic wit and refused to call the woman Mom or Stepmother, opting for Housekeeper instead. Dorothy grew up on Manhattan's Upper West Side and always considered herself a diehard New Yorker, working for trendsetting cultural magazines by her early twenties, including *Vogue* and *Vanity Fair*. She made a reputation as a theater critic and became a founder of what was called the Algonquin Round Table, a regular lunch gathering of witty intellectuals that met at the fashionable Algonquin Hotel, exchanging wordplay, witticisms, and wisecracks. Dorothy was evidently the best of them, and many of her quips were quoted in the other attendees' various columns and radio shows. Her reputation as a sharp-tongued humorist spread widely, and her many poems, which were often lyrical satires and limericks of sorts putting down all she deemed below par, frequently appeared in national magazines. Her equally observant short stories, always delivered with genius and wit, were collected into bestselling books. She repeatedly returned to the theme that women were more than equal to men, by the sheer force of their intelligence. She left New York when her first marriage fell apart and teamed with actor and writer Alan Campbell. They married, and the pair collaborated on screenplays, including *A Star is Born*, which earned them an Academy Award nomination. Parker was increasingly vocal about many social injustices, and her political views got her banned from Hollywood during the fifties; eventually she came back to New York alone, without her husband. She returned to Hollywood to reconcile with Campbell, but it wasn't long before he committed suicide by drug overdose in their home. Dorothy had been drinking with a vengeance from the beginning—she was described by friends as "hardcore." After this tragedy she wrote less and turned on many of the friends from the Algonquin days. She continued to write reviews with memorable lines like: "This is not a novel to be tossed aside lightly. It should be thrown with great force." She eventually tired of her own perpetual wisecracking and instead found a passion in supporting the Civil Rights Movement. When she died from complications of alcoholism in 1967 (at seventy-three she was found dead alone with her poodle), she bequeathed her estate to the Martin Luther King Jr. Foundation. Her friend and literary executor Lillian Hellman, also a writer, felt betrayed, having nursed Dorothy back from a number of suicide attempts and paid her hotel bills for many years. Hellman was furious she didn't get

the rights to Dorothy's writings, claiming that Parker "must have been drunk when she did it [made the will]." Dorothy Parker's writing legacy remains (*The Portable Dorothy Parker* is still in print after sixty years), even if her cremated ashes went unclaimed in her lawyer's filing-cabinet drawer for nearly twenty years. Perhaps anticipating the dilemma her ashes would cause, she wrote her epitaph: "Excuse my dust." Eventually, she was laid to rest and given a plaque in a garden outside the Baltimore headquarters of the NAACP.

> *I don't care what is written about me so long as it isn't true.*
> —DOROTHY PARKER

BREACH OF ETIQUETTE

*No one knew more about the etiquette required of high society than the genius astronomer and alchemist **Tycho Brahe**. He was of royal Swedish stock and made a faux pas once during his university days when he showed up for a duel slightly too drunk. During that sword fight he lost the tip of his nose, and during a second match, conducted in a dark room, he had his nose almost entirely sliced away. His search to form a prosthetic nose made from copper led him to study science—alchemy as it was then called—and medicine. He is credited as the first to map the solar system without the aid of telescope; many of his measurements proved to be off by only one-sixtieth of a degree. In his later years his castle was*

the host to numerous social gatherings that Dorothy Parker and the Algonquin crowd would have found delightful. Understandably, Tycho made a striking figure, sporting a nose as bright as a shiny new penny. Guests could expect to find a clairvoyant dwarf named Jepp who sat under the table during dinner—doing what exactly remains unclear. Tycho also kept a pet moose in the castle that died unfortunately after drinking too much beer and tripping down a staircase. During one long banquet Tycho, a stickler for social protocol, could not find a reasonably polite moment to excuse himself, though he had to pee tremendously badly. He subsequently died of a burst bladder, at age fifty-four, in 1601.

CHARLIE PARKER

> *If you don't live it, it won't come out your horn.*
> —CHARLIE PARKER

During his lifetime legendary jazz great Charles Parker, Jr., known as Bird, heard little of the kind of the praise that is bestowed upon him now. Musicians

who played alongside Parker immediately recognized his genius on the sax, but he failed to earn financial rewards or gain a wider recognition for his talent. He was also widely known to be a heroin addict. Hampton Hawes, a jazz pianist, after seeing Charlie Parker shoot up and then go on to play the greatest music he ever heard, said, "We'd be willing to do anything to warm ourselves by that fire, get some of that grease pumping through our veins." Bird died of a bleeding ulcer at age thirty-five, in 1955.

John Coltrane is considered second only to Charlie Parker in sax virtuosity. He reached the height of his fame and developed his original sound during the 1950s while hooked on heroin and alcohol. He eventually sought a spiritual cure, though he died in 1967 at the age of forty of a liver ailment, which appears to have been hepatitis C, a virus often acquired from intravenous drug use.

J. G. PARRY-THOMAS

A man with an obsession is a man who has very little sales resistance.
—C. S. Lewis

British racecar driver J. G. Parry-Thomas was obsessed with breaking the land-speed record—and did it, in 1926, in a four-hundred-horsepower car he called Babs, on a stretch of beach at Pendine, Wales. He hit 172 miles an hour with one hand on the steering wheel and the other working a hand pump for transmission lubrication. But he was probably more obsessed with keeping the record he broke when it seemed that challengers were everywhere ready to take away his moment of fame. The following year, back in the same car on the same beach, he attempted to break his own record and make it harder for spoilers to steal his crown. However, this time his ambidextrous skills didn't help. In mid-race, a chain from the rear wheel snapped, wrapped around the axle, and then uncoiled like a bullwhip. It decapitated the famous driver on the spot. Earlier that day he had risen from bed with a bad flu, and against the advice of doctors, insisted he race as planned, especially when he heard a rival racer planned to hit 200 miles an hour later that week in Daytona, Florida. Unfortunately, Parry-Thomas didn't break the record and died at a speed of only 160 miles an hour. Strangely, even though the head dangled off the retrieved corpse, the coroner officially cited severe burns as the cause of death. The car, Babs, was buried right where it came to rest in the sands of the beach. It was excavated in 1969 and after a fifteen-year restoration process it is currently on display at the Museum of Speed in Pendine, Wales.

JULES PASCIN

Expressionist painter Jules Pascin was one of the most magnetic figures in the art world at the turn of the century. The seldom-sober artist was seen everywhere in Paris wearing his trademark bowler hat, and was known to dash off a sketch of one of his famous languidly posed females in between rounds of drinks. With the steady cash he earned from his prolific output, for which there was good demand and which was easily sold to magazines, he threw riotous multiday parties. By 1930, when he was forty-five, he had come to consider himself

a frivolous doodler who squandered his chance of becoming a great painter with drink and drugs. He slashed his throat, and, not dying fast enough, somehow managed to hang himself.

JACO PASTORIUS

By and large, jazz has always been like the kind of a man you wouldn't want your daughter to associate with.
—Duke Ellington

Jaco Pastorius was voted the Greatest Bass Player Who Has Ever Lived by *Bass Guitar Magazine.* He was born into a musical family, playing drums from a young age, though he gave it up after he was injured playing high school sports. He was a clean-cut kid, an altar boy, and an exceptional athlete. His choice of the bass was a fluke; it was the only piece needed in his father's band. Jaco practiced with a vengeance until he mastered the extremely physical instrument, and by age twenty-five was recognized as a virtuoso. His 1976 debut album received two Grammy nominations and today is considered by many to be a classic. Jaco became a regular on the Miami and Fort Lauderdale club scene, and though cocky, he was full of life and liked by everyone. Until his early twenties he had never touched a drink or a drug, but after a band member suggested he have a cocktail before a performance to help him relax, there was no going back. He became the kind of drinker who would go berserk after only a few drinks, throwing chairs and acting crazy. In short order, his record label dropped him, and his notorious reputation was sealed when he was removed from the stage for drunkenness at the 1984 Playboy Jazz Festival. By the mid-eighties, Jaco was homeless, strung out on drugs and drink, though he would still show up to local gigs and regularly try to jump on stage to play. No

musician wanted this filthy-looking cat to touch their instruments, and he was thrown out of every club in town. In 1987, when Jaco kicked in the glass door of a nightclub that refused him entry, a bouncer beat the life out of him. He remained in a coma for a week before he died, at age thirty-five. The bouncer got four months in jail.

*Bobby Ramirez was the drummer for White Trash. In 1972, at age twenty-three, he was beaten outside a Chicago nightclub by some guys he met in the bathroom. The nature of the transaction remains cloudy, but for whatever reason, they followed him outside and, as they later said, beat him to death because he had long hair. **Hilton Ruiz**, a Latin-jazz piano virtuoso, was in New Orleans in 2006 to work on a Hurricane Katrina benefit recording when he was found unconscious outside a Bourbon Street club. When he died, at age fifty-four, authorities decided he had simply fallen and hadn't been beaten.*

CESARE PAVESE

Unable are the loved to die for love is immortality.
—EMILY DICKINSON

When Cesare Pavese killed himself, a week before his forty-second birthday, he was considered one of Italy's greatest writers of the twentieth century. He left behind clues that he had done so for unrequited love, a passion he hoped would endear him to his countrymen—and lift him into legendary status. But things backfired. He referred to the mystery woman who broke his heart only as "C.," though she was soon discovered to be American actress Constance Dowling, noted for appearing in several Danny Kaye flicks. They had met, but Constance knew of no burning love affair, though she did admit to having casual sex with him. A former model and chorus girl, she was certainly, in the vernacular of the fifties, "a looker," but when the poor girl was thrust into the limelight for causing a favorite son's suicide, she came off a bit shallow and superficial, especially when she indicated that she might've even helped little Cesare overcome his previously secret premature-ejaculation problem. The posthumous publicity Pavese had hoped for instead made him seem pathetic, deflating the macho ladies' man image he had cultivated. In the end, when he overdosed on barbiturates in 1950, he failed to join the ranks of the famous poetic souls destroyed by love. Instead, his journals revealed his frustration that his true genius was never appreciated.

At great periods you have always felt, deep within you, the temptation to commit suicide. You gave yourself to it, breached your own defenses. You were a child. The idea of suicide was a protest against life; by dying, you would escape this longing for death.
— CESARE PAVESE

UNREQUITED DRAMA

Cursed by his own genius art.
— THE SUNDAY TELEGRAPH (LONDON)

*When **Richard Gerstl** died, at the age of twenty-five, his brother took his sixty paintings and stored them in a warehouse. Gerstl had never exhibited his work, though he considered himself an underappreciated genius. He went about claiming that whatever he didn't want to do was "unworthy of an artist." When he had problems in school, his father paid for art lessons, seemingly the only subject in which his son had an interest, though Gerstl was quick to make enemies and failed to continue working under any number of mentors for too long. Gerstl gravitated to musicians rather than artists and became involved with Arnold Schoenberg. Gerstl fell in love with the composer's wife, and she briefly left her husband and children to join Gerstl on a trip to Vienna. When she abandoned Gerstl, in 1908, he threatened suicide if she didn't return. Without waiting for a response, he went on a rampage, apparently going berserk in his studio. He burned letters, sketches, and many of his paintings, before he used a butcher knife to disembowel himself. The paintings salvaged from the fire remained relatively undiscovered until after World War II. Gerstl is now considered, in the words of the* New York Times, *"one of Austria's significant modernists."*

LULU HUNT PETERS

Everyone has talent. What is rare is the courage to follow the talent to the dark place where it leads.
— ERICA JONG

The first diet guru, Lulu Hunt Peters had a 1923 bestseller with her book *Diet and Health With Key to the Calories.* For the first time readers learned that the right way to lose weight was by counting a thing called "calories," which became a fixed part of the lingo of weight loss from then on. Dr. Peters was not only an author but the first woman to intern at Los Angeles County

General Hospital; she also held the position of Chairman of the Public Health Committee of the California Federation of Women's Clubs. Before writing the book, Lulu had tipped the scales at 220 pounds, but lost more than eighty pounds with her program. When the book became a surprise bestseller, she became obsessed with keeping her slimmer physique. In 1930 she went on a crash diet before traveling by ship to London to attend a health convention. She got ill on board and died, officially of pneumonia, at age fifty-six, long before eating disorders were understood.

A KIND OF HUSH

*It was counting calories to the extreme, under the grip of the eating disorder anorexia, that was the sad undoing of singer and drummer **Karen Carpenter**. While still a teenager she went on a mostly meat, high-protein diet and got good weight-loss results. But after hitting her target weight, she kept on losing more. As her music career blossomed under the direction of her brother and record-industry managers, she felt the only aspect of her life still left in her control was what she chose to eat—or in her case, not eat. At five feet four inches and eighty pounds, she thought she looked her best, though others sensibly disagreed and urged her to seek help. She became hooked on syrup of ipecac, an herbal mixture used to induce vomiting. She died in 1983 at age thirty-two from fluctuating weight and weakened heart valves due to complications of anorexia.*

PETRONIUS

Let us together closely lie and kiss.
There is no labor, no shame in
this: This hath pleased, doth
please, and long will please, never,
Can this decay.
—GAIUS PETRONIUS

Gaius Petronius left for posterity only one fragment of a manuscript, *Satyrica*, now considered one of the first examples of the novel in Western literature. Written around AD 60, the story depicts the adventures of two Roman homosexuals, one younger and seemingly androgynous, the other an older man who tries constantly to keep his young friend faithful as they travel about,

seeing the common sights and locales during the time of Nero. Petronius's regular job was arbiter elegantiae, translated as "judge of elegance," in Nero's court, leading many to believe that the mannerisms attributed to Petronius's fictional characters were very much part of his own life. Regardless, his work hilariously satirizes those with unsavory habits, especially bad taste. The work was not published in his life, but was rather read aloud in segments, like a soap opera of sorts, for the amusement of those gathered in court. Some wonder where Petronius learned the colloquial language he captured in dialogue, sequestered as he was in the royal environs; however, he had a notorious reputation for "slumming," partying most nights and sleeping in the day.

It's uncertain what turned Nero's capricious wrath against Petronius, though it seems likely that the jealousy of another hanger-on, believing himself a greater judge of taste, soured Petronius's reputation. Tolerance of Petronius's wagging tongue and nonstop critiques abruptly ended, and Nero ordered him to commit suicide. Before Petronius was forced to comply, dying by his own hand in AD 66 at the age of thirty-nine, he turned his caustic pen on the emperor when writing his will, lampooning the pompous Nero as the greatest offender in history among the ill-mannered, impolite, and uncouth.

CROSS-DRESSING ARTISTS

*The motivation for cross-dressing is still not sufficiently understood. In the theater and performing arts, cross-dressing has always been accepted, though not in every-day life. However, reasons for dressing in the opposite gender's clothing remain var-ied: **Dorothy Lawrence** disguised herself as a man to fight in World War I. On her return, she was placed in an insane asylum and died there from unknown causes. Jazz singer **Billy Tipton** cross-dressed as a male, a secret he kept so well that his son didn't know his "father" was a biological female until the singer's death; by then, the former jazz legend was living in poverty in a mobile home. **Harris Milstead,** known as the drag singer **Divine**, died ul-timately from the complications of obesity and not the complications of cross-dressing at forty-two in 1988. Grunge rocker **Kurt Cobain** cross-dressed at home and on stage and died of a heroin overdose at twenty-six in 1994.*

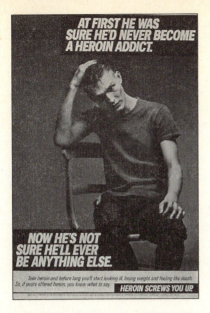

AT FIRST HE WAS SURE HE'D NEVER BECOME A HEROIN ADDICT.

NOW HE'S NOT SURE HE'LL EVER BE ANYTHING ELSE.

Take heroin and before long you'll start looking ill, losing weight and feeling like death. So, if you're offered heroin, you know what to say. **HEROIN SCREWS YOU UP**

RIVER PHOENIX

Addiction is not just for bad people or scumbags; it's a universal disease.
—RIVER PHOENIX

The downfall of rising stars in Hollywood has been part of the industry's legacy from the beginning. Yet the death from overdose of River Phoenix, at age twenty-three in 1993, was sadder than most. Playing the brave and loyal friend in *Stand By Me* and the young Indiana Jones in a *Raiders of the Lost Ark* sequel surely helped to make the public believe he was refreshingly clean-cut. There's no doubt River had a unique childhood that contributed to his unusual sensitivity before the camera. His parents started out as genuine hippies, though by the time they gave birth to their son in an Oregon log cabin, they were seeking the counterculture experience as members of a religious cult. After his parents broke from the cult, River, along with siblings Rain and Liberty, was sent out on street corners to sing for handouts. His parents encouraged their young ones' creativity and took the clan to Hollywood, seeking fame for the children. They originally did it supposedly not for money (though River lavishly supported the family with movie earnings) but only as a platform to alert the world of their beliefs and the value of their lifestyle. Even if some find that parental motivation dubious, River was acting regularly by the time he hit puberty. From the start he was praised for his natural talent and heralded as the next Marlon Brando. River seemed reluctant to partake in typical promotional hype or come off with the usual obnoxious star attitude. When he did give interviews, he presented a mature and grounded intelligence, though it's uncertain how his parents reacted when River spoke of his sexual abuse while a cult member. Some use this wound to explain why he turned to drugs, while others say River was curious and that naturally led to his addiction. On the day he died, out for some fun on Halloween, he rolled up a hundred-dollar bill and snorted a speedball, a mix of coke and heroin, in the bathroom of a hip Hollywood club. Immediately ill, he went outside for air and died minutes later of a seizure on the sidewalk, the place where his career began.

MIXING HOLLYWOOD

Among the many: **Mary Anissa Jones** *of* Family Affair *was eighteen when she overdosed in 1976.* **Christopher Pettiet**, *seen in* Don't Tell Mom the Babysitter's Dead, *was dead at twenty-four in 2000 from drugs.* **Paula Yates**, *the British actress, likewise went with a heroin overdose that same year, at forty.* **Lani O'Grady**, *who played the older*

sister on Eight Is Enough, *was forty-five in 2001, when she died from chemical overindulgence.* **Glenn Quinn** *was on the TV show* Angel *when, at thirty-two, a heroin overdose got him.* **Trevor Goddard,** *a boxer turned actor seen in* Mortal Kombat, *overdosed at forty in 2003.* **Robert Pastorelli**, *the chubby painter in* Murphy Brown, *OD'd in 2004 at forty-seven.*

Christopher Penn played the nice guy in Reservoir Dogs, *but at thirty-nine in 2006 was dead from drugs.* **Anna Nicole Smith** *was thirty-nine in 2007 when she, too, mixed multiple drugs and ultimately got more ink about her obsessions than she ever hoped.*

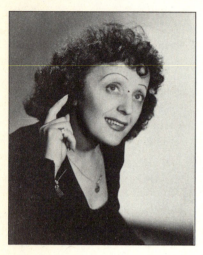

ÉDITH PIAF

All I've done all my life is disobey.
—ÉDITH PIAF

The French singer Édith Piaf, whose song *"La vie en rose"* still stirs many to take a trip to Paris, was born Édith Gassion in 1915, in the seedy section of the city less seen by tourists. Her parents scraped by; her mother was a drunk, a street hooker, and occasionally a lounge singer, her father a street performer who had no time to care for Édith. The young girl was raised in a brothel where her grandmother worked as a cook. Édith became ill with meningitis and was blind (other accounts say she was deaf) between the ages of three and seven, though miraculously she was restored to health when the prostitutes she lived with donated money to send their little mascot to the shrine of the patron saint of bodily ills. It worked, and at fourteen she was urged to leave, not to find herself earning a living on her back but to join her father's act as a street acrobat. His temperament hadn't changed (though Édith continued to love him to the day she died), and before long they parted ways. She sang solo on street corners, surviving by the coins dropped into her beret. At sixteen she married, and soon had a baby that she, too, left alone while out singing. The baby's father rescued the infant, but the tiny girl died shortly after. Édith then fell under the protection of a pimp who took a good portion of her street-serenade earnings, which were more than she would've earned turning tricks. In 1935 she was discovered by a passing nightclub owner, who convinced Édith to sing on stage. He dubbed the tiny Édith—four feet eight and very shy—"La Môme Piaf," the Little Sparrow. An instant sensation, she recorded two records within the year and before long became

France's most popular entertainer. Her voice captured every ounce of the life she lived, mournful and grief-stricken, though with an irresistible air of seduction. Businesswise, she learned from her father's passing the hat not to let a penny get away and despite her size held her own with the toughest of them. By the end of World War II she was known internationally, doing the *Ed Sullivan Show* eight times and Carnegie Hall twice. She fell in love easily, though many of her husbands and lovers died tragically, one in a plane crash, another in a car accident. After a serious car accident in 1951, she turned to pills, drinking, and morphine with a vengeance, with numerous attempts at rehab. In the height of dependence she actually recorded some of her best songs, and she forced herself to perform until she finally collapsed. She spit up blood on stage while singing at the Waldorf Astoria in New York City; she became swollen and impatient, a walking drug fiend and a caricature of the image she created. In the end she refused to be seen in daylight and even demanded hotel drapes be sealed with duct tape, as if a sliver of light might turn her to ash. She developed cirrhosis and eventually liver cancer, which killed her at age forty-seven, in 1963. A hundred thousand people lined the streets as her petite coffin passed, and more than forty thousand fans gathered in the cemetery, causing all of Paris traffic to come to a standstill.

THE OLDIES' WAY TO GO

*Drug overdoses capture headlines, but singers and stars mainly chose the classic way to go—by old-fashioned alcohol. Although from a medical point of view no one ever dies of alcoholism per se, rather from complications thereof, booze led to the end for this sampling: **Bix Beiderbecke** was a jazz singer and horn man who died of it in 1931, at twenty-seven; actor **John Barrymore** was sixty in 1942; comedian, actor, and misanthrope **W. C. Fields** was sixty-six in 1946; jazzman **Lester Young** was forty-nine in 1959; **Hank Williams** got to the age of twenty-nine in 1953; **Clyde McPhatter**, the rhythm and blues singer, was thirty-nine in 1972; **Ron "Pigpen" McKernan** of the Grateful Dead was twenty-seven in 1973; actor **Richard Burton**, in 1984, was fifty-eight; **David Byron**, singer for Uriah Heep, made it to thirty-eight in 1985; classical dancer and actor **Alexander Godunov** was forty-five in 1995; singer **Brian Connolly** was fifty-one in 1997; singer **David McComb**, in 1999, at thirty-six; actor **Oliver Reed** was sixty-one in 1999; musician **Rob Buck** was forty-two in 2000.*

MARY PICKFORD

To be really great and interesting, you
have to be a little crazy. I just don't think
one comes without the other.
—DREW BARRYMORE

Mary Pickford was the most popu-
lar actress during Hollywood's early
years, credited as the business ge-
nius behind the formation of Univer-
sal Studios. She retired from film in
1933. Although she made a few halfhearted attempts at a comeback, it never
materialized, and she preferred to stay out of the limelight, where she could
drink as much as she wished. In 1965 she retreated permanently to her fifty-
room Beverly Hills mansion and announced she would remain in bed. Those
visiting could converse with her only through a house phone, and the daily
newspapers were presented to her on a silver tray and were required to have all
potentially disturbing articles scissored out. Mary's diet consisted of a quart of
whiskey and scant else until her death in 1979, at age eighty-six.

JACK PICKFORD

Mary's younger brother Jack clung firmly
to her coattails as she rose to the top. When
Mary signed a million-dollar contract in
1917, the shrewd negotiations lumped Jack
into the deal, and he was soon cast in film
adaptations of Dickens's works and, at
twenty-one, as the lead in Tom Sawyer.
The endearing innocents he played convinc-
ingly onscreen were nothing like his off-
screen personality, marked by a voracious
appetite for drink, drugs, and women. He
tried to settle down by marrying a former
showgirl, Olive Thomas, who turned out
to be a heroin addict and who died in
their hotel room by accidentally ingesting
a mercury medication Jack took to treat
syphilis. During a police investigation he himself at first a suspect for murder, he contem-
plated suicide, but it was deemed an accidental overdose, and Pickford went on to marry
two more times. His famous sister Mary and others in the industry watched handsome Jack
waste away, emaciated by drugs, alcohol, and venereal disease. From his final hospital
room he coincidentally had a view of the hotel window where Olive had died thirteen years
earlier, and demanded his bed be positioned to see it. In 1933, at age thirty-six, he officially
succumbed to a disease of the nervous system.

FRANKLIN PIERCE

*You have summoned me in my weakness. You must
sustain me by your strength.*
—FRANKLIN PIERCE

Some have a genius for making their flaws so
widely known that they rise to great distinction
because of them. Franklin Pierce was elected the
fourteenth President of the United States, in 1853,
because of his reputation as a heavy drinker. The
party bosses that put him there knew Pierce would
do as they wished, since he said, "There's not much to do in the White House,
but drink." Pierce was a low-key and quiet drunk that cut a handsome figure.
He had achieved the rank of colonel in the Mexican-American War, even if his
detractors said the only war wound he got was when he fell off his horse drunk,
passed out, and had to be carried off the battlefield before it began. He was a
Northerner from New Hampshire who had a soft spot for slavery, or at least he
didn't want to cause that much of a stir with Southern friends such as Jefferson
Davis. His faithful wife begged Pierce to stay out of politics, and when their
two young children died of typhus she thought it a message. She may have
been right, since soon after Pierce was elected president a train car they trav-
eled in near Boston overturned, killing her last son at age eleven. Pierce, the
youngest president until Grant, took office at age forty-eight, newly childless
and drinking more heavily than ever. His vice president, William R. King, died
only a month after inauguration, and Pierce remained without a vice president
most of his term. After Pierce failed to get the backing of his Democratic Party
for reelection, he couldn't run and lost the presidency after one term. He said
there wasn't much to do after he left the White House but drink. His ineffec-
tiveness, inability to forge clear leadership, and alcoholic indecisiveness later
caused the formation of the Republican Party, which was specifically founded
in opposition to Pierce's wavering on the issue of extending slavery into new
territories. His tenure also paved the way to the nation's split, with the South's
secession, and ultimately the election of Abraham Lincoln, a member of the
new Republican Party. His wife finally left him after he ran over an old lady
with his carriage, and his already damaged public image made its final decline
during the Civil War, when he backed the Confederacy, his old pal Jefferson
Davis, and slavery. He died of cirrhosis of the liver in 1869 at age sixty-four.

BOURBON AND POLITICS

*President **Andrew Jackson** made no apologies for his drinking and claimed he was pre-
scribed to do so by a doctor. Vice President **Andrew Johnson** was sworn in as commander in
chief after Lincoln's assassination and went on to make quite a name for himself. He was the
first to face impeachment and holds the distinction of being the only new president to slur his
inauguration speech and stagger to the podium, seeming to be totally wasted. The second U.S.
president, **John Adams**, always had a beer with breakfast, while the eighth president, **Martin***

Van Buren earned favorable repute for downing large quantities of alcohol without getting drunk and was happily nicknamed "Blue Whiskey Van."

President **Warren Harding** was in office during Prohibition and stopped serving drinks at formal affairs. But with a wink and nod, he encouraged guests to drink as much as they wished from the full bar he had set up in a private room.

Alcohol consumption was part of everyday life in the 1800s. A good stiff drink was believed to help digestion and kill the ill effects of unrefrigerated and rancid food. Alcohol was even considered nutritious, given to children as a way to keep them healthy. The average per person's annual consumption of hard liquor was more than five gallons in 1830, while today it is less than one. A person who might be deemed an alcoholic now was considered merely fond of a drink back then.

SYLVIA PLATH

> *Dying*
> *Is an art, like everything else.*
> *I do it exceptionally well.*
>
> *I do it so it feels like hell.*
> *I do it so it feels real.*
> *I guess you could say I've a call.*
> —SYLVIA PLATH

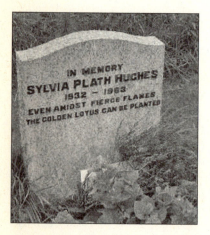

As a marketing strategy for a prospective literary icon, it would be hard to recommend opening an oven door, turning on the gas jets, and sticking your head inside. When Sylvia Plath killed herself on a cold February morning, her two young children asleep upstairs, it's seriously doubtful she was thinking of selling books. It seems her last act was more frantic, as if she were an Alice in Wonderland trying to find a way back through that magical looking glass, feeling stranded in a world she didn't belong in. The cause of this mental state has been the subject of many theories, often explained by the diagnosis du jour—bipolar disorder and PMS have been suggested—in an effort to make sense of the puzzle this skilled poet left behind, many preferring to blame biology rather than art.

In school, Sylvia was a straight-A student. She had already published poems in national magazines by age seventeen and was winner of a fiction prize that included an internship at *Mademoiselle* by her sophomore year at Smith College, which she attended on a scholarship. However, under the surface, all was not well. When she was not accepted into a writing program at Harvard, she ate a handful of sleeping pills and hid in the crawlspace under her mother's house, setting off a regional search.

The next day she was found covered in vomit and resuscitated. If any conclusion could be drawn from this, it was that her bouts of depression often

I shut my eyes and all the world drops dead; I lift my eyes and all is born again.
—SYLVIA PLATH

stemmed from rejection. For someone as sensitive as she was, Sylvia picked a tough road, since no profession has a higher negative response rate than that of poets, where each manuscript produces at least three times its weight in rejection letters. Yet she had to write, and did so in a highly disciplined manner. It is arguably this passion that held her together. She was clearly compelled to make a mark. However, Sylvia also sought normalcy through love, sometimes an even more difficult path than writing. Her attraction to what seem to have been abusive men made this no less difficult. By age twenty-four she was married to the older and then more famous English poet Ted Hughes. Within four years she was the mother of two and no longer accompanied Hughes at many of the literary gatherings as she had before. After she gave birth to their second child Sylvia learned of Hughes's ongoing affair with another young poet, Assia Wevill. In 1963, a dark depression returned soon after her most enduring work, the semi-autobiographical novel *The Bell Jar*, was published under a pseudonym, Victoria Lucas. Not only did she focus on the one or two bad reviews the book received rather than the majority of favorable ones, she felt the loss of her husband's loyalty too much to bear. Living alone, separated from her husband, with two young children in a cold, sparsely decorated flat in London, she took her own life. She had the foresight to place wet towels at the bottom of her children's bedroom door and to open their window a crack before she turned on the gas. She was thirty years old.

THAT FATAL FLIRT

Plath's suicide, some alleged, was caused by the philandering of an abusive spouse. Many made Plath the representative for radical feminists, and even to this day attempts are made to chisel off the married name Hughes from her tombstone. Assia Wevill, the woman Plath's husband was seeing at the time of her death, became another casualty of infidelity. Six years later she found Hughes cheating on her, and she too killed herself, along with the daughter Hughes had allegedly fathered. Wevill used gas, just as Plath had done. She and her four-year-old daughter took sleeping

pills and whiskey and lay down on a mattress pulled onto the kitchen floor until the gas fumes killed them. The exact number of suicides brought about by infidelity is undetermined. However, the end of a relationship is the most dangerous period for all women, poets or not. Women separated from their husbands are three times more likely than divorced women to die from suicide or murder, and twenty-five times more likely than married women are.

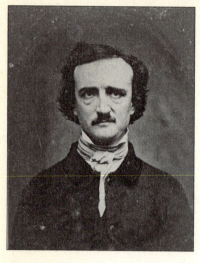

EDGAR ALLAN POE

The true genius shudders at incompleteness—and usually prefers silence to saying something which is not everything it should be.
—EDGAR ALLAN POE

More than one hundred and fifty years after Edgar Allan Poe's death, his baggy-eyed, unsmiling portrait has become an icon, representing both horror and mystery. Today, the prestigious Edgar Award is given out each year in honor of his invention, the modern detective story, and millions read his works, the most famous of which is his poem "The Raven." This admiration was not a luxury he encountered during his lifetime, except for a brief period near the end; his dedication and persistence to his art despite years filled with unfortunate events never earned substantial financial rewards. Although much of his writing found its way to print during his breathing years, his was considered a marginal voice, many regarding him as a perpetually morbid drunk. In reality, he was often exactly that—in addition to being a brilliant and innovative storyteller.

Deep into that darkness peering, long I stood there, wondering, fearing, doubting, dreaming dreams no mortal ever dared to dream before.
—EDGAR ALLAN POE

Poe was born in Boston to actor parents, his mother, talented and beautiful, and his father, a less talented alcoholic who mysteriously disappeared when baby Edgar was three years old. The next year his mother died during a tour, some say on stage. The tragedy was brought to the attention of Frances Allan, the childless wife of a well-to-do Virginia merchant. She persuaded her husband to take in Edgar. Although the young foster child was sent abroad to study at fine schools from the age of six, his aristocratic Southern stepfather was cold, aloof, and often cruel, demanding to be addressed as "Master Allan," never "Dad." By age of fourteen, when he wrote his first poem, Edgar had begun to fashion himself after his hero Lord Byron, the romantic poet and adventurer. Even at this young age he became easily infatuated with beautiful women—always dark-haired with an air of sickness about them. His first love was a schoolmate's mother, who died of a brain tumor. Poe was sent by his stepfather to the Uni-

versity of Virginia, where he was required to study law but given only part of the money required to cover its cost. Humiliatingly, he secretly borrowed from richer fellow students. He eventually found it less embarrassing to try his hand at gambling. Consequently, by the end of his first year he was in debt by today's equivalent of twenty thousand dollars. He also fell prey to a popular drink called peach and honey, which contained a considerable amount of bourbon and got him drunk frequently. From then on his taste for liquor would be his undoing. Yanked out of school by his stepfather, Poe was sent packing, leaving the Allan family mansion with only a small satchel of clothes and a few bills that his stepmother secretly pressed into his hand.

In 1827, at age eighteen, he arrived in Boston basically destitute. After a few hungry weeks he realized the only way to be spared death by starvation was to join the army. He adapted to the military regimen and used his spare time to continue to write and even saw two volumes of his poetry published, which critics compared to the work of English poet Percy Bysshe Shelley. When Edgar's stepmother died Mas-

I have great faith in fools; self-confidence my friends call it.
— EDGAR ALLAN POE

ter Allan appeared to have a moment of compassion, and thought it more dignified for Poe to serve his military stint as an officer. He arranged to send Edgar to West Point, though once again giving him only half the money he needed. After earning a reputation as a brandy drinker and falling behind on his tuition payments, Poe was court-martialed and expelled. Again penniless, he went to

Mᴿ HENRY LUDLOWE
in
THE RAVEN
THE LOVE STORY OF EDGAR ALLAN POE
DIRECTION
HAZELTON & NORTH
BY GEORGE HAZELTON

New York City just as a third volume of poetry was published, and nearly starved until he sought out blood relations to help him. Then in his mid-twenties, he lived with an aunt, his mother's sister, an invalid grandmother, and Edgar's older brother, who was dying of tuberculosis and alcoholism. In 1833, to find a way to help bring money into this destitute household, Poe wrote his first prose story and entered it in a contest. It won a prize of a hundred dollars—more money than his three books of poetry had earned. At first he intended his prose to be over-the-top versions of a classic Gothic tale, but he was actually inventing the techniques of the modern horror novel. During this period he pounded out more stories while liberally sampling the medication prescribed for his grandmother and brother. He quickly acquired an addiction to laudanum, which he told doctors he needed for a stomach ailment.

In 1886, at age twenty-seven, Poe fell in love with his aunt's thirteen-year-old daughter and married her, an occurrence not as uncommon then as it seems to modern sensibilities. It's been claimed the union was never consummated because Poe was impotent due to his alcohol and opium addiction. That seems unlikely; still, the marriage produced no children, yet he stayed faithful to his wife for the next ten years. Both she and his aunt frequently accompanied Poe as he traveled. Gaining sporadic employment editing numerous periodicals, he was a good editor and most papers or magazines he affiliated with grew in circulation during his tenure, though again and again he either quit before he was fired or was terminated, usually for behavior caused by his drinking, such as hangovers that left him bedridden. He continued to publish books, though never earned substantial royalties. It wasn't until he was thirty-five that national notoriety came his way. He had rented a cottage at Kingsbridge Road in Bronx, New York, when it was farmlands to escape the city with the hope that the clean air would help his wife, who by then was dying of tuberculosis. Here he wrote "The Raven" and a few more of his best poems. He went back into the city when money once again ran out, getting a job at *The New York Evening Mirror*, and he began to drink heavily once more. The paper published "The Raven," and it created such a stir that people sought his autograph, the circle of New York literary ladies flocking around him in adoration. (Ironically, he never made a dime from the poem, copyright laws being such that once it was printed in the newspaper, the work became fair use for anyone to reprint.) When his wife finally died after long suffering from consumption, Poe pursued a number of the ladies of the literary clique, but none returned his passion, put off by his unpredictable relapses into drunkenness. In 1848, Poe tried to commit suicide with an overdose of laudanum, but survived.

Throughout his life there were months when Poe willed himself to stay clean and sober, knowing that alcohol was killing him. Today, his drinking habits would probably place him in the category of periodic or binge drinker, since many of his copiously edited writings and his work at newspapers do not reflect the work of someone perpetually drunk, as so many biographies claim he was. Over the next four years Poe's health grew worse, punctuated by binges in both alcohol and opium, as he apparently substituted laudanum when keeping away from booze. He also switched from the horror genre to stories in a form that would be known as the forerunner of the modern detective story, featuring an investigator who solves crimes through deductive reasoning. He briefly rallied out of his disabling depression when he acquired a backer to help him fulfill his lifelong dream of editing his own literary magazine. Yet Poe sabotaged the venture by missing meetings and appointments as a result of relapses of drug use and bouts of drunkenness. On his way to Philadelphia to raise funds and subscriptions for the literary project he received an offer to edit a few poems in Baltimore for which he would be paid the exorbitant fee of a hundred dollars. He got off the boat as scheduled, but dodged those who were waiting for him,

I became insane, with long intervals of horrible sanity.

—EDGAR ALLAN POE

disappearing into the city, on a last revelry in taverns and opium dens. He was found three days later in a ditch outside a bar, wearing not the suit he arrived in but tattered clothes and an old hat. Why or how he had found his change of clothes remains unknown. Nevertheless, he was taken to the hospital, and for four days called out incoherent phrases and suffered obviously from violent hallucinations before passing away, at age forty in 1849. What exactly caused his death remains debatable—some say he was mugged, while others believe Poe was bitten by a wild black cat and died of rabies. Others say that famous portrait, taken a year before his death, showed signs in the face that he was suffering from "lesions on the brain," while a few new studies claim he had an enzyme disorder that made him allergic to alcohol and caused him to get drunk from a single glass of wine. Even more elaborate explanations suggest Poe suffered from dipsomania, which gave him a compulsive thirst, both physically and psychologically, for alcohol. In the end, it doesn't matter the semantics of his addiction, or how the precise details of his death pan out. Poe himself knew that his compulsions stole the true potential of his genius and factored substantially in his early death. His end was horrible as any he imagined in his macabre tales, and it did not come gently, rapping, rapping at his chamber door.

JOHN WILLIAM POLIDORI

By three methods we may learn wisdom: first, by reflection, which is noblest; second, by imitation, which is easiest; and third, by experience, which is the most bitter.
—CONFUCIUS

John William Polidori was a doctor and writer and a close associate of the nineteenth-century Romantic crowd, including Lord Byron and Percy Bysshe Shelley. It's fitting that a physician is noted for introducing the vampire genre into fiction with his story "The Vampyre," the very first to offer a cultured vampire, reportedly based on Lord Byron's aristocratic persona. It's also fitting that his thesis to graduate from medical school, in 1815, was on the subject of sleepwalking. Polidori was hired on the recommendation of a mutual friend to serve as Byron's personal physician, and at first the young doctor attended satisfactorily to Byron's every whim. In the summer of 1816, when the entourage of five travelers—Byron, Percy Shelley, Mary Shelley, Claire Clairmont (Mary's cousin and Byron's lover), and Polidori—relaxed one evening during a weekend of violent thunderstorms on Lake Geneva, Byron famously called for a competition to write the best ghost story. Byron was out to prove he had the more creative mind than upstart Percy Shelley. He had not even counted Shelley's wife Mary, or Dr. Polidori, both considered non-writers, but included them to hide the ruse. However, what Byron

and Percy Shelley offered was inconsequential, while Mary wrote *Frankenstein* and Polidori wrote "The Vampyre," both of which are still relevant today. When it was apparent that Polidori won that weekend's competition, Byron fired him as his physician, either because he didn't want another capable writer breathing in so close or because he decided that a doctor who contemplated with such relish drinking blood and sleepwalking was not the best choice for health care after all. The young doctor's return to England was laden with profound rejection, and he gave up medicine to study law and attempted to write nonfiction and some verse. When the vampire story saw print in 1819, it was attributed to Byron. Polidori waited three months before claiming authorship, which Byron confirmed. The tale was translated into numerous languages and a version made it to the stage, giving Polidori widespread attention, even if some considered him a mere plagiarist for having taken Byron's fragmentary idea of the cultured vampire character and developed it to full form. The questioning of his genius troubled Polidori deeply; he admitted in the introduction of his book that he lacked talent as a writer and felt it impossible to compete with Byron's reputation. Polidori began to drink heavily and gamble. In the end, although Polidori won the battle of the brains on that stormy night in Geneva, he lost the war. Faced with mounting gambling debts he could not repay, he decided it more honorable to commit suicide, drinking poison at the age of twenty-five, in 1821. The family had some connections and the medical examination jury decided to deem his death "Visitation from God" rather than the socially stigmatic suicide, claiming that the young doctor had ingested arsenic by accident. Polidori's father never allowed the name of his son mentioned in his presence for the remaining thirty-two years of the elder Polidori's life.

JOHN POLIDORI'S LETTER TO THE EDITOR

I beg leave to state that your correspondent has been mistaken in attributing that tale in its present form to Lord Byron. The fact is that though the groundwork is certainly Lord Byron's, its development is mine.

JACKSON POLLOCK

> *Genius is the ability to reduce the complicated to the simple.*
> —C. W. CERAN

He came into the world gasping for air, blue and nearly dead with the umbilical in a strangle hold around his neck: By all accounts he should've been stillborn. Jackson Pollock was the youngest of five boys raised by a despondent and unsuccessful father and a mother who embodied the pioneer spirit of the small Western towns where they lived, moving from Wyoming to Arizona to California. Pollock's violent birth left him with diminished learning abilities and compromised motor skills. His childhood was without incident; he roamed outdoors mostly under the protective muscle of his clan of brothers and worked alongside his father in odd jobs and labor gangs—an early life that gave few clues of the adult life of artistic innovation or the life of ruin that would follow. From the time of

his first art class in high school he loved the smell of paint and was determined to tag along after his older brother Charles left home to become an artist. The problem was that Jackson couldn't draw and was told by many that his talent was questionable. Nevertheless, he persisted, dropping out of high school to attend the Arts Students League in New York City, where he filled volumes of sketchbooks trying to make, as he said, "an image out of an image." Determined to overcome his inadequacies he naturally gravitated to art styles that required less accurate figure-drawing dexterity, such as cubism and surrealism, though he secretly wanted to paint massive murals like the Spanish Renaissance master El Greco. By his early twenties Pollock was a full-blown alcoholic, believing the booze helped silence the voices of the naysayers and enabled him to paint. During one creative session his hands shook so badly from a terrible hangover that he couldn't hold a brush to draw a straight line and flung the paint at the canvas. In another session he had fallen down drunk, and when he woke from a blackout, saw what a tipped can of paint had done to the canvas that fell to the floor next to him. Pollock saw a freeing technical innovation in the dripped paint when others

would've reached for a can of thinner to scrub away the mistake and start again. Years later, Jackson insisted he came to his style on purpose.

The world would not have heard of Jackson Pollock, who was bound for skid row or an institution with an alcoholic wet brain, if not for a few coincidences and the timing of his arrival. For one thing, alcoholism spared him from the World War II draft, and he remained in New York, where he submitted work to Peggy Guggenheim, a leading art dealer. She at first thought the work dreadful; however, the other painters and critics she enlisted to select pieces for one of her shows saw something she didn't. The art scene in New York desperately wanted an American Picasso, and there seemed to be a long-shot wager that Pollock could fit the bill, if not matching his talent, then by offering something new. Pollock dressed in blue jeans, T-shirt, and cowboy boots decades before it was fashionable; the outfit of road laborer from the West seemed outlandish to the art crowd. In addition, Pollock had already been hospitalized once for an alcoholic nervous breakdown and could be counted on to give a glimpse of the "eccentric artist," sure to keep his exhibitions from being dreadful bores. His seeming indifference to previous artistic styles embodied the free-thinking democratic American attitude then coming into vogue. The real clincher came in 1949 when *Life* magazine ran a four-page color spread with the almost tongue-in-cheek headline: "Is he the greatest living painter in the United States?" By then Pollock was painting giant canvases that he laid on the floor and ran around in a frenzy dripping paint, using trowels, sticks, turkey basters, or whatever he could find to splatter-make his wildly colorful pieces of abstract action-art, which he explained was his exploration of the theory of chaos. To the average Joe, it seemed like a howling good joke to suggest a painter whose work looked like kindergarten scribbles was a great artist.

> *When I am painting I have a general notion as to what I am about. I can control the flow of paint: there is no accident.*
> —JACKSON POLLOCK

The nearly two-year period when his most famous work was created in his studio barn in East Hampton, New York, was the longest stretch of sobriety in his life. But when his fame skyrocketed he returned to drink with a greater vengeance, and, perhaps strangest of all, abandoned the very style that brought him notoriety. Pollock said it was not painting but what to do when he was not painting that was most difficult. The chronicles of his life with his wife, artist Lee Krasner, portray a difficult relationship of love and loathing, with bursts of uncontrollable rage followed by almost dead silence that lasted for weeks. Financially, neither Pollock nor Krasner made any serious money and lived off wealthy friends for most of their life together. Not until 1956, the year of his death, when Pollock was considered an iconic avant-garde artist did the money and a firm place in the art world finally come to him. Yet the accolades

> *Abstract painting is abstract. It confronts you. There was a reviewer a while back who wrote that my pictures didn't have any beginning or any end. He didn't mean it as a compliment.*
> —JACKSON POLLOCK

he sought had a paradoxical effect. He was completely unable to paint and drank gin constantly. When his wife left him during a temporary separation, he took a young mistress into his house, believing she might help revitalize his talent. She did not, and a few weeks later, at age forty-four, after a day of heavy drinking, he got into his Oldsmobile convertible and crashed it into a tree, killing himself and a female passenger.

His paintings that hang in museums still draw daily criticism. The dripped and splattered mural-size canvases evoke from the uninitiated observer such comments as, "My kid could paint that." Jackson Pollock is now considered the hallmark of American abstract expressionism, and his painting *No. 5, 1948* is ranked as the most expensive painting ever sold, at a price of 140 million dollars in 2006, outdoing Picasso.

*The passenger in Pollock's car was twenty-five-year-old **Edith Metzger**. The young woman, who had escaped Nazi Germany with her family and had only met Pollock that morning, fought to the last to remove herself from Pollock's final chaos. When she saw how Pollock was driving she stood up in the back seat screaming to be let out of the car. Pollock turned to look at her and swerved from the road. She was crushed under the vehicle. Pollock was ejected and thrown against an oak tree.*

ELVIS PRESLEY

Simplicity has been held a mark of truth; it is also a mark of genius.
—THOMAS CARLYLE

Although traces of at least ten different drugs were found in Elvis Presley's blood after his death, in 1977 at age forty-two, the official word is that he succumbed to cardiovascular disease. Elvis had been drinking since the years before he began to perform, and had long thought it nothing to take a pill or a homespun remedy to help cure a hangover or whatever else ailed him. When his fame skyrocketed he took medication to keep up with a demanding schedule, with pills for waking, pills for sleeping, and even pills to control his bowel movements. The deterioration of his talent and mental state and his physical bloating from overindulgence in prescription drugs became impossible to hide from the public. Nevertheless, Elvis annually tops the charts for most revenue earned by dead artists: Presley earned nearly fifty million dollars in 2007.

MARCEL PROUST

The voyage of discovery is not in seeking new landscapes but in having new eyes.
—MARCEL PROUST

Marcel Proust's father, a stern and sensible man, was a leading medical expert of his time and one of the first

to think that microscopic germs were the true cause to many illnesses. His mother, in contrast, was Marcel's protector, a descendant from a rich, cultured French-Jewish family who made certain that Marcel's life from birth was one of complete luxury. Since his father wrote at length on epidemiology he knew firsthand that there were the innumerable germs out there ready to get him, so when young Marcel suffered an asthma attack as a young boy he was thereafter deemed sickly and coddled with a velvet touch. Although his family felt the pressure of the aristocratic classes' losing its sway to the vaster middle classes and nouveaux riches, they persisted in passing on an air of aristocratic propriety to Marcel. His greatest work, *Remembrance of Things Past*, chronicles this changing of the cultural guards, which Marcel felt destined to record. Despite Marcel's notion that he was a frail and ill man, he joined the French Army for a year, but after that adventure refused to work—much to his father's protest—at a regular job ever again. Instead, the elegant Marcel emerged at full glow in high society as a lover of art and thought he was surely the talk of the town; Proust had no clue people considered him an intolerable snob, an amateur dabbler and sentimental writer at best. He lived at home until the age of thirty-five when both his parents died, leaving Proust an inheritance worth nearly seven million dollars. Proust dedicated the next twenty years to writing *Remembrance of Things Past*, a thirty-two-hundred-page manuscript with more than two thousand characters that was published in full only after his death. This massive saga has often been praised as the greatest novel of the twentieth century. The last three years of Proust's life were his most bizarre: He thought it best to stay in his bedroom and feigned a fainting attack at the slightest ruffle to his composure. He applied corkboard to the bedroom's floor, walls, and ceiling because he didn't like to be made jittery by unexpected noise. He was singularly possessed with completing his masterpiece and making it perfect for the critic within himself. Yet it wasn't his perfectionism in writing that killed him, at the age of fifty-one. Instead, his imagined illness and the elaborate caution he took to safeguard his health was his downfall: The remembrance of his father's search for germs was his obsession. Throughout his whole life he was prone to wheezing attacks, thinking himself allergic to everything—at one point, even air. When he bathed he was petrified of catching cold and frantically dried himself with dozens of fresh towels and never let a damp one touch him twice. He thought it better to be up at night, when fewer germs circulated, and began taking sedatives to sleep in the morning and stimulants to rouse at dusk. When he went to bed during the winter months he wore three coats, four pairs of socks, and two hats, though sensibly dressed slightly lighter during summer, with only two jackets and two pairs of socks, and he was never uncovered. Enclosed as he was with his own germs, and the drugs he took to avoid them, he died of pneumonia in 1922.

MARJORIE RAWLINGS

Logic, like whiskey, loses its beneficial effect when taken in too large quantities.
—LORD DUNSANY

Marjorie Rawlings had tried for ten years to get published without success. However, the very last story she vowed to send off was accepted. Within a few years, in 1938, Rawlings was awarded a Pulitzer Prize for *The Yearling*, a story about human kindness and survival in the Florida backwoods. The first edition was later banned in some Northern cities for the use of certain words to describe blacks, though later Rawlings took up the cause of civil rights. Some praise her as an early environmentalist, fascinated as she was with the lives of people living in the swamps and remote locales of Florida. She said she formed her characters by immersing herself into the local community where she set up house, near Ocala, Florida. Rawlings also battled multiple demons, including drinking, smoking, and overeating. With a Lucky Strike in one hand and a bourbon in the other she could swear like the best of them. At five feet four inches tall and solidly built, she was capable of wringing a bad critic's neck, and threatened to do so when negative reviews came her way. Outwardly, Rawlings appeared a congenial author, although she was a tough, independent woman with scant tolerance for fools, and thought city life, especially after trips to New York City to see her editor, an abomination. When she drank she raised no dainty pinky finger but grabbed the bottle by the neck. She claimed that writing was an "agony" but worked at it eight hours a day, cursing her fate that she remained compelled to continue, saying, "I wish I was born beautiful but stupid." Her agony, among other habits, did her in at the age of fifty-seven, in 1953, when she died of a cerebral hemorrhage.

ARTHUR RIMBAUD

Genius is the recovery of childhood at will.
—ARTHUR RIMBAUD

When Arthur Rimbaud was a six-year-old boy living in a small French town on the Meuse River, his army-captain father deserted the family, leaving him, his mother, brother, and two sisters to fend for themselves. His mother took out her rage and frustra-

tion over being abandoned particularly on the boys, becoming cold and aloof and using the cane rather than a kiss to show affection. However, it didn't stifle his prodigy-like intelligence, and by age fifteen Rimbaud was as well read as the brightest of his contemporaries, already winning prizes and publishing poems he wrote in Latin. Soon after, he ran away from home by stowing away on a train to Paris, believing "the gentlemen of the press" would welcome him with open arms. Instead, he was thrown in jail upon arrival for having no money to pay for the ticket. After spending time caged with the worst of Paris's criminals, he was sent home, where he was beaten savagely, and hastily ran away again. For his next attempt he set off on foot, wandering through France and Belgium, writing poems on scraps of paper. When he made it back to Paris he slept in doorways and under bridges, scouring garbage cans for food; some reports mention that he fell ultimately into the hands of pedophiles who paid the teen for homosexual favors. It's reasonable to believe this traumatic experience, in conjunction with a less than cheery home life, led Rimbaud to view poetry as a path to salvation. He announced that debauchery was the key to liberate the senses and to achieve visionary insights into man's fate.

When he was seventeen he sent a few of his poems to popular French poet Paul Verlaine, who immediately recognized this young man's original voice and talent. Poets in those days were similar to today's pop stars, and the press was eager to latch on to a tidbit of gossip about their private lives. Before long, Verlaine and Rimbaud gave them more than they bargained for: Verlaine left his pregnant wife to shack up with Rimbaud. They flaunted their relationship, getting a flat in the Soho district of London, and their life together was replete with barroom brawls, lost days in opium dens, and public lovers' quarrels that eventually caused a major scandal.

Rimbaud was boisterous, considered uncivil, and he refused to suck up to anyone, even though many people other than Verlaine gave him decent apartments to live in. Before long, Rimbaud alienated each of these prospective patrons, getting himself

I believe that I am in hell, therefore I am there.

—**ARTHUR RIMBAUD**

thrown out or abandoning their hospitality to disappear back into the city. He became a legendary bad boy, then as now, like any number of modern-day hotel-room-wrecking rock stars.

In the spring of 1873 Verlaine convinced Rimbaud to give their relationship one more try. Within a week of their reunion a fight ensued that resulted in Verlaine's shooting Rimbaud in the wrist. Verlaine was arrested and sentenced to two years of hard labor. Suddenly Rimbaud, the bright, rising star on the literary scene, was ostracized; his next book of collected poems was either ignored or panned, many believing the misfortune of the more popular Verlaine was this young hooligan's doing. When Verlaine got out of prison, he tracked down Rimbaud, who was then living in Germany. After a few drinks they were once more at each other's throats, this time

parting for good, never to meet again. It is believed that at this brief reunion Rimbaud gave a copy of his manuscript *Illuminations* to Verlaine. Then in his early twenties, Rimbaud stopped writing altogether and burned every manuscript he could find, though a number of other works were found that he had left behind among the many places he had crashed during his adolescent period of hypercreativity. Years later Verlaine arranged for the publication of *Illuminations* and referred to Rimbaud as the "late poet." Rimbaud became idolized as a romantic poet who sacrificed his life for his art. In fact, Rimbaud wasn't dead; instead he was searching through the African jungles for another answer to the meaning of life. He had married a native tribal woman, had a longtime affair with a servant boy, and even tried his hand at illegal gunrunning.

Rimbaud did come back to France in July of 1891, when a gangrenous infection made him extremely ill. It's not certain whether it was caused by cancer, syphilis, drug addiction, or even jungle rot; however, once he was under the care of surgeons his leg was promptly amputated. He died in November of that year at age thirty-seven. As soon as he died another of his lost poems was published, only to have the periodical seized by police, deemed as too obscene for public consumption. There were no parades at the time of his death; instead, his simple gravestone bears the inscription *Priez pour lui*, meaning pray for him.

Idle youth, enslaved to everything; by being too sensitive I have wasted my life.
—ARTHUR RIMBAUD

DECADENT TIMES TWO

Paul Verlaine died five years later in 1896, at age fifty-two, and surely could have used the same priez pour lui *incantation while alive. Dubbed the "Prince of Poets," this other famous symbolist writer not only had an affair with young Rimbaud but was also infatuated with other underage pupils of schools where he taught. He was also known to beat his wife and once reportedly tossed his infant son against a wall. His trial transcripts reveal another anomaly: "[Verlaine's] anus can be dilated rather significantly by a moderate separation of the buttocks, and he bears on his person the signs of active and passive pederastic habits." His alleged propensity for farm animals understandably made him the black sheep of respectable society. In the end he was addicted to absinthe, destitute, and sleeping on the streets or in the equivalent of detox wards in public hospitals. He was at work on a series of masturbation poems when he died of heart failure due to complications of alcoholism and cirrhosis.*

DANTE GABRIEL ROSSETTI

He was a Prince of lust and pride;
He showed no grace till the hour he died.
—Dante Gabriel Rossetti

Dante Gabriel Rossetti was born in London to a family of Italian émigrés, nearly all of whom were poets, writers, and painters, or otherwise involved in the arts. He trained at the finest schools and by his late teens was writing some of his best verse. He was considered a first-rate artist in his time and made a good living selling his vivid oil paintings that to this day remain startling, fresh, and pleasing to look at, even if they were not thought to be revolutionary in technique. His most admired works are portraits of beautiful women that reveal an obsession for pleasure and sensuality. His family called him Gabe, but he used one of his many middle names, Dante, as his professional signature because he found an artistic and spiritual connection to the other Dante Alighieri, a fellow Italian and author of *The Divine Comedy*. Rossetti was also talented in literature and the translation of medieval texts in addition to painting. When his young wife, Lizzie Siddal, died of an overdose of laudanum after only two years of marriage, dramatically he buried the only copies of nearly all the poems he had written along with her. Friends badgered him to dig up the old manuscripts, and seven years later they gruesomely did so themselves with his blessing. He worked on these macabre pages and eventually published them as a collection that was both celebrated and criticized for their sexual and erotic content. Rossetti had any number of peculiar quirks that made him an interesting man in his day. He turned his house into an odd farm of sorts, allowing a number of kangaroos, raccoons, armadillos, a big Indian ox, a flock of peacocks, and a pet wombat to

have free rein. His other not so harmless idiosyncrasy was his persistent hypochondria, which became more pronounced after the death of his wife. He had always been a gregarious artistic celebrity and a regular at all the notable social gatherings, but in his later life he became reclusive. After the pet wombat, which he had named "Top," died, Rossetti for some reason became convinced he was about to go blind. Before long Rossetti's various self-medication regimens led to an addiction to chloral, one of the drugs marketed as a sleeping aid.

When it was mixed with alcohol, as Rossetti preferred, it gave a dreamy high—a screw-the-world buzz that was the primary cause of his antisocial behavior. Another downside of chloral was physiological dependence—the need for continually greater dosages, which eventually destroyed the liver. Consequently, Rossetti acquired many of the ailments he feared he'd get as a hypochondriac, as well as various manias and hallucinations. Death from withdrawal of this drug was common and was often the result of gagging on the tremendous amount of bile produced during the body's detoxification. Rossetti made a trip to the countryside in an attempt to rehabilitate himself but died shortly after, from stroke, at age fifty-three in 1882. Before expiring, Rossetti expressly instructed those at his deathbed not to bury him next to his wife, Lizzie. Perhaps he felt guilty for taking back her poems.

A class of men who became habituated to the use of chloral are men of extremely nervous and excitable temperament. . . . They are oversusceptible of what is said of them, and of their work, however good their work may be. They are too elated when praised, and too depressed when not praised or dispraised. They begin with a moderate dose, increase the dose as occasion seems to demand, and at last, in what they consider a safe and moderate system of employing it, they depend on the narcotic for their falsified repose.

—FROM *QUARTERLY JOURNAL OF INEBRIETY* (1880)

Look in my face; my name is Might-have-been.
I am also called No-more, Too-late, Farewell.
—DANTE GABRIEL ROSSETTI

EMPTY ZOO

*Sculptor **Rembrandt Bugatti** was also inspired by exotic animals, but he left them at the zoo, though he might've lived longer if he had taken a few home as Rossetti had done. Bugatti made a name by casting exquisite bronze sculptures of animals—panthers in mid-step and giraffes with front legs apart and necks gracefully lowered. He had spent years at the Antwerp Zoo studying the collection, but when the war came and the exotic creatures had to be destroyed, he lost his grip and sank into depression. He had* *been unable to work on the animal sculptures that made him famous, saying it was no longer the time for animals; he would focus instead on seeking "a new interpretation of Christ." In 1916 the thirty-one-year-old artist went to Mass, then returned to his Paris studio, where he dressed in his finest suit and turned on the gas jets to flood the flat. His brother became a successful car manufacturer and Rembrandt's elephant sculpture still sits as the hood ornament on classic Bugatti sports cars. Rembrandt Bugatti is considered the finest sculptor of animals, and a miniature baboon piece recently sold for more than 2.5 million dollars.*

MARQUIS DE SADE

In order to know virtue, we must first acquaint ourselves with vice.
—MARQUIS DE SADE

Although he lived to the old age of seventy-four, Donatien de Sade had an obsession that cost him nearly half of his years, as he spent most of his adult life locked down in prisons and insane asylums. As a child he seemed quite ordinary, diligent in his studies, attending an all-boys school instructed by Jesuits before starting a career in the military. He served as captain of a cavalry unit during the entire Seven Years War, which ended with France's world power greatly diminished and more than 1.4 million dead. Sade returned from battle to his ancestors' estate, assumed his rank among the family's long line of nobility, married, and had two children. To amuse himself, he constructed a theater in his castle and planned to become a patron of the arts, surely ready to put the war behind and have some fun. Instead, he ended up spending much of his time with prostitutes, although he got in trouble with authorities for spiking their drinks, tying them up, and flogging them. Many of the details of his sexual techniques have been clouded by rumor, but it is confirmed that he had an obsession for sex, primarily with women, although he reportedly liked to be frequently sodomized by his male valet as a warm-up exercise. His legal trouble started when he hired a group of prostitutes for an orgy. He poisoned the lot by giving them too much Spanish fly, his favorite aphrodisiac, made from beetle extract. None of them died, but he was sentenced in absentia to death. Sade fled to Italy but was captured soon after and sent to prison. Four months later he escaped and hid in his castle with the help of his wife, who now joined in his sexual romps. The endless parade of new female servants the duo hired were sexually harassed to the point that some fled for their lives by climbing through the castle windows to escape. Authorities lured Sade from his fortress by forging a note from his supposedly ill mother, who had taken refuge from the family madness by living in a convent. She was already dead when Sade

went to visit her and was captured. He then spent fourteen years in prison before the French Revolution's changing politics freed him. When he returned home, seeing that he had gained a hundred pounds, his wife divorced him.

Though Sade had always been writing, he began to try to earn money from it by anonymously publishing erotic novels. Within a few years he was destitute and forced to sell off his famed castle. When Napoleon rose to power, the anonymous author of erotica was put under arrest. From then on Sade was moved around from prison to insane asylum and died behind bars. His skull was taken for study, while his son gathered whatever writing wasn't already published and burned it. (His pornographic masterpiece, *120 Days of Sodom*, was found in 1904. His original scroll was discovered stashed in a bedpost.) Sade's

It is not my mode of thought that has caused my misfortunes, but the mode of thought of others.
—MARQUIS DE SADE

notorious legend grew even during his lifetime. Authorities believed him a sexual deviant who could not, and refused to be, rehabilitated. Others say he was just misunderstood. Sex, he came to explain, was actually a part of his philosophy on personal freedom. Sade used to say "*plaisir á tout prix,*" meaning pleasure at any price, although his was a steep tab to pay. He did get a word in the dictionary: sadism, which signifies getting pleasure from others' suffering, particularly sexual excitement by inflicting pain and/or humiliation. In recent times designer Pierre Cardin purchased Sade's infamous castle, refurbished it, and holds theater festivals there, just as the master of kink originally planned.

WHIPS AND CHAINS

What's done in the privacy of your bedroom is rightfully considered your business, unless of course you are a famous actor, and you're discovered dead under bizarre circumstances. **Albert Dekker** *played a distinguished, sophisticated, gentlemanly bad guy in dozens of films and was considered respectable enough in his affairs to be elected for one term as a California State Representative. He was quite serious about acting and once played the lead in a Broadway production of* Death of a Salesman. *His secret obsession was a surprise to everyone. In 1968, the sixty-three-year-old was found naked, kneeling in his bathtub. He had a noose around his neck and was handcuffed, wearing a black leather body-halter and*

a ball gag in his mouth—in other words, Dekker was decked out in the latest of S and M fashions—with the word "slave" written on his chest. The coroner attributed the distinguished actor's death to consensual sex gone awry, and ultimately to autoerotic asphyxia. Whomever Dekker's "master" was in the scenario remains a mystery.

SAPPHO

Death must be an Evil—and the gods agree; for why else would they live forever?
—Sappho

Much of what the ancient Greek poet Sappho actually wrote has been lost, but not her reputation, even if so many details about her life are unsubstantiated and were possibly invented. She is believed to have written nine books of verse, although only a small number of the original papyrus fragments have been retrieved from ancient artifacts. That she came from an aristocratic family seems likely, since only the very rich had privilege to devote time to verse as she did. It's also clear that Sappho was considered a star in her own time, for when she was exiled from her home on the Isle of Lesbos, the dignitaries of her destination city, Syracuse, erected a statue in her honor when they heard she was coming. Her reputation is based on love poems, passionate ones, often about females. This was not so radical in that time, when many men and women in Greek society were openly bisexual, though Sappho did seem to have a greater obsession than most, seeking out experiences to write authentically about the subject. For centuries after, Sappho's work was required reading, and in Roman times her books were transcribed and circulated widely. When medieval church scribes came across her vivid descriptions of female love they burned the bulk of her work but must have enjoyed some of it secretly, in the privacy of their candle-dim chambers, because a number of provocative lyrics were found squirreled away. Around the fifteenth century, the term Sapphic came into common use to refer to a bisexual or homosexual woman. Taken from the name of her birthplace, the word Lesbian came into use in the 1800s, when her work was rediscovered, during the more liberal Romantic Period. Assumptions about the way she died also varied as cultural views of homosexuality changed. Some say she threw herself off a cliff because of her unrequited love for a ferryman. Whether her demise was due to male or female love remains uncertain, but that she killed herself seems consistent. Sappho is often portrayed seminaked on a cliff top, strumming her lyre one last time before she jumped to her death, in her mid-forties in 569 BC.

OPPOSITE OF LOVE
Hypatia of Alexandria was a philosopher and mathematician in Athens during the third century. Her passionate advocacy for the pursuit of science as opposed to religious superstitions at first gained much respect. Unlike Sappho, she felt carnal passions were illogical and precarious distractions from higher pursuits. She once reached under her gown to pull out a

wad of menstrual cloth to repel a persistent suitor, asking rhetorically, "Is that beautiful?"
She met her end when a mob of angry Christian monks, enraged by her relentless lecturing,
ambushed her chariot. Hypatia was dragged through the streets naked, her skin scraped
from her bones by sharp tiles, and burned alive.

ROBERT SCHUMANN

There's a fine line between genius and
insanity. I have erased this line.
> —OSCAR LEVANT

Many psychoanalysts have pondered
why the composer Robert Schumann
had periods of brilliant creativity fol-
lowed by others when every note
came out wrong. Some experts say
he used music as a tool to cope with
the mood swings of a bipolar disor-
der. Schumann at first wanted to be a
poet, but his father thought to guide
his creative flair toward music, sitting
him down at a piano and hiring a reputable teacher to give lessons. When his
father died, Schumann's mother sent him to study law, but he couldn't keep
away from the keyboard and begged her permission to give it a try as a profes-
sional musician. He wrote that although he may not be a genius, with diligent
practice he could be as skillful as the best pianist out there within six years.
Shortly thereafter, under the strain of meeting his self-imposed timetable, his
hands began to cripple. He also began taking mercury medication in an ef-
fort to prevent further crippling after he acquired syphilis. He was known as
a partyer and rabble-rouser in his early years, but when he saw his future as a
pianist diminishing, he realized it would be better for his financial future if he
were a music critic.

Schumann did have an astute ear and helped bring attention to many new
talents, praising both musicians and poets then blossoming in what would be
called the Romantic Period. When
he fell in love with a beautiful per-
former, her parents had him keep his
distance, since they had knowledge
of his medical prognosis. Schumann
fell into deep despair and during

A man can know no greater torment than
to look forward to an unhappy, empty
and lifeless future of his own planning.
> —ROBERT SCHUMANN

this period composed some of his most moving pieces. Schumann eventu-
ally married his love, Clara Wieck, though he frequently spiraled into black
holes of despair when she left on tours. He began to expand his musical
range from writing songs for piano to entire symphonies for full orchestra. By
the age of forty-four Schumann had reported hearing strange hallucinatory
voices in his head, which culminated in a mad dash from a concert hall to

cast himself in the Rhine River. He was fished out and placed in an insane asylum. Schumann remained there for the last two years of his life, banging his meal dish and endlessly dragging his tin cup across the bars, lost in the cacophony of his own madness. He died in 1856, either from the mercury medication or the end-stage of syphilis, both of which resulted in lunacy. His music never brought him much attention during his life and he always played second fiddle to his performing wife, who was regarded as a virtuoso. Now, while his wife's legacy has dimmed, Schumann is considered one of the great composers of the nineteenth century. Schumann once wrote during his lighthearted days of debauchery, "Let it be remarked that my lodging has an insane asylum on the right, and a Catholic church on the left, so that I'm really in doubt whether I ought to go mad or go Catholic." It's doubtful he ever really had a choice.

THE MUSIC MOVES YOU

*Composer and conductor **Jean-Baptiste de Lully** was a regular in the court of King Louis XIV, though he was frequently in trouble for iniquity. He started out as a dancer and seemed most inspired when conducting live performances, noted for offering an animated show. Back then they didn't use thin batons to guide the orchestra but heavy staffs rapped on the floor to mark rhythm. During his last overly enthusiastic performance, due to a bit too much bubbly, Lully thoroughly smashed his big toe with the conductor's staff. The wound became infected, and because he refused amputation, thinking he could cure himself with champagne, he died shortly after of gangrene.*

BERTHOLD DER SCHWARZ

> *Where a new invention promises to be useful, it ought to be tried.*
> —THOMAS JEFFERSON

The genius firearms pioneer Berthold der Schwarz had many achievements, though the one for which he is most remembered is one he surely had hoped to avoid. Gunpowder was first discovered in the ninth century, when Chinese chemists were out to invent an elixir for immortality. When they combined sulfur, saltpeter, charcoal, and honey, the potion exploded, and the experiments were initially abandoned since it obviously hastened mortality rather than delay-

ing it. Although documents from an eleventh-century Song Dynasty battle describe the use of this "fire-powder," and how, when it was placed in hollowed bamboo, its combustion propelled flaming missiles at enemies, the Chinese didn't significantly develop it uses further. Over time, knowledge of its potency traveled slowly to Europe through Arab trade routes. Friar Berthold der Schwarz (also called Berthold the Black) was fascinated with a sample of the magic powder he acquired. When he should have been at prayers, he was in his room measuring, distilling, and mortaring, thoroughly obsessed with finding out why these ordinary ingredients ignited. When he finally deciphered the perfected formula, he became equally fixated on finding the best projectile for the powder's combustion to shoot out of a tube. Soon he had a reliable prototype, an iron pipe (like a pistol without a handle) that fired out small stones with a deadly velocity. In 1362 he was done in by an experiment that backfired when a bullet-stone got him right between the eyes. A victim of his obsession for perfection, Schwarz may be considered the first fatality from a self-inflicted gunshot wound.

*In 1612 **Marin de Bourgeoys** was the brains behind the first weapon to use a trigger and firing hammer to ignite gunpowder. He named his invention after the sparrow hawk (le mousquette) for its quick and deadly strike, and his rifle became known as a musket. His design remained the standard for two hundred years. After a lifetime of hard work making an untold number of round bullets, he died of lead poisoning in 1637, at age fifty-two.*

NOBLE OBSESSIONS
*Scientists and inventors are often as driven by obsession as artists, self-sacrifice being only a reasonable means to an end. Throughout recorded history various plagues have afflicted mankind, killing millions with no hope of cure. Most of these sudden epidemics were blamed on the wrath of God at the time. Army doctor Major **Walter Reed**, who set out to find a cure for yellow fever, was the first to discover that the disease was actually transmitted by mosquitoes and not divine whim. He and a team of assistants allowed themselves to be bitten by infected mosquitoes in an effort to prove their findings. **Dr. Jesse Lazear** (forty-four) sacrificed his life for the project, as did nurse **Clara Maass** (twenty-five). Reed died at age fifty-one in 1902, one year after he returned from Cuba, where the experiments were conducted. His work was honored with hospitals and landmarks named after him. (The photo depicts Dr. Lazear inoculating **Dr. James Carroll** with the disease. Carroll recovered, but his heart was damaged, and he died in 1907 at age fifty-three.)*

SENECA

*There is no great genius without some
touch of madness.*
—SENECA

Lucius Annaeus Seneca came from
the moneyed elite of ancient Rome.
His father was a writer and interpret-
er of texts, and the younger Seneca
followed in his footsteps. By his mid-
thirties Seneca was deeply involved
in politics and was nearly killed dur-
ing the violent comings and goings
of various Roman emperors; instead,
he was banished for adultery to an
island off of Italy. In this seclusion,
finally away from the hedonistic nightlife of Rome, Seneca sat to write his
thoughtful verse, *Consolations*, for which he is remembered today. Neverthe-
less, he was not forgotten in Rome as a learned man, a successful dramatist,
and poet, and as soon as Nero came into power he was summoned back to
Rome. Seneca first acted as a tutor and miraculously managed to remain
alive, serving the despot Nero for eight years. He was eventually elevated
to the position of advisor-scholar, then finally permitted to retire and con-
tinue his private writings. Seneca was a sickly child and in adulthood a hy-
pochondriac of sorts, always obsessed with trying new medicines and cures
to keep his blood balanced. When a plot was discovered to assassinate Nero,
the emperor used the opportunity to round up many, forty-one individuals
all told, whom he felt were unappreciative of his artistic genius; Seneca was
yanked back to center stage and ordered to commit suicide. In those days
condemned nobility were allowed to pick their own method of death, rang-
ing from ingesting poison, slitting one's wrists, running onto one's sword, or
having another cut one's throat (which was Nero's choice when his own time
came). Seneca selected wrist-slitting, the method most in vogue, since it
was considered less painful, in addition to allowing the dying to give a small
farewell speech. However, Seneca was on one of his regimens that made his
blood very thick and flow slowly. When he cut his wrists the blood trickled
out and he felt much more pain than anyone imagined. He hastily grabbed an
ill-prepared poison drink that didn't kill him, either. Not knowing what else
to do, Seneca jumped into a pool of scalding hot water, choking on the rising
steam and eventually drowning.

The road to freedom can be found in every vein of the body.
—SENECA

ANNE SEXTON

Live or die, but don't poison everything.
—ANNE SEXTON

Pulitzer Prizing-winning poet Anne Sexton was the last of three daughters born to a prosperous manufacturing family in Newton, Massachusetts. She had a pleasant childhood by most accounts, though she perceived herself as a mistake and the unwanted one of the clan. A somewhat bratty child by late adolescence, she had turned into a glamorous teen, and she focused on modeling, avoiding, at all costs, the literature crowd—the same people who would one day come to revere her. In college, during her first year, she met and eloped with a popular student who had little sense of the rocky road of constant infidelity and psychotic episodes he was in for. Soon after Anne gave birth to her second daughter, she attempted her first suicide. Who knows if it was undiagnosed postpartum depression or a true bipolar disorder that plagued her, but from then on she ingested an alphabet soup of prescribed drugs, some as powerful as Thorazine, and a more than liberal amount of alcohol—a mix sure to throw off the most sane person on the planet. She didn't begin to write poetry until her early thirties, at the suggestion of an analyst who recommended Anne get at the root of her feelings by "journaling." What she put on paper, unfettered by the influence of previous poets, had an original clarity and poignancy, and a leanness of language. A tag of confessional poetry was placed on her work, since she was unafraid to write about the taboo topics of female masturbation, abortion, adultery, and, of course, her own infatuation with suicide. Nevertheless, she rapidly ascended the ivory tower of literary stardom, becoming a National Book Award nominee and Pulitzer Prize winner by the age of thirty-seven.

All of this attention and adulation occurred during numerous breakdowns, suicide attempts, crazy episodes of drinking, sexual escapades, and family crises. It was a steep price to pay by any reckoning, but she believed she needed these chaotic highs and lows to tap into her muse so she could continue to produce the poetry that brought her the applause and attention she sought her entire life. In 1974 the last book she published, *The Death Notebooks*, received bad reviews—Anne's first. An extremely intelligent woman, though clouded by drugs, Anne knew she'd ultimately be dismissed as frivolously evoking suicidal imagery if she didn't die young and by her own hand: As a performer she believed the only way to give the audience the finale they wanted was to do herself in once and for all—and she did, in the most theatrical of ways, her hair fixed, makeup perfect, and dressed in her mother's old fur coat, as if ready to go out in style on a date with Mr. Death. She got into her car, turned it on, and revved the engine but didn't move it from the confines of the tomb-size closed

garage. She sang along to songs on the car radio until the carbon monoxide exhaust was potent enough to kill her. She was forty-five.

> *God has a brown voice, as soft and full as beer.*
> —ANNE SEXTON

THOMAS SHADWELL

> *Man is a noble animal, splendid in ashes*
> *and pompous in the grave.*
> —THOMAS BROWN SR.

Once poet laureate of England, Thomas Shadwell dropped out of college to become a writer. By the age of twenty-six Shadwell was established enough in London's theater district to have one of his plays produced to popular acclaim every opening season for the next fourteen years, and was considered the literary genius of his time. On the strength of his popularity, he turned to politics and championed Protestant causes. When his Whig party took over he immediately dismissed his former friend John Dryden, then a member of an opposing party, as poet laureate of England. In short, Shadwell was given the position instead. In his later years, Shadwell's irregular literary output and his failure to make his expected appearance at the winter theater season in London was attributed to his busy schedule and the cumbersome duties of a gentleman. In reality, he was a secret addict, concealing from many his use of opium. He started taking it for poor health, or so he said, but loved it from the first taste. He died in 1692 of an overdose at age forty-nine. His church funeral was attended by many, and the close friend giving the eulogy went out of his way to clarify Shadwell's drug addiction: "Death seized him suddenly, but could not unprepared, since he never took his dose of Opium," suggesting that Shadwell died by abstaining from drugs that day and not from an overdose. His reputation by then was ruined, especially after Dryden cut his character to shreds in a popular satire *Absalom and Achitophel*, calling Shadwell "The King of Dullness." It took twenty years and the efforts of his son to collect his works into a book before Shadwell's writing made it into the library, with the part about his being an opium-fiend relegated to the tiniest type of a marginal footnote.

> *Words may be false and full of art;*
> *Sighs are the natural language of the heart.*
> —THOMAS SHADWELL

TUPAC SHAKUR

My mama always used to tell me: "If you can't find somethin' to live for, you best find somethin' to die for."
—Tᴜᴘᴀᴄ Sʜᴀᴋᴜʀ

Musicians often seek to create a unique persona to rise above the ranks. Some of Tupac Shakur's family members were no petty criminals, with some making the FBI's Ten Most Wanted List. His mother was a member of the Black Panthers and other militant organizations. Although his birth certificate reads Lesane Crooks, his mom feared reprisal from former associates and changed the boy's name to honor an Incan outlaw and revolutionary. She was in prison during her pregnancy with Tupac, giving birth to the future rap and hip-hop star only one month after release. Tupac gravitated to the creative arts and performed in Shakespearean plays during high school, but because of continuing family upheaval, he eventually dropped out of school and tried turning his urban poetry into rap songs. He started as a roadie and backup dancer, but his talent was spotted and he was soon given a chance as a solo recording artist. His debut album, *2Pacalypse Now*, released in 1991, caused a stir. Tupac's outsider and outlaw image seemed a natural choice for him when he decided to break into the music scene. His lyrics caught the most attention, and back then, he was one of the first to seem to advocate violence against cops. His albums sold more copies and he became superstar-popular when Vice President Dan Quayle singled out Tupac from the rap genre and said his records "had no place in society." Shakur disagreed, believing he was offering underprivileged kids an example of how to rise above inherited disadvantages. This posture made him no favorite with law enforcement, and he, too, as some of his family did before him, earned a criminal record and served time in prison. Perhaps remembering from Shakespeare that all the world is a stage, his musical "thug" persona became more than an image to sell records, and he lived a dangerous lifestyle centered on drugs, drinking, women, and guns. His genius for tapping into the angst of youth made his albums wildly popular and he broke all sales records, with more than seventy million copies sold. His mother's fear of reprisal turned out to be an omen, though reprisal didn't come from her former acquaintances but from Tupac's own associates. In 1996, at age twenty-five, he was nailed with four bullets in a drive-by shooting and died. After his cremation, a portion of his ashes were given to members of his band. They mixed Tupac's remains with the best weed they could find and smoked him in a joint.

WHAT'S IN A NAME

Túpac Amaru II, Shakur's namesake, was one of last of the royal Inca nobility. He staged a revolt against Spanish conquistadors in Peru in 1781. The original Túpac was unsuccessful and was drawn and quartered. This process involved attaching his arms and legs by ropes to four separate horses that are whipped

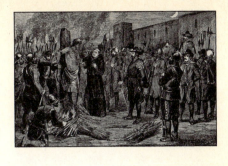

to gallop, but Túpac miraculously survived. They then diced the Incan rebel into four parts manually.

STREET SMARTS

The hip-hop scene is chock-full of dead artists and is fast exceeding rock star fatalities. A few include:

- **MC Trouble** (LaTasha Rogers), the first female to break into the previously all-male rap world when she was signed to Motown and recorded *Gotta Get a Grip*. Died of a seizure at twenty.
- Cowboy (**Keith Wiggins**), one of the Furious Five in the Grandmaster Flash group, got wrapped up in crack addiction, which cost him the career performing his revolutionary vocal mixing style that brought him the cushy comfort of limos, and left him with the bleak life of a street junkie. He died of complications of drug addiction in 1989 at age thirty-eight.
- **Buffy** (Darren Robinson) was the fattest of the emcees known as the Fat Boys. His lifestyle and ultimately a heart attack killed him in 1995 at age twenty-eight and 450 pounds. He was regarded a beatbox genius, using his mouth to make percussion sounds.
- **Eazy E**, formerly Eric Wright, was a member of the Los Angeles Crips street gang. It's fitting that Eazy is heralded as the father of gangster rap. Even after achieving fame he stayed loyal to his neighborhood, saying, "Yeah, I was a brother on the streets of Compton doing a lot of things most people look down on— but it did pay off." He got AIDS and died at thirty-one in 1995.
- **Notorious B.I.G.** (Christopher Wallace) was dealing drugs from age twelve and had climbed to the top as a bestselling rap artist by 1995. B.I.G. weighed 350 pounds and had a temper. Once, chasing autograph-seekers away, he busted their taxi window as they were trying to flee. In 1997, at age twenty-four, he was killed in a drive-by shooting, some say in retaliation for Tupac's death. He had denied involvement in rival rap singer Tupac's demise, but it looked bad when he didn't show for an antiviolence hip-hop roundtable, and then was soon after gunned down with four shots to the chest, fired by an unknown assailant wearing a bow tie.
- Christopher Rios, known as **Big Pun**, dropped out at twenty-eight from a heart attack, in 2000. His album *Yeeeah Baby* hit number three on *Billboard*, but he never knew it, as it was released posthumously. His weight fluctuated between four hundred and seven hundred pounds.

PERCY BYSSHE SHELLEY

And on the pedestal these words appear—
"My name is Ozymandias, king of kings:
Look on my works, ye Mighty, and despair!"
Nothing beside remains. Round the decay
Of that colossal wreck, boundless and bare
The lone and level sands stretch far away.

—FROM "OZYMANDIAS," BY PERCY BYSSHE SHELLEY

Reckless abandon is a phrase that could be used to describe the life of famous Romantic poet Percy Bysshe Shelley. He is also remembered as one of the original rebels, endeared to future generations as a figure who believed in love, drugs, and protest. This path began in 1811 when Shelley was expelled from Oxford for writing a paper, "The Necessity of Atheism," that he knew would get him the boot. As a child he was extremely hand-some, to the point that he was often mistaken for a girl. Subsequently, Shelley was bullied and beaten quite regularly at school, so his father, a big burly man of parliament, had him tutored privately at home during his younger years. When he was finally sent to Eton College, then to Oxford, Shelley had books torn from his hands and was viciously taunted on a daily basis. His father intervened and was able to stop Percy's expulsion from Oxford on the condition that he recant his atheistic view, but he refused. As a result, father and son parted ways, and before long, Percy lost all financial support. Four months later, at age nineteen, Shelley married a sixteen-year-old girl, had one child, and stayed with her for three years while writing protest pamphlets for the Irish. He eloped with another sixteen-year-old, Mary (later known for writing the novel *Frankenstein*), and his first wife eventually drowned herself in a lake. Meanwhile, Shelley met Lord Byron and other literary notables and began to write poetry more seriously, with many political overtones, though his work was lyrical and original. He won the respect of contemporary writers yet not of the wider public during his life. He and Mary, as well as her sister, lived a curious life, in a perpetual ménage à trois, moving from residence to residence throughout Italy, most often fleeing creditors. Although it appears that Shelley was never hooked on drugs per se, he took them "recreationally," especially if they augmented his more serious obsession of finding pleasure wherever he could. When not writing poetry Shelley penned political pieces for whatever underdog was at hand. The deaths of children and loved ones shadowed Shelley throughout his brief life. He died at age thirty, in 1822, supposedly drowned in a storm while sailing off the coast of Tuscany.

Since the time of his death, many scholars have come to believe he was assassinated for his obsessive political interferences and for the strong opinions he found impossible to keep to himself. Shelley and two other men, one a retired naval commander, all died in the accident, which a young boy, whose identity remains unknown, survived. The boat, once retrieved, showed signs it had been rammed, with the life raft still attached and money on board untouched. When Shelley's body washed ashore it was placed on a pyre of sticks and burned, citing reasons of

The pleasure that is in sorrow is sweeter than the pleasure of pleasure itself.
—PERCY BYSSHE SHELLEY

quarantine. When word got back to London, a newspaper made a brief mention: "Shelley, the writer of some infidel poetry, has been drowned, *now* he knows whether there is a God or no." One close friend attending the burning managed to snatch Shelley's heart before it became completely charred and gave it to Mary Shelley. She kept it in a jar for the rest of her life. It took almost fifty years before some of Shelley's less opinionated poems and writings found favor, although now he is often considered one of the greatest lyrical poets of the English language. The University College at Oxford currently displays a statue of Shelley dead as he was washed up on the beach.

Love is free; to promise forever to love the same woman is not less absurd than to promise to believe the same creed; such a vow in both cases excludes us from all inquiry.
—PERCY BYSSHE SHELLEY

TELL-TALE HEART
Mary Shelley's mother, the renowned feminist Mary Wollstonecraft, died of childbed fever ten days after giving birth to her. Her father was William Godwin, a bookshop owner, writer, and notorious dissenter and atheist. Godwin liked the free-thinking Percy Shelley— until he ran away with his daughter and her stepsister. It seemed the elder's essays on the eradication of marriage and a call for open love applied to others and not to his daughters. Mary admired Shelley's intelligence, but was put off by his tendency toward narcissism and his experiments in free love. Percy Shelley actually attempted to form a commune where sexual partners would be shared, starting with Mary and her stepsister Claire Clairmont. With Shelley's encouragement she published Frankenstein *anonymously when she was twenty-one. After Shelley drowned she never married again—it would've been impossible, perhaps, with his heart so close at hand. In reality, Mary had another secret. Even in her novel she had Dr. Frankenstein take laudanum to help him sleep after the death of a friend, and she, too, used opium to soothe her broken heart. In her later years, she was seriously addicted, using laudanum for sleep and much more. She died while dosed at the age of fifty-four, in 1851, though the cause was officially reported to be a brain tumor. Percy's heart was found in a jar, wrapped in a copy of his poem* Adonais, *written in eulogy for another dead poet, John Keats. The heart was finally buried in 1889, when Mary and Percy's only sur-*

viving son died, a long sixty-seven years after it was retrieved from the fire. Some experts say Shelley must've suffered from calcification of the arteries, since his heart didn't burn and remained preserved for so long.

JOSÉ ASUNCIÓN SILVA

I am better able to imagine hell than heaven; it is my inheritance, I suppose.
—ELINOR WYLIE

At the first chance he got, José Asunción Silva left his native Bogotá to travel throughout Europe, a moneyed bachelor hobnobbing with the best in London and Paris, gravitating to the literary and art crowd. When funds abruptly halted at his father's death, Silva was forced to return to the family estate, where he found the father's financial affairs in ruins, possibly due to Silva's own mismanagement, but more likely a result of a civil war. He wrote a number of poems while abroad, but claimed the majority of his work was lost during a shipwreck. To make an attempt to repay the family's massive debt Silva agreed to serve as a diplomat in Caracas, and it was there that friends encouraged him to gather his poems, which he usually shared with only a few, into a book. He did try honorably to set the family's affairs in order but was totally unsuited for business and utterly distressed, although it's noted that during this period he wrote his most memorable work. Silva put up the best of social fronts, but before long, visited a doctor purportedly to seek a prescription to cure the sudden avalanche of dandruff that began to speckle his coat. While there he made the odd request of the physician: to use a marker to draw the exact location of the human heart on his undershirt. Later that evening, after having supper with guests, he retired to his room. He retrieved a revolver from his nightstand drawer, placed the barrel in the center of the circle the doctor had drawn earlier, and pulled the trigger, dying instantly, at age thirty-one, in 1896, and was found the next morning by a servant. There was no question his death was a suicide, so the Catholic Church forbade his burial in any of the town's sanctified cemeteries, and instead his corpse was unceremoniously thrown into the local dump. His surviving poems are melancholic and lyrical, many inspired by Edgar Allan Poe. Silva came to be regarded as the first writer in Spanish of the Modernist school of literature after a collection of his work was published, more than a decade after his death.

> *I felt cold. It was the coldness that in your alcove*
> *your cheeks and your temples and your adoréd hands possessed*
> *within the snowy whiteness*
> *of the mortuary sheets.*
> *It was the coldness of the sepulcher, it was the ice of death,*
> *it was the coldness of oblivion.*
> — JOSÉ ASUNCIÓN SILVA

INGER STEVENS

A career, no matter how successful, can't put its arms around you. You end up being like Grand Central Station with people just coming and going. And there you are—left all alone.
—INGER STEVENS

From the snow-swept splendor of Switzerland, teenage Inger Stevens was taken to Manhattan, Kansas, to live with her father after her parents divorced. By sixteen she ran away from home and headed to New York City, a slightly different Manhattan. She found a job as a "popcorn girl," which required her to perform striptease and work efficiently at the pole. She used her money wisely and took acting lessons, and by her mid-twenties starred with Bing Crosby in *Man on Fire* (Stevens had an affair with Crowsby, then thirty years her senior). The Swiss beauty was exceptionally photogenic, and she appeared demure and shy in public. America fell in love with Inger when she starred in the television series *The Farmers Daughter* from 1963 to 1966. She was married twice, but she kept her marriage to Ike Jones, a black American actor, out of the press for more than nine years. While still married to Jones, she began dating Burt Reynolds. It was during this time that she committed suicide by taking sleeping pills and ammonia, at age thirty-five, in 1970, though this wasn't her first try. In 1959, after attending a disappointing New Year's Eve party, she attempted suicide with carbon monoxide. She also survived a plane crash two years later, the plane exploding a half-minute after she exited. Inger wasn't out of work at the time of her death, and had in fact returned to TV, set to star in a drama *The Most Deadly Game*. In addition to having that fitting title as her last credit, she is remembered for her creative performance in a *Twilight Zone* episode as a housewife killed in a car crash who doesn't know she's dead. Despite her success in film and TV, numerous romances, and stunning beauty, she was obsessed with loneliness; she believed it was her destiny and considered herself "a hard-luck girl." She was found lying face-down on her kitchen floor by a female roommate. At first, suspicions of murder floated about, but to this day, all that knew her offer "no comment" as her epitaph.

CREATIVE POISONS

When Christian Dior named his perfume "Poison," it was intended as a metaphor for sexual attraction, something exciting and dangerous, which Inger apparently had too much of. The real poisons used in suicides are less chic, though various combinations are amazing studies in last-minute creativity, as Inger's deadly combination

was. Arsenic has been used most frequently throughout history, with poisonings dating to 5000 BC, though it's usually the choice of murderers, since arsenic can be added to foods undetected and kill gradually. Cyanide was invented in the late 1800s for use in metallurgy, but the fumes were so toxic that a small whiff killed quickly. Cyanide stops breathing on a cellular level, causing unconsciousness in about a minute and death in anywhere from fifteen to forty-five minutes, with slim chances for revival. Aspirins have been used to commit suicide, but thirty tablets or more at a time are needed. It causes weird sounds in the ears and projectile vomiting, and may only destroy the kidneys and not kill. Alcohol is mostly used for the long, drawn out suicide, though in pure form, at least 300 milliliters when given as an enema is usually fatal. Drain cleaners and cleaning products with lye will kill the determined for sure, though the death is so painful people tend to jump out of windows to speed the process. From the medicine cabinet, females currently use antidepressants and analgesic medications, while males prefer opiates as the preferred route to lethal overdose.

SARA TEASDALE

I found more joy in sorrow than you could find in joy.
—SARA TEASDALE

It's true that everything is temporary, but famous poet Sara Teasdale couldn't shake the notion that death overshadowed even minor experiences, making the smallest trivialities cumbersome and intolerable distractions on the road toward the grand finale. She tried, though, for forty-eight years, at least publicly, to put one foot in front of the other and endure. By her late twenties her fixation with death became her obsession. She used it as a muse, an inspiration to work feverishly against what she called the "finality of nothingness," and believed that poetry came from "emotional irritation." Her lyrical verse was well received and she achieved notoriety in her lifetime, with nearly every English literature textbook in the twentieth century including her work. In 1933 she was found submerged in the bathtub of her Fifth Avenue apartment in New York City, dispatched via an overdose of sleeping pills and a warm bubble bath.

Beauty, more than bitterness, makes the heart break.
—SARA TEASDALE

LOU TELLEGEN

Don't forget when you're going up you're looking at the side of the mountain. When you're going down, you're looking at nothing.
—GLENN FORD

Lou Tellegen earned a reputation on stage starring in Oscar's Wilde's London production of *The Picture of Dorian Gray*. He came to America and did well, making twenty-six silent films. He had four marriages, including a short one to opera diva Geraldine Farrar, and numerous affairs with royalty as well as one with the legendary actress Sarah Bernhardt.

Despite previous successes, by 1934 he was washed up and bankrupt. A few years before, after drinking heavily, he fell asleep in a hotel room with a lit cigar in his mouth, and the subsequent fire had severely burned and disfigured his face. Once cast only as the leading man, he was now offered bit parts in horror flicks. After gathering newspapers to see what the critics thought of his latest comeback attempt, he wept. With the sewing scissors he used to cut out the clippings, he stabbed himself in the chest seven times. The *New York Times* thought enough of his reputation to give his death front-page coverage. It was noted that the fifty-two-year-old actor's persistence in jabbing himself so many times until he found his heart was a display of the same "fortitude" the matinee idol had shown throughout his career.

OCEANSIDE HIGH SCHOOL
Masque Society

will present

4 ONE ACT PLAYS

"RIDERS TO THE SEA"
"WHEN THE HORNS BLOW"
"A NEW SCHOOL FOR WIVES"
"A MINUET"

MAY, 19, '39 Jr. High Auditorium
8:15 P.M.

PRICES G.O. 35 REG. 50 RES. 65

TERENCE

For you to ask advice on the rules of love is no better than to ask advice on the rules of madness.
—TERENCE

Publius Terentius was a slave shipped out of Carthage as a young boy destined for Rome. Luckily, he was purchased by a kind-hearted patriarch and not relegated to the wine-squashing barrel or some other form of menial labor. Instead, Terence's personality and his cleverness made him an interesting household servant. He was eventually afforded an education typical of upper-class Roman youth, and was granted freedom as a young man. Terence followed his talents in the arts, gravitating to the theater. Using his knowledge of Greek, he reworked older Athenian dramas and gave them an updated comic spin for the Roman stage. He never forgot the hand that fed him and geared his work toward the appetites of the aristocrats, unconcerned about popular appeal or approval from the masses. He favored character development in contrast to song and pageantry common on stage, more concerned with psychological, comedic quirks and ironic twists. Some of his dialogue, such as, "Many men, many minds!" and "While there's life there's hope," have survived countless translations and are still used today. Even as just a handful of his works remain, the details of his life are equally limited. However, it does seem Terence was known and applauded for his downtime debauchery, for which young men in high society had a special talent. When he was about thirty years old, Terence was out partying on a boat and some say he slipped overboard while drunk. Rumors spread that it was a suicide and that the mask of comedy he donned hid an inner sadness. Others said it was

pirates, a bad storm, or just bad luck. Regardless, he was officially deemed "lost at sea." After his disappearance Roman theater took a serious nosedive, and Terence's intelligent productions were replaced with gladiator maimings, sea battle enactments, and ultimately jugglers and acrobats.

DYLAN THOMAS

An alcoholic is anyone you don't like who drinks as much as you do.
—DYLAN THOMAS

He was born into a loving home, doted on as a child, recognized for his poetic talent from an early age: as an adult he married a gorgeous woman and achieved major literary success by his thirties. Yet he couldn't stop drinking himself to death from the first time he snuck into a pub at age fifteen. There are many non-poetic luminaries who suffer the same fate; what made Dylan Thomas different is that he tried to explain his rationale through poetry. By all accounts, Thomas loved to be around people, standing elbow to elbow at the bar. He relished life so much, he said, he despised the notion that it had to ultimately end. Although this may seem a futile complaint, it has nevertheless been a theme in much of the world's greatest literature. Thomas tried to beat mortality's limitations by writing; he titled one of his first pieces "And Death Shall Have No Dominion," and it remained his battle cry for the remainder of his life.

In the early days he wrote at his parents' idyllic home in the south of Wales, composing nearly half of all his preserved writings before he sought out a decadent lifestyle in London and beyond. It wasn't the effect of alcohol or drugs that inspired Dylan's poems; in fact, during these years he kept the bottle of whiskey untouched by his side until he had written, edited, chiseled, and blessed the words on the sheet. However, as he got older the drink ultimately did steal away his literary powers.

In person, Thomas was alternately charming and a major pain in the ass. In taverns he liked being the center of attention and often resorted to stunts sure to get people in an uproar. He particularly liked barking like a dog, pretending to bite fellow drinkers. He even named a collection of stories after this curious occupation: *Portrait of the Artist as a Young Dog*. He also had a propensity for peeing in any place other than a urinal. When he returned home to Wales he was noted for watering the town's favorite cherry tree. Once, while visiting Hollywood, he was invited to Charlie Chaplin's house and after a few hours of obnoxious behavior was seen relieving himself in a potted palm next to the pool. Thomas's contemporary, Truman Capote, called him an overgrown baby, sure to destroy everything in his path, including himself.

Nevertheless, this *enfant terrible* veneer was just what the public liked in a crazy poet, and he was invited to America to do a series of poetry readings that paid five hundred dollars a pop. Drunk or not, he was good at it; he read his work with a loud, booming voice, raw with contagious emotion. On the first tour he earned more than seven thousand dollars, a considerable sum to be made from poetry at the time, but returned home to his weary wife and three children with only a few hundred, having spent the rest on drinking and entertaining his young mistress.

His end came in the fall of 1953, when he was thirty-nine. In New York City on another reading tour, he took his last public drink at Greenwich Village's White Horse Tavern, then a longshoremen's bar in a working-class Irish neighborhood. Legend has it that Thomas consumed eighteen whiskey sours in a row (for some unsound reason people still go there to attempt to replicate the feat in his honor), though it's more likely he had his regular half-dozen boilermakers, a drink made by dropping a shot of whiskey into a glass of beer. He went back to his room at the Chelsea Hotel and began to vomit uncontrollably. He was attended to by the organizers of the reading series, who had found him in a terrible state. A doctor was summoned, and Thomas was given a shot of morphine. The last thing he said before he slipped into a fatal coma was "What time is it?" He was taken to St. Vincent's Hospital, where crowds gathered, there in the halls and back at the lobby of the Chelsea Hotel, waiting to hear whether Dylan Thomas would utter the famous line from the poem he had written to his dying father, "Do Not Go Gentle into that Good Night." However, befitting the anticlimactic ending alcohol often brings, he did not say, "Rage, rage against the dying of the light." Instead, he died miserably, according to the New York City medical examiner, of "acute and chronic alcoholism, complicated by pneumonia." A fan asked the attending doctor what happened and was told that Thomas had been done in by an "alcoholic insult to the brain."

I hold a beast, an angel and a madman in me, and my enquiry is as to their working, and my problem is their subjugation and victory, downthrow and upheaval, and my effort is their self-expression.
—DYLAN THOMAS

HUNTER S. THOMPSON

I hate to advocate drugs, alcohol, violence or insanity to anyone, but they've always worked for me.
—HUNTER S. THOMPSON

Hunter S. Thompson's father died when he was fourteen. Afterward, some say his mom, a former reference librarian, started to hit the sauce more frequently, left as she was to raise three boys alone. Thereafter, while attending the Louisville, Kentucky, Male High School, Hunter had a few behavioral issues, culminating in a conviction for accessory to robbery. A week after he served his thirty days in the county slammer he got out of Dodge, so to say, by enlisting in the Air Force. He was rejected for pilot training, so he wrote about sports for the military base newsletter until he managed to secure an honorable discharge, even though his commander noted, "Sometimes his rebel and superior attitude seems to rub off on other airmen." He started his journalism career doing a few sports columns for local papers on the East Coast. He was a copyboy for *Time* but was fired for "insubordination." And he got canned from his next reporting job, at the upstate New York *Times Herald-Record*, after smashing in an office candy machine that stole his coin. In between stints he worked as a security guard, writing two novels and a handful of stories that found no home with publishers. He continued to freelance where he could, eventually winding up in San Francisco just as the sixties drug scene burst into full bloom. Aware of the writer's renegade reputation, an editor from *The Nation* asked Thompson to do a piece on the motorcycle group the Hell's Angels. Thompson lived, drank, drugged, and screwed among the bikers for a full year, but when they realized he was only hanging around to write a book about them, they demanded a piece of the profits. Thompson soon got the crap beat out of him and was locked in a trunk. His book about this experience, titled simply *Hell's Angels*, was praised and established his original voice, and from then on he was published in major magazines, peppering his stories with an outsider wit and personal commentary. After some time, when drugs and drinking began to slow down his productivity, his writing took on an even more original turn. His new style, eventually dubbed Gonzo journalism, combined fact and fiction. When he called it outright fiction, he scored a hit, for example, with the novel *Fear and Loathing in Las Vegas*, which was deemed by the *New York Times* as "the best book yet on the decade of dope." After that a few promised projects and novels failed to materialize, and he basically

reworked older stuff, living like a recluse at his compound in Colorado. The only truly new work that came from his drug-addled pen were sports pieces of the kind he first cut his teeth on. In 2005, when he decided to kill himself by firing a .45 into his mouth, his son, daughter-in-law, and grandchild were in the next room visiting. Thompson was at his typewriter, where only a single word was found written on the blood-splattered sheet of white paper: "counselor." A long suicide note was also discovered, proving Thompson wasn't about to turn sentimental; he had titled it "Football Season is Over." Two hundred and fifty of Hollywood's elite and a few of Washington's key figures attended the funeral to watch his ashes get blown out of a cannon amid a fireworks display.

"JUST SICK ENOUGH TO BE TOTALLY CONFIDENT"

*The flamboyant writer, Latino lawyer, and activist **Oscar Acosta** met Hunter S. Thompson in 1967, as portrayed in the book* Fear and Loathing in Las Vegas, *in which Acosta is referred to as "Dr. Gonzo," or a "300-pound Samoan." (The "gonzo" part of Acosta's nickname was later used to describe Hunter's journalistic style.) They drugged and partied together famously, and Acosta met his own dubious end. In 1974, with a reputation as having had a keen hunger for LSD and amphetamines, Acosta was last heard from when he called his son saying he was going to "board a boat full of white snow," meaning he was associating with cocaine smugglers. It's assumed that Acosta, who was thirty-nine, was, as Thompson described in an interview in* Rolling Stone, *when asked for his opinion on the subject: "shot two or three times in the stomach, with a .45." Although some still believe Acosta is alive and living in Miami, it seems more reasonable to concede to the notion that the body was dumped overboard as a result of a drug deal gone bad.*

HENRY DAVID THOREAU

A man is rich in proportion to the number of things he can afford to let alone.
—HENRY DAVID THOREAU

Henry David Thoreau, called Dave by his friends, never took a drink stronger than hard cider and thought tobacco a waste of money. He could be considered obsessed with proving a point, and he had many. When he first graduated from Harvard he taught school, but was dismissed for refusing to use a cane on the students. Along with his brother, he started his own academy, which was among the first to use alternative means of education, taking classes in the woods and on the first "field trips" to learn how businesses operated. He left that career when his brother stepped on a rusty nail and died of lockjaw, or tetanus.

Thoreau eventually befriended neighbor and prominent writer Ralph Waldo Emerson, who introduced him to New England's literary crowd. Nathaniel Hawthorne remembered Thoreau as "ugly as sin, long-nosed, and queer-mouthed," but Thoreau's honest demeanor swayed many. Emerson employed him as a sometime tutor for his nieces and nephews and as a handyman at the Emerson estate. Emerson let him build a cabin on his property to conduct a two-year experiment in simple living that became the impetus for Thoreau's most famous work, *Walden; or, Life in the Woods*. While there, Thoreau completed his first book, a memoir about travels with his brother, but couldn't find a publisher. Emerson suggested he self-publish by paying Emerson's publisher to print it. The book sold few copies, leaving Thoreau in serious debt. He was convinced Emerson got a kickback, so their friendship became strained and remained that way at best for the rest of his life. Thoreau supported himself, as a big believer in self-reliance, by working as a surveyor or at his family's pencil factory. He preferred solitude and never married. Thoreau's philosophies and writings were not popular in his times, though he remained steadfastly outspoken and was viewed as an abolitionist and a cranky anarchist, advocating nonviolent protests against any number of intrusive government policies. He fired off lengthy commentaries on a wide variety of issues based on the notion that, as he said, "Any fool can make a rule, and every fool can follow." In the end he became most fascinated with nature and his fame rested on his views on ecology and the environment. It's only fitting Thoreau died doing what he was most obsessed with. Although he knew he had signs of tuberculosis, successfully fighting off its effects for many years, he decided to go out in the middle of the night during a heavy rainstorm to count and catalog the rings on newly fallen tree stumps. Thoreau came down with bronchitis the next day and died shortly after. In the days before his death, in 1862 at age forty-four, one concerned and kindly aunt worried about his rebellious soul, knowing that he never went to church, never voted, and refused to pay taxes. She wondered aloud whether he had made peace with God. Thoreau opened his eyes one last time and said, "I did not know we had ever quarreled."

If a man does not keep pace with his companions, perhaps it is because he hears a different drummer.
—HENRY DAVID THOREAU

JOHN KENNEDY TOOLE

When a true genius appears in this world, you may know him by this sign, that the dunces are all in confederacy against him.
—JONATHAN SWIFT

Seventeen years after John Kennedy Toole finished his one famous manuscript and nearly a dozen years after his death, the novel *A Confederacy of Dunces* was published and won the Pulitzer Prize. The novel was a brilliant tragicomedy about an overweight, hot dog-eating outsider's observations on the hypocrisy of

society. The example of John Kennedy Toole as the unappreciated genius who collected more rejection letters than royalty statements has become an iconic symbol for the struggling writer. The way his obsessed elderly mother wrangled to resurrect the work of her "darling" is equally surprising, though few writers hoping to be discovered in death should count on repeating this strange tale of persistence.

John, called "Ken" by friends and family, was born the only child to parents in their late thirties, who had previously been told it was impossible for them to conceive. Ken's mother, Thelma, more than a tad eccentric, supported the family by giving elocution lessons. She doted on her only child and was by all accounts overbearing on the boy to the extreme. From Ken's toddler years and onward, Thelma told all who would listen, and even those who wouldn't, that her darling was a genius. As Ken grew older and left from under his mother's wing to teach in colleges, and later for a stint in the army, he began to believe her. Acquaintances have since remembered Ken as a sociable, witty, and charming guy, who carefully presented a clean image, preferring the latest fashions of the Ivy League crowd. Some say he was tormented by his homosexual desires, yet it seems he was more tormented about sex in general. There is no doubt he was devastated by his inability to find a publisher for what he called a "masterpiece." In the face of failure, the once charming Toole broke out in angry tirades, accusing unnamed sources of trying to steal his work. He began to drink heavily and took drugs to quell his severe headaches. In the summer of 1969 he had an argument with his mother, and soon after fled from his New Orleans environs for the West Coast. On his way back he stopped at a museum, a house where writer Flannery O'Connor once lived, and after the tour stopped his car on an isolated stretch of road. Presuming there would be no such fame for him, with museums and guided tours, he attached a garden hose to the tail pipe of his car and stuck the other end in his mouth, dying of carbon monoxide poisoning at age thirty-two. Although she read his suicide note, his mother destroyed it immediately. Nevertheless, once she found Ken's manuscript, she made it her mission to bring it to the world, even though it cuttingly lampooned her character. At age seventy-two she pestered Louisiana State University professor Walker Percy into reading the tattered pages. To his surprise, he found the manuscript, *A Confederacy of Dunces*, to be a unique farce and an exceptionally good satirical novel. He persuaded a university press to publish a small print-run. Quickly it became a sensation, with Thelma basking in the glory of good reviews. She toured and went on television to promote her son's work, with an I-told-you-so look of victory in her smile. During appearances Thelma was

noted for breaking out into a little song and dance number as a finale. When asked of Ken's suicide, Thelma told all who would listen, and many did now, that it was the failure to find a publisher that killed her son. Her only hand, she said, was as nurturer of a genius.

JULIEN TORMA

And now here is my secret, a very simple secret; it is only with the heart that one can see rightly, what is essential is invisible to the eye.
—Antoine de Saint-Exupéry

Whoever Julien Torma was, he believed so seriously in the idea that art doesn't exist that he went to great lengths to make sure he never existed, either. His supposed birthday, April 6, 1902, is commemorated in celebrations by many pataphysicists. This branch of studies is a parody of metaphysical studies, with its lengthy scientific interpretations of things that in fact no one can prove. Instead, pataphysical writers offer similarly long and scientific-sounding rebuttals in treatises of complete nonsensical language. (A current pataphysicist explains the Warren Commission Report of the President Kennedy assassination as a "Down Hill Motor Race" and makes as much sense as the official report in that it too gives no satisfactory conclusions.) Their key belief, in other words, is that there are no answers and everything is arbitrary. Surrealist painters used the ideas of Torma and his ilk to find the antithesis of harmony by combining disconnected images. Variations of the theory permeated much of twentieth-century art. In music, composer John Cage, with his unique compositions, exemplifies this theory, namely, his movement *4'33"*, in which not a single note is performed, making the audiences' shuffling and throat-clearing the only "music." Similarly, Julien Torma believed the process of creation, and not the created work, was the only aspect of art with merit. He gave poetry readings, at first standing quite traditionally before the podium, though he uttered only non-words connected by prepositions read from a sheet of paper that contained gibberish. Then he might grab a drum and beat it loudly, or run into the audience and clap near someone's ear, or yell as if he were cursing and swearing in insults that made no sense. He was quite a hit. Some believe "Torma" was a pen name and that his real identity will never be known. Others insist that Torma came from the remote, mountainous area near Tyrol, Austria, but was raised by a French relative in a suburb north of Paris after both his parents died, soon after his birth. Some stories and poetry using the Torma byline actually appeared in literary magazines. A photo also exists, but it may be a picture of one of

those models that comes already in the frame when purchased. Torma's papers, however, were located after his suicide, when he was thirty, in 1932, and are preserved by scholars at the French College of Pataphysique. His health failing, reportedly due to his occasional use of morphine and because he drank an extreme quantity of any number of random brands of wine, he abruptly disappeared from the literary scene. Seeking refuge from his last exhaustive tour, it was known that he rented a room at an inn near the town of his birth and he was seen hiking alone into the Alps one afternoon, wearing only a T-shirt and toting two bottles of wine. Torma never returned. In 1991 a well-preserved body was discovered frozen in a glacier that is now believed to be the remains of Julien Torma—or of whomever he was.

> *Joan was quizzical—studied pataphysical science in the home.*
> —THE BEATLES, "MAXWELL'S SILVER HAMMER"

GEORG TRAKL

> *For whoever is lonely there is a tavern.*
> —GEORG TRAKL

Georg Trakl's entire remaining works consist of a few hundred poems, and it's likely the sensitivity it took to write such enduring verse was the very thing that killed him. He grew up believing his parents were aloof and cold and had turned to drugs and hanging around brothels by the age of fifteen. Some reports suggest he had an incestuous affair with his younger sister, Margarete, likewise a drug addict. No wonder his merchant father wanted to find Trakl a trade and sent him to school, although, knowing his son's love of opium, it seems odd that he enroll Trakl in a pharmacy school. His studies went well, as he was more than interested in the subject, until he fell in with an artistic crowd that liked his writing and introduced him to the insider clique at a few leading literary magazines. His resolution to study pharmacology began to waver; he grew his hair long and began to dress more like an artist than in the typical refined garb students were required to wear back then. The decision of whether or not to stay in school was made for him, however, when his father died suddenly and the money to study dried up, leading Trakl to join the Austro-Hungarian military for a yearlong stint as a medic. When discharged, he went back to the bohemian crowd, though he had a tough time finding food and places to stay. A stroke of luck seemed about to change Trakl's fate—an aging philosopher was looking to divvy up his fortune. He intended to help young artists and offered to establish a patronage. He selected Trakl

as one promising young writer whom he would allow to work without worrying about money. However, Trakl never got to use this privilege. When World War I broke out he was drafted. He continued to write poems, now vividly describing the macabre landscape of death the war had created. On his last assignment, in 1914, he was sent alone, without necessary medications, to care for ninety seriously wounded men hospitalized in a rundown barn in Grodek, Poland. The sight was too grisly even for someone who wasn't as attuned to imagery as Trakl. When he arrived, one despairing soldier blew his brains out, splattering Trakl's face, and he ran from the barn. In his flight he encountered a barren grove of trees where dozens of locals and deserters had been hanged and remained swaying from the branches. The sight caused him to have a complete mental breakdown. Some reports say Trakl was found searching through the dirt for a bullet to use in a gun, with the intention of shooting himself. He was dispatched to a real hospital, and, knowing what drugs on hand would work best, he injected himself with a fatal dose of cocaine. He was twenty-seven. Two years later Trakl's sister, distraught and unable to kick her drug habit, shot herself.

> *When we are thirsty, we drink the white waters of the pool,*
> *the sweetness of our mournful childhood.*
> —GEORG TRAKL

ALAN TURING

Math genius Alan Turing was famous for inventing a machine that could break German codes during World War II and was considered the father of the computer. In the end, he performed his last probability calculation and figured it best to poison himself. After an arrest for "acts of gross indecency" and admitting to having sex with a man, he was ordered to take estrogen as a form of chemical castration. Instead, Turing laced an apple with cyanide and took a fatal bite of the forbidden fruit, in 1954 at age forty-one.

JACQUES VACHÉ

You are all poets and I am on the side of death.
—JACQUES VACHÉ

Jacques Vaché was considered the absolute coolest among the Paris art crowd after World War I. He dressed impeccably, wore a monocle, and could not be drawn into showing a reaction or losing his façade of utter detachment under any circumstance. Even if someone tried to tickle him with a feather or fire a gun near his ear—it was all irrelevant to Jacques. Although he was an artist, he believed everything created was garbage, and was known to make statements such as "Art is stupidity" and "Art does not exist." His influence on the entire Dadaist and the surrealist schools of painters and sculptors was amazing, considering he destroyed all his own work, leaving only a few fragments of letters and a handful of sketches. Vaché's ideas inspired Marcel Duchamp to rip a public urinal from the wall, title it "The Fountain," sign it, "R. Mutt," and install it as an art exhibit. Vaché's tall, striking figure was hard to miss on the streets of Paris, but when friends rushed over to say hello he simply stared, refusing to say either hello or goodbye, or even acknowledge their acquaintance, since he believed that even social niceties were merely artificial cultural contrivances without meaning. When people visited his flat they observed his girlfriend standing silently in the corner posed as a statue. She never answered when addressed, and is considered the forerunner of the type that now paint themselves in silver or blue and stand frozen on street corners for money. To create his next work of art, sometimes Jacques cut out a picture from a men's fashion magazine and added a caption, or rearranged postcards on a table in different positions, or set two tea cups in varying artistic angles, before ripping them up or smashing the porcelain into shards. On other occasions he could be spotted dressed as a doctor, or the next day as a general, and thought it nonsensical that interchangeable garb would elicit different reactions. He attempted a few "theatrical" productions that were billed as comedies but contained dialogue and scenes of nothing but nonsense. At certain points in the performance he might show up on stage and pull out a revolver and aim it with a demeanor of all seriousness at the crowd. He neither laughed nor smiled and simply observed as the crowds scurried and backed out of the theater in horrified retreat: That, presumably, was the comedy. In the context of his extreme cynicism, the act of suicide was the next logical expression of art remaining. In one of his letters he commented that it would be best to die among friends as opposed to being killed in war by a foreign enemy or by an unknown assailant on the street. To

that end he invited two young men who thought of Vaché as their closet friend over to his place with the promise of a little recreation. He served them both an overdose of opium and then took the same fatal amount for himself. He seemed to consider double murder and suicide the ultimate lesson the best art had to offer.

DITTO THE DADA

*Vaché's contemporary **Arthur Cravan** picked the opposite end of the spectrum to express the same Dadaist philosophy of anti-art, and anti-everything. He was known for violent outbursts and became infamous for hurling berserk, nonsensical insults on any occasion. During one fancy art exhibit given by a rich patroness at a salon at Lexington and 47th Street in New York City, Cravan was invited to speak about the then new Dada movement in art. He got up on stage and proceeded to give a five-minute performance of nothing but belches and loud farts. When the dignified, parasol-toting ladies took offense he began*

to curse at them with the foulest insults imaginable then attacked himself and tore off his clothes. After the police came and dragged Cravan off in handcuffs, the press asked Marcel Duchamp, who was in attendance, for a reaction. He commented: "What a wonderful lecture." Thereafter, Cravan's speaking engagements didn't linger on finer points and quickly turned into brawls, since he seldom appeared sober. Still, he retained a sort of pre-Hemingway larger-than-life attraction for the art world. He also made money when he could as a professional boxer. However, Cravan, just as Vaché had done, destroyed most of his art and poetry, although some of his published critical writings remain. In 1918, at age thirty-one, he decided the best way to reach his wife, who was waiting for him in South America was sail alone across the Gulf of Mexico. He disappeared on the journey, and his wife spent the rest of her years searching every South American prison and wayside bar in search of him. There's no doubt Cravan would've thought his death and his wife's fruitless search a great Dadaist joke. Some believe B. Traven, the reclusive author of The Treasure of the Sierra Madre, *was actually Cravan.*

NO JOKE INTENDED

*Hungarian painter **Dezsö Czigány**'s favorite subject seemed to be himself, as he did numerous self-portraits, seldom smiling, always stern-faced, often looking half-cocked. Who knew the rage he contained. Toward his later years he identified with the Fauvist movement, the term for which is taken from the French word meaning "wild beast." Though it referred to painting spontaneously from instinct in the manner of a wild beast, for Czigány it took on more literal connotations. At age fifty-four in 1937 he killed his entire family then himself.*

VINCENT VAN GOGH

If you hear a voice within you say "you cannot paint," then by all means paint, and that voice will be silenced.
—Vincent Van Gogh

The name Vincent Van Gogh has become our cultural synonym for the quintessential madcap artist, and no doubt the details of his life read like a dire variation on the Book of Job, with one misfortune followed by another. The difference between Biblical Job and Van Gogh was that the painter's relentless passion to create art led to his unimaginably grueling life.

The oldest son in a Dutch family of respectable art dealers, Van Gogh worked in galleries as a teenager and there got the taste, both figuratively and literally, for oil paintings. Some accounts suggest that while working in the galleries' back rooms, in addition to reading the Bible and making sketches, he acquired the obsessive-compulsive disorder known as pica, which drove him to eat chips of paint containing a dangerous amount of lead. At age twenty-five he abruptly announced that he was leaving the fold, having found his calling as an Evangelical preacher. After a small amount of training in theology he was sent to serve as a missionary at one of the most notoriously poor and destitute mining camps in Europe. Instead of presiding over the flock as a robed and dignified clergy, he thought it more Christlike to live as the miners did in a muddy hut and in tattered clothes. Once church officials got wind, he was booted out, and his hopes of pursuing a religious career were dashed. Disillusioned, Van Gogh retreated back home to recoup, but his mental state was such that his father quickly attempted to have him institutionalized. He fled before being committed and began in earnest an incredibly impoverished and nomadic life trying, as he said, to find God through art. During this time he was supported financially by his ever-loyal brother, Theo.

Whether Van Gogh found the answer is uncertain. During his nearly fifteen-year attempt to produce art, he sold only a handful of drawings, a few to an uncle, and another one at the very end of his life. Until only a short time before his death, his work was entirely unappreciated. At the outset of his painting career he was at first considered to possibly have artistic potential, although he was ostracized after he took in a pregnant prostitute, by the name of Sien, and tried to start a family. This arrangement, as were many other attempts at finding love, was a failure for Van Gogh, more often than not of his own doing. Nothing could interfere with his art, not basic hygiene, not lack of food, not raging storms. He was often seen out in the fields holding down canvases from blowing away or kneeling for hours in the mud trying to keep the image that

possessed him from slipping away. He was sensitive to criticism and was heard weeping in the hovels were he stayed, always struggling with his limitations. He tried a number of times to get formal training, and improve his basic skills in drawing and perspective, yet his idea of what art should be was as stubborn as his drive to keep at it. He knew many Impressionist painters personally and mingled with the soon-to-be masters of art, including Cezanne, Pissarro, Seurat, and Monet, although he disagreed with all of them and pursued a style that for most of his life was considered the sad, inferior efforts of a madman.

He moved from town to town using money he begged from his brother, using guilt and self-pitying letters that Theo never failed to fall for even after Theo was married and burdened by his own obligations. By the age of thirty-six he finally was committed to the asylum he had escaped long ago, after local citizens signed a petition to get the "redheaded madman" put away. Van Gogh by then began to suffer seizures and had long been fond of getting inebriated on absinthe. By then his well-known episode had passed in which, after a violent disagreement about the direction of art with the painter Paul Gauguin, he cut off a portion of his own ear, which he then sent wrapped in newsprint to a local brothel for safekeeping. The year he spent in the mental hospital, at Saint-Paul-de-Mausole, ironically a former monastery similar to one Van Gogh had once dreamed of attending, marked the period when many of his most famous paintings were created, including "Starry Night," which he completed as seen from the window of his locked cell. After he was released, despite being wracked by any number of debilitating illnesses, he went on to produce as many as 150 more paintings, at a feverish rate. Finally, in the few months before his death, his work was collected and exhibited. Leading artists and critics called

him a genius and an immediate rush was on to reclaim the many works that were once considered trash. By then Van Gogh was no longer able to hold on, the accolades being too little too late. After a visit from his brother, Theo, who was then married and living in Paris with a newborn baby, Van Gogh became depressed, perhaps because he saw the financial burden his constant pestering for more money had caused, or as some say, because he realized his most steadfast patron would then be incapable of providing further support. Whatever the case, in Auvers, a small village north of Paris, on one hot July afternoon in 1890, Vincent Van Gogh walked out into a field and shot himself with a pistol. He seemed to have forgotten that he had just suffered a self-inflicted mortal wound and calmly walked back into town bleeding to death. Whether his final madness was caused by syphilis, absinthe, or lead poisoning, he died a couple of days later at age thirty-seven.

Many leading medical experts have tried to figure out what really ailed him, other than his passion for art. At least thirty different diagnoses have been suggested in medical literature, even hypergrahia, a side effect associated with epilepsy that causes a fanatical urge to write or paint. Though all of

> *Even the knowledge of my own fallibility cannot keep me from making mistakes. Only when I fall do I get up again.*
> —VINCENT VAN GOGH

it seems somewhat reasonable, it is science's attempt to understand Van Gogh's persistence regardless of acceptance or financial gain; only a disease could make one so dedicated to art. It's unlikely Van Gogh ever imagined that his portrait of Dr. Gachet, a physician who treated him in his last months, would rank among the five highest-grossing works of art, fetching eighty-two million dollars in 1990. The scribbled message that was taken to be Van Gogh's suicide note simply read: "The sadness will never go away."

CONTAGIOUSLY MAD

Theo Van Gogh's familiarity of the art world, since he himself became a successful art dealer, explains in one way why he was so patient and tolerant with his older brother's quest. The brothers shared a strong bond that was more than the love of art, and three days after Vincent died Theo had a nervous breakdown. By October of that year his wife had committed Theo to an asylum due to "acute maniacal excitability." Less than six months after Vincent, he was dead, at age thirty-three, diagnosed with the end-phase of syphilis. Sein, the prostitute whom Vincent once loved, later drowned herself in a river. Margot Begemann, the woman who agreed to marry Vincent even though her family forbade it, took an overdose of strychnine. Theo's great-grandson, also named Theo Van Gogh, became a radical Dutch filmmaker: He was murdered for his anti-Islamic views in 2004 at age forty-seven.

THE GREEN FAIRY

Van Gogh might have had trouble finding lasting love because his teeth were green. Whether he flossed is uncertain, but his taste for absinthe chug-a-lugged straight out of the bottle turned his choppers emerald green, which must have looked scary contrasted with his red beard. In 1879, Harper's Weekly wrote: "Many deaths are directly traceable to the excessive use of absinthe," and called it "a quick coach to the madhouse." From the late 1800s through the early 1900s, thirty-six million liters of absinthe were sold annually. It wasn't the alcoholic content (although it was 90 percent) as much as the narcotic-like effects of thujone, a chemical found in the wormwood plant from which the liquor was distilled.

Recent studies indicate the chemical causes neurons in the brain to misfire similar to the way they behave during an epileptic seizure. Now absinthe is available for sale on the Internet, and although it's green and thick, it doesn't contain the potency of the poison du jour of years ago that made many mad artists madder. Absinthe, lovingly called the Green Fairy or holy water by the art crowd, was banned in France in 1915; during the height of its popularity, 9,000 deaths each year were attributed to its use. Artistic works that celebrated the drink and were created under its influence include Edgar Degas's "L'Absinthe," Manet's "The Absinthe," and Picasso's "Woman Drinking Absinthe." For Picasso, even occasional use led to depressive episodes, which showed artistically in his Blue Period—and might have had more to do with absinthe than with his favorite color for painting at the time.

TOWNES VAN ZANDT

> *Genius is eternal patience.*
> —Michelangelo

Descended from a long line of powerful Texan politicians, raised in the comfort provided by oil money, Townes Van Zandt was considered to have a brilliant mind, and his family's hopes were set on his eventually becoming governor of Texas. Instead, Van Zandt followed his creative side and dropped out of college. This behavior was thought to be such an anomaly that Van Zandt was subjected to various treatments (including insulin shock therapy) to knock this streak out of him, which resulted only in the loss of his long-term memory. His song "Pancho and Lefty," once recorded by Willie Nelson, established Van Zandt as a respected singer-songwriter. However, his own performances and personal life were often marred by his persistent alcoholism. He died in 1997 of a heart attack, at age fifty-two.

LOUIS VERNEUIL

He that seeks popularity in art closes the door on his own genius: as he must paint for other minds, and not for his own.
—ANNA BROWNELL JAMESON

Some artists, after achieving popular success, retain the notion that it had been a fluke, or that they sold out their true genius and are ultimately frauds. No amount of praise can dissuade them. Louis Verneuil was a highly regarded playwright who had many of his works performed in Europe and on Broadway. It seemed he grew more depressed with each hit, and although they made him wealthy, Verneuil considered most of his work to be no more than entertaining fluff. He was married briefly to the great-granddaughter of the famed actress Sarah Bernhardt and wrote the first biography of the theater legend, who, Verneuil reported, was referred to by family and friends as simply "The Great." This work, *La vie merveilleuse de Sarah Bernhardt*, was apparently more enduring than his ninety or so plays; it seems Verneuil may have been right in doubting himself, since his playwriting legacy is nearly forgotten today. At the age of fifty-nine, in 1952, he chose to die in the most dramatic of fashions, and in contrast to the comedies he left behind; he sat in an empty bathtub and filled it with his own blood by slitting his throat with a razor.

SID VICIOUS

During the late seventies, when punk musician John Ritchie of the notoriously famous Sex Pistols changed his name to Sid Vicious, he might not have real-

ized how much of the literal meaning of his nickname then would eventually acquire. With musical skills so questionable that band members turned off his bass guitar amp during performances, Vicious nevertheless had a genius for creating an iconic punk and rock star persona. He was also squarely hooked on heroin by the age of nineteen. Raised by his single mom who had at one point turned to drug-dealing to support the two, Sid was, in a way, a junkie of one sort or another practically from birth. In 1979, Sid Vicious died of a heroin overdose while out on bail, four months after he stabbed his girlfriend, Nancy Spungen, to death in a New York hotel, which was, as one police officer noted, "the first punk rock murder." Sid was twenty-one when his mother came from England to help her son. To keep him from going out on the street to buy drugs, where he might get into trouble, she had some envelopes of heroin for him in her purse. She watched him inject it and stood in awe as he seemed to turn pink, believing it to be an aura of some sort, and not the effects of a bad batch of dope. The next morning when she was bringing him a cup of tea, she found her little John, she said, "very cold and very dead."

ANDY WARHOL

Andy Warhol is the only genius I've ever known with an IQ of 60.
—GORE VIDAL

In addition to being an innovative artist and major influence on twentieth-century culture, Andy Warhol had a great ability to keep a straight face. When he unveiled his creations, stood among celebrities, street people, or aristocrats, he wore the expression he perfected—the zombified and detached look of supreme coolness. His own image, with his nearly albino-pale skin, colorless hair, and horn-rimmed glasses, became as iconic as his paintings of soup cans and other commercial symbols of modern America. He came from humble origins, the son of a coal miner, and was often sickly as a child. His lack of skin pigmentation was caused by early childhood diseases, including complications from a case of scarlet fever. Andy spent long years recuperating in bed and occupied himself by scissoring out pictures of celebrities from tabloids and making scrapbooks. After attending technical college he worked as a commercial advertising illustrator and stayed in the industry for more than ten years, becoming known as the best high-heel man in Manhattan, for drawing women's footwear so creatively. In 1960 he began to paint commercial products and celebrities, making his paintings into silk screens, intending to mass-produce them. The subjects he chose were iconic and appealed to everyone instantly. At first he was criticized for capitalizing on commercialism, but then people began to read a deeper statement into his work and deemed it art, but with a qualifier: to distinguish it from high art, they called it pop art. He made no bones about selling his reproductions for as much as he could. His methods

kicked off a perplexing philosophical discussion—what is art? Andy stood by, straight-faced, and pointed to his next unveiled creation.

Warhol was a man of paradoxes and obsessions, among them making and holding on to money. Another, stemming from his childhood illness, was hypochondria, though it was mostly manifest in a fear of doctors and hospitals. He was devoutly religious, a Byzantine Catholic who volunteered in soup kitchens, but also partied with the best, even if he was noted in his Studio 54 days for standing on the sidelines in observation. He gave the impression he was asexual, though his inner crowd knew he was definitely gay. He also had a fondness for Obetrol, a kind of speed he took as "casually as breath mints."

Warhol survived a near-fatal shooting at the hands of a disgruntled screenwriter, and was saved by doctors who massaged his heart back to life. But that incident aside, he might've fared better if he had listened to his fear of hospitals. After a routine gallbladder operation in 1987, he died of water intoxication (hyponatremia)

> *Before I was shot, I always thought that I was more half-there than all-there—I always suspected that I was watching TV instead of living life. Right when I was being shot and ever since, I knew that I was watching television.*
>
> —ANDY WARHOL

and the unmonitored retention of fluids in his body, at age fifty-eight, partly because he didn't want to spend extra money on a private nurse. He would be pleased that one obsession lives on and that he made more than twenty million dollars in 2007 while dead. Warhol once said, "Making money is art, and working is art and good business is the best art," such that earnings, for Warhol, equaled success.

> *Dying is the most embarrassing thing that can ever happen to you, because someone's got to take care of all your details.*
>
> —ANDY WARHOL

ANGRY WRITER, NO JOKE

Valerie Solanas had sent Warhol a script to be considered for one of his art flicks. When she went to Warhol's studio and asked if he had read it, Andy brushed her off and said he lost it. (In fact, the play was so pornographic that Warhol thought she was sent by the police to bust his production company for obscenity.) She shot him with a .32 revolver, hitting him three times in the chest and once in the abdomen. From then on, Warhol flinched whenever he was touched and feared her return for the rest of his life. He also wore a corset as a result of the injury. Solanas went to prison for a few years but was set free when a group of radical feminists demanded her release. Some believed she was insanely brilliant, while others thought she

was brilliantly insane. Solanas had been abused by her father and homeless and had worked as a prostitute by age fifteen—experiences that contributed to her extreme outlook. She self-published a book, SCUM Manifesto—*"SCUM" being an acronym for the Society for Cutting Up Men—that advocated an all-female society: "The male should be of use to the female, wait on her, cater to her slightest whim." She also hated landlords, "owners of greasy spoons," and "Great Artists." That Warhol had given her a role in a previous film apparently didn't count, since she received only twenty-five dollars for her scene, about which she later said, "A snake couldn't eat a meal off what he paid out." Nevertheless, she persisted with her passion, reportedly in and out of psych wards, until she died, at age fifty-three in 1988, of emphysema while living in a welfare hotel. Solanas's mother acquiesced to an interview and denied her daughter's mental instability, asserting that she was instead secretly at work on her craft: "She was writing. She fancied herself as a writer . . . She had a terrific sense of humor."*

SIMONE WEIL

> *I have always believed that the instant of death is the center and object of life . . . It is the instant when, for an infinitesimal fraction of time, pure truth, naked, certain, and eternal, enters the soul.*
>
> —SIMONE WEIL, *WAITING FOR GOD*

Simone Weil was born to a doctor and prominent Jewish family in Paris in 1909. Many considered her a prodigy, fluent in ancient Greek and Sanskrit by the age of twelve. But even as a youth she identified with martyrs, perhaps as a way to make sense of her own sickliness. After graduating with a degree in philosophy, she spent her energy on Marxist and labor union politics, earning a living primarily as a grade school teacher. She then quit to work in a factory and live as the poorest of laborers did. As sickly as she was, plagued with debilitating headaches, she vowed to commit suicide if she failed to persist. After a short stint as one of the "invisibles," Weil became discouraged in the labor movement, and perhaps even pacifism for that matter, when she went to the front line to help her comrades fight in the Spanish Civil War. There, her notorious clumsiness put her brigade in more danger, and after she stepped into a pot of hot cooking oil, she resigned herself to heading back to France to resume her teaching career. When the Nazis marched into Paris her parents finally

persuaded her to leave, and eventually she ended up in New York City in an apartment on Riverside Drive, visiting the poor in Harlem and seeking out numerous churches throughout the city. Despite her physical limitations she had a notion to start a troupe of nurses to work at the front line in World War II and was eventually permitted to travel to England to organize it. There, her health grew worse, and she was diagnosed with tuberculosis. Her condition was not grave and recovery seemed likely; however, she refused medicines, and eventually, all food. She had a secret passion for recording her ideas on paper; and her copious writings were discovered only after her death. She died in 1943 at age thirty-five of what doctors even then deemed a suicide but which might now be diagnosed as a form of anorexia. She had decided early on to be a life-long virgin and apparently achieved that, leading many who read her mystical writings to consider her more of a saint than a disenchanted Marxist.

PRODIGY AND SUICIDE

The Terman Genetic Study of Genius, conducted by psychologist Lewis M. Terman, monitored 1,528 gifted children born in 1920. In the end, this group had a 33 percent higher suicide rate than the general population. The report looked at the average IQ in eighty-five countries and correlated intelligence to self-destruction. For example, in Jamaica, the average IQ was 72 and the suicide rate was only 0.5 percent, while in Germany, where the average IQ was 102, there was a 21 percent suicide rate.

OSCAR WILDE

Moderation is a fatal thing—nothing succeeds like excess.
—OSCAR WILDE

Oscar Wilde came from an aristocratic Irish family and was singled out from a young age as a high achiever in Dublin's best schools. Soon after he finished college, the woman he was in love with married novelist Bram Stoker, of *Dracula* fame, and Wilde was devastated. He left Ireland in a huff to live in London, Paris, and the United States, returning only a few times to his native land. Although he married into a wealthy London family, fathering two children, Oscar had begun thoroughly indulging in homosexual and pederastic relations, as he said Socrates had done, with "rentboys"—teenage and younger male prostitutes from the working-classes. He dismissed questioning about his sexual preferences as quibbling over semantics, believing nearly everyone had the same urges, and that this type of noble affection was found in the works of the world's

greatest artists. Meanwhile, he had become the most popular playwright in the Victorian Era. He also wrote well-received novels and books of poetry that made him a major celebrity.

His wit and literary genius were undeniable, and people lined the streets just to get a sight of his striking figure, often surrounded by a lavishly dressed entourage. Privately, he was noted for supporting pioneer gay-rights groups and formed secret societies to foster what we would now call gay awareness.

His downfall came when a connected member of English royalty alleged that Wilde was corrupting his son. Wilde was the first to pursue the matter in court, suing for libel, but during the sensational trial, Wilde's true sexual appetites were revealed. He was subsequently arrested on suspicion of what was called "buggery," in violation of an English law that forbade anal intercourse. Convicted on a lesser charge of gross indecency, Wilde was sent to prison for two years of hard labor. Wilde's only retort: "Why does not the Crown prosecute every boy at a public or private school or half the men in the Universities?" When he was released from prison, he was in poor health and penniless, and started living under an assumed name in Paris. There, in a dingy hotel, he indulged openly in his desires and was reportedly "hand in glove with all the little boys on the Boulevard." In 1900, at age forty-six, Wilde died of meningitis, and since, his defenders have gone to great lengths to emphasize that he didn't die from a sexually transmitted disease. Nevertheless, in the end it wasn't the genius of his writing but another passion, namely, the public, indiscriminate pursuit of it that ruined him.

> *Ridicule is the tribute paid to the genius by the mediocrities.*
> —OSCAR WILDE

> *My wallpaper and I are fighting a duel to the death. One or other of us has got to go.*
> —OSCAR WILDE

THOMAS WOLFE

> *Death the last voyage, the longest, and the best.*
> —THOMAS WOLFE

As a child Thomas Wolfe watched his father chisel names onto tombstones and decided at some point that he would not follow this career path, instead becoming a famous performer. His mother separated from his father because of his alcoholism and selected only young Tom from among his siblings to live with her in a scary sixteen-bedroom boarding house. Thomas got out of there as soon as he could. At age sixteen he was attending

college so that he could partake in theater, and later refined his interest by obtaining a master's degree in play-writing from Harvard. He traipsed around the theater district trying to sell his plays, but his writing was considered too wordy. He finally realized that, once reformatted, his plays actually worked better as novels. This discovery gave him confidence; he wrote, "By God, I have genius." At twenty-four, he had the great fortune of capturing the notice of editor Max Perkins, who labored to cut and edit an unruly manuscript that was published as *Look Homeward, Angel,* an autobiographical novel that shredded almost everyone who ever helped Wolfe in his rise from the small Southern town where he lived. This biting the hand that fed him eventually led to serious rifts with the editor that saved him from his likely route toward drunken obscurity, his longtime mistress, his brother, and his famous literary friends. When Perkins wanted to cut down Wolfe's next manuscript, which came in at a million words, Wolfe was convinced it was part of a larger conspiracy to ruin him. Thomas Wolfe in the flesh was a hard man to cozy up with and from the first seemed prone to anti-Semitism, narcissism, and alcoholism. Wolfe believed that in addition to his superior writing prowess he had constitutional genius that allowed him to consume large quantities of alcohol. While visiting Berlin, Wolfe was seen downing eight quarts of German beer in an hour's time. He attributed the six days he then spent in the hospital recuperating not to the drinking but to a barroom brawl. Another time he stopped in to a bar for a drink and for no apparent reason slugged the guy sitting next to him. The man hadn't said a word; Wolfe later explained he hit him because the man had a "grey face." Wolfe saw only two of his books published in his lifetime, though others in varying edited formats came out posthumously. He died at the age of thirty-eight, in 1938, of a rare form of brain tuberculosis; his doctor suspected he caught the disease by taking a slug of whiskey from the flask of a stranger.

Most of the time we think we're sick, it's all in the mind.
—THOMAS WOLFE

VIRGINIA WOOLF

Great bodies of people are never responsible for what they do.
—VIRGINIA WOOLF

Few people have been chosen posthumously to hold the kind of lofty banner for an entire social movement as Virginia Woolf was. She became an icon of the feminist movement of the 1970s, not only for her ideas, but lifestyle as well, even if some of her personal idiosyncrasies were odd and obsessive by any standard. Her many bouts of depression, mood swings, and multiple suicide attempts were attributed to a bipolar disorder, yet she produced a large and lingering body of work, including the well-regarded *A Room of One's Own,* which states, "a woman must have money and a room of her own if she is to write fiction." Since her death, numerous treatises have theorized about what really

compelled her, some even alleging that childhood incestuous relations with her half-brothers drove her to the precipice of madness. Of course, while such a thing cannot be minimized, it does distract from the fact that she was remarkably insightful and intellectually ahead of her time, whether one agrees or not with her point of view.

From birth, Virginia Woolf was surrounded by the leading literary lights of the era, her father being a well-known British essayist that welcomed Henry James and other luminaries to their home. She was also trained in Victorian values, with their strict notion of women's place as secondary to men, making her rebellion that more striking. She did marry and remained so for nearly thirty years, though she had long-lasting lesbian affairs. She smoked cigars and in public gave the impression she cared not what others thought of her lifestyle. Her well-known frigidity with her husband, in contrast to her vibrant infatuation with her lesbian lover, has since been interpreted as a rebellion against the male-chauvinistic rule of the time. Nevertheless, Woolf turned over what money she made from writing to her husband. Her writing was her greatest passion and stirred her most shattering fears, as she was always struggling against inadequacy and was devastated by the slightest whiff of critical disdain.

During World War II the chaos of the world was actually, for the first time, greater than her interior turmoil: Her and her husband's names were in fact on Hitler's list to be arrested upon invasion, and husband and wife planned to commit suicide together if England fell. For much of her life she denied her mental illness, though she noted that many of her dramatic mood swings seemed cyclical and often correlated with the full moon. She often struggled with the notion that eating and having bowel-movements were disgusting and referred to them as "unladylike," an attitude that was perhaps part of her Victorian indoctrination she couldn't shake. Consequently, near-starvation seemed a logical way to avoid the need to defecate. During some of these prolonged fasts she heard voices and admitted once to overhearing birds outside her window having an elaborate discourse in Greek.

From childhood she had been fascinated by death and discussed it often in her work. Her descriptions of death follow the logical symmetry that it will mirror birth, but pushing in rather than out, through a narrow space that opens to the boundless other side. She regretted most that she wouldn't be around to record the experience of her own demise, which she hoped would be an orgasmic release, literally transcending her consciousness, into what she called

"the shower of atoms." In 1941 at age fifty-nine, Virginia Woolf walked down to the Ouse River near her home, put stones in her sweater pockets, and calmly walked into the freezing water. She opened her mouth and breathed deeply to fill her lungs rapidly, as if she were prepared to inhale an alien atmosphere. Unceremoniously, Virginia's husband gave her a plot of her own, burying her remains, which were retrieved three weeks later, under a tree in his garden.

RECORD OF THE LAST MOMENT

*As his last act, **Alberto Greco**, a flamboyant Argentine poet and performance artist, described what it was like to commit suicide—or so he tried. He wrote the word Fin on his hand and wrote about the fading feelings he experienced after he took an overdose of barbiturates on a label peeled off an ink bottle. When previously asked in an interview what were his upcoming projects, he smiled and replied, "To commit suicide." After he did so, in 1965 at age forty-nine, a number of critical thinkers, cupping their chins in their hands, discussed Greco's death as a legitimate act of art. Some construed his death as a statement that modern art too narrowly defines what is good and what is bad. His scribbling in the margins left no conclusive answers.*

CONSTANCE FENIMORE WOOLSON

Genius does what it must, and talent does what it can.
—Edward Robert Bulwer

Her granduncle was James Fenimore Cooper, author of *The Last of the Mohicans* and the first internationally famous American writer. This family legacy motivated Constance Fenimore Woolson to follow his footsteps, but ultimately set an impossibly high benchmark of success that led to her early demise. She was born in New England and wrote descriptively of its environs adequately enough to have her pieces published in national periodicals by her mid-thirties. She never married, lived with her parents, and remained their primary caregiver as they aged and died, thus squandering what were then considered her "eligible years." She was deaf in one ear and hard of hearing in the other and felt embarrassed by it, remaining socially aloof, living in solitude for most of her life. After her parents died, she went to Europe and began a platonic relationship with writer Henry James, who found Constance fairly attractive and not at all like the many bor-

ing, stodgy spinsters that forever bent his ear at tea parties. She admired and envied James's ability to write so well on first draft, while her novels and stories needed to be worked and reworked, with little improvement, according to her standards, though her work was good enough for her to make a living as a writer. The couple actually took up residence for a short time in Italy, James to have a safe place to stay, while Constance had a view toward marriage. James didn't encourage it; he was away traveling more often then not, though remained in contact with letters and occasional brief visits even after he stopped being a temporary house guest. Two passions consumed Constance in her last years: writing and getting married. She woke each morning at four a.m., dressed, always in black, threw the shutters open at her spatial apartment overlooking the Grand Canal in Venice, and labored diligently at her writing until evening. Her work seemed an imitation of James's style, and her stories about young girls marrying mostly became magazine-filler, never bringing her the literary status she strove for. When her last book was completed and sent off to the publisher, with James in England and no hope that he'd ever return her romantic love for him, she climbed through the shutters and threw herself out the window. She was found on the cobblestone street below, broken but alive, and was carried by strangers back to her bed. She died shortly after, at age fifty-three in 1894. Henry James offered to organize her estate, but he really only wanted to rifle through her papers so he could remove all letters he had sent and any mention of himself in her journals, which he burned in the fireplace.

I've always been interested in people, but I've never liked them.
—HENRY JAMES

STEFAN ZWEIG

It is the essence of genius to make use of the simplest ideas.
—Charles Péguy

Stefan Zweig was a significant figure in the 1920s, considered a leading literary man of letters, known primarily for producing insightful biographies. He was an Austrian Jew who first put on a uniform in World War I to write propaganda, but, once he had witnessed the horrors of the war, became a voice advocating pacifism and compassion as a way to bring about a new society. As the Nazis rose to power, his popular humanist philosophies, which advocated the search for solutions through an appeal to a universal morality, were in direct conflict with the regime's notions of nationalism and racial supremacy. As if that weren't enough, Zweig was a Jew, so his famously vast library was seized and publicly burned in a bonfire. The ashes of his treasured books lit the fuse to his disenchantment, and he believed civilization was at its end. Putting on a brave front, he escaped from Europe and eventually found a warm welcome in Brazil, setting up house there with his young wife (his second). The Brazilian government and other dignitaries offered Zweig access to their private library vaults, but he declined, perhaps reminded of how his library was destroyed. He had come to feel that his lifelong passion to pursue peace was a sad delusion. In 1942, Zweig, at age sixty, convinced his wife the only way to find ultimate peace was through death. After five days of meticulously setting their affairs in order, the couple simultaneously ingested a large dose of barbiturates. They were discovered the next day in a lovers' embrace.

Every wave, regardless of how high and forceful it crests, must eventually collapse within itself.
—Stefan Zweig

THE ULTIMATE CHECKMATE
Zweig was also noted as a chess master and left his last novel, The Royal Game, *a story about chess as it relates to genius and madness, to be published posthumously. He referred to players being so obsessed they succumbed to "chess poisoning." It seems true, since an inordinate number of famous chess players met bizarre and tragic endings:*

- George Mackenzie was a U.S. champion who took to chess after being arrested for desertion from the army. He holds the record as a marathon

player and won eighty-two games in a famous New York competition in 1866. In the end, he took an overdose of morphine at age fifty-four as his end strategy.

- Curt von Bardeleben, a German count and chess master, holds a legacy in the annals of the game as the worst sore loser. In a famous tournament he refused to witness his king captured and stormed out of the room before graciously resigning to defeat. He did a version of the same thing in real life when he jumped out of the window of a boarding house to his death, in 1924 at age sixty-three.
- Abe Turner was the victim of another person afflicted with "chess poisoning." At age thirty-eight, he was stabbed in the back more than nine times by a co-worker at the editorial offices of *The Chess Review* in 1962.
- Alvis Vitoliņš, heralded as a genius in Latvia, was also an International Master of chess. His last move was a leap from a railway bridge into an icy river, at age fifty-one in 1997.
- Lembit Oll, a chess prodigy who was awarded the title of International Master by seventeen, was only thirty-three when he leaped out of the window of his fourth-floor apartment in 1999.
- While leaping over an opponent's piece is an intricate part of the game, it was again the chess player's preferred manner of death when nineteen-year-old prodigy Jessie Gilbert flung herself from the eighth-floor window of a hotel in 2006.

APPENDIX

REHAB ROLL CALL

Genius, in one respect, is like gold—numbers of persons are constantly writing about both, who have neither.
—CHARLES CALEB COLTON*

People you might know who went to rehab:

- Ben Affleck
- Buzz Aldrin
- Kirstie Alley
- Tom Arnold
- Daniel Baldwin
- Marion Barry
- Drew Barrymore

- John Belushi
- Bo Bice
- Robert Blake
- Danny Bonaduce
- David Bowie
- Eileen Brennan
- James Brown

* Charles Caleb Colton, by the way, was an English cleric and writer of aphorisms. He left church service suddenly when he was busted for bootlegging wine. While hiding in Paris he blew the equivalent of a half-million-dollar inheritance on gambling. When Colton became ill he thought he must surely need surgery, but he was so afraid of doctors, he killed himself at age fifty-two, in 1832. This particular genius was discovered to be suffering from no more than the symptoms of a common cold.

- Bobby Brown
- Lenny Bruce
- Jenna Bush
- Noelle Bush
- Brett Butler
- Glen Campbell
- Naomi Campbell
- Ken Caminiti
- Jennifer Capriati
- Truman Capote
- George Carlin
- Richard Carpenter
- Nell Carter
- Nick Carter
- Johnny Cash
- Ray Charles
- Chevy Chase
- Dick Cheney
- Kurt Cobain
- Judy Collins
- Tara Conner
- Gerry Cooney
- Alice Cooper
- David Crosby
- Tony Curtis
- Jean-Claude Van Damme
- John Daly
- Pat Day
- Johnny Depp
- Pete Doherty
- Michael Douglas
- Robert Downey Jr.
- Richard Dreyfuss
- Dick Van Dyke
- Dock Ellis
- Eminem
- Colin Farrell
- Corey Feldman
- Stacy "Fergie" Ferguson
- Carrie Fisher
- Mark Foley
- Betty Ford
- James Frey
- James Gandolfini
- Jerry Garcia
- Leif Garrett

- Boy George
- Mel Gibson
- Vitas Gerulaitis
- J. Paul Getty Jr.
- Dwight Gooden
- Melanie Griffith
- Larry Hagman
- Jessica Hahn
- Corey Haim
- Eddie Van Halen
- Tonya Harding
- Prince Harry
- Philip Seymour Hoffman
- Billie Holiday
- Whitney Houston
- Steve Howe
- Michael Jackson
- Samuel L. Jackson
- Marc Jacobs
- Etta James
- Rick James
- Elton John
- George Jones
- Wynonna Judd
- Robert F. Kennedy Jr.
- Patrick Kennedy
- Ted Kennedy
- Rodney King
- Stephen King
- Ray Kroc
- Michael Largo
- Christopher Lawford
- Martin Lawrence
- Rush Limbaugh
- Annie Leibowitz
- Richard Lewis
- Lindsay Lohan
- Joe Louis
- Courtney Love
- Bela Lugosi
- Robert Mitchum
- John McVie
- Jo Dee Messina
- Liza Minnelli
- Keith Moon
- Demi Moore

- Mary Tyler Moore
- Eddie Money
- Kate Moss
- Randy Moss
- Joe Namath
- Leonard Nimoy
- Nick Nolte
- Pat O'Brien
- Tatum O'Neal
- Kelly Osbourne
- Ozzy Osbourne
- Haley Joel Osment
- Christopher Penn
- Matthew Perry
- Mackenzie Phillips
- Joaquin Phoenix
- Wilson Pickett
- Iggy Pop
- Paula Poundstone
- Jason Priestley
- Richard Pryor
- Dennis Quaid
- Jim Ramstad
- Keith Richards
- Nicole Richie
- Mickey Rourke
- Winona Ryder
- George C. Scott
- Charlie Sheen
- Roy Simmons
- O. J. Simpson
- Tom Sizemore
- Christian Slater
- Grace Slick
- Anna Nicole Smith
- Onterrio Smith
- David Soul
- Britney Spears
- Oliver Stone
- Darryl Strawberry
- Kiefer Sutherland
- Patrick Swayze
- Elizabeth Taylor
- Lawrence Taylor
- Billy Bob Thornton
- Ted Turner
- Mike Tyson
- Al Unser Jr.
- Keith Urban
- Stevie Ray Vaughan
- Jan Michael Vincent
- Dionne Warwick
- Chris Webber
- Hank Williams III
- Paul Williams
- Robin Williams
- Shelley Winters
- Franz Wright

SOURCES

BIBLIOGRAPHY AND ENDNOTES

Introduction: Dr. Stephen Ilardi quote: Klein, Julien M. "Simply Happy." *AARP, The Magazine*, December 2007.

Artemus Acord: "Art Acord Called Suicide; Ex-Cowboy Film Star, Working at Mining in Mexico, Takes Poison." *New York Times*, January 5, 1931; "Pauper's Grave for Acord, Film Star." *New York Times*, January 7, 1931; Menefee, David W. *The First Male Stars: Men of the Silent Era*. Bear Manor Media, 2007; Mix, Paul E. *The Life and Legend of Tom Mix*. A. S. Barnes and Company, 1972. Snyder, Solomon H. "Opiate Receptors and Internal Opiates." *Scientific American*, March 1977; Goldstein, Avram. *Addiction from Biology to Drug Policy*. Oxford University Press, 2001.

James Agee: Fuller, Edmond. "'I'd Do Anything on Earth to Write': James Agee's Correspondence Records the Quandaries of a Dedicated Artist 'To Write.'" *New York Times*, July 22, 1962; Ashdown, Paul, ed. *James Agee, Selected Journalism*. University of Tennessee Press, 2005; Agee, James. *A Death in the Family*. Grosset and Dunlap, 1957; Doty, Mark Allen. *Tell Me Who I Am: James Agee's Search for Selfhood*. Louisiana State University Press, 1981; "Death and Taxis": Baseline Studio Systems; New York City Taxi and Limousine Commission, New York City Police Department, "Annual Reports." 2001-2005; Danohoe, Pete. "From Queens to Arizona." *Daily News* (New York), April 15, 2007; "Mitchell, Margaret." *Encarta Online Encyclopedia*, 2007. http://au.encarta.msn.com.

Henry Alexander: "Artist Alexander Commits Suicide; Ends His Life with Poison—Despondent Because Without Funds." *New York Times*, May 16, 1984; "A Magnificent Charity; The Hebrew Benevolent and Orphan Asylum Society. A History of Its Grand Work. From an Effort to Care for One Jew in 1820 It Has Extended Its Work and Has Cared for Thousands." *New York Times*, February 3, 1895; Kramer, Hilton. "The Ordeal of Alfred Maurer." *New York Times*, February 16, 1969.

GG Allin: GG Allin official Web site http://www.ggallin.com/ retrieved April, 2007; Allin, Merle. E-mail message to author, November 9, 2007; "Kevin Michael Allin; Rock Performer, 37." *New York Times,* July 1, 1993; Nehring, Neil. *Popular Music, Gender and Postmodernism: Anger Is an Energy.* Sage Publications, 1997; "Broker to the stars killed in Manhattan apartment." *Newsday* (New York), November 1, 2007; Sege, Irene. "The Life and Death of Jimmy Reject." *Boston Globe,* October, 7, 2006.

Diane Arbus: Van Ripper, Frank. "Diane Arbus: Revealed And Rediscovered." *Washington Post,* February 8, 2003; Bosworth, Patricia. *Diane Arbus: A Biography.* W. W. Norton & Company, 2005; Townsend, Chris. *Francesca Woodman.* Phaidon Press, 2006; Riding, Alan. "Picture, Perhaps, Her Despair." *New York Times,* May 17, 1998.

Antonin Artaud: Knapp, Bettina L. *Antonin Artaud; Man of Vision.* David Lewis, 1969; Shattuck, Roger. *Artaud Possessed.* Farrar Straus Giroux, 1984; Artaud, Antonin. *Collected Works of Antonin Artaud.* Calder and Boyars, 1971; Barber, Stephen. *Blows and Bombs: Antonin Artaud, the Biography.* Creation Books, 2003; Esslin, Martin. *Antonin Artaud.* John Calder, 1976. Lemov, Rebecca. *World as Laboratory: Experiments with Mice, Mazes, and Men.* Hill & Wang, 2005; Gray, Spalding. *Life Interrupted: The Unfinished Monologue.* Crown, 2005; McKinley, Jesse. "Body of Spalding Gray Found." *New York Times,* March 9, 2004.

Isaac Babel: Bernstein, Richard. "Critic's Notebook; Isaac Babel May Yet Have The Last Word." *New York Times,* July 11, 2001; Pirozhkova, A. N. *At His Side: The Last Years of Isaac Babel.* Steerforth Press, 1996; Radzinsky, Edvard. *Stalin: The First In-depth Biography Based on Explosive New Documents from Russia's Secret Archives.* Anchor, 1997; Cowell, Alan. "A Year Later, Poisoned Agent's Family Accuse Russia." *New York Times,* November 24, 2007.

Honoré de Balzac: Balzac, Honoré de. *The Human Comedy and Other Short Novels.* BiblioBazaar, 2006; Wedmore, Frederick. *Life of Honoré de Balzac.* Kessinger Publishing, 2007; Weber, Eugen. "The Man Who Drank Life in Big Gulps." *New York Times,* September 11, 1994; Henningfield, J. E. "Caffeine Dependence." *Journal of the American Medical Association,* October 5, 1994; Connors, Joseph. *Francesco Borromini: Opus Architectonicum,* Columbia University Press, 1998.

Jean-Michel Basquiat: Smith, Roberta. "Mass Productions." *Village Voice,* March 23, 1982; Wines, Michael. "Jean-Michel Basquiat: Hazards Of Sudden Success and Fame." *New York Times,* August 27, 1988; O'Sullivan, Michael "Examining the Artist as Subject." *Washington Post,* February 14, 2003.

Charles Baudelaire: Baudelaire, Charles. *On Wine and Hashish.* Hesperus Press, 2002; Lloyd, Rosemary. *Baudelaire's World.* Cornell University Press, 2002; Holland, Eugene. *Baudelaire and Schizoanalysis: The Socio-Poetics of Modernism.* Cambridge University Press, 1993. Morgan, Edward. *Flower of Evil: A*

Life of Charles Baudelaire. Ayer Company Publishing, 1943; Booth, Martin. *Opium: A History.* St. Martin's Griffin, 1999; Hayden, Deborah. *Pox: Genius, Madness, and the Mysteries of Syphilis.* Basic Books, 2003.

Brendan Behan: Behan, Brendan. *Borstal Boy.* David R. Godine Publisher, 2000; O'Sullivan, Michael. *Brendan Behan: A Life.* Roberts Rinehart Publishers, 1999; Childers, Rory. "Brendan Behan: A Remembrance." *New York Times,* July 26, 1976.

John Berryman: "John Berryman, Poet, Is Dead; Won the Pulitzer Prize in 1965; He Jumps Off Bridge Near University of Minnesota, Where He Held Chair." *New York Times,* January, 8, 1972; Kalstone, David. "Recovery; The record of a struggle with prose and life." *New York Times,* May 27, 1973; Mariani, Paul. *Dream Song: The Life of John Berryman.* University of Massachusetts Press, 1996; Donner, Gene. *The Beautiful Bridge of Death: Accounts of Those Who Died, or Nearly Died, in Falls from the Golden Gate Bridge.* Self-Published, 1995; Mercey, James, et al. "Is Suicide Contagious." *American Journal of Epidemiology,* 2001.

Ambrose Bierce: Bailey, Milliard. "Mexican War Ends Career Of Ambrose Bierce, Picturesque Literary Figure; He Went to the Front and Has Never Been Heard From Since—A Remarkable and Interesting Character Who Was Anything but Conventional." *New York Times,* November 29, 1914; McWilliam, Carey. *Ambrose Bierce: A Biography.* Archon Books, 1967; The Ambrose Bierce Appreciation Society, http://www.biercephile.com/, retrieved March 2007; Bierce, Ambrose. *The Unabridged Devil's Dictionary.* University of Georgia Press, 2002; Katz, Frederick. *The Life and Times of Pancho Villa.* Stanford University Press, 1998.

William Billings: "Music in This Country: Dr. Ritter's Interesting Account of American Music." *New York Times,* December 16, 1883; Tubman, Howard. "William Billings, 18th Century Composer." *New York Times,* February 16, 1941; Schottenfeld, D. "Snuff Dipper's Cancer." *New England Journal of Medicine,* March 26, 1981; "Tobacco Related Deaths," Annual Reports, World Health Organization.

Boudicca: Shipway, George. *The Imperial Governor.* Doubleday, 1968; Terrence, Henry. *Red Queen, White Queen.* Random House, 1958; Cotrell, Leonard. *The Great Invasion.* Coward-McCann, 1962; Green, Miranda. *The Celtic World.* Routledge, 1996; Trow, M. J. *Boudicca: The Warrior Queen.* Sutton Publishing, 2005.

Louis Braille: Keller, Helen. "Light-Bearer to the World of Darkness; One hundred years ago Louis Braille died, but his alphabet remains precious to the blind." *New York Times,* January 6, 1952; Mellor, Michael C. *Louis Braille: A Touch of Genius.* National Braille Press, 2006; Davidson, Margaret. *Louis Braille: The Boy Who Invented Books for the Blind.* Scholastic Paperbacks, 1991; Davis, Francis. *The History of the Blues: The Roots, the Music, the People.* Da Capo Press, 2003. Oakley, Giles. *The Devil's Music: A History of the Blues.* Da Capo Press, 1997; Gray, Michael. *Hand Me My Travelin' Shoes: In Search of Blind Willie McTell.* Bloomsbury, 2007.

Richard Brautigan: McDowell, Edwin. "Richard Brautigan, Novelist, A Literary Idol of the 1960s." *New York Times*, October, 27, 1984; Abbot, Keith. *Downstream from Trout Fishing in America: A Memoir of Richard Brautigan.* Capra Press, 1989; Brautigan, Ianthe. *You Can't Catch Death: A Daughter's Memoir.* St. Martin's Griffin, 2001.

Larry Brown: Watson, Jay. *Conversations With Larry Brown.* University Press of Mississippi, 2007; Applebome, Peter. "Larry Brown's Long and Rough Road to Becoming a Writer." *New York Times*, March 5, 1990; Minzesheimer, Bob. "Remembering Larry Brown." *USA Today,* November 29, 2004; Stininson, F., and G. Williams. "Surveillance Report #4–19, 1989–2001." National Institute on Alcohol Abuse and Alcoholism, Alcohol, Drug Abuse, and Mental Health Administration.

Lenny Bruce: Skover, D., and R. Collins. *The Trials of Lenny Bruce: The Fall and Rise of an American Icon.* Sourcebooks, 2002; Thomas, W. K. *Lenny Bruce: The Making of a Prophet.* Archon Books, 2000; Solomon, Norman. "The Unpardonable Lenny Bruce." *Humanist* 64 (March 2004); Toto, Christian. "Lenny's Laughless Legacy." *Washington Times*, November 12, 2004; "Lenny Bruce, Uninhibited Comic, Found Dead in Hollywood Home; His Nightclub Act Blended Satire With Scatology and Led to Arrests." *New York Times*, August 4, 1966; Porter, Roy. *The Cambridge History of Medicine.* Cambridge University Press, 2006.

Charles Bukowski: Weizmann, Daniel, ed. *Drinking with Bukowski: Recollections of the Poet Laureate of Skid Row.* Thunder's Mouth Press, 2000; Ciotti, Paul. "Bukoski on Buksoski." *Los Angeles Times*, March 22, 1987; Iyer, Pico. "Celebrities Who Travel Well." *Time* magazine, January 16, 1986; Bukowski, Charles. *Ham on Rye.* Ecco, 2002.

William S. Burroughs: Burroughs, William, S. and Grauerholz, James, ed. *Last Words: The Final Journals of William S. Burroughs.* Grove Press, 2001; Severo, Richard. "William S. Burroughs, the Beat Writer Who Distilled His Raw Nightmare Life, Dies at 83." *New York Times*, August 4, 1997.

Lord Byron: Galt, John. *The Life of Lord Byron.* Echo Library, 2007; McCarthy, Fiona. *Byron: Life and Legend.* Farrar, Straus and Giroux, 2004; Robinson, Charles. *Lord Byron and His Contemporaries.* University of Delaware Press, 1982; Jefferson, John. *The Real Lord Byron: The Story of the Poets Life.* Hurst and Blackett, 1883; Hunt, Leigh. *Lord Byron and Some of His Contemporaries with Recollections of the Author's Life and of His Visit to Italy.* London H. Colburn, 1828; George, Athelstan. "Douglas of the Fir: A Biography of David Douglas, Botanist." *Pacific Historical Review* 17, no. 2 (May 1948).

Maria Callas: Ericson, Raymond. "Maria Callas, 53, Is Dead of Heart Attack, in Paris."*New York Times*, September 17, 1977; Galatopoulos, Stelios, *Maria Callas, Sacred Monster.* Simon and Schuster, 1998; Stanicoff, Nadia. *Maria Callas Remembered: An Intimate Portrait of the Private Callas.* Da Capo Press, 2000.

John Candy: Knelman, Martin. *Laughing on the Outside: The Life of John Candy*. St. Martin's Griffin, 1998; Collin, Glen. "John Candy, Comedic Film Star, Is Dead of a Heart Attack at 43." *New York Times*, March, 5, 1994; "Did Candy Miss Clues of Heart Failure?" *Toronto Star*, March 31, 1994; Salem, Rob. "Johnny, We Hardly Knew Ye: Even in the Face of His Own Mortality, John Candy Chose to Celebrate Life." *Toronto Star*, April 3, 1994; Guse, Joe. *The Tragic Clowns: An Analysis of the Short Lives of John Belushi, Lenny Bruce, and Chris Farley*. Aardvark, 2007; Baron, James. "Chris Farley, 33, a Versatile Comedian-Actor." *New York Times*, December, 19, 1997; "La Mettrie, Julien Offray de." *Columbia Encyclopedia*, 2001–2007.

Max Cantor: Aronowitz, Al. "The Strange Case of Max Cantor." Online: Retrieved July 23, 2007 "Black Listed Journalist" http://www.bigmagic.com.

Truman Capote: Clarke, Gerald. *Capote: A Biography*. Carroll & Graf, 2005; Plimpton, George. *Truman Capote*. Picador, 1999; Davis, Deborah. *Party of the Century: The Fabulous Story of Truman Capote and His Black and White Ball*. Wiley, 2006; Moates, Marianne. *Truman Capote's Southern Years*. University Alabama Press, 1996; Fleming, Anne. "Capote's World: Descent from the Heights." *New York Times*, July 16, 1978; Capote, Truman. "Answered Prayers." *Esquire*, November 1975; Geracimos, Ann. "Braudy Tale Reflects High Society's Lows." *Washington Times*, September 10, 1992; Woo, Elaine. "W. Woodward, Scion of Rich Family Plagued by Tragedy." *Los Angeles Times*, May 8, 1999.

Lewis Carroll: Carson, Robert C., James N. Butcher, and Susan Mineka. *Abnormal Psychology and Modern Life*. Longman, 1998; Reed, Langford. *The Life of Lewis Carroll*, W. and G. Foyle, 1932; Russell, L. J. "A Problem with Lewis Carroll." *Journal of Symbolic Computation* vol. 21, no. 2, (1956); Kincaid, James. "Child-Loving: The Erotic Child and Victorian Culture." *Nineteenth-Century Literature*, University of California Press, 1993; Cohen, Morton. "Lewis Carroll: A Biography." *Journal of Aesthetic Education* 32, no. 1 (1998); Edwards, Griffin, et al. "Opium and the People: Opiate Use in Nineteenth-Century England." *Journal of Modern History* 56, no. 4 (1984); Berridge, Virginia. "Victorian Opium Eating: Responses to Opiate Use in Nineteenth-Century England." *Victorian Studies* 21, no. 4 (1978).

Johnny Cash: Holden, Stephen. "Johnny Cash, Country Music Bedrock, Dies at 71."*New York Times*, September 13, 2003; Cash, Johnny. *Cash: The Autobiography*. HarperOne, 2003.

Neal Cassady: Sandison, David. *Neal Cassady: The Fast Life of a Beat Hero*. Chicago Review Press, 2006; Cassady, Carolyn. *Off the Road: Twenty Years with Cassady, Kerouac, and Ginsberg*. Penguin, 1990; Maher, Paul. *Kerouac: The Definitive Biography*. Taylor Trade Publishing, 2007; Cassady, Neal. *Grace Beats Karma: Letters from Prison, 1958–1960*. Blast Books, 1993; ———. *The First Third & Other Writings*. City Lights Books, 1971; ———. *Collected Letters, 1944–1967*. Penguin, 2005. Brugha, T., et al. "Psychosis in the community and in prisons." *American Journal of Psychiatry*, April 2005.

Catullus: Putnam, Michael. *Poetic Interplay: Catullus and Horace.* Michael C. J. Princeton University Press, 2006; Lindsey, Jack. *The Complete Poetry of Catullus.* Walter V. McKee, 1930; Wheeler, Arthur. *Catullus and the Tradition of Ancient Poetry.* University of California Press, 1934. Michealman, Maurice. "Sirmione's Secret Revealed in Verse of Poet Catullus." *New York Times,* May 3, 1970; Powys, John Cowper. *The Art of Happiness.* Simon & Schuster, 1923; Strauss, Eric. "Porn Industry Still Struggles with Condom Issue." *ABC News,* January 14, 2007; Williams, Linda. *Porn Studies.* Duke University Press, 2004; Kapelovitz, Dan. "Who Killed Lolo Ferrari?" *Hustler Magazine,* September 2003.

Paul Celan: Felstiner, John. *Paul Celan: Poet, Survivor, Jew.* Yale University Press, 1997; Celan, Paul. *Selected Poems and Prose of Paul Celan.* W. W. Norton & Company, 2001; Garloff, Katja. *Words from Abroad: Trauma and Displacement in Postwar German Jewish Writers.* Wayne State University Press, 2005; Kaplan, Ann. *Trauma Culture: The Politics of Terror and Loss.* Rutgers University Press, 2005; Cohen, Arthur. "An esthetic atrocity; The Holocaust and the Literary Imagination." *New York Times,* January 18, 1976.

Ray Charles: Lydon, Michael. *Ray Charles: Man and Music.* Routledge, 2004; Charles, Ray and Ritz, David. *Brother Ray: Ray Charles' Own Story.* Da Capo Press, 2004.

Thomas Chatterton: "That 'Marvelous Boy,' Thomas Chatterton." *New York Times,* January 25, 1931; Haywood, Ian. *The Making of History: A Study of the Literary Forgeries of James Macpherson and Thomas Chatterton in Relation to Eighteenth-Century Ideas of History and Fiction.* Fairleigh Dickinson University Press, 1986; Chatterton, Thomas. *Thomas Chatterton: Early Sources and Responses.* Routledge, 1993; Aggrawal, Anil. "Arsenic, The King of Poisons." *Poison Sleuths,* February 1995.

Anton Chekhov: Avilova, Lydia. *Chekhov in My Life: A Love Story.* Greenwood Press, 1971; Bruford, W. H. *Anton Chekhov.* Yale University Press, 1957; Hahn, Beverly. *Chekhov: A Study of the Major Stories and Plays.* Cambridge University Press, 1977; Karlinsky, Simon, ed. *Anton Chekhov's Life and Thought: Selected Letters and Commentary.* University of California Press, 1975. Bakhtin, Mikhail. *Rabelais and His World.* Indiana University Press, 1984.

Winston Churchill: Manchester, William. *The Last Lion: Winston Spencer Churchill, Visions of Glory.* Little, Brown and Co., 1983; Humes, James C. *The Wit & Wisdom of Winston Churchill.* Harper Perennial, 1995.

Montgomery Clift: "Clift's Suit on 'Freud' Film For $131,000 Going to Trial." *New York Times,* July 2, 1963; "Montgomery Clift Dead at 45; Nominated 3 Times for Oscar; Completed Last Movie, 'The Defector,' in June; Actor Began Career at Age 13." *New York Times,* July 24, 1966; Bosworth, Patricia. *Montgomery Clift: A Biography.* Limelight Editions, 2004; Alumit, Noel. *Letters to Montgomery Clift.* McAdam, 2002; LaGuardia, Robert. "Clift's life: pathos without much drama." *Chicago Tribune,* July 24, 1977; Wolfe, Donald H. *The Assassination of Marilyn Monroe.* Warner Books, 1999; Wolfe, Donald H. *The Last Days of Marilyn Monroe.* William Morrow & Company, 1998.

Robert Clive: Davis, Mervin. *Clive of Plassey*, Charles Scribner and Sons, 1939; Minnie, R. T. *Clive*. Appleton & Company, 1931; "Robert Clive: Tearaway to Empire Builder." *BBC Online*; Lawson, Philip. *The East India Company: A History*. London, 1993; Chaudhuri, K. N. *The Trading World of Asia and the English East India Company 1600–1760*. Cambridge, 1978; "Tortoise That Saw the Rise and the Fall of the British Empire Dies." *New York Times*, March 24, 2006. "The Drug's History Traced from the Plant to the Pipe." *New York Times*, March 29, 1896. "Increase in Morphinomania." *London Daily News*, August 2, 1896.

Kurt Cobain: "The Dark Side of Kurt Cobain." *Advocate*, February 1992; Cobain, Kurt. Interview at Riverfront Hotel, Seattle, Washington. *Much Music*, August 9, 1993; "Poster Boy for Heroin Use." *Washington Post*, May 14, 1994; Balzar, John. "Grunge Rock's Kurt Cobain Dies in Apparent Suicide." *Los Angeles Times*, April 9, 1994; "Cobain Statue a Touchy Subject in His Hometown." *Chicago Tribune*, July 7, 1994; "Suicides of 2 Youths Are Linked to Singer's." *New York Times*, July 17, 1994; Allman, Kevin, and Michael Saunders. "The Most Hated Woman in Rock and Roll." *Boston Globe*, August, 4, 1995.

Samuel Taylor Coleridge: Hartley, Ernest. *The Letters of Samuel Coleridge*. Houghton and Mifflin Company, 1895; Coleridge, S. *Memories and Letters of Sara Coleridge*. Harper and Brothers, 1873; "The Work of Coleridge." *New York Times*, July 31, 1897; Holmes, Richard. *Coleridge: Early Visions, 1772-1804*. Pantheon, 1999; Worthen, John. *The Gang: Coleridge, the Hutchinsons, and the Wordsworths in 1802*. Yale University Press, 2001; Schneider, E. *Coleridge, Opium, and Kubla Khan*. University of Chicago Press, 1953; Lefebure, Molly. *The Bondage of Love: A Life of Mrs. Samuel Taylor Coleridge*. W. W. Norton & Company, 1987; Hodgson, Barbara. *In the Arms of Morpheus: The Tragic History of Morphine, Laudanum, and Patent Medicines*. Firefly Books, 2001; "Drug Victims Suffer." *Washington Post*, March 20, 1915.

Hart Crane: Kart, Harry. "An Inside-the-Bottle Look at Our Boozed Writers." *Chicago Tribune*, March 18, 1981; "Two Sides of Hart Crane." *Christian Science Monitor*, July 24, 1969; Smith, Russell. "The Poet as Poet." *Washington Post*, June 9, 1937; "Purser Describes Suicide of Poet." *Washington Post*, April 30, 1932; Utereckers, John. *Voyagers: A Life of Hart Crane*. Farrar, Strauss and Giroux, 1969; "Poet's Death Linked to Loss of Father." *New York Times*, April 29, 1932; Horton, Philip. *Hart Crane: The Life of An American Poet*. W. W. Norton & Company, 1937; Pennebaker, James W., et al. "Word Use in the Poetry of Suicidal and Nonsuicidal Poets." *Psychosomatic Medicine*, May 2001.

Stephen Crane: Corwin, Linson K. *My Stephen Crane*. Syracuse University Press, 1958; Hilliard, John. "Stephen Crane: Letters to His Friends." *New York Times*, July 14, 1900; "A Seaman Novelist." *Atlanta Constitution*, February 17, 1901; "The Distinguished Dead of 1900." *Chicago Daily Tribune*, December 28, 1900; "Stephen Crane's Case Hopeless." *Los Angeles Times*, April 13, 1900; "Death of Stephen Crane." *Boston Daily Globe*, June 6, 1900; Wertheim, Stanley. *The Crane Log: A Documentary Life of Stephen Crane*

1871–1900. G. K. Hall, 1994; Benfey, Christopher E. G. *The Double Life of Stephen Crane.* Knopf, 1992; "A Green Private Under Fire. 'The Red Badge of Courage': An Episode of the American Civil War." *New York Times*, October 19, 1895; Brown, J. B., "Politics of the Poppy: The Society for the Suppression of the Opium Trade, 1874–1916." *Journal of Contemporary History*, July 1973; La Motte, Ellen. "The Opium Problem." *American Journal of Nursing*, July 1929.

Harry Crosby: Wolff, Geoffrey. *Black Sun: The Brief Transit and Violent Eclipse of Harry Crosby.* NYRB Classics, 2003; Boyle, K., et al. *Being Geniuses Together 1920-1930.* North Point Press, 1984; Conrad, Barnaby. *Absinthe: History in a Bottle.* Chronicle Books, 1997; "Couple Found Dead in Artist's Hotel; Suicide Compact Is Indicated Between Henry Grew Crosby and Harvard Man's Wife. He Was Socially Prominent in Boston—Bodies Found in Friend's Suite." *New York Times*, December 11, 1929; Cowley, Malcolm. "Of Love, Death, Poetry, Money, and Scandal." *Washington Post*, July 8, 1976; "Mary Crosby Dies—Published Works of Joyce." *Hartford Courant*, January 26, 1970; "The Tattoo Artists." *Washington Post*, April 15, 1883; Rich, Louis. "Tattooing Enters Machine Age: Once Exclusive Art Now Is Invaded by Novices." *New York Times*, September 14, 1930.

Dorothy Dandridge: "Dorothy Dandridge Died of Pill Dosage, Coroner Now Says." *New York Times*, November 18, 1965; "44-Word Handwritten Will Of Miss Dandridge Filed." *New York Times,* October 12, 1965; "Actress-Singer Dorothy Dandridge Found Dead in W. Hollywood Home." *Los Angeles Times*, September 9, 1965; Dandridge, Dorothy, and Earl Conrad. *Everything and Nothing: The Dorothy Dandridge Tragedy.* Abelard-Schumann, 1970; Bogle, Donald. *Toms, Coons, Mulattoes, Mammies, and Bucks: An Interpretive History of Blacks in American Films.* Viking, 1973; Crowther, Bosley. "Negroes in a Film; 'Carmen Jones' Finds American Types Singing a Foreign Opera Score." *New York Times*. October 31, 1954; Hill, Gladwin."2 Film Actresses Testify on Coast; Maureen O'Hara, Dorothy Dandridge Deny Stories Carried in Confidential." *New York Times*, September 4, 1957; Randle Jr., William. "Black Entertainers on Radio." *Black Perspective in Music*, Spring 1977.

Dante: Whiting, Mary Bradford. *Dante the Man and the Poet.* W. Heffer & Sons, ltd, 1922; Alighieri, Dante. *The Divine Comedy.* The Modern Library, 1950; Gardner, Edmund G. "Dante Alighieri." *Catholic Encyclopedia*, Volume IV. Robert Appleton Company,1908; Bloom, Harold. *Genius: A Mosaic of One Hundred Exemplary Creative Minds.* Warner Books, 2002; Stone, Irving. *The Agony and the Ecstasy.* Signet, 1987; Liebert, R.S. *Michelangelo: A Psychoanalytic Study of His Life and Images.* Yale University Press, 1983.

Salvino D'Armato: "The Invention of Spectacles." *College of Optometrists Newsletter*, June 2005; Herald, Jacqueline. *Renaissance Dress in Italy, 1400–1500.* Bell and Hyman, 1981; Pullan, Brian. *A History of Early Renaissance Italy:*

From the Mid-Thirteenth to the Mid-Fifteenth Century. Allen Lane, 1973; Rosen, Edward. "Carlo Dati on the Invention of Eyeglasses." *Isis*, June 1953; Maldonado, Tomas. "Taking Eyeglasses Seriously." *Design Issues*, Autumn 2001; McCray, Patrick W. "Glassmaking in Renaissance Venice: The Fragile Craft." *Sixteenth Century Journal*, Spring 2001; Cipolla, Carlo. "Public Health and the Medical Profession in the Renaissance." *American Journal of Sociology*, May 1978; Pace, Erik. "Edwin H. Land Is Dead at 81; Inventor of Polaroid Camera." *New York Times*, March 2, 1991.

John Davidson: Townsend, Benjamin J. "John Davidson, Poet of Armageddon." *Philosophy and Phenomenological Research*, June 1963; Macleod, R. D. *John Davidson: A Study in Personality.* Folcroft Library Editions, 1974; Sloan, John. *John Davidson, First of the Moderns; A Literary Biography.* Oxford University Press, 1995; "John Davidson Disappears; Anxiety Felt for the Author of 'Fleet Street Eclogues.'" *New York Times*, March 26, 1909; "John Davidson's Will; Poet Asks That Seven Plays Should Not Be Published." *London Times*, November 7, 1909.

Miles Davis: Davis, Miles. *Miles.* Simon & Schuster, 1990; Carr, Ian. *Miles Davis: The Definitive Biography.* Da Capo Press, 2006.

Humphry Davy: Knight, David. *Humphry Davy: Science and Power.* Blackwell, 1992; Treneer, Anne. *The Mercurial Chemist. A Life of Sir Humphry Davy.* Methuen & Co., Ltd., 1963; Bing, Franklin. "Humphry Davy and Carbon Monoxide Poisoning." *Scientific Monthly*, December 2004; Foote, George. "Sir Humphry Davy and His Audience at the Royal Institution." *Isis*, April 1952; Hartley, Harold. "The Wilkins Lecture. Sir Humphry Davy, Bt., P.R.S. 1778–1829." *Proceedings of the Royal Society of London. Series A, Mathematical and Physical Sciences*, April 1960; Hutchinson, W. K., et al. "The Relative Stability of Nitrous Oxide and Ammonia in the Electric Discharge." *Proceedings of the Royal Society of London. Series A, Containing Papers of a Mathematical and Physical Character*, December, 1927; Field, William, et al. "Hallucinations and How to Deal with Them." *American Journal of Nursing*, April 1973.

Thomas De Quincey: De Luca, V. A. "Thomas De Quincy: The Prose of Vision." *Rocky Mountain Review of Language and Literature*, Summer, 1981; Burwick, Frederick. *Selected Essays on Rhetoric by Thomas De Quincey.* Southern Illinois University Press, 1967; "Review of Thomas De Quincey: His Life and Writing." *British Quarterly Review*, Spring 1877; "Death of Thomas De Quincey." *Scotsman*, December 10, 1859; "Life and Adventures of an Opium-Eater." *Dublin University Magazine*, Fall 1854; "Death of De Quincey." *New York Times*, December 23, 1859; Rzepka, Charles J. "The Literature of Power and the Imperial Will: De Quincey's Opium War Essays." *South Central Review*, Spring 1991; Milligan, Barry. *Pleasures and Pains: Opium and the Orient in Nineteenth-Century British Culture.* University Press of Virginia, 1995; Harding, Geoffrey. *Opiate Addiction, Morality and Medicine: From Moral Illness to Pathological Disease.* St. Martin's Press, 1988; Pope, Willard Bissell. "The Diary of Benjamin Robert Haydon." *Journal of Modern History*, December 1965.

James Dean: McKernan, John. "James Dean in Nebraska." *College English*, November 1992; Dalton, David, and Ron Cayen. *James Dean: American Icon*. St. Martin's Press, 1984; "James Dean, Film Actor, Killed in Crash of Auto." *New York Times*, October 1, 1955; "Ex-Farm Boy Now Is Making Hay in Movies; James Dean Gets Label of 'Genius.'" *Los Angeles Times*, March 27, 1955; Hopper, Hedda. "James Dean to Make Movie on Story of Wayward Youth." *Chicago Tribune*, December 16, 1954; Nielsen, Evelyn Washburn. "The Truth About James Dean." *Chicago Tribune*, September 9, 1956; Goode, Erica. "Rating Life: Live Fast, Die Young." *New York Times*, March 13, 2001.

Emily Dickinson: White, Jean M. "Death in New England." *Washington Post*, December 21, 1986; Erkkila, Betsy. "Emily Dickinson and Class." *American Literary History*, Spring 1992; *Dickinson and the Strategies of Reticence: The Woman Writer in Nineteenth-Century America*. Indiana University Press, 1989; Smith, Martha Nell. *Open Me Carefully: Emily Dickinson's Intimate Letters to Susan Dickinson*. Paris Press, 1998; Vincent. "Confessions of an Agoraphobic Victim." *American Journal of Psychology*, July 1919; Brown, Gillian. "The Empire of Agoraphobia." *Representations*, Autumn 1987; Peitzman, Stephen. "From Dropsy to Bright's Disease to End-Stage Renal Disease." *Milbank Quarterly*, Spring 1989; Swanson, Guy E. "Phobias and Related Symptoms: Some Social Sources." *Sociological Forum*, Winter 1986.

Diogenes: Navia, Luis. *Diogenes the Cynic: The War against the World*. Humanity Books, 2005; Dudley, D. R. *A History of Cynicism from Diogenes to the 6th Century AD*. Cambridge University Press, 1937; Navia, Luis E. *Diogenes of Sinope: The Man in the Tub*. Greenwood Press, 1990; Branham, Bracht and Marie-Odile Goulet-Cazé, eds. *The Cynics: The Cynic Movement in Antiquity and Its Legacy*. University of California Press, 1996; "A Famous Dog Is Dead; Champion George of Philadelphia Succumbs to the Heat."*New York Times*, August 11, 1892.

Michael Dorris: Lyman, Rick. "Michael Dorris Dies at 52; Wrote of His Son's Suffering." *New York Times*, April 15, 1997; Streitfeld, David. "Writer Was Suspected of Child Abuse." *Washington Post*, April 16, 1997; Coltelli, Laura. *Winged Words: American Indian Writers Speak*. 1993; Rawson, Josie. "A Broken Life." *Salon*, retrieved: September 5, 2007, http://www.salon.com/april97/dorris970421.html; Dorris, Michael. *The Broken Cord: Fetal Alcohol Syndrome and the Loss of the Future*. HarperCollins, 1989; Gleick, Elizabeth. "An Imperfect Union." *Time*, April 28, 1997; Terry, Don. "Novelist's Public Death Creates Chicago Mystery." *New York Times*, December 15, 1996.

Ernest Dowson: Longaker, Mark. *Ernest Dowson*. University of Pennsylvania Press, 1944; Flower, Desmond. *The Letters of Ernest Dowson*. Fairleigh Dickinson, 1968; Cevasco, George. *Three Decadent Poets: Ernest Dowson, John Gray, and Lionel Johnson*. Routledge, 1990; Marshall, Birkett. "A Note on Ernest Dowson." *Review of English Studies*, April 1952; Schaffner, Margaret. "Absinthe Prohibition in Switzerland." *American Political Science Review*, November 1908; Plarr, Victor. *Ernest Dowson 1888–1897 Reminiscences, Unpublished Letters and Marginalia*. L. J. Gomme, 1914;

"Mrs. Atherton on Genius and Drink; Interview with the Author of 'The Gorgeous Isle'—The Originals of the Besotted Poet." *New York Times*, December 12, 1908; Reed, John. "Bedlamite and Pierrot: Ernest Dowson's Esthetic of Futility." *ELH*, March 1968; Grossman, Manuel L. "Alfred Jarry and the Theatre of the Absurd." *Educational Theatre Journal*, December 1967.

Stuart Engstrand: "Lake Suicide Had Best Seller Novel." *Los Angeles Times*, September 10, 1955; "Author Walks To His Death In Park Lake." *Washington Post and Times Herald*, September 10, 1955; Engstrand, Stuart. "Author Returns to Native Heath for His Locale." *Chicago Daily Tribune*, December 2, 1951; Tidwell, John Edgar. "An Interview with Frank Marshall Davis." *Black American Literature Forum*, Autumn 1985; Slide, Anthony. *Lost Gay Novels*. Haworth Press, 2003; Preto-Rodas, Richard A. "Francisco Rodrigues Lobo: Dialogue and Courtly Lore in Renaissance Portugal." *Hispania*, May 1974; McGregor, Craig. "Jackson's Dead. So Is Albert Ayler." *New York Times*, December 5, 1971; Eustis, Helen. "Schizophrenia of Herbert Dawes; The Sling and the Arrow." *New York Times*, May 11, 1947.

Sergei Esenin: Karlinsky, Simon. "Isadora Had a Taste for 'Russian Love'; Esenin." *New York Times*, May 9, 1976; Wolff, G. "Entering World of the Suicide." *Los Angeles Times*, May 21, 1972; "What Is the Reason That Dance Artists and Matrimony Won't Mix." *Atlanta Constitution*, October 1, 1921; Visson, Lynn. *Sergei Esenin: Poet of the Crossroads*. Jal-Verlag,1980; Bethea, David M. "Sergei Esenin." *Russian Review*, October 1984;. Briggs, A. D. P. *Vladimir Mayakovsky: A Tragedy*. Willem A. Meeuws, 1979.

Chris Farley: Barron, James. "Chris Farley, 33, a Versatile Comedian-Actor." *New York Times*, December 19, 1997; Guse, Joe. *The Tragic Clowns: An Analysis of the Short Lives of John Belushi, Lenny Bruce, and Chris Farley*. Aardvark, 2007; Anderson, Marilyn D. *Chris Farley (They Died Too Young)*. Chelsea House Publications, 2000.

William Faulkner: "William Faulkner Is Dead In Mississippi Home Town." United Press International (UPI), July 7, 1962; "Faulkner's Home, Family and Heritage Were Genesis of Yoknapatawpha County; Novels Praised as Powerful Tragedy and Scorned as Raw Slabs of Depravity." *New York Times*, July 7, 1962; Culligan, Glendy. "Author Faulkner's Life Was Marked By Contradictions—Like His Works." *Washington Post*, July 7, 1962; "Understanding Faulkner." *Christian Science Monitor*, July 12, 1962; Grimwood, Michael. *Heart in Conflict: Faulkner's Struggles with Vocation*. The University of Georgia Press, 1987; Yin, Hum Sue, et al. "Alcohol, Faulkner, and *Sanctuary*: Myth and Reality." *Publications of the Arkansas Philological Association*, Fall 1993; Singal, Daniel J. "William Faulkner: The Making of a Modernist." *Journal of Southern History*, November 1998; Lukas, Anthony, J. "One Too Many for the Muse." *New York Times*, December 1, 1985.

F. Scott Fitzgerald: "Scott Fitzgerald, Author, Dies at 44; Writer of 'The Great Gatsby' and 'This Side of Paradise' Interpreted 'Jazz Era'; Stricken in Hollywood; Brilliant Novelist of Twenties, Inactive Recently, Likened Self to 'Cracked Plate.'" *New York Times*, December 23, 1940; Wood, Mary E. "A Wizard Cultivator: Zelda Fitzgerald's Save Me the Waltz as Asylum Autobiography." *Tulsa Studies in Women's Literature*, Autumn 1992; Bryer, Jackson R. *The Critical Reputation of F. Scott Fitzgerald*. Archon Books, 1967; Berg, Scott. *Maxwell Perkins: Editor of Genius*. Dutton, 1978; Milford, Nancy. *Zelda*. Harper and Row, 1970; Graham, Sheilah, and Gerold Frank. *Beloved Infidel*. Holt, Rinehart & Winston, 1958; Ring, Frances Kroll. *Against the Current: As I Remember F. Scott Fitzgerald*. Ellis-Creative Arts,1985; Mizener, Arthur, ed. *F. Scott Fitzgerald: A Collection of Critical Essays*. Prentice-Hall, 1963; Turnbull, Andrew, ed. *The Letters of F. Scott Fitzgerald*. Scribner, 1963; Maurer, David W. *Kentucky Moonshine*. University of Kentucky Press, 2003.

Gustave Flaubert: Brombert, Victor. *The Novels of Flaubert: A Study of Themes and Technique*. Princeton University Press, 1966; Starkie, Enid. *Flaubert: The Making of the Master*. Atheneum Press, 1967; Steegmuller, Francis, ed. *The Letters of Gustave Flaubert, 1830–1857*. Harvard University Press, 1980; Sartre, Jean-Paul. *The Family Idiot: Gustave Flaubert, 1821–1857*. University of Chicago Press, 1987; "Gustave Flaubert." *Fortnightly Review*, December 1895; Steegmuller, Francis. "The Real Inside Dope on Flaubert and Maupassant." *New York Times*, October 5, 1974; "Gustave Flaubert." *New York Times*, December 12, 1886; Gugliotta, Guy. "Why Brahms Dozed and Van Gogh Saw Yellow." *Washington Post*, January 29, 2001; Murai, T., MD, et al. "Temporal lobe epilepsy in a genius." *Neurology*, Fall 1998; LaPlante, Eve. *Seized*. Backinprint.com, 2000.

Errol Flynn: Elkin, Frederick."Popular Hero Symbols and Audience Gratifications." *Journal of Educational Sociology*, November 1955; Flynn, Errol. *My Wicked, Wicked Ways*. Buccaneer Books, 1978; "Errol Flynn Dies; Stricken in Canada While Arranging Sale of Yacht—Had Adventurous Career." *New York Times*, October 15, 1959; "Flynn Pursued Beverly; Lawyer Affidavit Says." *Los Angeles Times*, December 3, 1959; Coe, Richard L. "Flynn 'Ways' Wry and Racy." *Washington Post*, January 2, 1960; "Flynn Old Before Time." *Chicago Daily Tribune*, October 16, 1959; "Errol Flynn Pleads Not Guilty." *Los Angeles Times*, October 22, 1957.

Sigmund Freud: Boucher, Douglas H. "Cocaine and the Coca Plant." *BioScience*, February 1991; Freud, Sigmund. *Cocaine Papers*. Ed. R. Byck. Stonehill Publishing Co., 1974; Jones, Ernest. *The Life and Work of Sigmund Freud*. Basic Books, 1953; Friedman, Susan Stanford, ed. *Complete Correspondence of Sigmund Freud*. New Directions Publishing, 2002; "Dr. Sigmund Freud Dies in Exile; Founder of Psychoanalysis Theory Succumbs at His Home Near London." *New York Times*, September 24, 1939; Inciardi, James, ed. *Heroin in the Age of Crack Cocaine*. Sage Publications, Inc., 1998.

Federico García Lorca: Gibson, Ian. *Federico García Lorca*. London: Faber & Faber, 1989; Stainton, Leslie. *Lorca: A Dream of Life*. Farrar Straus & Giroux, 1999; Fuchs, Dale. "Artist Looks for Lorca's Mysterious Spirit." *Herald Tribune*, December 11, 2007; Keeley, Graham. "Who Killed Lorca?" *London Independent*, August 19, 2006; "Sole Fascist Body Outlawed in Spain; Formal Charges Made Against Arrested Group." *New York Times*, March 19, 1936; *Surrealism*. Columbia University Press, 1994.

Judy Garland: Canby, Vincent. "Judy Garland: Loneliness and Loss." *New York Times*. June 29, 1969; Gerold, Frank. *Judy*. Da Capo Press, 1999.

Romain Gary: Gary, Romain. *Promise at Dawn: A Memoir*. New Directions Publishing, 1987; Boorsch, Jeanne. "Romain Gary." *Yale French Studies*, Fall 1951; Barbanel, Josh. "Romain Gary Is Dead; Novelist Shot in Head, Apparently a Suicide." *New York Times*, December 3, 1980; "Romain Gary's Suicide Testament Disclosed." *Washington Post*, December 4, 1980; Rawls, Wendell, Jr. "F.B.I. Admits Planting a Rumor to Discredit Jean Seberg in 1970." *New York Times*, September 15, 1979; Pace, Eric. "Arthur Koestler and Wife Suicides in London." *New York Times*, March 4, 1983.

Marvin Gaye: "'I Pulled the Trigger.'" *Washington Post*, April 9, 1984; "Gaye's Dad: 'Didn't Mean to Do It.'" *Chicago Tribune*, April 8, 1984; Steward, Robert W. "Gay Sr. Granted Probation in Shooting Death of Son." *Los Angeles Times*, November 2, 1984; Hunt, Dennis. "Artist Marvin Gaye Was Man of Talent, Strong Ego." *Hartford Courant*, April 4, 1984; "Slain Soul Singer Marvin Gaye Apparently Died Broke; No Will." *Los Angeles Times*, April 27, 1984; Ritz, David. *Divided Soul: The Life of Marvin Gaye*. Da Capo Press, 2003; "Record Producer Slain; Police Charge His Wife." Associated Press (AP), April 18, 1983.

John Gilbert: "John Gilbert Dies; Romantic Silent Screen Star Lost Public When Voice Was Found Unsuited to Talkies." *New York Times*, January 10, 1936; "Dietrich And Garbo Sad at Death of Close Friend." *Los Angeles Times*, January 10, 1936; "John Gilbert, Dashing Lover of Films, Dies; Heart Attack Is Fatal to 38 Year Old Actor." *Chicago Daily Tribune*, January 10, 1936; MacGowan, Kenneth. "When the Talkies Came to Hollywood." *Quarterly of Film Radio and Television*, Spring 1956; Ross, Nathaniel Lester. *Lon Chaney: Master Craftsman of Make Believe*. Quality RJ, 1987.

Ulysses S. Grant: Grant, Ulysses, McFeely, Mary D. and McFeely, William S. *Ulysses S. Grant: Memoirs and Selected Letters*. Library of America, 1990; Smith, Jean Edward. *Grant*. Simon & Schuster, 2002.

Robert Greene: Mildenberger, Kenneth. "Robert Greene at Cambridge." *Modern Language Notes*, December 1951; Greene, Robert. *The Plays and Poems of Robert Greene*. Ed. C. J. Collins. Clarendon Press, 1905; Bates, Alfred, ed. *The Drama: Its History, Literature and Influence on Civilization*. Historical Publishing Company, 1906; Sykes, H. Dugdale. "Robert Greene and George a Greene, the Pinner of Wakefield." *Review of English Studies*, April 1931; Willey, G. R. "The Wassail Tradition." *Folklore*, Winter 1978.

D. W. Griffith: Stern, Seymour. "D. W. Griffith: An Appreciation." *New York Times*, August 1, 1948; Batman, Richard. "D. W. Griffith: The Lean Years."

California Historical Society Quarterly, September 1958; Fishbein, L. "The Demise of the Cult of True Womanhood in Early American Film." *Journal of Popular Film and Television*, Summer 1984; Kirby, Jack Temple. "D. W. Griffith's Racial Portraiture." *Phylon*, Fall 1978; Lynn, Kenneth S. "The Torment of D. W. Griffith." *American Scholar*, Spring 1990; Kauffmann, Stanley. "D. W. Griffith's 'Way Down East.'" *Horizon*, Spring 1972; Bellesiles, Michael A., ed. *Lethal Imagination, Violence and Brutality in American History*. New York University Press, 1999; Jacobs, Christopher P. "Pioneer film director dishonored by those who follow in his footsteps." *High Plains Reader*, January 2000.

Jean Harlow: "Jean Harlow, Film Star, Dies in Hollywood at 26 After an Illness of Only a Few Days." *New York Times*, June 8, 1937; *Stenn, David. Bombshell: The Life and Death of Jean Harlow*. Doubleday, 1993; Shulman, Irving. *Harlow: An Intimate Biography*. Dell Publishing, 1964.

Thomas Heggen: "T. O. Heggen, Author, Found Dead In Bath." *New York Times*, May 20, 1949; Leggett, John. *Ross and Tom: Two American Tragedies*. Simon & Schuster, 1974; Stegner, Wallace. "The Anxious Generation." *College English*, January 1949; "Henry Fonda's Wife Ends Own Life in Sanatorium." *Los Angeles Times*, April 15, 1950; Ross, Theodore. "Gargoyles in Motion: On the Transmigration of Character from Page to Screen and Related Questions on Literature and Film." *College English*, November 1977; Phillips, David P. "The Influence of Suggestion on Suicide: Substantive and Theoretical Implications of the Werther Effect." *American Sociological Review*, June 1974; Young, Allen. *The Harmony of Illusions: Inventing Post-Traumatic Stress Disorder*. Princeton University Press, 1997; Priest, D., and A. Hull. "Mental Health Problems Still Stigmatized in the Military." *Boston Globe*, December 2, 2007.

Ernest Hemingway: "Hemingway in Mayo Clinic." *Los Angeles Times*, January 11, 1961; Charnock, Richard. "Hemingway Death 'Incredible Accident' to Widow." *Washington Post*, July 9, 1961; "Hemingway Death Leaves Great Legacy of Mystery." *Hartford Courant*, July 11, 1961; "Higbe Recalls Hemingway and Bouts in Living Room." *Chicago Daily Tribune*, July 12, 1961; "Coroner Cites a Lack of Evidence of Foul Play in Gun Death." *New York Times*, July 4, 1961; Meyers, Jeffery. *Hemingway: A Biography*. Harper & Row, 1985; Reynolds, Michael S. *Hemingway: The Final Years*. W. W. Norton & Company, 1999; Shizukuda, Y., et al. "Oxidative stress in asymptomatic subjects with hereditary hemochromatosis." *American Journal of Hematology*, Summer 2007; "Hemingway Son Dies in County Jail Cell." *Miami Herald*, October 4, 2001. "Jean-Michel Frank, Obituary." *New York Times*, March 11, 1941.

Jimi Hendrix: "Jimi Hendrix, Rock Star, Is Dead in London at 27; Guitarist Led 3-Man Group to Top of Music World Flamboyant Performer Noted for Sensuous Style." *New York Times*, September 19, 1970; Cross, Charles, R. *Room Full of Mirrors : A Biography of Jimi Hendrix*. Hyperion, 2005.

Henry VIII: Ankersmit, F. R. "Historicism: An Attempt at Synthesis." *History and Theory*, October 1995; Strakey, David. "Tudor Government: The Facts?" *Historical Journal*, December 1988; Levin, Carole. "A Good Prince: King John and Early Tudor Propaganda." *Sixteenth Century Journal*, Winter 1980; Ganz, Paul. "Henry VIII and His Court Painter, Hans Holbein." *Burlington Magazine for Connoisseurs*, October 1933; MacCulloch, Diarmaid. "The Myth of the English Reformation." *Journal of British Studies*, January 1991; Slavin, Arthur J., ed. *Henry VIII and the English Reformation*. D. C. Heath, 1968; Cressy, David. *Birth, Marriage, and Death: Ritual, Religion, and the Life-Cycle in Tudor and Stuart England*. Oxford University Press, 1997; Weir, Alison. *Henry VIII: The King and His Court*. Ballantine Books, 2001; Erickson, Carolly. *Royal Panoply: Brief Lives of the English Monarchs*. St. Martin's Press, 2006.

O. Henry: "O. Henry, Writer, Dies in Hospital; Ill So Brief a Time that His Wife Could Not Reach His Bedside." *New York Times*, June 6, 1910; "O. Henry on Himself, Life, and Other Things; For the First Time the Author of 'The Four Million' Tells a Bit of the 'Story of My Life.'" *New York Times*, April 4, 1909; "O. Henry Dead; Well known as Writer of Brilliant Stories. Real Name William S. Porter." *Boston Globe*, June 6, 1910; "Americans Whose Pace Led to the Road of Death." *Washington Post*, July 10, 1911; Long, Hudson. *O. Henry: The Man and His World*. Russell & Russell, 1949; Pike, Cathleen. *O. Henry in North Carolina*. Folcroft Library Editions, 1978.

Robert E. Howard: Lord, Glenn, ed. *The Book of Howard E. Hunt*. Berkley, 1980; Davidson, Don. "Sword and Sorcery Fiction." *English Journal*, January 1972; *The Dark Man: The Journals of Howard E. Hunt Studies*, nos. 1–10 (2007); *Blood & Thunder: The Life and Art of Robert E. Howard*. Monkeybrain, Inc., 2006; Sprague de Camp, Lyon, et al, eds. *Dark Valley Destiny: the Life of Robert E. Howard*. Bluejay Books, 1983; Van Allen, Lanny. "Recommended: H. P. Lovecraft." *English Journal*, April 1986; Eddy, Muriel, and C. M. Eddy. *The Gentleman From Angell Street: Memories of H. P. Lovecraft*. Fenham Publishers, 2001; Joshi, S. T. *H. P. Lovecraft: A Life*. Necronomicon Press, 1996.

Aldous Huxley: "Aldous Huxley Dies of Cancer on Coast; Called Himself an Essayist Eye Affliction at 17 Could Write on Anything Enjoyed His Work ." *New York Times*, November 23, 1963; Huxley, Aldous, Horowitz, Michael, et al, eds. *Moksha: Aldous Huxley's Classic Writings on Psychedelics and the Visionary Experience*. Park Street Press, 1999; Bedford, Sybille. *Aldous Huxley: A Biography*. Ivan R. Dee, 2002.

William Inge: Sullivan, Dan. "William Inge: A Mark Too Indelible to Vanish." *Los Angeles Times*, June 17, 1973; Hailet, Jean R. "William Inge Dies." *Washington Post*, June 11, 1973; Voss, Ralph F. *A Life of William Inge: The Strains of Triumph*. University of Kansas, 1989; Atkinson, Brooks. "A Haunted Playwright; After a Successful Career, Inge Lost His Gift of Seeing the Living

Truths." *New York Times*, June 11, 1973; Brandeburg, Janice. "Inhalation Injury: Carbon Monoxide Poisoning." *American Journal of Nursing*, January 1980; Dutra, Frank R. "Carbon Monoxide Poisoning from the Exhaust Gases of Motor Vehicles." *Journal of Criminal Law, Criminology, and Police Science*, Fall 1957.

Ivan the Terrible: Cherniavsky, Michael. "Ivan the Terrible as Renaissance Prince." Slavic Review, June, 1968; Madariaga, Isabel de. *Ivan the Terrible*. Yale University Press, 2006; Payne, Robert. *Ivan the Terrible*. Cooper Square Press, 2002.

Charles R. Jackson: "Charles Jackson, Author of 'Lost Weekend' Dies." *New York Times*, September 22, 1968; Jackson, Charles. *The Lost Weekend*. Black Spring Press, 1998; Crowley, John W. *The White Logic: Alcoholism and Gender in American Modernist Fiction*. University of Massachusetts Press, 1994; Goodwin, Donald. *Alcoholism: The Facts*. Oxford University Press, 1994; National Institute on Drug Abuse Fact Sheets: www.DrugAbuse.gov.

Randall Jarrell: Jarrell, Mary, and S. Wright, eds. *Randall Jarrell's Letters*. Houghton Mifflin, 1985; Jarrell, Randall. *The Complete Poems*. Farrar, Straus and Giroux, 1981; Jarrell, Randall. *No Other Book: Selected Essays*. Ed. Brad Leithauser. HarperCollins, 2000; Stafford, William. "The Poet's Art in Clear Focus." *Chicago Tribune*, October 3, 1965; "Randall Jarrell, Poet, Killed by Car in Carolina." *New York Times*, October 15, 1965.

Alfred Jarry: Grossman, Manuel L. "Alfred Jarry and the Theatre of the Absurd." Educational Theatre Journal, December, 1967; Beaumont, Keith. "Alfred Jarry: A Critical and Biographical Study." The Modern Language Review, July, 1986; McGann, Jerome. "Culture and Technology: The Way We Live Now, What Is to Be Done? *New Literary History*, Winter, 2005; Fisher, Ben. *The Pataphysician's Library: An Exploration of Alfred Jerry's "Livres Pairs."* Liverpool University Press, 2000; Shattuck, Roger. *The Banquet Years: The Arts in France, 1885-1918: Alfred Jarry, Henri Rousseau, Erik Satie, Guillaume Apollinaire*. Harcourt, 1958.

James Jones: Carter, Steven R. *James Jones: An American Literary Orientalist Master*. University of Illinois Press, 1998; Glicksberg, Charles I. "Racial Attitudes in from Here to Eternity." *Phylon*, Fall 1953; Mitgang, Herbert. "James Jones, Novelist, 55 Dies; Best Known for 'Here to Eternity.'" *New York Times*, May 10, 1977; Davis, L. "G.I. Jones: The End of an Epic." *Washington Post*, March 12, 1978; Moramarco, Fred. "The Most Overpraised and Undervalued Modern American Novelist." *Los Angeles Times*, September 2, 1984; Shay, Arthur. "James Jones Off on a Spree: A *Life* Photographer Remembers." *Chicago Tribune*, June 5, 1977; "VA General Rating Formula for Psychoneurotic Disorders." Department of Veterans Affairs, 1996.

Janis Joplin: Friedman, Myra. *Buried Alive: The Biography of Janis Joplin*. Harmony Books, 1992; Echols, Alice. *Scars of Sweet Paradise: The Life and Times of Janis Joplin*. Metropolitan Books, 1999; Rudnick, Tracey. "Janice Joplin as Feminist Heroine." *New Periodicals*, September 2003; Gent, George.

"Death of Janis Joplin Attributed to Accidental Heroin Overdose." *New York Times*, October 6, 1970; Hilburn, Robert. "Janis Joplin's Lifetime: 'A Rush'." *Los Angeles Times*, October 7, 1970; Von Hoffman, Nicholas. "Dope as Emancipation." *Washington Post*. October, 12, 1970.

Franz Kafka: Corngold, Stanley. *Franz Kafka: The Necessity of Form*. Cornell University Press, 1988; Dietz, Ludwig. *Franz Kafka*. Meltzer, 1975; Strauss, Nina. "Transforming Franz Kafka's 'Metamorphosis.'" *Signs*, Spring 1989; Brod, Max. *Franz Kafka: A Biography*. Schocken Books, 1947; Kafka, Franz. *Letters to Felice*. Ed. Erich Heller et al. Schocken Books, 1973; Brod, Max, ed. *The Diaries of Franz Kafka, 1914–23*. Schocken Books, 1949; Roth, Phillip. "In Search of Kafka And Other Answers." *New York Times*, February 15, 1976; "How It Feels to Be Forcibly Fed." *New York World Magazine*, September 6, 1914.

Andy Kaufman: Prial, Frank J. "Andy Kaufman, Known for Unorthodox Skits." *New York Times*, May 18, 1984; Thackery, Ted Jr. "Andy Kaufman, Offbeat Comic, Dies of Cancer." *Los Angeles Times*, May 17, 1984; Shales, Tom. "Kaufman, Taboo Toppler." *Washington Post*, May 18, 1984; McNally, Owen. "It Was a Long Way to 'Improv' Show." *Hartford Courant*, February 13, 1983; Daly, Maggie. "Andy Kaufman Isn't So Funny Off Camera." *Chicago Tribune*, September 27, 1979; Hecht, Julie. *Was This Man a Genius?: Talks with Andy Kaufman*. Vintage, 2002; Zumda, Bob. *Andy Kaufman Revealed!: Best Friend Tells All*. Back Bay Books, 2001.

John Keats: Roe, Nicolas. *John Keats and the Culture of Dissent*. Clarendon Press, 1997; Stillenger, Jack, ed. *The Poems of John Keats*. Harvard University Press, 1978; Briggs, H. E. "The Birth and Death of John Keats." *PMLA*, June 1941; Ward, Aileen. *John Keats: The Making of a Poet*. Vintage, 1963; Colvin, Sidney. *John Keats: His Life and Poetry, his Friends, Critics, and After-Fame*. Charles Scribner's Sons, 1917; "Keats Roman Home; How He Lived Half a Century Ago." *London News*, April 29, 1879; Keats-Shelly House (Museum), Piazza di Spagna 26, Rome, Italy; Bewell, Allan. *Romanticism and Colonial Disease*. Johns Hopkins, 1999; "Art of Léon Bonvin," *Arts Magazine*, September 1987.

Jack Kerouac: Lelyveld, Joseph. "Jack Kerouac, Novelist, Dead; Author of 'On the Road'." *New York Times*, October 22, 1969 French, Warren. *Jack Kerouac*. Twayne. 1986.

Sam Kinison: Lambert, Bruce. "Sam Kinison, 38, Comedian, Dies; Wife Injured in Head-on Collision." *New York Times,* April 12, 1992; Wallace, Amy. "Friends Shocked by Violent Death of Mellower Kinison Entertainer: The Shock Comedian was Sobering Up, Associates Say. A Teenager Is Held in the Collision." *Los Angeles Times*, April 12, 1992; Masters, Kim. "Sam Kinison's Race with the Reaper." *Washington Post*, April 19, 1992; Kinison, Bill. *Brother Sam: The Short, Spectacular Life of Sam Kinison*. William Morrow & Co., 1994; "Comedienne Cass Daley, in Accident." *Washington Post*, March 25, 1975.

Jerzy Kosinski: Rothstein, M. "In Novels and Life, a Maverick and an Eccentric." *New York Times*, May 4, 1991; Treadwell. David. "Novelist Jerzy Kosinski, 57, Kills Himself in N.Y. Home." *Los Angeles Times*, May 4, 1991; Blades, John. "Jerzy Kosinski, Author of 'The Painted Bird.'" *Chicago Tribune*, May 4, 1991; Trueheart, Charles. "Kosinski, Facts and Fictions." *Washington Post*, July 9, 1991; Corry, John. "The Most Considerate of Men." *American Spectator*, July 1991; Lilly Jr., Paul R. *Nobody's Instrument: Jerzy Kosinski*. Kent State University Press, 1988; Liggio, Leonard P. "The Right to Die." Literature of Liberty, June 1978; Saunders, C. M. "Voluntary Euthanasia." *Palliative Medicine*, Winter 1992.

Barbara La Marr: "Illness Drives Miss La Marr From Films." *Chicago Tribune*, November 8, 1925; Blake, Doris. "Farewell to the Vamp." *Washington Post*, November 15, 1925; "Screen Star is Dead; End Comes Suddenly in Altadena, Cal., Following a Breakdown Last Summer." *New York Times*, January 31, 1926; "Women Riot at Star's Funeral." *Los Angeles Times*, February, 3, 1926; Bangley, Jimmy. "Goddesses of the Silent Screen." *Classic Images*, May 1996; "Max Linder and Wife in Double Suicide; They Drink Veronal, Inject Morphine and Open Veins in Their Arms." *New York Times*, November 1, 1925; "Max Linder and his wife open their artery: Both die." *London Times*, November 1, 1925.

Veronica Lake: Townshend, Dorothy. "Veronica Lake, Peek-a-Boo Star of the 1940s, Dies at 51." *Los Angeles Times*, July 8, 1973; "Veronica Lake dies of hepatitis." *Chicago Tribune*, July 8, 1973; Washington, Martin Weil. "Veronica Lake, Ex-Actress, Dies." *Washington Post*, July 8, 1973; Lenberg, Jeff. *Peekaboo: The Story of Veronica Lake*. St. Martin's Press, 1983; Lake, Veronica. *Veronica, the autobiography of Veronica Lake*. Carol Publishing, 1971; "Cause of Alan Ladd's Death to Be Determined by Tests." *New York Times*, February 1, 1964; Schallert, Edwin. "Jean Harlow, Screen Star, Dies After Spectacular Rise to Fame." *Los Angeles Times*, June 8, 1937.

Pierre Lallement: Herlihy, David. *Bicycle: The History*. Yale University Press, 2004; Betro, Frank J. *The Dancing Chain: History and Development of the Derailleur Bicycle*. Van der Plas Publications, 2004; Sharp, Archibald. *Bicycles & Tricycles: A Classic Treatise on Their Design and Construction*. Dover Publications, 2003; "Col A. A. Pope Dies; Pioneer Bicycle Manufacturer's Health Failed Since His Company's Embarrassment." *New York Times*, August 11, 1909; Arnold, David. "Bike Historian Seeks Fame for Unknown." *Boston Globe*, October 14, 1993; "Tour de France: Pioneers and 'Assasins.'" *BBC Sports*, June 5, 2001.

Mario Lanza: "Mario Lanza Dies; Singer, Actor, 38; Tenor Who Starred in 'The Great Caruso,' Other Films Was Recording Artist." *New York Times*, October 8, 1959; "Singer Mario Lanza Dies of Heart Attack in Rome." *Washington Post*, October 8, 1959; "4 Lanza Children Subject of Kidnap Scare." *Chicago Tribune*, November 20, 1959; "Friend Dies Viewing Body of Mario Lanza." *Los Angeles Times*, October 18, 1959; Mannering, Derek.

Mario Lanza: Singing to the Gods. University Press of Mississippi, 2005; Reid, K., et al. "The Acoustic Characteristics of Professional Opera Singers." *Journal of Voice*, January, 2007; Ericson, Raymond. "Maria Callas, 53, Is Dead of Heart Attack in Paris." *New York Times*, September 17, 1977.

Ring Lardner: "Ring Lardner Dies; Noted as Writer." *New York Times*, September 26, 1933; "Ring Lardner Dies After Long Illness." *Atlanta Constitution*, September 26, 1933; Elder, Donald. *Ring Lardner*. Doubleday & Company, Inc., 1956; Geismar, Maxwell. *Ring Lardner and the Portrait of Folly*. Crowell, 1972; Yardley, Jonathan. *Ring: A Biography of Ring Lardner*. Random House, 1977; Bruccoli, Matthew. "A Literary Friendship." *New York Times*, November 7, 1976; Wood, Barbara L. *Children of Alcoholism: The Struggle for Self and Intimacy in Adult Life*. New York University Press, 1987.

D. H. Lawrence: Daly, Macdonald. "D. H. Lawrence and Labour in the Great War." *Modern Language Review*, January 1994; Sagar, Keith. *The Art of D. H. Lawrence*. Cambridge University Press, 1966; "D. H. Lawrence Very Low; Doctors Abandon Hope for British Novelist, ill at Nice." *New York Times*, March 1, 1930; "D. H. Lawrence Dies; English Author Succumbs to a Long Illness in 45th Year Near Nice. Often Target of Censors; A Voluntary Exile Since World War." *New York Times*, March 4, 1930; Mulligan, Ralph C. "Those Naughty Senate-Banned Books." *Washington Post*, March 30, 1930; "D. H. Lawrence, Novelist, Leaves Estate of $12,000." *Chicago Tribune*, June 12, 1930; Boulton, James T., ed. *The Letters of D. H. Lawrence*. Cambridge University Press, 1979; Whorton, John. *D. H. Lawrence: The Early Years 1885–1912*. Cambridge University Press, 1991; Roberts, William. *Mark Gertler*. London and Leeds, 1992.

T. E. Lawrence: Mack, John E. *A Prince of Our Disorder: The Life of T. E. Lawrence*. Harvard University Press, 1976; Stewart, Desmond. *T. E. Lawrence*. Harper & Row, 1977; Wolfe, Daniel. *T. E. Lawrence: Lives of Notable Gay Men and Lesbians*. Chelsea House Publications, 1995; "Lawrence Dies of Crash Injuries After a Six-Day Fight by Doctors; Leader of Revolt in Arabia Was Unconscious Since Accident in Dorset in Which He Swerved Motorcycle to Save Boy—Called One of Britain's Greatest Heroes." *New York Times*, May 19, 1935; "Bonsal Reveals Unpublished Report by Lawrence of Arabia." *Washington Post*, December 19, 1935; Laffan, William. "Robert Fagan in Sicily." Pyms Gallery, 2000; Russel, John. "The Wealth of Irish Contributors." *New York Times*, February 15, 1981.

Timothy Leary: Cloud, John. "Was Timothy Leary Right?" *Time*, April 19, 2007; Greenfield, Robert. *Timothy Leary: A Biography*. Harcourt, 2006; Mansnerus, Laura. "Timothy Leary, Pied Piper of Psychedelic 1960s, Dies at 75." *New York Times*, June 1, 1996; Donadio, Rachel. "The Paranoiac and the Paris Review." *New York Times*, February 17, 2008.

Heath Ledger: Barron, James. "Heath Ledger, Actor, Is Found Dead at 28." *New York Times*. January 23, 2008; Gutierrez, Lisa; "Rise in Deaths by Accidental Overdose Cited; 'Doctor Shopping,' Increased Use of Painkillers Among Contributing Factors." *The Washington Post*; Feb 17, 2008; Lieberman, Paul. "6-drug combo blamed." *Los Angeles Times*, February 7, 2008.

John Lennon: Montgomery, Paul L. "Police Trace Tangled Path Leading to Lennon's Slaying at the Dakota." *New York Times*, December 10, 1980; "Lennon Is Given 60 Days to Leave." *New York Times*, July 18, 1974; Lennon, John. Interview by Jann S. Wenner. In *Rolling Stone*, December 1970; Wiener, Jon. *Come Together: John Lennon In His Time*. University of Illinois Press, 1991.

Sinclair Lewis: Hutchinson, James M., ed. *Sinclair Lewis: New Essays in Criticism*. Whitston Publishing, 1997; Schorer, Mark. *Sinclair Lewis: An American Life*. McGraw-Hill Book Company, 1961; Barry, Joseph A. "Sinclair Lewis, 65 and Far from Main Street; The Novelist's 'Quiet and Good Life' in Italy." *New York Times*, February 5, 1950; Babcock, Frederick. "Lewis Forced Us to Look at Ourselves." *Chicago Tribune*, January 21, 1951; "Novelist Sinclair Lewis Dies in Rome After Pneumonia." *Washington Post*, January 11, 1951; Waldron, Ann. "Writers and Alcohol." *Washington Post*, March 14, 1989.

Vachel Lindsay: Ruggles, Eleanor. *The West-Going Heart: A Life of Vachel Lindsay*. W. W. Norton & Company, Inc., 1959; Massa, Ann. *Vachel Lindsay: Fieldworker for the American Dream*. Indiana University Press, 1970; Lindsay, Vachel. "To Be a Poet in America." *Saturday Evening Post*, November 1926; Lindsay, Vachel. *The Congo and Other Poems*. Macmillan, 1912; "Vachel Lindsay's Voice Survives in Records." *Los Angeles Times*, February 12, 1933; Trimmer, Eric J. "Medical Folklore and Quackery." *Folklore*, Autumn 1965; Lendrum, Frederick C. "A Thousand Cases of Attempted Suicide." *American Journal of Psychiatry*, November 1933.

Ross Lockridge: Tindal, William York. "Many-Leveled Fiction: Virginia Woolf to Ross Lockridge." *College English*, November 1948; Leggett, John. *Ross and Tom: Two American Tragedies*. Simon & Schuster, 1974; Jamison, Kay Redfield. *Touched with Fire: Manic-Depressive Illness and the Artistic Temperament*. Free Press, 1993; Lockridge, Larry. *Shade of the Raintree: The Life and Death of Ross Lockridge, Jr.* Viking Penguin, 1998; "Publishers Back 'Raintree County'; Houghton Mifflin Deny Obscenity Charges by Father Barrett of Fordham." *New York Times*, February 22, 1948; "Lockridge, Author, Suicide at 33; Worn by Writing 'Raintree County.'" United Press, March 8, 1948.

Jack London: "Jack London Dies Suddenly on Ranch; Novelist Is Found Unconscious from Uremia, and Expires After Eleven Hours." *New York Times*, November 23, 1916; "Famous Novelist Dies." *Chicago Tribune*, November 23, 1916; Labor, Earl, ed. *The Letters of Jack London*. Stanford University Press, 1988; London, Joan. *Jack London and His Times*. Doubleday, 1939; London, Charmian. *The Book of Jack London*. The Century Co., 1921.

Robert Lowell: Leffler, Merrill. "On a Poet Dying Young." *Washington Post*, November 20, 1977; McQuiston, John T. "Robert Lowell, Pulitzer Prize Poet, Is Dead at 60." *New York Times*, September 13, 1977; Mariani, Paul. *Lost Puritan: A Life of Robert Lowell*. W. W. Norton & Company, 1994; Axelrod, Steven Gould. *Robert Lowell: Life and Art*. Princeton University Press,

1978. Gioglio, Gerald R. *Days of Decision: An Oral History of Conscientious Objectors.* Broken Rifle Press, 1989.

Malcolm Lowry: Max, D. T. "The Day of the Dead." *The New Yorker*, December 17, 2007; Hays, H. R. "Drunken Nightmare of the Damned; Under the Volcano." *New York Times*, February 23, 1947; Bowker, Gordon. *Pursued by Furies: A Life of Malcolm Lowry.* St. Martin's Press, 1997; Gabriel, Jan. *Inside the Volcano: My Life with Malcolm Lowry.* St. Martin's Press, 2001; Vice, Sue. *Malcolm Lowry Eighty Years On.* St. Martin's Press, 1989. Cross, Richard K. "Malcolm Lowry and the Columbian Eden." *Contemporary Literature*, Winter 1973.

Lucan: Ahl, Frederick M. *Lucan: An Introduction.* Cornell University Press, 1976; Morford, M. *The Poet Lucan: Studies in Rhetorical Epic.* Oxford University Press, 1967; Gresseth, Gerald K. "The Quarrel between Lucan and Nero." *Classical Philology*, January 1957; Dulaney, S., et al. "Cultural Rituals and Obsessive-Compulsive Disorder." *Ethos*, September 1994.

Fitz Hugh Ludlow: Mathre, Mary Lynn. *Cannabis in Medical Practice; A Legal, Historical and Pharmacological Overview of the Therapeutic Use of Marijuana.* McFarland & Co., 1997; Gross, Dave. *The Hasheesh Eater* (hypertext version): http://nepenthes.lycaeum.org/Ludlow/THE/index.html; Dulchinos, Donald P. *Pioneer of Inner Space: The Life of Fitz Hugh Ludlow, Hasheesh Eater.* Autonomedia, 1998; Herer, Jack. *The Emperor Wears No Clothes: The Authoritative Historical Record of Cannabis and the Conspiracy Against Marijuana.* Quick American Archives, 2000; Rowan, Robinson. *The Great Book of Hemp: The Complete Guide to the Environmental, Commercial, and Medicinal Uses of the World's Most Extraordinary Plant.* Park Street Press, 1995.

Bela Lugosi: "Bela Lugosi Dies; Created Dracula; Portrayer of Vampire Role on Stage and Screen Was Star in Budapest Began Career in 1900." *New York Times*, August 17, 1956; "Bela Lugosi Rites Attract Few Notables." *Los Angeles Times*, August 19, 1956; "Bela Lugosi, of 'Dracula' Fame, Is Dead." *Chicago Tribune*, August 17, 1956; Oldenburg, Don. "Fangs for the Memories." *Washington Post*, October 31, 1986; Trow, M. J. *Vlad the Impaler: In Search of the Real Dracula.* Sutton Publishing, 2004; Florescu, Radu. *Dracula: A Biography of Vlad the Impaler, 1431-1476.* Hale Publishing, 1974.

J. Anthony Lukas: Lukas, J. Anthony. *Common Ground: A Turbulent Decade in the Lives of Three American Families.* Vintage, 1986; Haberman, Clyde. "J. Anthony Lukas, 64, Dies; Won 2 Pulitzer Prizes." *New York Times*, June 6, 1997; Harden, Blaine. "Troubled Ground; Tony Lukas Had a Hunger for Truths That Are Hard to Face Up to. But He Couldn't—or Wouldn't—Look Far Enough Inside Himself." *Washington Post*, July 20, 1997.

Norman Mailer: McGrath, Charles. "Norman Mailer, Towering Writer With Matching Ego, Dies at 84." *New York Times*, November 10, 2007; "Quotes About Norman Mailer." Associated Press (AP), November 10, 2007; Adams, Laura. *Existential Battles: The Growth of Norman Mailer.* Ohio University Press, 1976.

Klaus Mann: "Klaus Mann, Son of Famous Novelist, Dies." *Washington Post*, May 23, 1949; "Mann's Son Said to Slash Wrists." *New York Times*, July 13, 1949.

Mickey Mantle: Durso, Joseph. "Mickey Mantle, Great Yankee Slugger, Dies at 63." *New York Times*, August 14, 1995; "Mantle Brings Out Memorabilia Vultures." *Washington Post*, July 10, 1995; Castro, Tony. *Mickey Mantle: America's Prodigal Son.* Potomac Books, 2003; Fortin, Mickey Mantle. E-mail message to author, October, 26, 2007.

Christopher Marlowe: Brooke, Tucker. *The Life of Christopher Marlowe.* Methuen, 1930; Eccles, Mark. *Christopher Marlowe in London.* Harvard University Press, 1934; Danson, Lawrence. "Continuity and Character in Shakespeare and Marlowe." *Studies in English Literature*, Spring 1986; Sterling, Eric. "Christopher Marlowe and English Renaissance Culture." *Sixteenth Century Journal*, 1997; Honan, Park. *Christopher Marlowe: Poet and Spy.* Oxford University Press, 2005.

Guy de Maupassant: Boyd, Ernest. *Guy de Maupassant.* Alfred A. Knopf, 1926; Artinian, Artine. "Maupassant as Seen by American and English Writers of Today." *French Review*, October 1943; ———. "New Light on the Maupassant Family." *Modern Language*, 1948; Viti, Robert M. "The Elemental Maupassant: The Universe of Pierre et Jean." *French Review*, February 1989; Bogousslavsky, J., et al. "Neurological Disorders in Famous Artists." Krager, 2005.

Joseph McCarthy: Oshinsky, David. "In the Heart of the Heart of Conspiracy." *New York Times*, January 27, 2008; Herman, Arthur. *Joseph McCarthy: Reexamining the Life and Legacy of America's Most Hated Senator.* Free Press, 1999; Daynes, Gary. *Making Villains, Making Heroes: Joseph R. McCarthy.* Garland Publishing, 1997; Weiner, Tim. "Hoover Planned Mass Jailing in 1950." *New York Times*, December 23, 2007.

Carson McCullers: "Carson McCullers Dies at 50; Wrote of Loneliness and Love." *New York Times*, September 30, 1967; "Handicapped Novelist Dies After Illness." *Chicago Tribune*, September 30, 1967; Harford, Margaret. "'Sad Cafe' Fascinates in a Bizarre Way." *Los Angeles Times*, August 10, 1966; Casey, Phil. "Author Carson McCullers Dead; Dramatized Human Loneliness." *Washington Post*, September 30, 1967; Carr, Virginia Spencer. *The Lonely Hunter: A Biography of Carson McCullers.* Doubleday, 1975.

Michelangelo: Robertson, Charles. "Bramante, Michelangelo and the Sistine Ceiling." *Journal of the Warburg and Courtauld Institutes*, Winter 1986; Saslow, J. M., *The Poetry of Michelangelo: An Annotated Translation.* Yale University Press, 1991; Sedgwick-Wohl, A. *The Life of Michelangelo.* Louisiana State University Press, 1976; Rowland, Ingrid D. "The Sistine Chapel Walls and the Roman Liturgy." *Church History*, June 1995; Seymour, Charles. *Michelangelo and the Sistine Chapel Ceiling.* W. W. Norton & Company, 1995.

Edna St. Vincent Millay: MacDougall, Allan Ross, ed. *Letters of Edna St. Vincent Millay.* Harper & Brothers, 1952; Gould, Jean. *The Poet and Her Book: A Biography of Edna St. Vincent Millay.* Dodd, Mead, 1969; Epstein, Daniel Mark. *What Lips My Lips Have Kissed: The Loves and Love Poems of Edna St.*

Vincent Millay. Holt Paperbacks, 2002; "Edna St. V. Millay Found Dead at 58; Noted Poet Succumbs of Heart Attack in Upstate Home, Body Discovered 8 Hours Later." *New York Times*, October 20, 1950.

John Minton: Spalding, Francis. *John Minton: Dance Till The Stars Come Down.* Lund Humphries Publishers, 2005; Gibson, Robert. "John Minton's 'Self Portrait.'" *Burlington Magazine*, October 1969.

Yukio Mishima: Oka, Takashi. "Renowned Author Raids Tokyo Military, Ends Life; Yukio Mishima and Aide Die by Hara-Kiri, 6 Hurt in Attack; Japanese Writer Commits Hara-Kiri." *New York Times*, November 25, 1970; Scott-Stokes, Henry. *The Life and Death of Yukio Mishima.* Farrar Straus Giroux, 1974; Wagenaar, Dick. "Yukio Mishima: Dialectics of Mind and Body." *Contemporary Literature*, Winter 1975; Piven, Jerry S. *The Madness and Perversion of Yukio Mishima.* Praeger Publishers, 2004; Ross, Christopher. *Mishima's Sword—Travels in Search of a Samurai Legend.* Da Capo Press, 2007; Harrison, Selig. "Novelist's Grisly Death Stirs Japanese." *Washington Post*, December 7, 1970.

Amedeo Modigliani: Gilbert, Sari. "Modigliani's Post-Ruse Ripples." *Washington Post*, October 6, 1984; Plagens, Peter. "Modigliani's Recipe: Sex, Drugs and Long, Long Necks." *New York Times*, August 3, 2003; Katz, Sally A. "Modigliani the Sculptor." *Art Journal*, Autumn 1964; Bloch, Vitale. "Modigliani at Milan." *Burlington Magazine*, March 1959; Restellini, Marc. *Modigliani: The Melancholy Angel.* Skira Publishers, 2003; Braun, Emily, et al. *Modigliani and His Models.* Royal Academy, 2006; Meyers, Jeffery. *Modigliani: A Life.* Harcourt, 2006.

Seth Morgan: Blau, Eleanor. "Seth Morgan, 41, Dies in Crash; His Novel, 'Homeboy,' Won Praise." *New York Times*, October 19, 1990; Campbell, Robert. "Stoned on Words." *Washington Post*, May 20, 1990; "Ex-Convict Writer Killed in Motorcycle Accident." *Los Angeles Times*, October 18, 1990; "'Homeboy' Author Seth Morgan, 41." *Chicago Tribune*, October 21, 1990.

James Murray: "Ex-Star of Movies Drowning Victim; Body of James Murray Lies in Morgue, Unidentified, Until Mother Claims It." *New York Times*, July 12, 1936; "Mourns Death of Husband; Water Greatly Feared by Drowned Film Actor." *Los Angeles Times*, July 13, 1936; "James Murray Dies in Fall; Skyrocketed to Fame as an Actor." *Chicago Daily Tribune*, July 12, 1936.

Alfred de Musset: Le Sage, Laurence. "Marcel Proust's Appreciation of the Poetry of Alfred de Musset." *French Review*, March 1948; Musset, Alfred de. *The Confession of a Child of the Century.* Hard Press, 2006; Vincens, Cecelia. *The Life of Alfred de Musset.* E. C. Hill Company, 1906; Rees, Margaret A. *Alfred de Musset.* Irvington Publishers, 1971; Sices, David. *Theater of Solitude: Alfred De Musset.* University Press of New England, 1974.

Gérard de Nerval: "Gérard de Nerval." *New York Times*, March 12, 1898; Huneker, James. "Masters of Hallucinations." *New York Times*, May 11, 1913; Knapp, Bettina Liebowitz. *Gérard de Nerval, the Mystic's Dilemma.*

University of Alabama Press, 1980; Hubert, Clair Marcom. *The Still Point and the Turning World: A Comparison of the Myths of Gérard de Nerval and William Butler Yeats.* University Microfilms, 1964.

Friedrich Nietzsche: Bloom, Harold. *Modern Critical Views: Friedrich Nietzsche.* Chelsea House Publishers, 1987; Kemal, Salim, et al., eds. *Nietzsche, Philosophy and the Arts.* Cambridge University Press, 1998; "Prof. Nietzsche Dead: He Was One of the Most Prominent of Modern German Philosophers." *New York Times,* August 26, 1900.

Roger Nimier: "Roger Nimier, 36, French Novelist; Leader in Postwar Letters Is Killed in Auto Crash."*New York Times,* September 30, 1962; Magny, Claude-Edmonde. "Roger Nimier." *Yale French Studies,* Fall 1951; McCarthy, Patrick. *Camus: A Critical Study of His Life and Work.* Hamish Hamilton Ltd, 1982.

Mabel Normand: Madden, David. "Harlequin's Stick, Charlie's Cane." *Film Quarterly,* Autumn 1968; Kingsley, Grace. "The Evolution of the Wild Party." *Los Angles Times,* April 20, 1930; "Mabel Normand Dies, Ending Tragic Career." *Washington Post,* February 24, 1930; "Mabel Normand, Film Comedienne, Called by Death." *Atlanta Constitution,* February 24, 1930; Giroux, Robert. *A Deed of Death: The Story Behind the Unsolved Murder of Hollywood Director William Desmond Taylor.* Knopf, 1990.

John O'Hara: Bruccoli, Matthew. *The O'Hara Concern: A Biography of John O'Hara.* Random House,1975; Wolff, Geoffrey. *The Art of Burning Bridges: A Life of John O'Hara.* Alfred A. Knopf, 2003; Montgomery, Paul L. "John O'Hara Dead; Novelist Dissected Small-Town Mores; John O'Hara, the Novelist, Dies in His Sleep at 65." *New York Times,* April 12, 1970; McGrath, Charles. "The Crucifixion of John O'Hara." *New York Times,* August 19, 2003.

Eugene O'Neill: Bogard, Travis, et al., eds. *Selected Letters of Eugene O'Neill.* Yale University Press, 1988; "Eugene O'Neill Dies of Pneumonia; Playwright, 65, Won Nobel Prize." *New York Times,* November 28, 1953; Black, Stephen A. *Eugene O'Neill: Beyond Mourning and Tragedy.* Yale University Press, 2002.

Charlie Parker: "Charlie Parker, Jazz Master Dies; A Be-Bop Founder and Top Saxophonist Is Stricken in Suite of Baroness." *New York Times,* March 15, 1955; "John Coltrane, Jazz Star, Dies; Inventive Saxophone Player, 40." *New York Times,* July 18, 1967.

Dorothy Parker: Whitman, Alden. "Dorothy Parker, 73, Literary Wit, Dies; Dorothy Parker, Short-Story Writer, Poet, Critic, Sardonic Humorist and Literary Wit, Dies at Age 73." *New York Times,* June 8, 1967; "Miss Parker Wills Estate to Dr. King." *Washington Post,* June 27, 1967; Frewin, Leslie. *The Late Mrs. Dorothy Parker.* Macmillan, 1987; Miller, Nina. "Making Love

Modern: Dorothy Parker and Her Public." *American Literature*, December 1992; Zeeberg, Peter. *Tycho Brahes "Urania Titani": Et digt om Sophie Brahe*. Museum Tusculanum, 1994.

J. G. Parry-Thomas: "Parry-Thomas Killed, Seeking Motor Record; England's Leading Auto Racer Is Nearly Decapitated by a Broken Driving Chain." *New York Times*, March 4, 1927; Villa, Leo. *The Record Breakers*. Hamlyn Publishers, 1969; J. G. Parry-Thomas Family Archive. http://www.parry-thomas.co.uk.; Pendine Museum of Speed: South West Wales Tourist Board.

Jules Pascin: Werner, Alfred. "Jules Pascin in the New World." *College Art Journal*, Autumn 1959; Werner, Alfred. "Pascin's American Years." American Art Journal, Spring 1972; Diehl, Gaston. *Pascin*. Crown, 1968; Richard, Paul. "Vision of Light." *Washington Post*, December 13, 1985.

Jaco Pastorius: Milkowski, Bill. *Jaco: The Extraordinary and Tragic Life of Jaco Pastorius*. Backbeat Books, 2005; "Man Admits Guilt in Beating Death Plea Consoles Jazz Great's Kin." *Miami Herald*, November 8, 1988; "Dark Days for a Jazz Genius." *Miami Herald*, September 20, 1987; "Jazzman Hilton Ruiz dies." *USA Today*, June 6, 2006.

Cesare Pavese: Mollia, Franco. *Cesare Pavese*. Nouva Publishers, 1963; Shallert, Edwin. "Dowlings Wild About Italy, and Vice Versa." *Los Angeles Times*, November 5, 1950; Pavese, Cesare. *The Burning Brand: Diaries 1935–1950*. Walker & Co., 1961; Riding, Alan. "When Anguish Among Artists Became Both Respected and Expected." *New York Times*, July 27, 2006; Perlez, Jane. "Arts Abroad; In Vienna (Where Else?), a Show on Art and Insanity." *New York Times*, November 6, 1997.

Lulu Hunt Peters: Peters, Lulu Hunt. *Diet and Health (With Key to the Calories)*. Reilly and Lee Co., 1928; "Find No Sure Guide to Women's Weight." *New York Times*, February 23, 1928; "Lulu H. Peters Dies; Wrote on Dietetics; Author of 'Diet and Health with Key to Calories' Succumbs to Pneumonia in London." *New York Times*, July 29, 1930; "Karen Carpenter, 32, Is Dead." *New York Times*, February 5, 1983; "Too fast, too young." *Los Angeles Times*, September 17, 2007.

Petronius: Cameron, Averil. "Petronius and Plato." *Classical Quarterly*, November 1969; Sullivan, J. P. *The Satyricon of Petronius. A Literary Study*. Faber, 1968; Firebaugh, W. C. *The Satyricon of Petronius Arbiter*. Kessinger Publishing, 2004; Williams, Craig A. *Roman Homosexuality: Ideologies of Masculinity in Classical Antiquity*. Oxford University Press, 1999; Leigh, Lacey. *Out & About: The Emancipated Crossdresser*. Double Star Press, 2002; Merlino, Joseph, et al, eds. *Freud at 150: 21st Century Essays on a Man of Genius*. Jason Aronson Publishers, 2007.

River Phoenix: Phoenix, River. Interview by David Rensin. In *US Magazine*, no. 162 (1991); "River Phoenix, 23, Intense Young Actor in a Range of Films." *New York Times*, November 1, 1993; Britt, Donna. "On Losing River Phoenix." *Washington Post*, November 19, 1993; "Facing Up to the Death of River Phoenix." *Los Angeles Times*, December 4, 1993; Glatt, John.

Lost in Hollywood: The Fast Times and Short Life of River Phoenix. St. Martin's Press, 1996.

Édith Piaf: "Death Ends Adversities for Singer Edith Piaf." *Washington Post*, October 12, 1963; "Song Stylist, 47, Cast a Spell Over Many Audiences—Tragedy Marked Life; Edith Piaf Dead; A Frail Artiste Lost Her Sight Made 'Suicidal' Tours Was Perfectionist Songs of Her Life." *New York Times*, October 12, 1963; Crosland, Margaret. *Piaf*. Putnam, 1985; Jige. "Songs of a Season." *Yale French Studies*, Spring 1954; Piaf, Édith. *The Wheel of Fortune: The Autobiography of Édith Piaf*. Peter Owen Publishers, 2004.

Mary Pickford: Whitfield, Eileen. *Pickford: The Woman Who Made Hollywood*. University Press of Kentucky, 2007; Brownlow, Kevin. *Mary Pickford Rediscovered*. Harry N. Abrams, 1999; Whitman, Alden. "Mary Pickford Is Dead at 86; 'America's Sweetheart' of Films." *New York Times*, May 30, 1979; "Jack Pickford, 36, Is Dead in Paris; Career Colorful, Tragic; His First Wife, Olive Thomas, Died of Poisoning—Marilyn Miller, Second Wife, Divorced Him." *New York Times*, January 4, 1933.

Franklin Pierce: "Arrival of Gen. Pierce, President Elect, at the Astor House—His Health and Request to Be Retired—Incidents of the Railway Trip from Boston to New York." *New York Times*, February 17, 1853; "Family Secrets." *Hartford Daily Courant*, October 18, 1853; "Franklin Pierce." *Atlanta Constitution*, October 12, 1869; Nichols, Roy. *Franklin Pierce: Young Hickory of the Granite Hills*. American Political Biography Press, 1993; Trefousse, Hans L. *Andrew Johnson: A Biography*. American Political Biography Press, 1998; Hooker, Richard J. *Food and Drink in America: A History*. Bobbs-Merrill Co., 1981.

Sylvia Plath: Butscher, Edward. *Sylvia Plath: Method and Madness: A Biography*. Schaffner Press, 2004; Becker, Jullian. *Giving Up: The Last Days of Sylvia Plath*. St. Martin's Press, 2003; Feinstein, Elaine. *Ted Hughes: The Life of a Poet*. W. W. Norton & Company, 2003; Drexler, Rosalyn. "Her Poetry, Not Her Death, Is Her Triumph; Sylvia Plath Took Her Life in 1963." *New York Times*, January 13, 1974; Van Dyne, Susan. "Sylvia Plath: The Wound and the Cure of Words." *New England Quarterly*, December 1991; Bundtzen, Lynda K. "Poetic Arson and Sylvia Plath's 'Burning the Letters.'" *Contemporary Literature*, Autumn 1998.

Edgar Allan Poe: Quinn, Arthur Hobson. *Edgar Allan Poe: A Critical Biography*. Johns Hopkins University Press, 1997; Meyers, Jeffrey. *Edgar Allan Poe: His Life and Legacy*. Cooper Square Press, 2000; Rosenheim, Shawn, et al, eds. *The American Face of Edgar Allan Poe*. Johns Hopkins University Press, 1995; "The Home of Edgar A. Poe; A Bit of the Cottage Remains, but is Marked for Destruction." *New York Times*, July 18, 1888; Dudley, U. "Genius in Rags." *Boston Daily Globe*, April 16, 1916; "If Only Poe Had Succeeded When He Said Nevermore to Drink." *New York Times*, September 23, 1996.

John William Polidori: Rieger, James. "Dr. Polidori and the Genesis of Frankenstein." *Studies in English Literature*, Autumn 1963; Herbert, Christopher. "Vampire Religion." *Representations*, Summer 2002; Astle, Richard.

"Dracula as Totemic Monster: Lacan, Freud, Oedipus and History." *Sub-Stance*, Spring 1979; Spencer, Kathleen L. "Purity and Danger: Dracula, the Urban Gothic, and the Late Victorian Degeneracy Crisis." *ELH*, Spring 1992; Polidori, John. *The Vampyre, a Tale*. Project Gutenberg EBook; Polidori, John. Extract of "A Letter to the Editor." Retrieved: April 14, 2007. http://www.gutenberg.org.

Jackson Pollock: "8 Killed in 2 L.I. Auto Crashes; Jackson Pollock Among Victims." *New York Times*, August 12, 1956; "Jackson Pollock." *Life*, August 8, 1949; Landau, Ellen G. *Jackson Pollack*. Abrams, 1989; Ranzal, Edward. "Art Patron Sues Pollock's Widow; Miss Guggenheim Demands $122,000—Says Painter Was Her Protégé." *New York Times*, June 9, 1961; Naifeh, Steven, et al. *Jackson Pollock: An American Saga*. Clarkson Potter, 1989; Valliere, James T. "The El Greco Influence on Jackson Pollock's Early Works." *Art Journal*, Autumn 1964.

Elvis Presley: Ivins, Molly. "Elvis Presley Dies: Rock Singer Was 42; Heart Failure Is Cited by Coroner Acclaim Followed Early Scorn Elvis Presley; Object of Teen-Age Adulation and Adult Ire in 1950s." *New York Times*, August 17, 1977; Schiffman, Betsy. "Top-Earning Dead Celebrities." *Forbes*, October 30, 2007.

Marcel Proust: "Marcel Proust." *New York Times*, December 10, 1922; Alden, Douglas W. "Marcel Proust's Duel." *Modern Language Notes*, February 1938; Bernard, Anne-Marie. *The World of Proust*. MIT Press, 2002; Painter, George D. *Marcel Proust: A Biography*. Chatto & Windus, 1959; White, Edmund. *Marcel Proust*. Viking, 1999; Tadie, Jean-Yves. *Marcel Proust: A Life*. Yale University Press, 2000; Shattuck, Roger. *Proust's Way: A Field Guide to in Search of Lost Time*. W. W. Norton & Company, 2001.

Marjorie Rawlings: "Mrs. Rawlings Dies; Wrote 'The Yearling.'" *Washington Post*, December 16, 1953; "Mrs. Rawlings, 57, Novelist, Is Dead." *New York Times*, December 16, 1953; "'The Yearling,' Fall's Best Seller, Is Named Pulitzer Prize Winner." *Atlanta Constitution*, May 2, 1939; "Marjorie Rawlings Tells Story of Her Long Struggle to Write." *Los Angeles Times*, April 26, 1953.

Arthur Rimbaud: Kernan, Michael. "Promoting a Famous Memory." *Washington Post*, March 25, 1977; Mason, Wyatt, ed. *I Promise To Be Good: Letters of Arthur Rimbaud*. Modern Library, 2004; Starkie, Enid. *Arthur Rimbaud*. New Directions Publishing, 1961; Robb, Graham. *Rimbaud*. W. W. Norton & Company, 2000; Maslin, Janet. "Rimbaud: Portrait of the Artist as a Young Boor." *New York Times*, November 3, 1995; Schiff, Stephen. "Rimbaud and Verlaine, Together Again." *New York Times*, July 22, 1990; Burch, Francis F. "Paul Verlaine's *Les Poetes Maudits*: The Dating of the Essays and Origin of the Title." *Modern Language Notes*, December 1961; Nicolson, Harold. *Paul Verlaine*. Norman R. Shapiro, 1997.

Dante Gabriel Rossetti: McGann, Jerome. *Dante Gabriel Rossetti and the Game That Must Be Lost*. Yale University Press, 2002; Ash, Russell. *Dante Gabriel*

Rossetti. Harry N. Abrams. 1995; Prettejohn, Elizabeth. *The Art of the Pre-Raphaelites.* Tate Gallery, 2007; Camhi, Leslie. "The Face: Painted Lady." *New York Times*, August 27, 2006; "Abuse of Chloral Hydrate." *Quarterly Journal of Inebriety*, January, 1880; "Sculptor Bugatti Dead; Found In His Paris Studio Suffering from Gas Poisoning." *Washington Post*, December 11, 1916.

Marquis de Sade: Ryland, Hobart. "Recent Developments in Research on the Marquis de Sade." *French Review*, October 1951; Berman, Lorna. "The Thought and Themes of the Marquis de Sade: A Rearrangement of the Works of the Marquis de Sade." *Modern Language Review*, October 1974; Clements, Marcelle. "A Man for All Centuries, and Sins." *New York Times*, April 21, 2002; Schaeffer, Neil. *Marquis de Sade: A Life.* Knopf, 1999; "Dekker's Death Accidental, Tentative Ruling Declares." *New York Times*, May 9, 1968.

Sappho: Lloyd-Jones, Hugh. "Sappho's Poetry." *Classical Review*, December 1966; Wyatt, William F. Jr. "Sappho and Aphrodite." *Classical Philology*, July 1974; Hallet, Judith P. "Sappho and Her Social Context: Sense and Sensuality." *Journal of Women in Culture and Society*, Fall 1979; Carson, Anne. *If Not, Winter: Fragments of Sappho.* Vintage, 2003; Deankin, Michael. *Hypatia of Alexandria: Mathematician and Martyr.* Prometheus Books, 2007.

Robert Schumann: Worthen, John. *Robert Schumann: Life and Death of a Musician.* Yale University Press, 2007; Ostwald, Peter. *Schumann: The Inner Voices of a Musical Genius.* Northeastern Publishers, 1985; Daverio, John. *Robert Schumann: Herald of a "New Poetic Age."* Oxford University Press, 1997; Newman, Joyce. *Jean-Baptiste de Lully and His Tragedies Lyriques.* University of Rochester Press, 1979.

Berthold der Schwarz: Kelly, Jack. *Gunpowder: Alchemy, Bombards, and Pyrotechnics: The History of the Explosive That Changed the World.* Basic Books, 2005; Buchanan, Brenda J. *Gunpowder: The History of an International Technology.* University of Chicago Press, 1998; "Berthold Schwarz." *Catholic Encyclopedia*, 1913; "Gave Life For Science; Major Carroll's Last Illness Due to Yellow Fever Experiments." *New York Times*, September 18, 1907.

Seneca: Motto, Anna Lydia. "Seneca on Trial: The Case of the Opulent Stoic." *Classical Journal*, March 1966; Sorenson, Villy. *Seneca. The Humanist at the Court of Nero.* University of Chicago Press, 1984; Pratt, Norman T. *Seneca's Drama.* University of North Carolina Press, 1983; Saloman, J. H. "Stoicism and Roman Example: Seneca and Tacitus." *Journal of the History of Ideas*, June 1989; Procopé, J. F., ed. *Seneca: Moral and Political Essays.* Cambridge University Press, 1995.

Anne Sexton: "Anne Sexton Ruled Suicide." *New York Times*, October 9, 1974; Cam, Heather. "'Daddy': Sylvia Plath's Debt to Anne Sexton." *American Literature*, October, 1987; Middlebrook, Diane. *Anne Sexton: A Biography.* Vintage, 1992; Furst, Arthur. *Anne Sexton: The Last Summer.* St. Martin's Press, 2001; Salvio, Paula M. *Anne Sexton: Teacher of Weird Abundance.* State University of New York Press, 2007.

Thomas Shadwell: Borgman, Albert S. *Thomas Shadwell: His Life and Comedies.* New York University Press, 1929; Hobbs, Joseph J. "Troubling Fields: The Opium Poppy in Egypt." *Geographical Review*, January 1998; Winn, Anderson James. *John Dryden and His World.* Yale University Press, 1987.

Tupac Shakur: Pareles, Jon. "Tupac Shakur, 25, Rap Performer Who Personified Violence, Dies." *New York Times*, September 14, 1996; Carlson, Peter. "Gangsta Rapper's Radical Mama." *Washington Post.* September 23, 2003; Mar, Alex. "Biggie Mistrial Declared." *Rolling Stone*, July 7, 2005; "2Pac." *The Rolling Stone Encyclopedia of Rock & Roll.* Simon & Schuster, 2001; Cendive, Drah. *2Pac Lives: The Death of Makaveli / The Resurrection of Tupac Amaru.* Hard Evidence Research & Publishing, 2004; Thompson, Gale. "Tupac: life goes on: why the rapper still appeals to fans and captivates scholars a decade after his death." *Black Issues Book Review*, September 1, 2001; Chang, Jeff, et al. *Can't Stop Won't Stop: A History of the Hip-Hop Generation.* Picador, 2005.

Percy Bysshe Shelley: Wroe, Ann. *Being Shelley: The Poet's Search for Himself.* Pantheon, 2007; Holmes, Richard. *Shelley: The Pursuit.* New York Review Classics, 2003; Rogers, N., ed. *The Complete Poetical Works of Percy Bysshe Shelley.* Clarendon Press, 1992; Veeder, William. *Mary Shelley and Frankenstein: The Fate of Androgyny.* University of Chicago Press, 1986; Feldman, Paula R., ed. *The Journals of Mary Shelley.* Johns Hopkins University Press, 1995; St. Clair, William. *The Godwins and the Shelleys: A Biography of a Family.* Johns Hopkins University Press, 1991; "Shelley's Heart." *New York Times*, August 6, 1995; Sunstein, Emily W. *Mary Shelley: Romance and Reality.* Little, Brown & Company, 1989.

José Asunción Silva: Lodato, Rosemary. *Beyond the Glitter: The Language of Gems in Modernista Writers Rubén Darío, Ramón Del Valle-Inclán, and José Asunción Silva.* Bucknell University Press, 1999; Orjuela, Hector H. "De sobremes y otros estudios sobre José Asunción Silva." *Hispania*, March, 1978; Silva, José Asunción. *Poemas de José Asunción Silva.* Lingua S.L. Publishers, 2007.

Inger Stevens: "Inger Stevens, Actress, Is Dead; Star of TV 'Farmer's Daughter'; Swedish-Born Performer in Many Movies Was Due to Start New Video Series." *New York Times*, May 1, 1970; Villasenor, Rudy. "Inger Stevens' Negro Husband Awarded Her $171,000 Estate." *Los Angeles Times*, August 4, 1970; Patterson, William T. *The Farmer's Daughter Remembered: The Biography of Actress Inger Stevens.* Xlibris Corporation, 2000; Woolf, Thomas, ed. *Handbook of Drug Metabolism.* Informa Healthcare, 1999.

Sara Teasdale: "Sara Teasdale, Poet, Found Dead; Body Discovered in Bathtub of Her Fifth Avenue Apartment—Despondent over Illness. Doctor Reports Suicide but Medical Examiner Awaits Autopsy Today—She Won Pulitzer Prize for Verse." *New York Times,* January 30, 1933; "Police Sift Death of Sara Teasdale." *Washington Post,* January 30, 1933; Drake, William. *Sara Teasdale: Woman and Poet.* Harper and Row, 1979.

Lou Tellegen: "Tellegen Stabs Himself to Death; Actor Inflicts Seven Wounds with Scissors in Home of Hollywood Host. Had Feared Loss of Mind Illness and Waning Fame Had also Depressed Ex-Husband of Geraldine Farrar."*New York Times*, October 30, 1934; "'Doesn't Interest Me,' Says Geraldine Farrar." *Los Angeles Times*, October 30, 1934.

Terence: Lowe, J. "Terence's Four-Speaker Scenes." *Phoenix*, Summer 1997; Terence. *Eunuchus*. Ed. John Barsby. Cambridge University Press, 1999; Beacham, Richard C. *The Roman Theatre and Its Audience*. Harvard University Press, 1992; Dorey, T. A. *Roman Drama*. Basic Books, 1965.

Dylan Thomas: "D. Thomas, 39, Welsh Poet, Dies; Often Called 'Modern Keats,' He Represented a Romantic Revolt Against Classicism." *New York Times*, November 10, 1953; Brown, Tony. "R. S. Thomas's Elegy for Dylan Thomas." *Review of English Studies*, August 2000; Moynihan, William T. *The Craft and Art of Dylan Thomas*. Cornell University Press, 1966; Thomas, Dylan. *The Portrait of the Artist as a Young Dog*. New Directions Publishing, 1968; Lycett, Andrew. *Dylan Thomas: A New Life*. Overlook Press, 2005.

Hunter S. Thompson: O'Donnell, Michele. "Hunter S. Thompson, 67, Author, Commits Suicide." *New York Times*, February 21, 2005; Loiederman, Roberto. "The Darker Side of a Night with Hunter S. Thompson." *Los Angeles Times*, February 27, 2005; Brinkley, Douglas. "Football Season Is Over: Dr. Hunter S. Thompson's final note—Entering the no more fun zone." *Rolling Stone*, September 2005; "Hunter S. Thompson on Oscar Acosta." *Rolling Stone*, December 15, 1977; Stavens, Ilan. *Bandido: The Death and Resurrection of Oscar "Zeta" Acosta*. Northwestern University Press, 2003.

Henry David Thoreau: Meltzer, Milton. *Henry David Thoreau: A Biography*. Twenty-First Century Books, 2006; Robinson, David M. *Natural Life: Thoreau's Worldly Transcendentalism*. Cornell University Press, 2004; Richardson Jr., Robert D. *Henry David Thoreau: A Life of the Mind*. University of California Press, 1986; "At Concord's Shrines." *Boston Daily Globe*, May 1, 1896; Shenker, Israel. "Thoreau: More Than a Big Fish in Walden Pond." *New York Times*, July 21, 1977.

John Kennedy Toole: Joel L. Fletcher, *Ken and Thelma: The Story of A Confederacy of Dunces*. Pelican Publishing Company, 2005; Nevils, Rene Pol, et al. *Ignatius Rising: The Life of John Kennedy Toole*. Louisiana State University Press, 2001; Freidman, Alan. "A Sad and Funny Story; Dunces." *New York Times*, June 22, 1980.

Julien Torma: Conover, Roger. *4 Dada Suicides*. Atlas Press, 1995; Jarry, Alfredo *Adventures in Pataphysics*. Atlas Press, 2001; Dachy, Marc. *Dada: The Revolt of Art*. Harry N. Abrams, 2006; Richter, Hans. *Dada: Art and Anti-Art*. Thames & Hudson, 1997; Wirtz, Jean. *Julien Torma*. P. Lang Publishers, 1996.

Henri de Toulouse-Lautrec: Perruchot, Henri. *Painted From Life; Toulouse-Lautrec*. World Publishing Company, 1961; Goldschmidt, Lucien, et al, eds. *The Unpublished Correspondence of Toulouse-Lautrec*. Phaidon, 1969; "Physician Offers Theory on Artist; Believes Toulouse-Lautrec Had Rare Bone

Disease." *New York Times*, February 14, 1965; Begleiter, H., et al. "The collaborative study on genetics of alcoholism." *Alcohol Health & Research World*. Fall 1995.

Georg Trakl: Williams, Eric. *The Dark Flutes of Fall: Critical Essays on Georg Trakl*. Camden House, 1991; Sharp, Michael Francis. *The Poet's Madness: A Reading of Georg Trakl*. Cornell University Press, 1981; Simko, Daniel, ed. *Autumn Sonata: Selected Poems of Georg Trakl*. Moyer Bell, 1998.

Alan Turing: Leavit, David. *The Man Who Knew Too Much: Alan Turing and the Invention of the Computer*. W. W. Norton & Company, 2006; Teuscher, Christof. *Alan Turing: Life and Legacy of a Great Thinker*. Springer, 2003.

Jacques Vaché: Rosemont, Franklin. *Jacques Vaché and the Roots of Surrealism: Including Vaché's War Letters and Other Writings*. Charles H. Kerr Publishers, 2007; Becker, Annette. "The Avant-Garde, Madness and the Great War." *Journal of Contemporary History*, January 2000; Banerjee, Maria Nemcova. "Nezval's Prague with Fingers of Rain: A Surrealistic Image." *The Slavic and East European Journal*, Winter 1979; "Arthur Cravan." *3:AM Magazine*. Retrieved: July 4, 2007. http://www.3ammagazine.com.

Vincent Van Gogh: Hammacher, Abraham M. *Genius and Disaster: The Ten Creative Years of Vincent Van Gogh*. Harry N. Abrams, 1968; Lubin, Albert J. *Stranger on the Earth: A Psychological Biography of Vincent Van Gogh*. Da Capo Press, 1996; Arnold, Wilfred Niels. *Vincent Van Gogh: Chemicals, Crises, and Creativity*. Birkhäuser, 1992; Powers, Kathleen. *At Eternity's Gate: The Spiritual Vision of Vincent Van Gogh*. Eerdmans Publishers, 1998; Heinich, Nathalie. *The Glory of Van Gogh*. Princeton University Press, 1996; "Absinthe Drinking: The Fast Prevailing Vice Among Our Gilded Youth." *Harper's Weekly*, July 14, 1879; Conrad, Barnaby. *Absinthe: History in a Bottle*. Chronicle Books, 1997.

Townes Van Zandt: "T. Van Zandt; Country Singer, Songwriter." *Los Angeles Times*, January 3, 1997; Strauss, Neil. "For a Moody Poet of Folk, an Unmournful Tribute." *New York Times*, February 27, 1997; Kruth, John. *To Live's to Fly: The Ballad of the Late, Great Townes Van Zandt*. Da Capo Press, 2008.

Louis Verneuil: "Playwright Verneuil Found Dead In Paris." *New York Times*, November 4, 1952; Verneuil, Louis. *Fabulous Life of Sarah Bernhardt*. Greenwood Publishing Group, 1981; Kurz, Harry. "Louis Verneuil, 1941." *French Review*, January 1942.

Sid Vicious: Kifner, John. "Sid Vicious, Punk-Rock Musician, Dies, Apparently of Drug Overdose; Bail Is Reinstated." *New York Times*, February 3, 1979; Hilburn, Robert. "Life and Death in the Fast Lane." *Los Angeles Times*, February 25, 1979; Zibert, Eve. "Death of a Punk Star." *Washington Post*, February 3, 1979; Segell, Michael. "Sid Vicious: The Punk Murder Case." *Rolling Stone*, November 30, 1978; Bardach, Ann. "The Not so Lonesome Death of Nancy Spungen." *Soho Weekly News*, October 26. 1978.

Andy Warhol: McGill, Douglas. "Andy Warhol, Pop Artist, Dies." *New York Times*, February 23, 1987; "Warhol's Private Nurse Banned from N.Y. Hospital." *Chicago Tribune*, March 6, 1987; "Andy Warhol, Recorded Pop Images of His Time." *Boston Globe*, February 23, 1987; "Suspect Says Warhol Tried to Block Play." *Los Angeles Times*, June 5, 1968; Brockris, Victor. *Warhol: The Biography: 75th Anniversary Edition*. Da Capo Press, 2003; Watson, Steven. *Factory Made: Warhol and the Sixties*. Pantheon, 2003.

Simone Weil: Pruette, Lorine. "Backward Child Is Tested Anew; Work of 'Ungraded' Classes Is Adapted to Meet Individual Needs—Health of Pupils Is a Vital Factor." *New York Times*, July 3, 1927; Hardwick, Elizabeth. "A Woman of Transcendent Intellect Who Assumed the Sufferings of Humanity; Simone Weil." *New York Times*, January 23, 1977; Gray, Francine Du Plessix. *Simone Weil*. Viking, 2001.

Oscar Wilde: "Death of Oscar Wilde; He Expires at an Obscure Hotel in the Latin Quarter of Paris. Is Said to Have Died from Meningitis, but There Is a Rumor That He Committed Suicide." *New York Times*, December 1, 1900; "Wilde Dead." *Boston Globe*, December 1, 1900; "A Wasted Life." *Washington Post*, December 23, 1900; "Wilde's End Has Come." *Los Angeles Times*, December 1, 1900; Ellmann, Richard. *Oscar Wilde*. Vintage, 1988.

Thomas Wolfe: "Thomas C. Wolfe, Novelist, 37, Dead; Wrote 'Look Homeward, Angel' in 1929 and 'Of Time and the River'; Teacher for Six Years; Began Literary Career with Plays, but Never Found Producer for Them." *New York Times*, September 16, 1938; "Thomas Wolfe Dies at Johns Hopkins." *Atlanta Constitution*, September 16, 1938; "Thomas Wolfe." *Washington Post* , September 17, 1938; Donald, David Herbert. *Look Homeward: A Life of Thomas Wolfe*. Little, Brown & Co., 1989.

Virginia Woolf: Strode, Hudson. "The Genius of Virginia Woolf; In Her Last Book the English Novelist Again Says the Unsayable Between the Acts." *New York Times*, October 5, 1941; "Virginia Woolf Believed Dead; Novelist Is Thought to Have Been Drowned Friday—Had Been Ill." *New York Times*, April 3, 1941; Woolf, Virginia. *A Room of One's Own*. Harvest Books. 1989; Love, Jean O. *Virginia Woolf. Sources of Madness and Art*. University of California Press, 1977; Poole, Roger. *The Unknown Virginia Woolf*. Cambridge University Press; Rangel, Gabriela. "Alberto Greco: Signing the Transient." *Literature and Arts of the Americas*, November 2007.

Constance Fenimore Woolson: "Death of Constance F. Woolson; The Novelist Dies in Venice, Italy—Her Literary Career." *New York Times*, January 25, 1894; Moore, Rayburn S. *Constance F. Woolson*. Louisiana State University Press, 1988; Dean, Sharon L. *Constance Fenimore Woolson: Homeward Bound*. University of Tennessee Press, 1995; McWhirter, David. *Desire and Love in Henry James: A Study of the Late Novels*. Cambridge University Press, 1989.

Stefan Zweig: "Stefan Zweig, Wife End Lives in Brazil; Austrian-Born Author Left a Note Saying He Lacked the Strength to Go On; Author and Wife

Die in Compact; Zweig and Wife Commit Suicide." *New York Times*, February 24, 1942; Alsberg, Henry G., et al, eds. *It Ended in Despair; Stefan and Friderike Zweig. Their Correspondence, 1912–1942*. Hastings House, 1954; Shenk, David. *The Immortal Game: A History of Chess*. Doubleday, 2006; Hallman, J. C. *The Chess Artist: Genius, Obsession, and the World's Oldest Game*. St. Martin's Press, 2004.

ACKNOWLEDGMENTS

Gratitude to the archivists at the *New York Times*, the staff at American Histori-cal Association, and I accommodate the archivists and librarians at the Library of Congress for their help to navigate and access this great depository of hu-manities' brilliance. I am principally grateful to HarperCollins for producing a wonderful looking book and for all the staff whose hard work made it pos-sible, namely, Carrie Kania, publisher, for her continued support; Cal Morgan, editorial director; Nicole Readon and Jen Hart for their creative marketing ef-forts; and Alberto Rojas, publicity director. I especially thank my editor, Peter Hubbard, for his steadfast encouragement and insights. Much thanks to the diligence and talent of Kolt Beringer, assistant managing editor; Justin Dodd, designer; Greg Kulick, cover illustrator; and Milan Bozic, art director. I am also indebted to all the hard working folks in sales who have made my books available in so many areas. Appreciation to my agent, Frank Weinman, for his acumen, and the crew at the Literary Group International for their assistance. I also express thanks to my friends at the Horror Writers Association for their unswerving support. Kudos to all the great folks at bookstores and book fairs across the country I met whose hospitality and fervor for books has been heart-ening. I also acknowledge the many radio personalities and their producers who invite me on their programs time and time again for motivationally uplifting conversations about my books. I lest not forget, Jared, Colette, Michael, Erik, and Joe for their enthusiasm. And finally, after all I learned writing *Genius and Heroin*, I thank those who persist and practice at offering respite from whatever obsessions that grab us, giving the opportunity for many to have peaceful and creative lives.

PHOTOGRAPHIC CREDITS

Alcoholism: Anita Kunz; Art Accord: Courtesy Lone Pine Film Festival; Tom Mix: National Photo Company; Opium Den lithograph: J. Keppler; James Agee: Walker Evans; Death and Taxis: C. J. Hibbard; Henry Alexander: Forst, Averell & Co.; Dante Etching: William Blake; GG Allin: Courtesy www.nndb.com; Diane Arbus: Office of War Information; Arbus camera: Horydczak Collection; Antonin Artaud: Courtesy France Department of Tourism, photo by D. R. Tous; Artaud, Re-Charged: Around the Clock: U.S. Lithograph Co.; Babel: Jewish Currents.org; Babel: John R. Fischetti; Balzac: U.S. Printing Co.; Candlelight: Dr. Giles Everard, 1659; Baudelaire: Félix Nadar; Baudelaire poor man: S. Lyne; Jeanne Duval: Edouard Manet; Man at Tavern: Laurie & Whittle; Brendan Behan: Phil Stanziola; John Berryman: Courtesy Columbia University; Berryman/Bridge: Thomas Fogarty; Ambrose Bierce: J.H.E. Partington; Gen. Villa: W.H. Durborough; William Billings Poster: Paul Revere; Tobacco Advertisement: Julius Bien & Co.; No Smoking: Library of Congress Prints and Photographs Division; Celtic Kegs: Horydczak Collection; Boadicea: Thomas Stothard; Richard Brautigan: Erik Weber; Lenny Bruce: New York World-Telegram and the Sun Newspaper Photograph Collection; John Horne Burns: Office of War Information; Braille: Roy Perry; Blind man: Lewis Hines; King Alcohol: John Warner Barber; Eat: T. Ungerer; Capote party: Mel Finkelstein; Alice Liddell: Lewis Carroll; Bob Dylan with guitar: Douglas Gilbert; Chatterton's holiday: W. B. Morris; Dance of Death: Hartmann Schedel; Dr. Jekyll and Mr. Hyde: National Prtg. & Engr. Co.; Blood Transfusions: J. S. Elsholtz; Montgomery Clift: New York World-Telegram and the Sun Newspaper Photograph Collection; Man with Bull: National Council of American-Soviet Friendship; Help Yourself: Work Projects Administration; Large Head Diner: Isaac Cruikshank; Woman Shotgun: George Grantham Bain Collection; Lewis Carroll: Library of Congress Prints and Photographs Division; Sick Friend: L. M. Glackens; Hart Crane: New York World-Telegram and the Sun Newspaper Photograph Collection; Saw Head: Auguste Bouque;

Opium Seller: Frank and Frances Farmer Collection; Catullus: Gottscho Schleisner; Effects of Masturbation: S. Pancoast; Highlights and Shadows: Exhibit Supply Co.; Samuel Coleridge: Washington Allston; Hand of Destiny: The Strobridge Lith. Co.; The Great Remedy: Library of Congress Prints and Photographs Division; The Rats: Bernard F. Reilly; Death Bed: J. J. Grandville; Winston Churchill: Office of War Information; Oysters: A.Hoen & Co.; Belle Boyd: Brady-Handy Photo Collection; Schoolitis: Norman Rockwell; Death of Tippoo: S. W. Fores; Charlotte Bronte: George Richards; New Solar System: J. Ottman Lith. Co.; Zelda Sears: Arnold Genthe; Poppy Plant: Pierre Tupin; The sea hawk: Library of Congress Prints and Photographs Division; Rock 'n' Roll: Library of Congress Prints and Photographs Division; Tattoo: Gottscho Schleisner; Singing Piano: Office of War Information; Stephen Crane: Infrogmation Collection; Salvino D'Armati: Sebastian Brandt; Shakespeare's Cliff: Detroit Publishing Co.; Dope: Frederick Opper; Snow's Inhaler: National Library of Medicine; Opium Den: J. W. Alexander; Strongman: Library of Congress Prints and Photographs Division; Phantasm: David Salot; The Bath: Harry Whittier Frees; Mystery Asylum: Work Projects Administration; F. Scott Fitzgerald: Carl Van Vechten; Archer's Competition: Horydczak Collection; William Faulkner: Carl Van Vechten; Town Red: Grant E. Hamilton; Prohibition: New York World-Telegram and the Sun Newspaper Photograph Collection; Moonshine: National Photo Co.; John Gilbert: New York World-Telegram and the Sun Newspaper Photograph Collection; Lon Chaney: Eugene Rosow; Prodigal Son: Thomas Rowlandson; Ernest Hemingway: New York World-Telegram and the Sun Newspaper Photograph Collection; Henry VIII: Hans Holbein; William Sydney Porter: Library of Congress Prints and Photographs Division; Mickey Mantle: LOOK Magazine Photograph Collection; Retirement Years: Gary Yanker; The Lost Weekend: Lester Glassner Collection of Movie Posters; Phyllis Wheatley: Scipio Moorhead; Buy Bonds: Alex Raymond; John Keats: R. R. Haydn; Love is a many-splendored thing: AFI Gift Collection; Polish children: Polish American Council; Fools Tower: George Grantham Bain Collection; Dorothy Dandridge: New York World-Telegram and the Sun Newspaper Collection; Colored Glasses: Library of Congress Prints and Photographs Division; Cock and Chickens: W. Benbow; Moments with Genius: Work Projects Administration; Sigmund Freud: Library of Congress Prints and Photographs Division; Min kone er en Heks: Størvald & Sønner; Dinner at Eight: Tooker Litho. Co.; Treatment for Insanity: National Library of Medicine; Cocaine: Rene Gilliard; Royal Lilliputians: U.S. Printing Co.; Renaissance Couple: Joseph Lindon Smith; Seven Men: Alexander Dessene; D. W. Griffith: National Photo Company Collection; Temperance Crusade: A. J. Fisher; Imperial Wizard: National Photo Company Collection; Way down East: Strobridge Lith. Co.; Maria Callas: New York World-Telegram and the Sun Newspaper Photograph Collection; James Dean: Lester Glassner collection of Movie Posters; Emily Dickinson: Library of Congress Prints and Photographs Division; Diogenes: Salvator Rosa; American Indian Movement: Gary Yanker; Join the Navy: Ralph Armstrong; Catcher: Lee Russell; Boy with Sword: Edouard

Manet; Fantastic Spectacle: U.S. Printing Co.; Homecoming: State Historical Society of Colorado; Ernest Hemingway: New York World-Telegram and the Sun Newspaper Photograph Collection; Hemingway Sons: Library of Congress Prints and Photographs Division; Modern Chair: Gottscho Schleisner; Hunchback: British Cartoon Prints Collection; Runaway Horse: E. Reichenbach; Sir Humphry Davy: Hodgson & Co.; William Inge: Carl Van Vechten; Mercedes Racer: George Grantham Bain Collection; James Weldon Johnson: Carl Van Vechten; Scream: Office of War Information; Tumble Bug: Edward Williams Clay; Forcibly Fed: World Magazine; Slap and Absurdity: Russell-Morgan; Opera Singer: British Cartoon Prints Collection; Spook Party: Triangle Poster & Printing Co.; Keats Death Bed: S. Largo; End of Pain: British Cartoon Prints Collection; Balloon Girl: Quigley Lith. Co.; Scale: Office of War Information; Evil Eye: U.S. Printing Co.; The Drunk: George Bellows; Steeplejack: Hughes & Hammond; Stunt Plane: Library of Congress Prints and Photographs Division; Woman on Lap: Celebrity Art Co.; Blindfold: Russell Lee; Art Poster: Work Projects Administration; Velocipede: M. V. Noody; Bicycle Quad: George H. Van Norman; Vachel Lindsay: Victor George; Happy Hooligan: Russell-Morgan; Ring Lardner: New York World-Telegram and the Sun Newspaper Photograph Collection; T. E. Lawrence: New York World-Telegram and the Sun Newspaper Photograph Collection; Sinclair Lewis: Man Ray; Jack London: George Grantham Bain Collection; Ross F. Lockridge, Jr.: New York World-Telegram and the Sun Newspaper Photograph Collection; Federico García Lorca: Walter Torres; Henri de Toulouse-Lautrec: zeno.org; Faust: Work Projects Administration; Devils' Drum: Warren Johnson; Drunk's Prison: M. Marques; El Vulcano: M. Leopold; Herman Melville: Joseph O. Eaton; Looking Up: Office of War Information; Death of Adonis: Benjamin West; Man Smoking Water Pipe: Pierre Vallement; Man Envisioning Suicide: Honore Daumier; Underground Life in New York: Charles Stanley Reinhart; Dracula: Work Projects Administration; Robert Lowell: Library of Congress Prints and Photographs Division; Ether Inhaler: Laurence Turnbull; J. Edgar Hoover: Library of Congress Prints and Photographs Division; Vlad the Impaler: Library of Congress Prints and Photographs Division; Hanging Square: French Political Cartoon Collection; Mann family: E. Wasow; Carson McCullers: Carl Van Vechten; Joseph McCarthy: Granik Collection; People's Saint: Library of Congress Prints and Photographs Division; The Old Maid: British Cartoon Prints Collection; Norman Mailer: Carl Van Vechten; Edna St. Vincent Millay: Arnold Genthe; Katherine Millay: Arnold Genthe Collection; Looking Backward: Laura E. Foster; Miyamoto Musahi: K. Utagawa; Yukio Mishima: Shirou Aoyama; Le Lever: Jules Pascin; Don't Kill Our Wildlife: John Wagner; The Flying Merkel: Miamicycle & Mfg. Co.; Bum on Bowery: Marjory Collins; Guy de Maupassant: Maurice Devriès; Alfred de Musset: Library of Congress Prints and Photographs Division; Children's Benefit: Rodger Smith; The Prime Lobster: William Heath; Woman Statue: Russell Lee; Mabel Normand: George Grantham Bain Collection; Tyco Branche: E. Desrochers; The Four Freedoms: Alfred T. Palmer; Can't Be Beat: Currier & Ives; Eating Habits: Louis Boiley;

Heroin screws you up: Great Britain Department of Health; Coca Wine: Illustrated Medical News; Last Drop: M. Darley; Vegetables on Scale: Horydczak Collection; Roman Toga: J. E. Abbe; John O'Hara: Matthew J. Bruccoli; Fallen Thieves: Strobridge Lith. Co.; Barefoot Man: Library of Congress Prints and Photographs Division; Dorothy Parker: New York World-Telegram and the Sun Newspaper Photograph Collection; Cesare Pavese: Courtesy Turismo e Promozione della Città di Torino; Jack Pickford: George Grantham Bain Collection; Mary Pickford: George Grantham Bain Collection; Social Qualities: J. Childs; Gen. U.S. Grant: Library of Congress Prints and Photographs Division; Open Oven Door: Ann Rosener; Women in Window Flirting: A. S. Seer; The Raven: U.S. Lithograph Co.; U.S. Marines Want You: Library of Congress Prints and Photographs Division; Aleksandr Sergeevich Pushkin: Vezenberg & Co.; Edgar Allan Poe: Edwin H. Manchester; Vampire Embracing: Library of Congress Prints and Photographs Division; Marcel Proust: Maurice Devriès; Jackson Pollock: Namath Hans; Arthur Rimbaud: Maurice Devriès; Paul Verlaine: Maurice Devriès; Dante Gabriel Rossetti: Library of Congress Prints and Photographs Division; Marjorie Kinnan Rawlings: Carl Van Vechten; Mrs. Wallace Reid: National Photo Company; Man in Blackface: Frances Benjamin Johnston Collection; Bookies: Marion Post Walcott; Portefaix: Abdullah Frères; Lady Lilith: Dante Gabriel Rossetti; The Giraffe: Keystone View Co.; Calcutta: Lester Glassner Collection; Human Passions: John Collier; Plague Doctor: Thomas Bartholin; Amputation: National Library of Medicine; Sappho: Francis Holl; Robert Schumann: Detroit Publishing Company Photograph Collection; Berthold der Schwarz: Wikimedia Commons; Conquerors of Yellow Fever: New York World-Telegram and the Sun Newspaper Photograph Collection; Last Request: John Caspar; Lucius Annaeus Seneca: P. P. Rubens; Anne Sexton: Elsa Dorfman; Percy Bysshe Shelley: Count Alfred D'Orsay; Heart Gunshot Wound: National Library of Medicine; Revolver: George Grantham Bain Collection; George Sterling: Arnold Genthe; Farmer's daughter: John Vachon; Figure of death: Jacques-Antony Chovin; Tupac: Courtesy of halloween costumes 4u.com, Inc. Lou Tellegen & Farrar: George Grantham Bain Collection; Masque Society: WPA Federal Art Project; Darkest Russia: The Strobridge Lith. Co.; Blood Bitters: National Library of Medicine; Mother with child holding gun: Black Panther Party; Monkeys Strangled: N. Boldrini; Frenzylogical chart: Oliver Hereford; Sara Teasdale: Wm. Drake; The Daintier Finger: Glen Lowry; Dylan Thomas and Oscar Williams: Library of Congress Prints and Photographs Division; Henry David Thoreau: Geo. F. Parlow; Dream of a Rarebit Fiend: Library of Congress Prints and Photographs Division; Animal Locomotion: Edward Muybridge; Homemade Jelly: Office of War Information; Women against violence: Gary Yanker; Basement urinal: Gottscho-Schleisner Collection; Philosophy of Expression: Charles Bell; Alcoholismo: Gustavo Philliphon; J. G. Parry-Thomas: Courtesy of S. J. Parry-Thomas; Andy Warhol and Tennessee Williams: New York World-Telegram and the Sun Newspaper Photograph Collection; Oscar Wilde: N. Sarony; Thomas Wolfe: Carl Van

Vechten; Bottle running: Oliver Hereford; Broken Wings: Maurice Greiffenha-
gen; Virginia Woolf: New York World-Telegram & Sun Collection; Man playing
chess with grim reaper: Walter Appleton Clark; Parting Ways: René Descartes;
Eugene O'Neill: Patkirk; Turing: National Security Agency; Sid Vicious:
Punk Paper.

BOOKS BY MICHAEL LARGO

GENIUS AND HEROIN
The Illustrated Catalogue of Creativity, Obsession, and Reckless Abandon Through the Ages

ISBN 978-0-06-146641-0 (paperback)

What is the price of brilliance? Why are so many creative geniuses also ruinously self-destructive? An addictively readable reference to the untidy lives of our greatest artists and thinkers.

"Meticulous, fascinating, and often intriguingly bizarre." —Simon Winchester, author of *The Professor and the Madman*

THE PORTABLE OBITUARY
How the Famous, Rich, and Powerful Really Died

ISBN 978-0-06-123166-7 (paperback)

An irresistible compendium of how celebrated persons have met their end—providing the ultimate demise of heroes and icons, politicians and celebrities, radicals, murderers, and Nobel Prize winners.

"Largo reveals the secrets of the celebrated dead!"
—*Miami Herald*

FINAL EXITS
The Illustrated Encyclopedia of How We Die

ISBN 978-0-06-081741-1 (paperback)

An eye-opening and entertaining look at the truth behind kicking the bucket, *Final Exits* is the definitive A to Z illustrated sourcebook on the way we die.

"Reading just one more item in *Final Exits*, then another, then still another, is as compulsive as eating popcorn ... frequently stunning." —*Chicago Sun-Times*

Visit www.AuthorTracker.com
for exclusive information on your favorite HarperCollins authors.

Available wherever books are sold, or call 1-800-331-3761 to order.